PERFORMANCE ANTHOLOGY

Source Book for a Decade of California Performance Art

CONTEMPORARY DOCUMENTS

A series of comprehensive resource books
for the new art

Carl E. Loeffler, Series Editor

Vol. 1 *Performance Anthology: Source Book for a Decade of California Performance Art*

Forthcoming works in progress to be published 1980-81, focus on
subject areas of art video, narrative art, and new art theory.

PERFORMANCE ANTHOLOGY

Source Book for a Decade of California Performance Art

Carl E. Loeffler, Editor
and
Darlene Tong, Associate Editor

CONTEMPORARY ARTS PRESS
SAN FRANCISCO
1980

This book is dedicated to the
Museum of Conceptual Art

Contemporary Arts Press is a division of La Mamelle, Inc.
Copyright © 1980 La Mamelle, Inc.
All rights reserved.
Printed in the U.S.A.

First Edition

International Standard Book Number: 0-931818-01-x
Library of Congress Catalog Card Number: 79-55054
Printed by Mendocino Lithographers, Ft. Bragg, Ca.

CONTEMPORARY ARTS PRESS
P.O. BOX 3123, RINCON ANNEX
SAN FRANCISCO, CA 94119

Cover: Terry Fox, *Corner Push*, Reese Palley Gallery,
San Francisco, 1970. (Photo by Barry Klinger)

CONTENTS

PREFACE AND ACKNOWLEDGMENTS

Performance Anthology offers documentation of a vital contemporary art expression that emerged fully in the 1970's. Our intention with this book is to establish a framework for the development of a documented history of performance art in California. The major part of *Performance Anthology* consists of the "Chronology of Literature," an extensive annotated bibliography of important literature and marginal works related to performance art in California. The four essays that follow can be considered an adjunct to the chronology since they offer in-depth discussions of specific aspects of performance art, clarifying and embellishing the enormous amount of information offered in the chronology.

Performance Anthology is structured to be used as a reference source, textbook and visual resource. 1) As a reference source, it provides the reader with an extensive, annotated list of publications where further information on the subject of performance art can be found; 2) As a textbook, it offers major theoretical and historical essays as well as excerpts from the literature with statements by artists and descriptions of their work; 3) As a visual resource, *Performance Anthology* fully documents a decade of California performance activity through photographs and provides references to some major works on videotape, film, postcards and other visual presentations of performance art.

* * * *

It has taken over two years to gather and compile the information for *Performance Anthology*. The editors would like to thank the artists and writers whose generosity in contributing information and photographs made the publishing of *Performance Anthology* possible. We would especially like to acknowledge our contributing writers, Tom Marioni and Allan Kaprow, for their introductory statements; Linda Frye Burnham, publisher of *High Performance* magazine, for her essay on Southern California performance art; and Judith Barry and Moira Roth for their essays on feminist performance art in Northern and Southern California. We would also like to acknowledge the individuals and institutions whose initial enthusiasm and early support of performance art contributed to its development as a major contemporary art form, especially Willoughby Sharp and Liza Bear, publisher and editor of *Avalanche*; Tom Marioni, Director of the Museum of Conceptual Art in San Francisco, one of the first alternative spaces in the U.S.; Ken Friedman, Director of Fluxus West and the Institute for Advanced Studies in Contemporary Art; Cecile N. McCann, publisher and editor of *Artweek*; Dick Higgins, founder of Something Else Press; the institutions who supported performance activity during the early 1970's, such as the Reese Palley Gallery (San Francisco), and the University Art Museum (Berkeley) under the direction of Peter Selz and curator Brenda Richardson; and finally, the alternative spaces which have continued the support of performance activity, such as LAICA, 80 Langton St., and the Floating Museum, among many others.

We would like to give special acknowledgment to Nancy Frank, Assistant Director of La Mamelle, Inc., for establishing the communications network necessary to contact all artists included in this book, for gathering the photographs and other pertinent information from the artists, and for assisting in book production and publicity. We would like to thank Richard Alpert, Anna Banana and Bill Gaglione, and the San Francisco Museum of Modern Art for generous use of their archives; Mary Stofflet, writer and Coordinator of the Rockefeller/NEA Fellowships at the Fine Arts Museums of San Francisco and Miriam Morgan, feature writer for the *San Mateo Times*, for their editorial assistance; Annette Randell for typing assistance; Persis Giebeler for production assistance; Norman Buck for copy camera work; and *The Goodfellow Catalog of Wonderful Things* Typesetting for its tireless effort in typesetting this exceedingly difficult copy.

We wish to also thank the National Endowment for the Arts and the California Arts Council for their continuing support of La Mamelle, Inc., to further the exploration of contemporary new art activity.

INTRODUCTION

During the 1970's California occupied a leading role in the development of performance as a contemporary expression of visual art. Interestingly, the term performance has continued to elude a specific definition and most often artists who have produced performance-type works do not think of themselves as performance artists. Consequently, performance has sometimes served as a misused catch-all category. There are, however, specific parameters in which performance has been presented as a contemporary visual art form. This anthology is a documentation, and hopefully a clarification, of those parameters.

Theatre, dance, music, poetry, video and film are often employed in performance as interdisciplinary components but none of them as single forms of expression can be considered performance art. Expressive of the post-modernist ideal which eradicates distinct categorical disciplines, performance is all of the above categories yet none of them. This distinction in definition becomes important to maintain, in light of some new art activities that possess strong performance aspects, e.g., sound poetry, experimental theatre and dance.

Performance art is executed both in private or before a live audience, and is variously called actions, events, performances, pieces, things, or even happenings. Some performance is about the artist's body and has been termed body art. Performance also has been regarded as "sculpture as action" where the work exists only during the time utilized to demonstrate it, often through a non-theatrical, direct use of materials. Other performance work is theatrical in the use of illusion and can convey a fictional or autobiographical narrative that stresses elements of staging. Performance can also illustrate socio-political concerns and the idea of performance can "frame" religious rituals and daily routine activity. The materials utilized in performance can be high-tech or biological, tangible or intangible. Our condition is examined through performance and the information relayed can be closed, systematically reporting on itself, or open, reporting on interaction and communion with other materials and situations.

The decade which this anthology documents has had the most impact with regard to the initial rise and progression of performance art. Elsewhere in this anthology Tom Marioni states that his use of performance is now "old fashioned," because performance has become theatrical. A more concise statement of the condition of performance could not be made. It is interesting to observe through the information presented in this anthology how an art form owing so much to conceptual concerns, where it often was neither necessary for the work to be performed nor witnessed, has now evolved to a major degree into theatre. I continue to remain taken by the idea of performance, and I often hear rumblings regarding the tough and boring nature of its form. Perhaps this anthology will assist in illuminating the wealth of ideas expressed through the form of performance art.

Carl E. Loeffler
December 1979

INTRODUCTORY STATEMENT

I have come to realize that my concept of performance art has become old-fashioned. It is old-fashioned to insist that performance is sculpture action or sculpture evolved into the fourth dimension (time). Something I learned from Miles Davis was that by turning his back on the audience when he played music he was an artist working; he said once that he was an artist, not a performer. I have held onto this notion of the sculpture action, where the action is directed at the material being manipulated rather than at the audience as in theater. But I can see that this is a late 60s, European (Klein, Beuys, Brus) concept of this art. In 1970 when I founded MOCA, as a specialized, sculpture museum, I established my own rules. I defined conceptual art as "Idea oriented situations not directed at the production of static objects." Now, in 1979, the break from the object is no longer an issue. Ten years ago it was important to make a statement against materialism by making actions rather than objects. Now, with some artists in my generation, there seems to be a return to the subject—the object not as an end in itself (aesthetic), but rather as material to explain a function. This is a kind of pre-Renaissance idea of art. Where the object is used in a social, architectural or religious function. The 70s, is an age (in art) of theatricality and decoration.

<div align="right">

July 12, 1979
Tom Marioni

</div>

PERFORMING LIFE

Coming into the Happenings of the late 50's, I was certain the goal was to "do" an art that was distinct from any known genre (or their combinations). It seemed important to develop something else than another type of painting, literature, music, dance, theater, opera, etc.

Since the substance of the Happenings was events in real time, as in theater and opera, the job, logically, was to bypass all theatrical conventions. So, over a couple of years, I eliminated art contexts, audiences, single time/place envelopes, staging areas, roles, plots, acting skills, rehearsals, repeated performances, and even the usual readable scripts.

Now if the models for these early Happenings were not the arts, then there were abundant alternatives in everyday life routines: brushing your teeth, getting on a bus, washing dinner dishes, asking for the time, dressing in front of a mirror, telephoning a friend, squeezing oranges. Instead of making an objective image or occurrence to be seen by someone else, it was a matter of doing something that was experienceable for yourself. It was the difference between watching an actor eating strawberries on a stage and actually eating them at home. Doing life, consciously, was a compelling notion to me.

Of course, when you do life consciously, life becomes pretty strange—paying attention changes the thing attended—so the Happenings were not nearly as lifelike as I supposed they might be. But I learned something about life and "life".

The new art genre therefore came about, or more accurately, gradually became an art/life genre, reflecting equally the artificial aspects of everyday life and the lifelike qualities of created art. For example, it was clear to me how formal and culturally learned the act of shaking hands is; just try to pump a hand five or six times instead of two and you'll cause instant anxiety. I also became aware how autobiographical and prophetic art works of any kind could be. You could read a painting like its maker's handwriting, and over a period of time chart her or his abiding fantasies, just as you might from a collection of personal letters or a diary. The Happenings, and later the Activities, were less purified languages than the visual, auditory and literary arts, and less clearly framed than the theatrical arts, thus they lent themselves more readily to such insights.

Today, in 1979, I'm paying attention to breathing. I've held my breath for years—held on to it for dear life. And I might have suffocated if (in spite of myself) I hadn't had to let go of it periodically. Was it mine, after all? Letting it go, did I lose it? Was (is) exhaling simply a stream of speeded up molecules squirting out of my nose?

I was with friends one evening. Talking away, our mouths were gently spilling air and hints of what we'd eaten. Our breaths, passing among us, were let go and reabsorbed. Group breath.

Sometimes, I've waked beside someone I loved and heard our breathing out of sync (and supposed that was why I woke). I practiced breathing in and out, copying her who slept, and wondered if that dance of sorts was echoing in her dreaming.

There's also the breathing of big pines in the wind you could mistake for waves breaking on a beach. Or city gusts slamming into alleyways. Or the sucking hiss of empty water pipes, the taps opened after winter. What is it that breathes? Lungs? The metaphysical me? A crowd at a ballgame? The ground giving out smells in spring? Coal gas in the mines?

These are thoughts about consciousness of breathing. Such consciousness of what we do and feel each day, its relation to others' experience, and to nature around us, becomes in a real way the performance of living. And the very process of paying attention to this continuum is poised on the threshold of art performance.

I've spoken of breathing. Yet I could have mentioned the human circulatory system, or the effects of bodies touching, or the feeling of time passing. Universals (sharcables) are plentiful. From this point on, as far as the artist is concerned, it is a question of selecting and joining those features of breathing (or whatever) into a performable plan that may reach acutely into a participant's own sense of it *and* resonate its implications.

Here is sketch for a possible breathing piece. It juxtaposes the auditory and visual manifestations of breath, moves the air of the environment (by fan) to render it tactile, and ties the rhythmic movement of breathing to that of the ocean. In the three parts of the piece the participant is first alone, is then with a friend (but kept apart by a glass membrane), and again is alone. The first part makes use of self-consciousness; the second changes that to awareness of self in another person; and the third extends self to natural forces but folds back on artifice in the form of tape-recorded memory.

> 1 alone, studying your face in a chilled* mirror
> smiling, scowling perhaps
>
> a microphone nearby
> amplifying the sound of your breathing
>
> a swiveling electric fan
> directing the air around the room
>
> gradually leaning closer to your reflection
> until the glass fogs over
>
> moving back until the image clears
>
> repeating for some time
>
> listening

2 sitting opposite a friend
(who has done the above)

 a chilled pane of glass between you

 your microphones amplifying your breathing
 your fans turning at opposite sides of the room

 copying each other's expressions

 matching your breathing

 moving gradually to the glass
 until your images fog over

 moving back until the images clear

 repeating for some time

 listening

3 sitting alone at the beach

 drawing in your breath and releasing it
 with the rise and fall of the waves

 continuing for some time

 walking along the waves' edge

 listening through earphones
 to the record of your earlier breathing

Since this piece has not been performed, I can only speculate what would happen in carrying it out. Breathing as an abstract idea is unexceptionable; like integrity it is desirable. And formally manipulating verbal exercises on it might even provoke mild curiosity. But breathing as a real and particular event can be an awkward and painful business. Anyone who has jogged seriously, or done breathing meditation, knows that in the beginning, as you confront your body you face your psyche as well.

In this piece, I suspect that the innocent playfulness and poetic naturism of its prescriptions could gradually become for the participant perverse and disturbing. Release from its dead-pan literalness might be possible only by accepting a temporary alienation of the breath from self.

Consider what the piece proposes to do. It exaggerates the normally unattended aspects of everyday life (fleeting mist on glass, the sound of breathing, the circulation of air, the unconscious mimicry of gestures between friends) and frustrates the obvious ones (looking at ourselves in a mirror, breathing naturally, making contact with a friend, listening to the ocean waves). The loudspeaker, the mirror, the waves, the tape recording, are each feedback devices to insure these shifts.

Such displacements of ordinary emphasis increases attentiveness of course but attentiveness to the peripheral parts of ourselves and surroundings. Revealed this way they are strange. The participant could feel momentarily separated from her/himself. The coming-together of the parts, then, might be the event's residue, latent and felt, rather than its clear promise.

*Literally, a mirror propped
against, or standing in, ice.

Allan Kaprow
August 1979

CHRONOLOGY
OF
LITERATURE
1970—1979

PREFACE TO THE CHRONOLOGY

Performance as a visual art form flourished in California throughout the 1970's. Documentation of this activity appeared in various forms: books and journal articles produced by commercial publishers; exhibition catalogues; marginal works such as videotapes, films, audiotapes and postcards; and most importantly, artists' writings published as "alternative" literature in the form of artists' books, catalogues and journals. The emergence of "alternative" publications in the 1970's came about as a means for artists and writers to document "new art" activity often ephemeral by nature, and to share ideas and information with others in the contemporary art community. And because the publications often functioned as exhibition space and were the only form of presentation for many artworks, the information in these publications is regarded as primary Art.

The "Chronology of Literature" is essentially a bibliography which attempts to document the most important literature about California performance art published during the 1970's by alternative presses and individuals acting as self-publishers, as well as by commercial publishers. The chronology provides a wealth of information that is by and large inaccessible through the most common resources used to find art information, i.e., art indexes and art historical surveys. Most of the bibliographic references include annotations. Selected references also include excerpts from the literature. The excerpts usually are statements by artists about their work or descriptions of works illustrating the artist's concepts and direct use of materials pertaining to performance. Photographs documenting performance works included in the chronology most often appear near the first bibliographic reference to the work. The material in the chronology primarily is about performance art and artists in California, although some selected material about performance art in general is included. And although the time span of the chronology is the 1970's, a few major works published in the late 1960's which are historically significant with regard to performance art are included in the 1970 section.

1

Arranged broadly by year, the chronology is a documentation of performance art literature and not a chronology of events. Bibliographic references therefore are arranged by year of publication, which is not necessarily the same year the activity was performed. For example, the event *South of the Slot* occurred during October/November, 1974, but reviews and the catalogue were not published until early the next year. Information and photographs therefore are in the 1975 section, i.e., year of publication. The index to *Performance Anthology* draws together information about a work or event. Under an artist's name, titles of works by the artist are listed with reference to pages throughout the book where the work is cited.

Within each year, the information is divided into two sections—GENERAL LITERATURE and ARTISTS/ART SPACES. Within a section, references are arranged alphabetically by author, or by title when an author was not given. The GENERAL LITERATURE section lists major books and essays, new periodicals, special issues, and reviews and catalogues of group exhibitions (three or more artists). If there is more than one reference to an event within a year, such as *Sound Sculpture As* in 1970, a sub-head by title of the event is arranged alphabetically within the general literature section and is set off from the rest of the sequence by a dotted line. The second section, ARTISTS/ART SPACES, includes publications primarily about individual artists or art spaces. Publications concerning collaborative works are cited under one artist with references made in the index to other contributors. Collaborative works by artist groups, such as the Feminist Art Workers, are listed by the group name.

The "Chronology of Literature" is reflexive in form of the original information cited in the chronology. Its arrangement by year is intended to facilitate a review of California performance activity during the 1970's which in turn may help develop an historical framework for performance art. An examination of the changes which have taken place in the form of performance art and of the publications documenting it will help the reader to develop a sense of the impact this activity has had upon the contemporary art world as well as the non-art world in general.

Darlene Tong
October 1979

2

1970

GENERAL LITERATURE

Avalanche, New York, no.1, Fall 1970. Publisher, Willoughby Sharp; Editor, Liza Bear. **The first major artist-produced periodical published in the U.S. reporting on post-object art and other new art activities. Published from 1970-1976.**

Celant, Germano. *Art Povera*. New York: Praeger, 1969. (Originally published as *Arte Povera*, Milano: Mazzotta, 1969). Excerpt:
Art Povera, which has been called by various critics process or conceptual art, tends toward immensity, fragility, even invisibility. It is more often concerned with process than product. Dennis Oppenheim gives a farmer a pattern in which to plow a field or makes a design of concentric rings on the melting ice of a river. Douglas Huebler says, "The world is full of objects, more or less interesting: I do not wish to add any more. I prefer simply to state the existence of things in terms of time and/or place." So he documents existing things by marking them on maps and describing them. Michael Heizer considers the world so full of objects he refuses to make more, and he creates "negative objects" by digging holes and trenches. Walter de Maria showed what Art Povera has to say to the art establishment by filling three rooms of a Munich gallery with three feet of dirt. Like de Maria's "Art Yard," the work can exist only as a concept. It can even be impossible to execute.
..

THE EIGHTIES

Free. Berkeley: University Art Museum, University of California, 1970. Catalogue for an exhibition originally titled *The Eighties*, organized by Susan Rannells and Brenda Richardson, at UAM, March-April 1970. The catalogue text is notes transcribed from a tape-recorded meeting of the participants, March 4, 1970. Among artists included in exhibition: Terry Fox, Howard Fried, Mel Henderson, Paul Kos, Stephen Laub, James Melchert, William T. Wiley. Excerpt:
Yeah, we were talking on the way over here. And she said, what would be

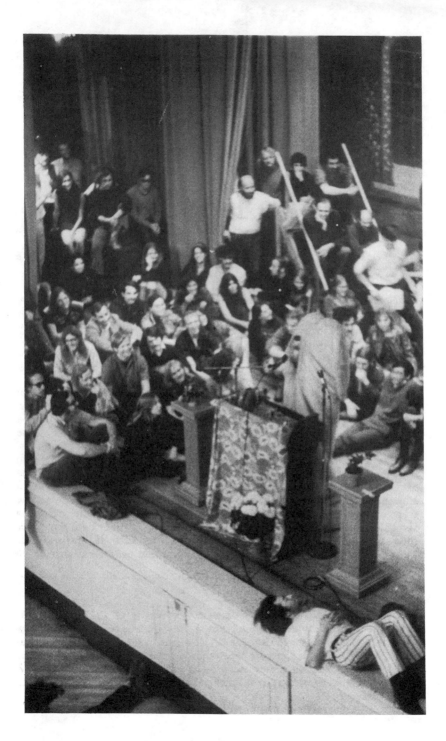

in that space? And I said Bach might be. A little funky recording. In the meantime maybe somebody comes along with an idea that really makes a lot of sense, that I can go over there and present an idea to somebody or call somebody up. I think that in a way, just because of time, certain people haven't even been thought of as far as being asked to participate. If we could somehow organize the idea that there is a space available, that there are ideas available.

You kind of get the public to come in every day to see what's happening, instead of to come in once to see what has happened. In most galleries and museums it's past tense, instead of like this, where you might want to come back every day.

Yeah, well you wouldn't do that if you had to drive across the bridge to do it, but probably if you were in the neighborhood you would do it.

That idea of open space, would be nice to have it all the time. Designate one space, and it would always be open. A poem or a painting or a print, or pile some rocks in there or whatever.

Like a neutral country?

Yeah. That's what we need for the eighties. We'd just sign a pact, and get them to designate one eternal, open space.

"U.C. Project for the Eighties," *Artweek*, v.1, March 14, 1970, p.3. Review of many of the events and processes initiated at the preview of *The Eighties* exhibition, University Art Museum, University of California, Berkeley. Excerpt:

Brenda Richardson and Susan Rannells, who organized the show, explained, "The exhibition as a whole is designed to encourage communica-

(PHOTO LEFT)

Trans-parent Teacher's Ink, Paul Cotton, Medium. *Uni-Verse-All-Joint*. **Berkeley, Ca., 1969. "Uninvited to the line-up of Eye-Stablished–Meaning poets on the roster of People's Park Poetry Reading, People's Prick introduced the unspeakable "Uni-Verse-All-Joint" with the ejaculation: 'In the spirit of the Revolution, Eye'm taking over the mike . . .'**

This vulgar move-meant disconcerted the polite decorum policed by the dis-Organ-Eyes'd, but well-meaning, chairperson: Denise Levertov. Concerned with Eye-Stablished Order based upon property and propriety, she failed to re-member that the people who built People's Park were anti-proprietary and ProPriapus. Her protests were over-ruled by the vox pop. who chanted, in the spirit of Free Speech and Movement: 'Let the Prick speak.' Lou Welch announced that the committee running the reading had decided that 'this gentleman can speak.' Justified, People's Prick pro-seeded to consumate Hir intercourse with the brief verbal-eye-zation:

Eye Pledge Allegiance to the Flesh:
The United State of One Consciousness,
And to the Vision that Under-Stands
The Eye-Magi-Nation, In Dei/Visible
In Just-Us and Liberty Be-Held.''

5

tions and the free flow of ideas about the future, the quality of life as it may exist in the eighties, and equally important, ideas about art and the function of an art museum in a radically changing world. . . . With this in mind, participants have decided to spend as much time as possible in the gallery throughout the exhibition for purposes of direct communication with visitors. In addition, a group of the show's participants have designated one area in the gallery as a 'free space,' where visitors to the gallery can present their own ideas for the 80's.''

..

Happening & Fluxus. Koeln: Koelnischer Kunstverein, 1970. Catalogue for an exhibition entitled, *Happening and Fluxus*, November 6, 1970-January 6, 1971. Includes a chronology 1959-70 with artist documentation (texts and photos), a bibliography and contributions by artists. Primarily in German.

James McCready, Paul Kos, Terry Fox. Richmond, California: Richmond Art Center, 1970. Catalogue for three exhibited selections of the 1970 Sculpture Annual. Includes Introduction by curator, Tom Marioni. Also includes three loose pages; one designed by each selected artist. Excerpt:

The sculpture selected for this annual by Larry Bell reflects an attitude about the direction many serious sculptors have taken. Two of the three works selected are not tangible objects; they are concepts. James McCready's photo of old St. Mary's Church burning documents what I feel to be environmental theatre and is a ''City Work.'' Although he did not set fire to the church, he has selected the event as an environmental sculpture. The documented proof is entered for exhibition in the form of a photo, since the actual work can no longer be seen.

Paul Kos has submitted for exhibition a kinetic work that involves people, money, checks, banks and the Art Center. This work also falls into the category of theatre-oriented sculpture called ''Process Art,'' where the acting out of the instructions submitted by the artist becomes the work of art. [Fox's] piece submitted is a 9' x 24' length of thin plastic sheeting blowing across the floor of the artist's studio with the help of an electric fan.

Kaprow, Allan. *Assemblage, Environments & Happenings.* New York: Abrams, 1966. Text and book design by Kaprow with text and photo documentation of 42 Happenings by: 9 Japanese of the Gutai Group, Jean-Jacques Lebel, Wolf Vostell, George Brecht, Kenneth Dewey, Milan Knizak, Allan Kaprow.

Marioni, Tom. *The Return of Abstract Expressionism.* Richmond, Ca.: Richmond Art Center, 1969. Catalogue for the group exhibition entitled *The Return of Abstract Expressionism*, September 25-November 2, 1969. Excerpt, *Introduction* by T. Marioni:

When Jackson Pollock and Morris Louis let the paint leave their hands, gravity formed the shape of the stain on the raw canvas. This exhibition of abstract expressionism is a direct extension of the painting of the 50's; the action is the same only the dimensions are different. The gesture is the same and the procedure similar if more athletic. The artists exhibit the same love of organic and natural forces, they place a familiar emphasis on the role of accident and chance.

The renewed interest in natural forces and raw materials exists for several

QUID PRO QUO
PROCESS SCULPTURE

Remove the "object" in art, or so de-objectify it, that the passing of money between patron and artist becomes the art. Process becomes art. Patron becomes artist. Artist becomes patron. Banks become museums.

```
                                              _____1970

  name of drawee and branch
  pay to
  order of___PAUL   KOS_____  $_____
  _____dollars

  account no._____

                        _____
                        signature of drawer
```

1. Cut out above check.
2. Fill in your appropriate banking information.
3. Inscribe any amount of money you desire, which may be charged to your account.
4. Endorse the check.
5. Your cancelled check will be your art. Not valid unless cancelled.
6. I will in turn send you a check for the exact amount you send me.
7. Mail to: "NON-OBJECT" Paul Kos
 c/o Richmond Art Center
 Richmond, California. 94804
8. Your check will be exhibited in Richmond's Sculpture Annual, and deposited in my account at show's close, at which time you will receive your "cancelled art", and a check from me for the same amount.

Paul Kos. *Quid Pro Quo—Process Sculpture*. **Richmond Art Center, Richmond, Ca., 1970. Kos' contribution to the Sculpture Annual 1970 catalogue,** *James McCready, Paul Kos, Terry Fox.*

reasons. There is, certainly, a tremendous dissatisfaction with the destructive forces of modern culture; war, pollution, and the generally widespread ignorance of nature. Another influence is the popularity of drug use, and the religious importance that it places on an awareness of our environment and also upon the reality of natural processes and environment. But perhaps more importantly, the artists are not interested in producing objects. The majority of the pieces exist only for the duration of the show. There are no photographs in the catalogue because some work cannot be seen before installation. In fact, several artists have sent only instructions for the creation of their works. It would harm the intent of the work to frame or reduce them to the degree needed for reproduction and, the nature of the work precludes reproduction. For the first time, the artist is freeing himself from the object. As a result, the historian is now faced with the responsibility of recording the work. The artist is involved with the direct manipulation of materials that possess qualities of spontaneity and improvisation, and that normally produces dispensable work.

It is the act of creation which is art.

McShine, Kynaston L. (ed.). *Information.* **New York: The Museum of Modern Art, 1970. Catalogue for an exhibition at MOMA, July 2-September 20, 1970; "an 'international report' of the activity of younger artists."**

Richardson, Brenda. "Bay Area Survey: The Myth of Neo-Dada," *Arts Magazine*, **v.44, Summer 1970, pp.46-49. Excerpt:**
There is a tendency in San Francisco, as elsewhere, to "take to the streets" for various art activities now. Most (if not all) of these activities are oriented toward more or less political or environmental concerns. This direction seems significantly more relevant to more people (including the many artists involved) than the traditional art channels of museums, galleries, and collectors. By the very nature of the trend, many of these events go unnoticed and thus undocumented by the "art world" — but this is good, since these events are not intended for us anyway. There seems to be an increasing wish to involve the various communications media in street events — particularly television, for both its creative and mass appeal potential.

Sharp, Willoughby. "Body Works: A Pre-Critical, Non-Definitive Survey of Very Recent Works Using the Human Body or Parts Thereof," *Avalanche*, **no.1, Fall 1970, pp.14-17. Excerpts:**
The previous year (in 1968), Bruce Nauman made a series of eight by ten inch holograms, *Making Faces*. On the afternoon of Tuesday May 12, 1970 he went into a vacant Pasadena lot and clapped his hands. . . .

During the morning of Monday May 18, just prior to the opening of his one-man show at the Reese Palley Gallery, San Francisco, Terry Fox executed a three-part piece *Asbestos Tracking*. In one part, Skipping, he laid down a broken line of black foot marks on the gray concrete floor. . . .

Variously called actions, events, performances, pieces, things, the works present physical activities, ordinary bodily functions and other usual and unusual manifestations of physicality. The artist's body becomes both the subject and the object of the work. The artist is the subject and the object of the action. Generally the performance is executed in the privacy of the studio. Individual works are mostly communicated to the public through the strong

visual language of photographs, films, videotapes and other media, all with strong immediacy of impact. . . .

In focusing on the creative act itself, body works are yet another move away from object sculpture. If objects are used, they only serve to reinforce aspects of the body. But body works do not represent a return to figuration. At most their relation to figurative art is ironic. Assumptions about our modes of being are questioned and explored, often with a wry sense of humor. Picking one's nose is presented as an artistic statement.

On another level, the new work can be seen as a reaction to conceptual art which tries to remove experience from sculpture. This does not mean that body works are a return to some kind of expressionism. This is definitely not the case. The artists feel no need to vent their personal emotions in their work. The artist's own body is not as important as the body in general. The work is not a solitary celebration of self.

Software. **New York: Jewish Museum, 1970. Catalogue for** *Software* **exhibition at the Jewish Museum. Participants included Eleanor Antin, John Baldessari, Douglas Huebler, and Allan Kaprow, among others.**

Bruce Nauman. *Studies for Hologram.* **1970. Silkscreen on glossy cover stock, 26" x 26".**

SOUND SCULPTURE AS

"Rumbles; The Museum of Conceptual Art," *Avalanche*, no.1, Fall 1970, p.6. Description of the opening of MOCA, San Francisco, and the show, *Sound Sculpture As*. Excerpt:

MOCA's latest show, *Sound Sculpture As*, a one night presentation of successive sound events by ten Bay Area artists, was held on April 30. For the first piece, *Peter Maccan* laid plastic wrapping material on the floor which popped when arriving visitors walked over it. *Mel Henderson* paced up and down the large loft with a 30 caliber rifle. He took aim and fired a single shot at a film image of a tiger being projected on a paper-covered saw horse. Just then, the telephone rang fifteen times, twice in succession; *Jim Melchert* had dialed the museum from Breen's, a famous bar across the street. *Allan Fish's* piece was performed by Tom Marioni. Perched atop an eight foot ladder, he pissed into a galvanized washtub. As the tub filled, the sound dropped in pitch. He was followed by *Terry Fox*, who scraped a shovel across the linoleum floor and vibrated a thin plexiglass sheet very fast. *Jim McCready* paraded four girls wearing shiny nylons down a 3 x 9' long rug. As they rubbed their thighs together a swishing sound was heard. *Paul Kos*, who is known for outdoor works using ice and salt licks, collaborated with *Richard Beggs*, an electronic musician, on a piece in which eleven boom-microphones tried to pick up the sound of two 25 lb. blocks of melting ice. For the finale, *Arlo Acton* distributed several hundred metal crickets and the loft began to ring with chirping sounds. Then he released a polished metal ball hung from the ceiling which smashed into a heavy glass plate.

Tarshis, Jerome. "Sound Sculpture As:Museum of Conceptual Art, San Francisco; Exhibit," *Artforum*, v.9, September 1970, p.91. Review of *Sound Sculpture As*, a one night sound event sponsored by MOCA on April 30, 1970. Includes description of works by participating artists: Mel Henderson, Jim Melchert with Jim Pomeroy, Allan Fish (Tom Marioni), Terry Fox, Paul Kos and Richard Beggs, Jim McCready, and others.

Mel Henderson. Museum of Conceptual Art., San Francisco, Ca., 1970. Henderson's event for *Sound Sculpture As* consisted of pacing up and down MOCA with a 30 caliber rifle and firing a single shot at a projected image of a tiger.

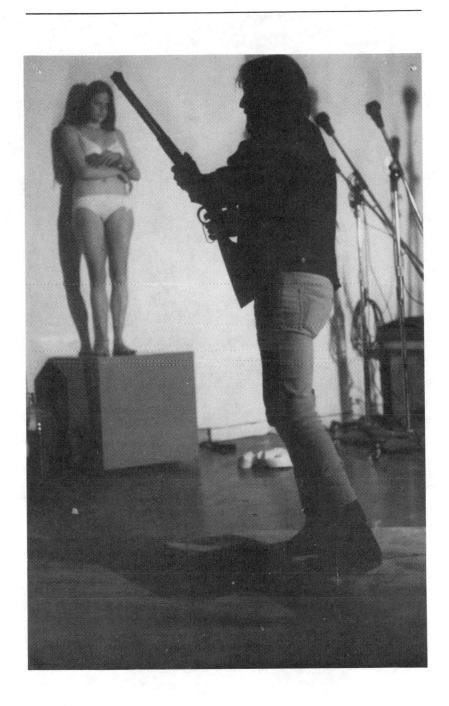

Paul Kos. Museum of Conceptual Art, San Francisco, Ca., 1970. Kos' event for *Sound Sculpture As* consisted of utilizing 11 boom microphones to record the sound of two 25 pound blocks of melting ice.

Tom Marioni as Allan Fish. *Pissing*. Museum of Conceptual Art, San Francisco, Ca., 1970. Performed in the MOCA series *Sound Sculpture As*, Marioni after drinking beer all day pissed into a tub and "the sound pitch went down as the water level went up."

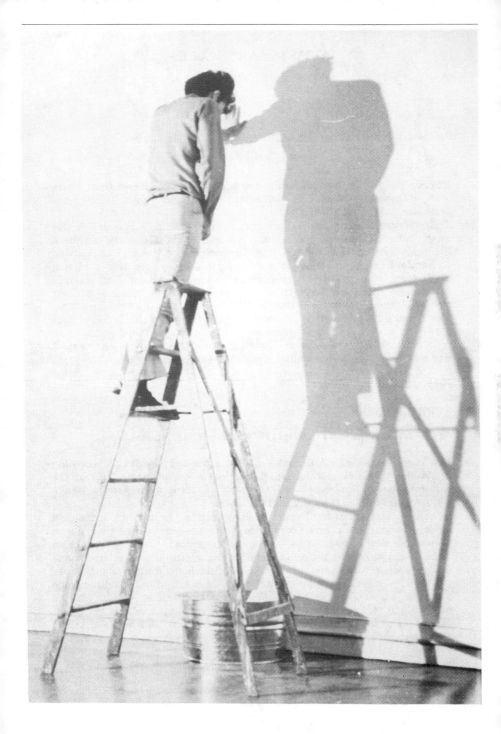

ARTISTS / ART SPACES

JOHN BALDESSARI

Baldessari, John. *Folding Hat*. 1970. Videotape, 15 mins., b/w.

F SPACE GALLERY

F Space Gallery. Irvine, California. Founded 1970/71. Excerpt from Moira Roth, "Toward a History of California Performance: Part Two," *Arts Magazine*, v.52, June 1978, p.115:

The Irvine students, not the faculty, were primarily responsible for establishing this campus as another central point for early Southern California Performance. The graduate art program at Irvine (University of California, Irvine campus) began in 1969. By fluke or by fate, the first batch of students were shortly to become a seminal force in Los Angeles Performance. Performance artists who attended Irvine, then and later, include Barbara Smith, Chris Burden, Nancy Buchanan, Bob Wilhite, Brad Smith, and Richard Newton. . . . in the main the Irvine School of Fine Arts felt ill at ease with the Performances which its graduates insisted on producing. So, to create an environment hospitable to their art, several students formed an off-campus cooperative gallery known as "F Space," located in Santa Ana's industrial sector within notoriously conservative Orange County.

TERRY FOX

Fox, Terry. *Breath*. San Francisco, 1970. Super 8 film, 3 mins., color.

Fox, Terry. *Isolation Unit*. Dusseldorf, 1970. Extended play disc. A recording of "Action" by Fox and Joseph Beuys made in November 1970 at the Kunstakademie, Dusseldorf, W. Germany. Excerpt from Achille Bonito Oliva, "Terry Fox," *Domus*, April 1973, p.45:

I came to Dusseldorf and I wanted to do something, to make an action, and I didn't have the space. So I went to Beuys and met him the first time and he showed me all the rooms of the Academy where it was possible to make an action. Then we went to the cellar and it was wonderful there: so I decided to make an action with sounds and iron pipes (like bells) in the cellar because the sound was very good there. One or two days before he asked me to do something together and he made something too. But I didn't ask him what he was going to do. His action was a kind of dream about a dead mouse he had, like a funeral for the mouse together with the sound, and fire, and ashes. Beuys too made sounds, we have a record we made of them.

Fox, Terry. *Rain*. New York, 1970. Super 8 film, 3 mins., b/w.

Fox, Terry. *Sweat*. New York, 1970. Super 8 film, 3 mins., b/w.

Fox, Terry. *Tounging*. New York, 1970. Videotape, 30 mins.

McCann, Cecile N. "Authority and Art (Again)," *Artweek*, v.1, October 3, 1970, p.2. Article describes Terry Fox's *Levitation* at the Richmond Art Center, Richmond, Ca., on September 17, 1970, and the ensuing problems with Richmond City Administration officials who declared the work a fire and health hazard and ordered it to be removed from the gallery by curator Tom Marioni.

McCann, Cecile. "Terry Fox Sculpture," *Artweek*, v.1, May 30, 1970, p.1. Review of an installation/performance at the Reese Palley Gallery, San Francisco, in which Fox works with four elements: earth, air, fire and water. Excerpts:
An important aspect of Fox's work, as Willoughby Sharp pointed out in an excellent catalog essay, is that: "The inspiration for much of Fox's work stems from direct perception and heightened awareness of ordinary events."

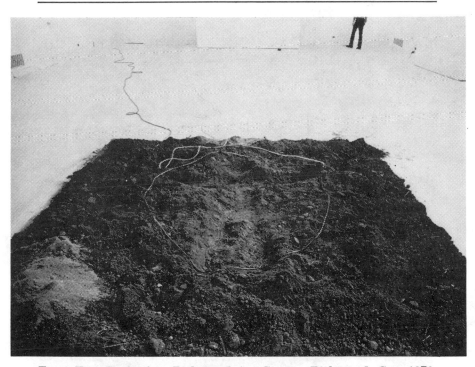

Terry Fox. *Levitation*. Richmond Art Center, Richmond, Ca., 1970. Fox attempts to levitate while lying upon 1½ tons of earth in the middle of a circle holding four clear polyethylene tubes filled with blood, urine, milk, and water. Afterwords there was an imprint of his body on the earth.

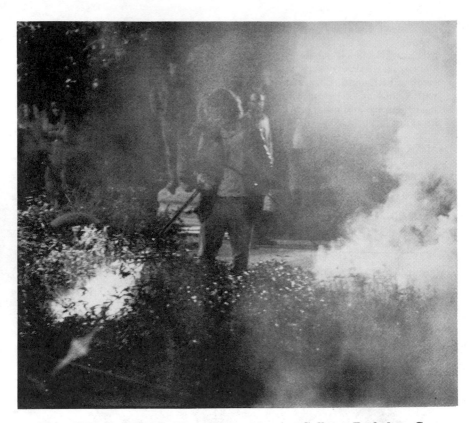

Terry Fox. *Defoliation Piece.* University Art Gallery, Berkeley, Ca., 1970. Fox with flame thrower burns rare flowers before an unsuspecting audience.

[Terry Fox]: I went along the wall three times, taking my shoes off at the end and carrying them back to the beginning. The first time was shuffling along, the second time skipping, and the third time walking on the right foot and dragging the left. It's a drawing. Looks like bamboo, doesn't it?

Sharp, Willoughby. "Elemental gestures: Terry Fox," *Arts Magazine,* **v.44, May 1970, pp.48-51. Essay on Fox, illustrated with photos by Barry Klinger of Fox's works:** *Free Flying Polyethylene Sheet* **(1969),** *Defoliation Piece* **(1970),** *Air Pivot* **(1969),** *Liquid Smoke* **(1970),** *A Sketch for Impacted Lead* **(1970),** *What Do Blind Men Dream?* **(1969),** *Push Piece* **(1970). Excerpts:**
Fox's basic concern is with the interaction of matter and energy in different forms; he has little interest in exploring formal problems, and his choice of artistic media — fluid, amorphous, or non-material — precludes a tight control over the final configuration of his pieces: "I am only conscious of how the piece looks when I see the photographs."

Free flying Polyethylene Sheet: "I held a nine-by-twelve-foot polyethylene sheet out to the wind. When it started billowing I released it into the air. It moved vertically down the beach like a flame."

Defoliation Piece: "This was my first political work. I wanted to destroy the flowers in a very calculating way. By burning a perfect rectangle right in the middle, it would look as though someone had destroyed them on purpose. The flowers were Chinese jasmin planted five years ago which were to bloom in two years. It was also a theatrical piece. Everyone likes to watch fires. It was making a beautiful roaring sound. But at a certain point people realized what was going on — the landscape was being violated; flowers were being burnt. Suddenly everyone was quiet. One woman cried for twenty minutes."

Air Pivot: "I attached a polyethylene sheet to a freely rotating pivot so that the material responded to changes in the wind direction. The sheet swung in a 360° arc. These photographs show segments from one complete turn in front of a stationary camera."

Liquid smoke: "Throwing liquid smoke against the wall was really an anarchistic gesture, like throwing a Molotov cocktail. But it wasn't really that at all. As soon as the glass vial exploded on the cement, it became an aesthetic event. Exposed to the air, the liquid began to smoke until it had completely evaporated. It was so extraordinary and so unrelated to any previous ideas you had about that material that it became art. You would never think of a cement wall smoking, and to see it happening was stunning."

A Sketch for Impacted Lead: "I wanted to do a work with lead using physical forces, and I thought of bullets. When a bullet is fired through the barrel of a rifle, it spins at an incredible rate, moving forward faster than the speed of sound. On impact, the lead changes its shape, just from the pure force of that energy. Hopefully the way I'm going to execute this piece at the Reese Palley Gallery is to fire the bullets close together in a straight horizontal line. Then they might form a small, fragile bar of lead."

What Do Blind Men Dream?: "This was the second in a series of Public Theater events. I discovered a beautiful blind lady and asked her to sing on a San Francisco street corner near a gigantic open pit, from 5:30 p.m. until dark. Announcements were sent out and a lot of people came. We made a recording of the work that I still have."

Push Piece: "When we were moving Tom out of his studio, I noticed a brick wall in an alley. I went over and started feeling it. Then I started pushing. When I did that, I realized what that wall was, what material strength it had. I don't think I could say what that meant to me right now."

Terry Fox. San Francisco: Reese Palley, 1970. An exhibition catalogue; includes a short essay by Willoughby Sharp and five pages of photographs of *Amsterdam from July 19, 1968, 11A.M.-Noon.*

HOWARD FRIED

Fried, Howard. *ALLMYDIRTYBLUECLOTHES*. San Francisco: Reese Palley, 1970. Catalogue for an exhibition, June 16-July 11, 1970. Text is divided into the "accumulation," "establishment," and "disestablishment." Excerpt from "establishment":

Formerly, my blue clothing and the symbols that best identify them to me were in a position of constant arbitration. My object is to retire the elements

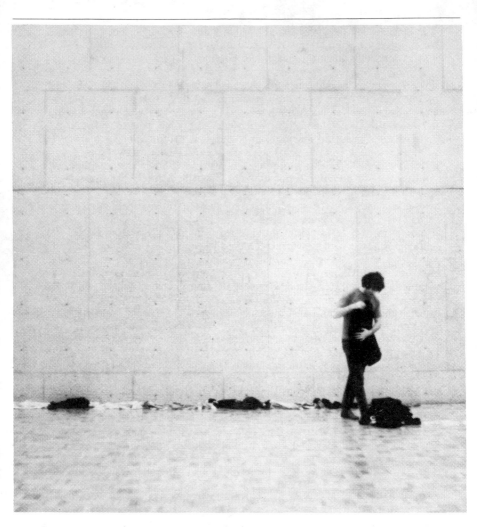

Howard Fried. *Allmydirtyblueclothes*. **Oakland, Ca., 1969-70. Described in 3 parts—accumulation, establishment, and disestablishment. "Everyactionisapotentialmistake."**

of this piece and protect them from unsolicited physical arbitration. By tieing the clothing one to the next and by drawing the symbols on the wall, a gesture to finalize their arrangement is made. Simply placing the clothes and symbols in a room wouldn't reduce their mobility sufficiently. A shirt might be kicked across the room or symbols might be rearranged altering the function of the clothing and/or the meaning of the symbols. While a tied shirt might be untied and then kicked across the room, this would be in conscious and direct violation of my implicit intentions which are apparent both in the

performance and the resultant piece. A minor rearrangement such as a chance kick without first untieing the clothes would not castrate my intention or alter the piece's function. A more drastic measure to render the relationship static would only serve to enunciate my intent while actually still failing to achieve it since total control is impossible.

Jaszi, Jean. "Allmydirtyblueclothes," *Artweek*, **v.1, June 27, 1970, p.3. Review for a performance at Reese Palley Gallery, San Francisco. Excerpt:**
Howard Fried wrote of his work, "The subject of the performance and the resultant piece is all my dirty blue clothes and those symbols which best identify these clothes to me. These symbols are letters of the English alphabet and arabic numerals."

Fried arranged the clothes on the floor and marked the symbols on the wall in a carefully reasoned sequence. . . .

In summing up his description of the work "Allmydirtyblueclothes" Howard Fried also stated: "Everyactionisapotentialmistake."

KEN FRIEDMAN

Friedman, Ken. *The Aesthetics***. San Diego: Self-published, 1966. Excerpt:**
The artist, in his role as a worker, no matter what particular career-identification he may undertake, has the right to work and earn an honest living. The present system of art marketing and access to public realms constrains the right of the art worker in all but a few prominent cases. The artist is treated as a commodity, and thus is dehumanized, denied the right of any working person, and further — even if successful — liable to the merest vagary of fashion or of ill practice at the hands of the marketeer.

I proposed that henceforth I will regard myself not as a commodity, but as a professional. As such, rather than selling art works, I will only sell my professional services.

MEL HENDERSON

Champion, Dale. "Huge Light Show Over the City," *San Francisco Chronicle*, **June 4, 1969, pp.1,30. News coverage of an event staged by Mel Henderson, Joe Hawley, and Alfred Young in which a line of searchlights from Twin Peaks to the Ferry Building lit up the San Francisco sky the night of June 3, 1969.**

Champion, Dale. "Yellow Sea Beside the Golden Gate," *San Francisco Chronicle*, **June 12, 1969, pp.1,26. Article announces an environmental event planned by Mel Henderson, Joe Hawley and Alfred Young in which yellow dye oil was placed on the bay marking "the invisible line defining the limit of the territorial fishing waters of the United States."**

DOUGLAS HUEBLER

Harrison, Charles. "Against Precedents," *Studio International*, **v. 178, September 1969, p.90. Philosophical essay on art as a force for effecting political/social change. Also used as the catalog Introduction to the Kunsthalle exhibition,** *When Attitudes Become Form* **(1969). Includes discussion of Huebler's** *Duration Piece No. 9***. Excerpt:**

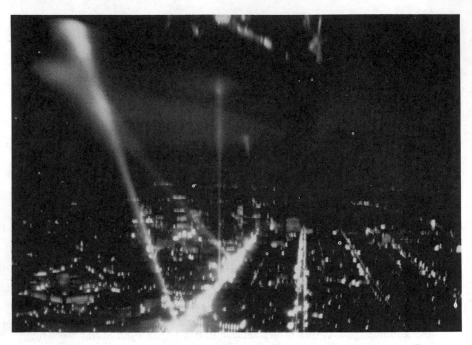

Mel Henderson. *13 Searchlights*. Market Street, San Francisco, Ca.,
1969. Collaboration with Joe Hawley and Alfred Young.

Now that the 'steady-state' of the object is no longer to be seen as an
absolute priority in art, artists are free to use the experience of time and
distance as means to isolate the particular idea they wish to assert. Much of
the most exciting and potent of recent art has been concerned with time as
duration, and with distance spanned as a means of invoking the passage of
time through the spaces embraced by the mind.

ALLAN KAPROW

Cyr, Donald J. "A Conversation with Allan Kaprow," *Arts and Activities*,
v.65, April 1969, pp.24-25. Excerpt:
 C: Is there much thought-out effort that went in to the development of your
distinctive style?
 K: The conscious, critical faculty that's been operating all the way through
is to eliminate as much as possible connections to the art world as we know it.
And so, whenever theatrical allusions, or dance allusions, or poetic allusions
involving the standard arts appear unconsciously, as they will very often, I
eliminate them immediately.
 C: When you're not working do you remain constantly the observer looking
for something which can be of use?
 K: Oh, I'm always attentive. If the happenings have any usefulness to me
at all as creator and participant, they are to make me more attentive to the

world about. And so, at every moment I tend to be fairly awake to what is going on around me: a bus passing, the way a person walks, the way the wind blows in the trees, the way people congregate in stores, how supermarkets operate, the crowding in subways, the way we make breakfast.

Higgins, Dick. "Allan Kaprow=nostalgia+legend+pipe dream/severe moral conscience: Thoughts on Allan Kaprow's Work," *Arts in Society*, Happenings and Intermedia issue, 1968, pp.18-27.

Higgins, Dick. *foew&ombwhnw*. New York: Something Else Press, 1969.

Kaprow, Allan. *Allan Kaprow, Untitled Essay and Other Works*. ("Great Bear Pamphlet.") New York: Something Else Press, 1967. "The historic statement which accompanied the text of the first published Happening (1958) with a sampling of characteristic scenarios."

Kaprow, Allan. *Calling—A Big Little Book*. New York: Something Else Press, 1967. Special, limited edition of Happening of 1965 in concrete poetry format.

Kaprow, Allan. *Days Off: A Calendar of Happenings*. New York: The Junior Council of the Museum of Modern Art, 1970. Newsprint calendar of Happenings photographs. The Introduction:
This is a calendar of past events. The days on it are the days of the Happenings. They were days off. People played. Each day is a page, or more, that can be taken off and thrown away. The Happenings were throw-aways. Once only. Nothing left —except maybe thoughts. Photos and programs of such events are leftover thoughts in the form of gossip. And gossip is also play. For anybody. As the calendar is discarded like the Happenings, the gossip may remain in action.

Kaprow, Allan. *How to Make a Happening*. Vermont/New York: Something Else Press, 1965. Record. An historic document of early performance work. "A Pandora's Box of incendiary ideas masked as a straight lecture."

Kaprow, Allan. "Interview with Richard Kostelanetz." In *The Theater of Mixed Means*, by Richard Kostelanetz. New York: Dial Press, 1968, pp.100-132.

Kaprow, Allan. "On Happenings," *Arts in Society*, Happenings and Intermedia issue, 1968, pp.28-37. Article enumerates major "principles of action" related to a Happening, stressing the importance of the non-art world for the substance and form of the Happenings. Includes photos.

Kaprow, Allan. *Pose*..... New York: Multiples, Inc., 1970. Artist book.

Kaprow, Allan. *Some Recent Happenings*. ("Great Bear Pamphlet.") New York: Something Else Press, 1966. "Four characteristic scenarios by the inventor of the Happening concept."

Kaprow, Allan. "Untitled," *Manifestos*. ("Great Bear Pamphlets.") New

York: Something Else Press, 1966, pp.21-23. Excerpts:
The history of art and of esthetics are on all bookshelves. To this pluralism of values, add the current blurring of boundaries dividing the arts, and dividing art and life; and it is clear that the old questions of definition and standards of excellence are not only futile but naive. Even yesterday's distinction between art, anti-art and non-art are pseudo-distinctions which simply waste our time ...

Contemporary art, which tends to "think" in multi-media, intermedia, overlays, fusions and hybridizations, is a closer parallel to modern mental life than we have realized. Its judgements, therefore, may be acute. "Art" may soon become a meaningless word. In its place, "communications programming" would be a more imaginative label, attesting to our new jargon, our technological and managerial fantasies, and to our pervasive electronic contact with one another.

BARRY LE VA

Sharp, Willoughby. "New Directions in Southern California Sculpture," *Arts Magazine*, **v.44, Summer 1970, p.38. Discussion of Barry Le Va's "body sculptures," although a major part of the article discusses more traditional L.A. sculptors, such as Robert Irwin and Larry Bell. Excerpt:**
One of Le Va's more recent works was his contribution to "Projections: Anti-Materialism" at La Jolla Museum of Art, which consisted of the artist

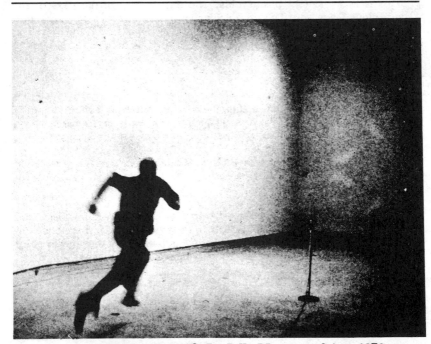

Barry Le Va. *Velocity Piece #2.* **La Jolla Museum of Art, 1970.**

running at top speed along a fifty-foot room and throwing his body into the far wall as hard and as long as he could stand it. Besides the physical activity and strain of the work, which resembled an athletic event—Le Va succeeded in leaving his mark on the wall.

TOM MARIONI

Caen, Herb. "Is There or Isn't There a Sculptor Allan Fish?," *San Francisco Chronicle*, November 12, 1970.

McCann, Cecile N. "Fish's Beer-Based Concept," *Artweek*, v.1, November 7, 1970, p.3. Brief description of *The Act of Drinking Beer with Friends Is the Highest Form of Art*, a work by Tom Marioni (a.k.a. Allan Fish) at the Oakland Museum. Excerpt:
... work by Allan Fish ... celebrated the artist's contention that "the Act of Drinking Beer with Friends is the Highest Form of Art." Created one Monday afternoon when the museum was closed to the public, a pile of empty beer cans, torn papers and cigarette butts—a contemporary midden of sorts—testified to the involvement of some twenty artists in a minor rite of creation-destruction-consumption.

JAMES MELCHERT

McCann, Cecile N. "Melchert Games," *Artweek*, v.1, February 21, 1970, p.1,16. Review of exhibit at the San Francisco Art Institute in which the letter "a" (verbal and visual puns) was used for large-scale environmental works. Viewers were invited to enter the structure and to intermingle with the environment.

MUSEUM OF CONCEPTUAL ART

McCann, Cecile N. "Museum of Conceptual Art Opens," *Artweek*, v.1, March 28, 1970, p.2. Short review describing Willoughby Sharp's participation piece, done for MOCA's opening: participants drew on walls with white paint while Sharp photographed the activity from within a black plastic enclosure.

"Museums: MOCA, San Francisco," *Avalanche*, no.1, Fall 1970, p.10. Photograph of The Cockettes' performance piece, *Madame Butterfly*, at MOCA, May 18, 1970.

BRUCE NAUMAN

Burton, Scott. "Time on Their Hands: Summer Exhibitions at the Whitney and the Guggenheim," *Art News*, v.68, Summer 1969, pp.42-43. Article discusses artists shown during Summer 1970 at the Guggenheim and Whitney; includes Bruce Nauman. Excerpt:
As anyone who follows any of the performing arts more than briefly understands, the artist's own body is not an enduring material. Artists like Nauman or Robert Morris, in his box with photograph of his nude self, begin to blur the traditional distinction between performing and producing arts; that is, between art as service and art as object. If a work of plastic art can exist as a gesture (and not just as the result of a gesture) then critics of the

Tom Marioni as Allan Fish. *The Act of Drinking Beer with Friends is the Highest Form of Art.* Oakland Museum of Art, 1970. In a Museum gallery, Marioni drank beer with friends and the remaining residue was the exhibition on view.

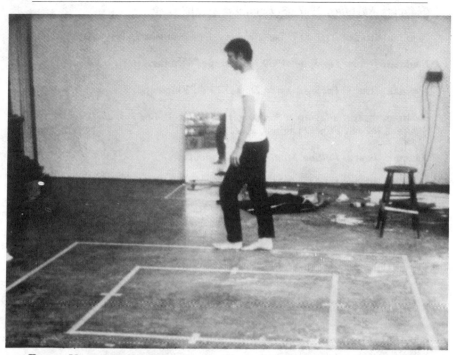

Bruce Nauman. *Walking in an Exaggerated Manner Around the Perimeter of a Square*. 1968. Black and white 16 mm film, silent.

most recent art are right to feel threatened by the "theatricality" of temporalized work. The chief characteristic of live performance is that, after it is completed, there is nothing left to quantify. The witness is forced to examine his own impressions and thus his own psyche instead of being able to pretend to a formal objectivity.

Celant, Germano. "Bruce Nauman," *Casabella*, no.345, February 1970, pp.38-41.

Nauman, Bruce. *Art Makeup No.1, White*. 1969. 16mm film, 11 mins., color.

Nauman, Bruce. *Art Makeup No.2, Pink*. 1969. 16mm film, 11 mins., color.

Nauman, Bruce. *Art Makeup No.3, Green*. 1969. 16mm film, 11 mins., color.

Nauman, Bruce. *Art Makeup No.4, Black*. 1969. 16mm film, 11 mins., color.

Nauman, Bruce. *Bouncing in a Corner*. 1969. Videotape.

Nauman, Bruce. *Bouncing Two Balls Between the Floor and Ceiling with*

Changing Rhythms. 1967-68. Film, 9 mins., b/w.

Nauman, Bruce. *L.A. AIR*. Los Angeles: Self-published, 1970. Artist book.

Nauman, Bruce. *Lip Sync*. 1969. Videotape, 60 mins., b/w.

Nauman, Bruce. *Pacing Upside Down*. 1969. Videotape, 8 mins., b/w.

Nauman, Bruce. *Playing a Note on the Violin While I Walk Around the Studio*. 1967-68. Film, 11 mins., b/w.

Nauman, Bruce. *Pulling Mouth*. 1969. Videotape.

Nauman, Bruce. *Revolving Upside Down*. 1969. Videotape.

Nauman, Bruce. *Slo-Mo (Black Balls, Bouncing Balls, Gauze, Pulling Mouth)*. 1969. Film. 8-9 mins. each, b/w. Four works on one reel.

Nauman, Bruce. *Slow Angle Walk*. 1968. Videotape, 60 mins., b/w.

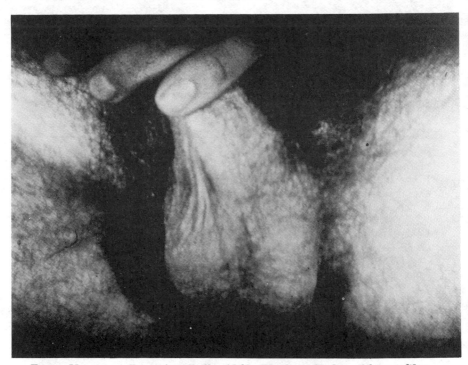

Bruce Nauman. *Bouncing Balls*. 1969. Black and white 16 mm film, silent, 9 min. A slow motion and close-up film of Nauman moving his testicles.

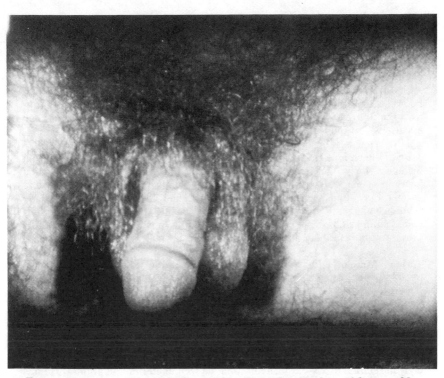

Bruce Nauman. *Black Balls*. 1969. Black and white 16 mm film, silent, 9 min. A slow motion and close-up film of Nauman applying black makeup to his testicles.

Nauman, Bruce. *Thighing*. 1967. 16mm film, 8-10 mins., color.

Nauman, Bruce. *Violin Film No.1*. 1969. 16mm film.

Nauman, Bruce. *Violin Film No.2*. 1969. 16mm film.

Nauman, Bruce. *Violin Tuned D.E.A.D.* 1968. Videotape, 60 mins., b/w.

Nauman, Bruce. *Walk Dance*. 1969. 16mm film.

Nauman, Bruce. *Walking in an Exaggerated Manner Around the Perimeter of a Square*. 1967-68. Film, 9 mins., b/w.

Nauman, Bruce. *Walking in Contraposto*. 1969. Videotape.

Sharp, Willoughby. "Nauman Interview," *Arts Magazine*, v.44, March 1970, pp.22-27. Excerpt:
 WS: In *Flour Arrangements*, the photographs documented a work,

whereas in *Portrait of the Artist as a Fountain* the photo documented you as a work. Does that mean that you see yourself as an object in the context of the piece?

BN: I use the figure as an object. More recently that's roughly the way I've been thinking, but I didn't always. And when I did those works, I don't think such differences or similarities were clear to me. It's still confusing. As I said before, the problems involving figures are about the figure as an object, or at least the figure as a person and the things that happen to a person in various situations—to most people rather than just to me or one particular person.

WS: What kind of performance pieces did you do in 1965?

BN: I did a piece at Davis which involved standing with my back to the wall for about forty-five seconds or a minute, leaning out from the wall, then bending at the waist, squatting, sitting and finally lying down. There were seven different positions in relation to the wall and floor. Then I did the whole sequence again standing away from the wall, facing the wall, then facing left and facing right. There were twenty-eight positions and the whole presentation lasted for about half an hour.

Tucker, Marcia. "PheNAUMANology," *Artforum*, v.9, December 1970, pp.38-44. Lengthy article on Bruce Nauman, includes several illustrations. Excerpt:

Our bodies are necessary to the experience of any phenomenon. It is characteristic of Nauman's work that he has always used his own body and its activities as both the subject and object of his pieces. He has made casts from it (*Hand to Mouth, Neon Templates of the Left Half of My Body Taken at 10 Inch Intervals*, etc.) and manipulated it (in earlier performances using his body in relation to a T-bar or neon tube, as well as in the holograms). He has made video tapes of his own activities (*Bouncing Balls in the Studio*) and films of parts of his body being acted upon; *Bouncing Balls* and *Black Balls* are slow-motion films of Nauman's testicles moving and being painted black. He has questioned, in various pieces, his behavior as an artist and his attitudes toward himself as such. He has contorted his body and face to the limits of physical action as well as representation. By making audiotapes of himself clapping, breathing, whispering and playing the violin, he has also explored a range of noises made and perceived by his own body.

This concern with physical self is not simple artistic egocentrism, but use of the body to transform intimate subjectivity into objective demonstration.

REESE PALLEY GALLERY SAN FRANCISCO

Reese Palley Gallery, San Francisco, open from 1968-1972. Directed by Carol Lindsley. Excerpt from Moira Roth, "Toward a History of California Performance, Part One,"*Arts Magazine*, v.52, February 1978, p.103 (footnote no.12):

During this time (1968-1972) Carol Lindsley was in charge of the Reese Palley Gallery (San Francisco branch), she presented Performances and exhibitions by Bruce Nauman, Steve Kaltenbach, Dennis Oppenheim, Howard Fried, Paul Kos, Terry Fox and Jim Melchert, among others. In 1972 Reese Palley closed the San Francisco branch.

"Galleries: Reese Palley, San Francisco," *Avalanche*, no.1, Fall 1970, p.11. Includes a photo of a Terry Fox installation/exhibition at Reese Palley, May

18-June 13, 1970. Works shown in photo: *Pusten, Impacted Lead*, and *Asbestos Tracking*.

ALLEN RUPPERSBERG

Sharp, Willoughby. "Outsiders: Baldessari, Jackson, O'Shea, Ruppersberg," *Arts Magazine*, Summer 1970, p.42.

BONNIE SHERK

Tarshis, Jerome. "Portable Park Project 1-3," *Artforum*, v.9, October 1970, p.84. Excerpt:

. . . "Portable Park Project 1-3," in which turf, palm trees, and livestock were set down for brief periods at three unlikely places Miss Sherk has said she is no longer interested in the kind of object art that is shut up in museums, but in environmental art that confronts people who do not necessarily go out in search of art.

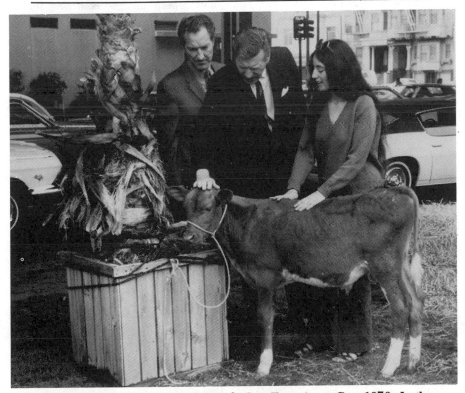

Bonnie Sherk. *Portable Park No. 2*. San Francisco, Ca., 1970. In the Portable Park series, Nos. 1-3, turf, palm trees and livestock were installed for brief periods of time at unlikely places. Site for *Portable Park No. 2*, Mission Street freeway off-ramp.

UNIVERSITY ART MUSEUM

University Art Museum, University of California, Berkeley, opened 1970. Director, Peter Selz; Curator, Brenda Richardson. Excerpt from Moira Roth, "Toward a History of California Performance, Part One," *Arts Magazine*, v.52, February 1978, p.99:

At the same time as MOCA started, a new institutional space for Performance was provided in Berkeley. Directed by Peter Selz, the new building of the University Art Museum opened with much celebration in 1970. Ann Halprin defined the space of the building through dance, and, during the gala opening, Bill Wiley did a piece called *The American Dream*. In the basement of the museum there was a bar set up Western style where many artists in cowboy suits lounged and drank until interrupted by Peter Selz, who had been cued to enter, sling his money down on the bar and demand, "Give me some art." Paul Cotton literally "stuck him up" from behind by printing rubber stamp marks on his back.

Brenda Richardson, then curator of the Berkeley Museum, has written vividly of those times: "We had dance, music, performance—both local and national people . . . Marioni floating chicken feathers all round the building, Paul Cotton in his bunny suit posing, as I recall, with George Segal. Steve Reich's magic concert for the building's opening. Jim Melchert's chair piece. San Francisco Ballet performing Shaker dances. Wiley leading a parade of people playing Jew's harps. Terry Fox inducing a trance in himself—and all of us watching—by shaping a labyrinth out of flour. Days of videotapes with dozens of bored people on pillows on the floor. Simone Forti. Somebody climbing the concrete museum building. James Lee Byars with yards and yards of fuchsia satin draped over and around hundreds of participants in the old powerhouse gallery. My memories go on and on. But my memory is unreliable and erratic. There were many many other events.

1971

GENERAL LITERATURE

Baker, Elizabeth C. "Los Angeles, 1971," *Art News*, v.70, Summer 1971, pp.27-29. Extensive overview of art activity in the Los Angeles area. Baker describes the institutions/galleries and their support (or lack of support) of local artists and discusses the work of several Los Angeles artists. Excerpt on John Baldessari:

Baldessari set up a situation to paint on a canvas not directly visible to him; he could see his hand only on the TV screen; a 4-second delay in the playback was arranged so that the correlation of action to result was neither directly visible nor immediately perceptible on the screen. Or, more recently, a maddening multiplication of mediums was the crux of a color videotape whose subject was previously shot color photos of the artist running, stopping the action, Muybridge-like, into a series of linked stills. These were then held up for the TV camera to "see," and then taken down in sequence; the hand performing this action, along with the photos themselves, were videotaped.

"Body Sculpture Sky Paintings," *Artweek*, v.2, April 3, 1971, p.1. Review of exhibition, *Body Movements*, at the La Jolla Museum of Contemporary Art. Participants included Bruce Nauman, Barry Le Va, Chris Burden, and Mowry Baden, among others. Excerpts:

(On Nauman): For his piece in the exhibition at La Jolla, Nauman uses a corridor 40 feet long and only 12 inches wide. A participant must go through sidewise, physically in contact with the wall along its entire length. It is not recommended for people with claustrophobia. The interior of the corridor is lit with bright green fluorescent light, which seems to change to dazzling white after a few seconds. At the end of the corridor, normal light is seen on a spectrum of pink to purple.

(On Burden): Chris Burden, the third in the trio of conceptual artists, is currently completing his MFA requirements at U.C. Irvine. All of his pieces have a built-in level of achievement that requires the participant to use them in a certain way. For example, one piece requires two people to stand on a low bar and, leaning back, balance each other by means of a flexible

31

handgrip, which each one holds. The effect of this piece is that using it one experiences his own physical determinants and, through dependence on the partner at the other end of the fulcrum, experiences the necessity of placing his trust in another individual.

FISH, FOX, KOS

Fish, Fox, Kos. Santa Clara, California: De Saisset Art Gallery, University of Santa Clara, 1971. Catalogue for an exhibition, February 2-28, 1971, includes visual, verbal and recorded material.

McCann, Cecile. "Three Concepts," *Artweek*, v.2, February 13, 1971, p.2. Review of *Fish, Fox, Kos*, a three person exhibition at the De Saisset Art Gallery, University of Santa Clara. Includes description of Fox's performance, *Pisces*, Kos' video documentation, *rEVOLUTION*, and Allan Fish (Tom Marioni's) performance with his son and a hen. Excerpt: describing *Pisces*:

Below the shelter of the parachute Fox, barefooted and wearing white pants and shirt, lay asleep on a floor covered with white canvas. Tied to a tuft of his hair a cord ran out across the floor to the tail of a fat grey fish, a carp perhaps, about a foot long, that lay on a patch of white cloth superimposed on the floor covering. A second fish nearby was tied by a cord that ran to Fox's mouth. Close to the fish a grey pan of water held something that looked like soap.

Near the barred doorway where viewers stood, two large flashlights were almost buried in a pile of soap powder, the light of one just visible, burning feebly in competition with the big bulb above.

Kultermann, Udo. *Art and Life*. New York: Praeger, 1971.

Nemser, Cindy. "Subject-Object: Body Art," *Arts Magazine*, v.46, September 1971, pp.38-42. Excerpt:

By 1966, Bruce Nauman, realizing the full implications of Duchamp's star image, began to incorporate his body, both as phenomenon and as activator into the total conception of his artwork. He had himself photographed with water squirting out of his mouth in the *Portrait of the Artist as a Fountain*. Then in 1968, Richard Serra went a step further and made a film entitled *Hand Catching Lead*, in which the body in the act of creating the artwork, simultaneously became the artwork. Finally the actor and the acted upon came together, the processor became the processed, the verb and the subject were one. Both Nauman and Serra had grasped the implications of James Gibson's assertion that "the equipment for *feeling* is automatically the same equipment as for *doing*."

This premise is the essential element that unites all the body works that have been executed in the past three years.

Tarshis, Jerome. "San Francisco: Body Works," *Artforum*, v.9, February 1971, p.85. Review of *Bodyworks*, a traveling video exhibition curated by Willoughby Sharp and coordinated by Tom Marioni, the Museum of Conceptual Art. North American premiere took place October 18, 1970 in San Francisco at Breen's Bar (next to MOCA). Included video by American artists from both East and West coasts (Vito Acconci, Terry Fox, Bruce Nauman,

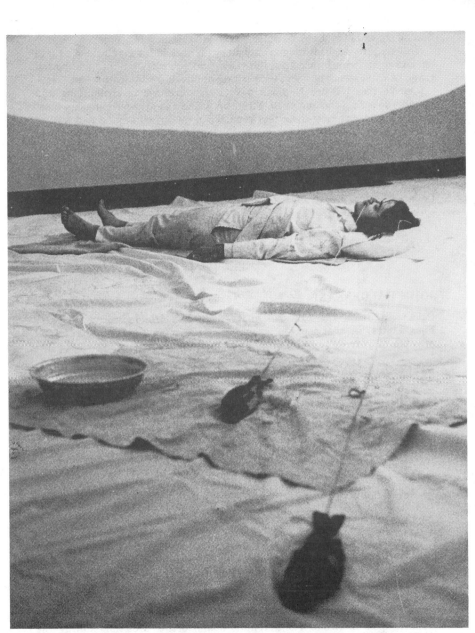

Terry Fox. *Pisces*. De Saisset Art Gallery, University of Santa Clara, Santa Clara, Ca., 1971. Performance presented for the exhibition, *Fish, Fox, Kos*. Fox attached string between two fish and the hair on his head and his teeth. He slept in an attempt to dream about the killing of the fish.

Dennis Oppenheim, Keith Sonnier, William Wegman). Excerpts:

[On Fox:] He stuck his tongue out and put it back in his mouth, moved it to left and right, made it turn up at the sides, and generally ran through the full range of movements possible with a long and well-controlled tongue.

[On Nauman:] Bruce Nauman gave us an exercise in challenging and possibly torturing the audience. First, he walked away, swiveling his hips, down a corridor at most three feet wide. Then he turned around and walked toward us, his T-shirt filling the screen as he came close to the camera. And away from us, and toward us, on and on and on and on.

Tuchman, Maurice. *A Report on the Art and Technology Program of the Los Angeles County Museum of Art: 1967-1971.* Los Angeles: Los Angeles County Museum of Art, 1971. Catalogue to the *Art and Technology* program sponsored by LACMA.

ARTISTS / ART SPACES

JOHN BALDESSARI

Baldessari, John. *The Excesses of Austerity and Minimalism.* June 1971. Film, 3 mins. Sheet of paper in typewriter on which the title is typed as fast as possible . . . etc.

Baldessari, John. *I Am Making Art.* 1971. Videotape, b/w.

GUY DE COINTET

de Cointet, Guy. *Acrcit.* 1971. Artist book.

TERRY FOX

"A Discussion with Terry Fox, Vito Acconci, and Dennis Oppenheim," *Avalanche,* no. 2, Winter 1971, pp. 86-89. An interview with the three artists on the occasion of *Environmental Surfaces: Three Simultaneous Situational Enclosures,* Reese Palley Gallery, New York, January 16, 1971. For Fox's one man show, he invited Acconci and Oppenheim to participate in an event in which the three presented performances related to the body. Excerpts:

At the far end of the 20' by 80' room, the floor of which was covered with white paper, Fox had set up a tent-like environment with a square piece of canvas, hung five feet from the floor, under which he performed a series of actions involving different elements: a bar of white soap, a pan of water, two flashlights, two bags of flour, a strainer, a box of *Fab,* a small bench, a piece of bent wire, smoke from a cigarette, and a scratched mirror attached to a wooden spool of twine. The amplified sound of his breathing during the performance was counterpointed by a tape of himself breathing . . .

[T. Fox]: My artistic concerns are very old-fashioned and romantic. What I am involved in is creating certain kinds of spatial situations. I am dealing with objects in a space and their relationships to each other, and with how my mood alters them. The way I move a flashlight is going to affect not only the quality of the light but also my relation to it. Two flashlights aimed at a bar of

soap mean much more to me than anything the spectator could imagine. They create a certain translucence, a modification of materials that I find very interesting, like the idea of two flashlights eventually melting the soap.

Fox, Terry. *Clutch*. San Francisco, 1971. Videotape, 50 mins., b/w.

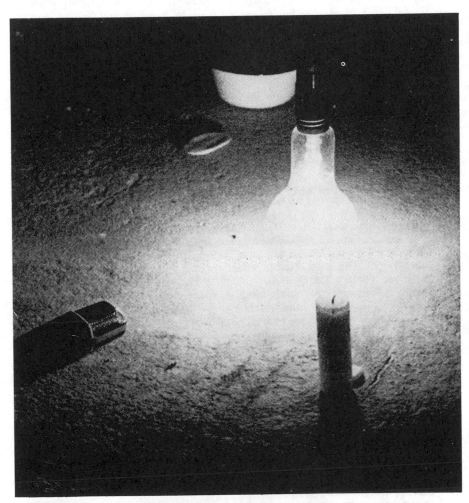

Terry Fox and Joseph Beuys. *Isolation Unit*. Kunstakademie, Dusseldorf, Germany, 1970. Fox made an action with sounds and iron pipes; Beuys made an action that "was a kind of dream about a dead mouse he had, like a funeral." A record was produced from this event.

Fox, Terry. "Joseph Beuys and Terry Fox: Action/Fotodokumentation," *Interfunktionen 6*, Koln, September 1971, pp.34-54.

Fox, Terry. *Prospect 71: Projections.* Dusseldorf: Kunsthalle, 1971.

Fox, Terry. *Turgescent Sex.* San Francisco, 1971. Videotape, 40 mins., b/w.

McCann, Cecile N. "Hospital as Art Environment," *Artweek*, v.2, November 13, 1971, p.1. Review of Fox's hospital piece at Reese Palley Gallery, San Francisco. Excerpts:
 At one side of the gallery a large blackboard lifted high on black tape-wrapped two-by-fours bears all the hospital charges inscribed on it—wiped out so that they are barely readable—gone but still there. On the other side a vertical blackboard rests on the floor
 Between the two boards, two tape recorders play continuous loops which include intervals of silence. One is a stereo recording of Fox's breathing, the other a chant in which his voice intones "needles pierced my arm (etc. naming parts of the body)" and in counterpoint on the other track, "many times." Wires snake out from the recorders to speakers near either wall, "carrying the breath of my heart to both sides."

"Rumbles; Exhibitions, Terry Fox," *Avalanche*, no.2, Winter 1971, p.5. Description of *Isolation Unit*, a performance by Terry Fox and Joseph Beuys. Excerpt:
 On November 24 [1970] at 7 p.m., after spending four hours alone together in the cellar of the Dusseldorf Kunstakademie, Joseph Beuys and Terry Fox carried out *Isolation Unit,* a half hour performance, for an audience of about thirty friends. The event acted as a requiem for a pet mouse kept by Beuys for three years which had just died. Clad in his special felt suit, (a Block multiple) Beuys gave the mouse a ride on a tape recorder reel, and then stood gently cradling it in one hand while he ate an exotic fruit and spat the seeds into a silver bowl. A 33 rpm record, with Beuys on one side and Fox on the other, has been made of the event.

"Rumbles; Terry Fox," *Avalanche*, no.3, Fall 1971, p.7. Brief description of "the 'Elements, Actions, and Condition' of Terry Fox's *Turgescent Sex*, a 40-minute black/white kinescope, shot by George Bolling on June 13 at the San Francisco Rose Street studio." Excerpt:
ELEMENTS:
Cloth Bandage
Cigarette
Match
Fish
Rope
Bowl of Water
Bar of Soap
Despair
ACTIONS:
Sit crosslegged surrounded by the elements/wash hands/wash fish bound by the rope in many knots/blindfold with the bandage/mark eyes on the blindfold with the blood of the fish/release the fish from bondage/form a nest with the bindings/wrap the fish with the bandage/cover the fish with smoke.

CONDITIONS:
The rite was performed in a state of despair caused by prolonged viewing of a photograph of the victims at My Lai.

"Terry Fox: . . . 'I Wanted My Mood to Affect Their Looks,'" *Avalanche*, no.2, Winter 1971, pp.70-81. An interview. Excerpts:
[Fox, on his work *Levitation*]: I wanted to create a space that was conducive to levitation. The first thing I did was to cover the sixty by thirty foot floor with white paper and to tape white paper on the walls. The floor had been dark, but it became such a brilliant white that if you were at one end of it, it glared, it hurt your eyes to look at someone standing at the other end. It was such a buoyant space that anyone in it was already walking on air. Then I laid down a ton and a half of dirt, taken from under a freeway on Army Street, in an eleven and a half foot square. The mold was made with four redwood planks each twice my body height—I used my body as a unit of measure for most of the elements in the piece. The dirt was taken from the freeway because of the idea of explosion. When the freeway was built, the earth was compressed, held down. You can conceive of it expanding when you release it rising, becoming buoyant. Of course, it's physically impossible. But for me the mere suggestion was enough. I was trying to rise too. I fasted to empty myself I drew a circle in the middle of the dirt with my own blood. Its diameter was my height. According to the medieval notion, that creates a magic space. Then I lay on my back in the middle of the circle, holding clear polyethylene tubes filled with blood, urine, milk, and water. They represented the elemental fluids that I was expelling from my body. I lay there for six hours with the tubes in my hand trying to levitate. The doors were locked. Nobody saw me. I didn't move a muscle. I didn't close my eyes. I tried not to change my focal point
[Avalanche]: What do you see as your earliest body work?
[Fox]: The *Push Wall* piece. It was like having a dialogue with the wall, exchanging energy with it. I pushed as hard as I could for about eight or nine minutes, until I was too tired to push anymore
[Avalanche]: What other work came out of that
[Fox]: Pushing myself into a corner at Reese Palley in San Francisco. That was the negative of the *Push Wall* piece. A corner is the opposite of a wall. That was a short piece, it was hard to do. I was trying to push as much of my body as I could into the corner. My feet got in the way. I tried to stand on my toes, but it didn't work. You lose your balance.

HOWARD FRIED

Fried, Howard. *Cheshire Cat II*. 1971. Film.

Fried, Howard, *Fuck You Purdue*. San Francisco, 1971. Videotape.

Glueck, Grace. "New York: Big Thump in the Bass Drum," *Art in America*, v.59, May/June 1971, pp.132-33. Exerpt on Howard Fried's *Chronometric Depth Perception*:
Fried wrestles with a professional wrestler. But while the latter wrestles on a scale of time that's all in the present, Fried wrestles on a time scale that's correlated with his projected life span (he's twenty-four). Having distributed

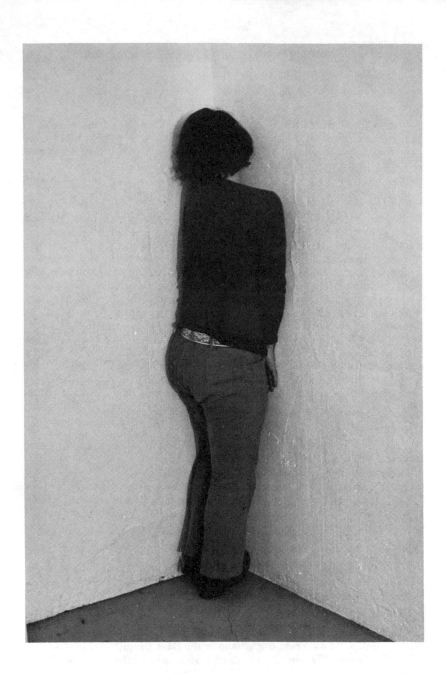

Terry Fox. *Corner Push*. Reese Palley, San Francisco, 1970.

his allotted seventy-two-and-then-some years over the regulation wrestling-match time of nine minutes, he has found that the present occurs at a point of two minutes and fifty-two seconds. But Fried can wrestle normally only while he has chronometric depth perception—i.e., when he can "see" his life in time in the same way that two eyes are necessary to perceive depth in space. So, at the instant when the artist's projected time scale correlates with the "real" one of the wrestler, the artist freezes, incapable of action. The professional wrestler pins him to the mat.

"The model of this phenomenon happens in every area of life," explains Fried. "You have to have two vantage points to understand anything other than that small increment that corresponds to the present. There's a psychological need to see things from more than one space."

"Howard Fried," *Flash Art,* **nos. 28/29, December 1971/January 1972, p.8. Documentation for** *Chronometric Depth Perception* **(1971), and a photo from** *Inside the Harlequin: Approach Avoidance III* **(film, 1971).**

Richardson, Brenda. "Howard Fried: The Paradox of Approach-Avoidance," *Arts Magazine,* **v.45, Summer 1971, pp.30-33. Excerpt:**
Fried has intellectualized his life to a point almost inconceivable to most people. Because of this, his daily activity (and the multiplicity of decisions that go into the process of each activity) bears little relationship to any common norm of daily human activity. For this reason his activities "look" more like art than do my activities, for example. His artistic and studio life is ascetic and highly intellectual, belying the appearance of a childish and haphazard personality. He frequently spends long periods of time in his studio (not eating, sleeping, or seeing people), totally enveloped in a structure completely of his own contrivance. There is not one inch of the studio that manifests any other personality or any arbitrary state of being not of his own making:

"This particular phase of my life (and therefore my work) started when I moved into this place about a year ago. I was immediately aware of a kind of paranoia or insecurity in myself at walking into a place—a pretty big place—that had no feeling of me, but only it. Like a foreign place. So ever since then I've been covering progressively every surface of it. Because I've conceived it, I know what every inch of it is about. I can use the analogy of a caterpillar weaving a cocoon: he makes an environment about which he can feel completely secure, because it surrounds him and, even more important, he made every bit of it. There's no room for the hazards or insecurities of the unknown or the arbitrary. What happens with me, though, when I formulate this kind of structure is that I start feeling self-conscious about the form it's taking, because it's a contrived form and therefore artificial. This relates to the approach-avoidance sequence—the closer I get to completing the form, the more necessity I feel to decimate it."

ALLAN KAPROW

Kaprow, Allan. "Education of the Un-Artist," *Art News,* **v.69, February 1971, pp.28-31,66. Excerpt:**
To escape from the traps of art, it is not enough to be against museums or to stop producing marketable objects; the artist of the future must learn how to evade his profession;

Howard Fried. *Fuck You Purdue.* **Videotape, 1971. The work refers to Fried's brother, Billy, and his Marine Corps drill instructors, Purdue and Ward.**

Sophistication of consciousness in the arts today (1969) is so great that it is hard not to assert as matters of fact:

that the LM mooncraft is patently superior to all contemporary sculptural efforts;

that the broadest verbal exchange between Houston's Manned Spacecraft Center and the Apollo 11 astronauts was better than contemporary poetry;

that, with its sound distortions, beeps, static and communication breaks, such exchanges also surpassed the electronic music of the concert halls;

that certain remote control video tapes of the lives of ghetto families recorded (with their permission) by anthropologists, are more fascinating than the celebrated slice-of-life underground films;

that not a few of those brightly lit, plastic and stainless-steel gas stations of, say, Las Vegas, are the most extraordinary architecture to date;

that the random, trancelike movements of shoppers in the supermarket are richer than anything done in the modern dance;

that the lint under beds and the debris of industrial dumps are more engaging than the recent rash of exhibitions of scattered waste matter;

that the vapor trails left by rocket tests—motionless, rainbow colored, sky-filling scribbles—are unequaled by artists exploring gaseous mediums;

that the Southwest Asian theater of war in Viet Nam, or the trial of the "Chicago Eight," while indefensible, is better theater than any play;

that . . . etc., etc., . . . non-art is more art than ART-art.

Kneubuehler, Theo. "The Happening: History, Theory and Consequences," _Werk_, v.58, February 1971, pp.116-24, 142-3. Extensive historical essay on the Happening, in German with English translation. Excerpts:
In 1958, in [Kaprow's] paper 'The Inheritance of Jackson Pollock', he wrote as follows: 'Pollock left us at the point where we had to take possession, in fact, where we were dazzled by space and the objects of our everyday existence . . . Not satisfied by the excitation of our other senses by the materials of painting, we have to make use of the special content of seeing, tone, motion, people, smells, touch. Objects of all kinds are material for the new art: paint, chairs, food, electric light, neon light, smoke, water, old socks, a dog, films, a thousand other things, which have been discovered by the present generation of artists. These bold creators will not only show us, as if for the first time, the world which has always surrounded us but which we have ignored, but they will also disclose totally unheard of things which they have found in refuse bins, police material, hotel corridors, have seen in the windows of department stores and on the streets and have felt in dreams and in frightful events.' . . .
The Happening, art understood as process and as product, demands modes of behavior. The individual can assume a role, or reject it. As soon as he rejects it, he violates the group code and places himself beyond the pale of the given system. The Happening as an event reproducing social mechanisms promotes consciousness, without thereby having any direct consequences for society.

PAUL KOS

Crawford, Margaret. "Paul Kos Sculptures," _Artweek_, v.2, April 24, 1971, p.3. Review of Kos' exhibition at the Reese Palley cellar, San Francisco. Excerpt:
[One work] is a process piece involving sand. It begins with a smooth

mound of fine, white sand, shaped like a volcano, with a cone-shaped indentation in the center, placed in the middle of the first-floor gallery. The indentation is created by a small hole in the floor, directly underneath the center of the mound, which allows a steady stream of sand to fall through a funnel into the cellar gallery below, where it slowly forms a second mound. The whole thing works on the same principle as an hourglass When the spectator first notices the mound on the upper floor, it has no particular significance. Only after going down into the cellar, seeing the falling sand, and then returning upstairs, can he finally understand the whole process.

"Rumbles: Exhibitions, Paul Kos," *Avalanche,* **no.2, Winter 1971, p.6. Brief description of three works by Kos, including** *rEVOLUTION,* **documentation included in** *Fish, Fox, Kos,* **a three person exhibition at the De Saisset Art Gallery, University of Santa Clara.**

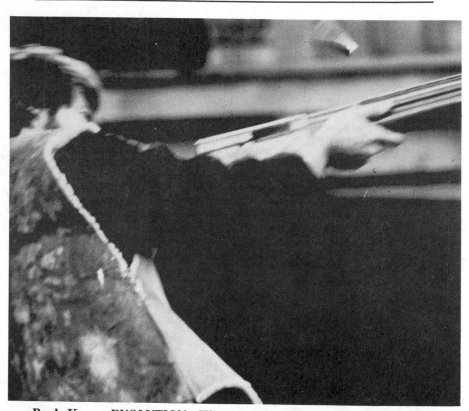

Paul Kos. *rEVOLUTION.* **Winery Lake, Napa, Ca., 1971. Kos discharged 375 rounds of Winchester rifle ammunition into a plywood target suspended from a metal scale effect a "ninety minute invisible weight exchange." Documented from the ground and the air.**

Allen Ruppersberg. *Al's Grand Hotel.* Los Angeles, Ca., 1971.

43

Bonnie Sherk. *Grosgrain*. Artist book, 1971. A book served on a silver platter.

BARRY LE VA

"Discussions with Barry Le Va," *Avalanche*, no.3, Fall 1971, pp.62-75.
Interview; includes several photos. Excerpt:
[Le Va; on *Velocity Piece #1*, presented at Ohio State University, October 1969]: The exhibition at Ohio State consisted of a taped stereo recording of me running hard into the gallery walls as long as I could; the sounds were of my footsteps and the impact of my body against the walls. . . .

Could you say something about the subtitle of the piece, which is *Impact Run, Energy Drain*?

Okay. I think Impact Run is self-explanatory. The energy drain was one of the main purposes of this piece, and that of course increased with time until I was completely worn out and couldn't move at all. The distance between the far walls of the gallery was about fifty-five feet, enough to maintain quite a speed. I'd say the first few runs took about three seconds, then longer and longer up to about seven seconds. After a while I was in extreme physical

pain, but I'd anticipated that because I'd made test runs in my studio beforehand.

How did that affect you? I mean the pain.

Well, what basically interested me was my psychological response to the sheer physical experiences of fatigue and pain. Of course it was a foregone conclusion that if I kept banging into the wall I would get tired and it would hurt. But what I couldn't tell in advance was how I would feel in between the runs. What in fact happened was that every time I hit the wall, I became more and more determined to continue and to keep up my initial velocity.

TOM MARIONI

Marioni, Tom. "Letter (to Willoughby Sharp)" *Artweek*, v.2, June 26, 1971, p.2. Reprint of a letter sent to Willoughby Sharp, publisher of *Avalanche*, New York, from Tom Marioni, Director of the Museum of Conceptual Art, San Francisco. Includes discussion of San Francisco art activity. Excerpt:

ABOUT the piece i did in the berkeley gallery in san francisco (thats the place that did the slant step show a few years ago). Richard Beggs taped my heart beat — put it on a loop and with an oscillating machine speeded it up to a 4/4 tempo equil. to a heart beat at its fastest. the piece was 34 min. long. first 15 min. was the heart beat slowing down gradually to a Dead stop. while this was going on I was siting in a chair facing people siting on the floor. i was wearing the Fish disguise and old clothes. on the tv monitor was my face as Marioni, Hanging on the wall was a change of clothes. at end of fifteen min. heart beat was a constant hum and image on tv put on fake glases, nose, mustache and hat while I (Fish) took off same disguise. that image was switched to stop frame. everything was frozen and i changed clothes, piled old clothes in a pile on the floor, went from orange to blue underwear, dressed in undertaker coat and cowboy shirt, heart beat started slowly and monitor started. the next 15 min. was reverse of first 15 except last 5 min. i mixed two ½ pint bottles of white and chocolate milk into 1 pint bottle that i dug up in my back yard. i drank the 50-50 mix while image on tv drank white milk. it was a reward for myself. when i was a kid my grandfather had a dairy in syracuse n.y. and i drank milk from those little glass bottles. the video tape was an element in the piece and means nothing by itself. it was distroyed. . . .

i did a piece at san jose state college may 25. it was in a mud brick house that tony May and his students built on a lot that the school owns about a mile from the campus. I sent you an announcement that read come prepared to EAT with a piece of bread in it. the school payed me to do the piece. i presented it as a fish piece as part of a 3 lecture series i did there. it was very plastic just like san jose. Layed out all orange food on straw floor of hut enough for at least 50 people, passed out and ate one item at a time. american cheese, ½ slice, orange soda, potato chip dipped in mustard, carrots and candy corn eaten in three sections white tip first.

BRUCE NAUMAN

"Bruce Nauman," *Avalanche*, no.2, Winter 1971, pp.22-35. Major interview with Bruce Nauman, also includes photographs of the artist by Gianfranco Gorgoni and stills from eight videotapes: *Slow L Walk* (1968), *Bouncing in a Corner* (1968), *Stamping in the Studio* (1968), *Violin Tuned D.E.A.D.* (1968), *Bouncing in a Corner* (1969), *Walking in Contraposto* (1969), *Lip Sync* (1969),

Wall/Floor Positions **(1968). Excerpt.:**

[A]: Some of the works must be stimulated by a desire to experience particular kinds of situations. Just to see how they feel. Are you doing the work basically for yourself?

[BN]: Yes. It is going into the studio and doing whatever I'm interested in doing, and then trying to find a way to present it so that other people could do it too without having too much explanation.

[A]: The concern for the body seems stronger now. . . .

[BN]: Well, the first time I really talked to anybody about body awareness

Bonnie Sherk. *Public Lunch.* **San Francisco Zoo, 1971. Sherk sat alone in a cage at feeding time at the Lion House and ate a formal public lunch catered from Vanessi's Restaurant.**

was in the summer of 1968. Meredith Monk was in San Francisco. She had thought about or seen some of my work and recognized it. An awareness of yourself comes from a certain amount of activity and you can't get it from just thinking about yourself. You do exercises, you have certain kinds of awarenesses that you don't have if you read books. So the films and some of the pieces that I did after that for videotapes were specifically about doing exercises in balance. I thought of them as dance problems without being a dancer, being interested in the kinds of tension that arise when you try to balance and can't. Or do something for a long time and get tired. In one of those first films, the violin film, I played the violin as long as I could. I don't know how to play the violin, so it was hard, playing on all four strings as fast as I could for as long as I could. I had ten minutes of film and ran about seven minutes of it before I got tired and had to stop and rest a little bit and then finish it.

[A]: But you could have gone on longer than the ten minutes?

[BN]: I would have had to stop and rest more often. My fingers got very tired and I couldn't hold the violin any more.

[A]: What you are saying in effect is that in 1968 the idea of working with calisthenics and body movements seemed far removed from sculptural concerns. Would you say that those boundaries and the distance between them has dissolved to a certain extent?

[BN]: Yes, it seems to have gotten a lot smaller.

Nauman, Bruce. *Studio Problems No.1.* **1971. Videotape.**

Nauman, Bruce. *Studio Problems No.2.* **1971. Videotape.**

Irv Tepper. *Lin Roger and Me on a Sunday Morning, November 1971.* **Artist book.**

LOS ANGELES FREE PRESS

35¢ Outside L.A. County

25¢ Hear's Looking at You...

MASS ARRESTS ARE IN See page 3

Volume 8, No. 20 (Issue No. 356) Copyright 1971 The Los Angeles Free Press In two parts: Part one Phone YES-1971 May 14 - 20, 1971

Art Museum Throws Art Out

"Pillar of Society"

Second Coming

ARTHUR KUNKIN

The setting for the comic, brutal, significant, pathetic drama shown in the photographs on this page was the exclusive cocktail party last Monday evening at the Los Angeles County Museum of Art immediately prior to the preview opening of the Art and Technology exhibit.

The script for the event was initiated by artist Paul Cotton who came to the cocktail party, ticket in hand, accompanied by LaCienega Boulevard art dealer Eugenia Butler. Cotton, who has presented himself as a living sculpture at various events throughout the world, was dressed in his Astro-Naught Bunny costume from which everything hangs out. This time he was also carrying a cigarette girl's tray, a towel neatly folded over the tray to conceal rolled paper tubes containing an illegal vegetable.

Cotton's plan was to mix with the cocktailers and, if possible, peacefully distribute his familiar vegetable to the elite of the Los Angeles art world, most of whom partake at home but never in

(please turn to page 8)

The Walls are Paper Thin

SCULPTURE TRYING TO ENTER MUSEUM

SCULPTURE FORCED TO LEAVE MUSEUM

SCULPTURE LEAVING (Continued)

In Sight Out

SCULPTURE & ART DEALER THROWN OUT (Virtue prevails)

Trans-Parent Teacher's Ink. Paul Cotton, Medium. *Betrayal of 'The Prince of Peace'.* **Los Angeles County Museum of Art, 1971.**

ALLEN RUPPERSBERG

Ruppersberg, Allen. *Al's Grand Hotel*. Hollywood: Self-published, 1971. 12 page artist catalogue of Ruppersberg's hotel-show at Al's Grand Hotel, 7175 Sunset Blvd., Hollywood, California, May 7-June 12, 1971. Includes photo documentation of rooms in the hotel that one could visit or rent during the 6 week show. Photo captions include a pricelist of objects seen in the photographs.

Terbell, M. "Los Angeles: Al Ruppersberg's Grand Hotel," *Arts Magazine*, v.46, September 1971, p.53. Review.

BONNIE SHERK

Sherk, Bonnie. *Grosgrain:A Book Served on a Silver Platter*. Photos by Larry Fox. Self-published, 1971. Photo book.

Sherk, Bonnie. *Response*. San Diego, 1971. Videotape.

Sherk, Bonnie. "Untitled." Unpublished documentation for *Public Lunch*, written February 20, 1971 in the Lion House, San Francisco Zoo, on Waldorf-Astoria stationery, during Sherk's performance/event.

IRVIN TEPPER

Tepper, Irvin. *Lin, Roger, and Me On a Sunday Morning in November, 1971*. Oakland: Self-published, n.d. Artist book includes six photographs of the artist, Lin, and Roger (cat) in bed, taken with Polaroid Land Process.

TRANS-PARENT TEACHER'S INK. . PAUL COTTON. MEDIUM

Kunkin, Arthur. "Art Museum Throws Art Out," *Los Angeles Free Press*, v.8, May 14-20, 1971, pp.1,5.

WILLIAM WILEY

Richardson, Brenda. *William T. Wiley*, Berkeley: University Art Museum, University of California, 1971. Catalogue for a one man exhibition. Includes an introduction by curator, Brenda Richardson, and notes by William Wiley: "Sub Standard Test," 1968; "Hides Log — How to Chart A Course," 1971; thoughts on Marcel Duchamp, 1970. Also includes biographical notes, a list of selected exhibitions, bibliography, and catalogue documentation of the exhibition. Excerpt:

If you accept Duchamp's example as an ultimate limit or universe you miss a facet of his existence I deem essential. His universe is ultimate only in relation to him. We must use his example of mobility and flexibility as an imperfect but well intentioned model of existence. If you do not agree with his model you do not have to dissipate your energy by belaboring the point he made—an endless unresolvable rhetoric. His life and death in conventional terms make disproving or discrediting his achievement a moot point. However, that phenomenon of his existence was such that it will sustain almost any point of agreement or disagreement. The puzzle of man or a man's life should be enjoyed not feared.

Wiley, William. *Man's Nature*. San Francisco, 1971. Film.

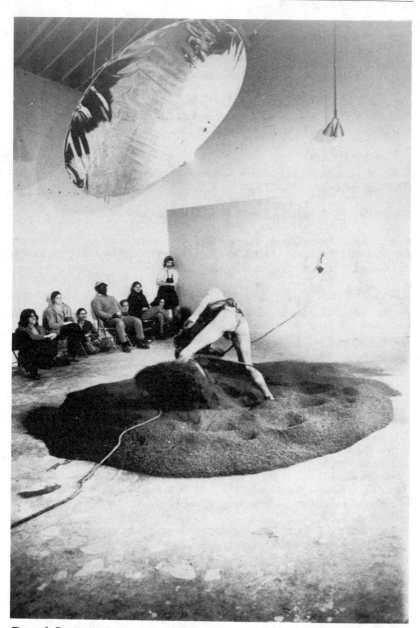

Darryl Sapien. *Synthetic Ritual.* **San Francisco Art Institute, 1971. Performed with Michael Hinton.**

1972

GENERAL LITERATURE

Documenta 5.Befragung der Realitat — Bildwelten Heute. Kassel, Germany, 1972. Exhibition catalogue for *Documenta 5*, June 30-October 8, 1972, Kassel, Germany. California artists selected for the category, "Individual Mythology, Self-Representation [Performance], Process," included: Paul Cotton, Terry Fox, Howard Fried, Barry Le Va, Jim Melchert, Bruce Nauman, and others.

File, Toronto, no.1, v.1, April 1972. Publisher, General Idea. Excerpt:
FILE is precisely this: the extension and documentation of available space, the authentication and reinforcement of available myths lying within the context of Canadian art today.
FILE is a transcanadada (*sic*) art organ produced by artists for artists.

Flash Art, nos.32/33/34, May/July 1972. A Special issue on Documenta 5, Kassel, Germany.

Friedman, Ken. "Fluxus and Concept Art," *Art & Artists*, v.7, October 1972, pp.50-53.

Hale, Bruce. "Notes for Sound," *Artweek*, v.3, January 29, 1972, p.2. Review of the third sound exhibition organized by Tom Marioni, entitled *Notes and Scores for Sounds*, at Mills College, Oakland, California. Excerpt, Marioni's statement:
Notes and Scores for Sounds includes score notations, and other visual preparatory material for the production of sound. There is a continuous running tape of two minutes or less of sound pieces by fifteen sculptors and

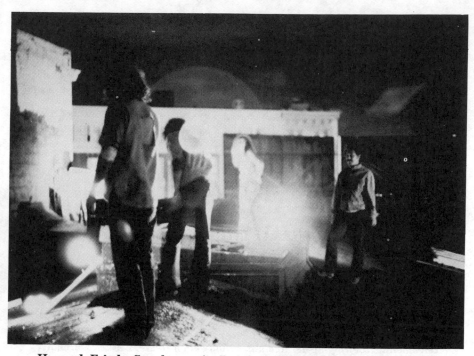

Howard Fried. *Synchromatic Baseball*. San Francisco, Ca., 1971. Performed at night with friends on the roof of Fried's studio at 16 Rose St. Game is interrupted when Fried falls through the skylight.

composers. Charles Amirkhanian, Eric Anderson, Tony Gnazzo, Peter Kennedy, and Barbara Smith's work in this show function musically — that is, the sounds produced have a sense of time relative to musical structure. Vito Acconci, Robert Ashley, Robert Barry, Andrea Brown, Howard Fried, Nancy Gardner, James Melchert, and John White's work function as sculpture or theatre. They all involve the use of the artist's mouth. Acconci screaming, Gardner laughing, Melchert blowing, White spitting, and the others reading aloud. Terry Fox and Petr Stembera's work functions as poetry, although Fox's sound of a violin playing is music played from a poem which was written using only the letters A to G, as in musical writing.

International Image Exchange Directory. Vancouver, B.C.: Talonbooks, 1972. Correspondence Art directory, includes photos and brief information about correspondence artists; compiled by Image Bank (Vincent Trasov and Michael Morris).

Juris, Prudence. "Fun and Games at the Institute," *Artweek*, v.3, August 12, 1972, p.12. Review of San Francisco Art Institute's exhibition, *The Game Show*. Participants included: Lynn Hershman, Tom Marioni, Jock Reynolds, Jim Pomeroy, Irv Tepper, Susan Subtle, John White, and Paul Kos, among others.

Astral-Naughty Rabb-Eyes

Documenta V, 1972

Kassel

Trans-Parent Teacher's Ink., Paul Cotton, Medium, and Diana Coleman. *Astral-Naughty Rabb-Eyes*. Documenta V, Kassel, 1972. "The Astral-Naughty Rabb-Eyes were projected into a luncheon at the castle of a local Count, into a Mayor's reception at City Hall and into the streets of Kassel at random times and places."

Paul Kos. *A Trophy/Atrophy* **(Two-headed Cow Self). Videotape, 1971/72.**

Lambie, Alec. "16 Rose Street," *Artweek,* **v.3, January 1, 1972, p.1. Photos and text on the history of 16 Rose Street, a building in San Francisco leased by Reese Palley Gallery and given over as studio space to artists such as Sam Richardson, Terry Fox, James Pennuto, Howard Fried, Barney Bailey, and Alec Lambie. Excerpt:**

[A description of Howard Fried's *Synchromatic Baseball*]: One of Howard Fried's studio pieces was a baseball game, using over-ripe tomatoes as balls, played on the roof at 16 Rose Street during August [1971]. Artists and visiting friends were divided into 2 teams, one made up of people Fried considered apt to behave dominantly in their relationship to him (though not necessarily so in other situations) and the other made up of people he thought not apt to behave dominantly toward him. As the wild game progressed, Fried found that the dominant group took charge and the non-dominant stood around and did very little.

Before the evening was over Fried fell through a skylight, cut his arms and made a hurried trip to the nearest hospital emergency room. Content with the strength of the situation and not in the least distressed by this end to the evening, he considers the baseball game one of his more interesting and successful works.

Mayer, Rosemary. "Performance & Experience," *Arts Magazine*, v.47, December 1972/January 1973, pp.33-36. General essay on performance art, the influence of life experiences on the art produced by an artist. Excerpts:

For a number of reasons, performance art is most open to elucidation by consideration of the personalities, life experiences, and life styles of the people who do it. Firstly, with performance art there is the immediate, obvious connection between artist and work—the artist as performer. The artist's physical capacities and appearance partially define the work. Secondly, performance art has almost no inherited, traditional form to come between the artist and his idea. The art idea is not mediated through canvas and stretchers or the materials of sculpture. The artist and his activities make up the physical presence of the work. Thirdly, some new way of looking at performance art is needed since this kind of art deals with psychology, philosophy, cybernetics, sociology, learning theory, little of which is considered in most present art criticism when it deals with specific works and all of which are as equally if not more intimately connected with the life experiences of the artists concerned than with their experiences from past and contemporary art.

It could be said that performance artists develop their ideas through conversation and readings in psychology, philosophy, etc. But when one reads in any of these fields it is the principles and situations most like those one has personally known which influence thought.

Paul Kos. *rEVOLUTION—Notes for the Invasion-Mar Mar March.* Video installation, 1972/73. Redwood 2x4's, a red box with typewriter, manuscript, one inch T.V., cassette player, videotape—*Mar Mar March.*

Chris Burden. *TV Hijack*. Los Angeles, Ca., February 9, 1972. "On January 14 I was asked to do a piece on a local television station by Phyllis Lutjeans. After several proposals were censored by the station or by Phyllis, I agreed to an interview situation. I arrived at the station with my own video crew so that I could have my own tape. While the taping was in progress, I requested that the show be transmitted live. Since the station was not broadcasting at the time, they complied. In the course of the interview, Phyllis asked me to talk about some of the pieces I had thought of doing. I demonstrated a TV hijack. Holding a knife at her throat, I threatened her life if the station stopped live transmission. I told her that I had planned to make her perform obscene acts. At the end of the recording, I asked for the tape of the show. I unwound the reel and destroyed the show by dousing the tape with acetone. The station manager was irate, and I offered him my tape which included the show and its destruction, but he refused."

Muller, Gregoire. *The New Avant-Garde: Issues for the Art of the Seventies.* New York: Praeger, 1972.

..

THE SAN FRANCISCO PERFORMANCE

San Francisco Performance. **Newport Beach: Newport Harbor Art Museum, 1972. Catalogue for the exhibition,** *The San Francisco Performance,* **organized by Tom Marioni, March 12-April 16, 1972. Artists included: Terry Fox, Howard Fried, Paul Kos, Mel Henderson, Bonnie Sherk, Sam's Cafe, Larry Fox, and George Bolling. Excerpt:**

Today artists are using videotape to record unedited the stream of conscious flow of life. The hand-held camera records the movement of the artist's hand and body. Because of the use of drugs in our society, and especially in San Francisco, there has been a new art climate developing there. Since the advent of the hippies and rock music there are strong feelings to communicate in a personal way in the Area and it is definitely influencing many artists to the point that the taking of drugs is important to the execution and even the understanding of the work. In the new sculpture there are no illusions as in theatre. The artist functions as an element/material and the relationships of his movement, spaces, sound, light, surface quality, presence, and so on function exactly the same as in traditional sculpture. The life span or performance of the piece is shorter and the methods for recording the artists' hand today are in keeping with the materials (technology) that are available to the artist. We approached in the late 60's a love of natural processes, raw materials and moved to the country so to speak. Museums were dealing with dealers and collectors and not the artist himself. The new sculpture demands the artist execute his work in the space that it is to be shown in. That way the artist has control over all aspects of its environment.

"San Francisco Performances," *Artweek,* **v.3, April 8, 1972, p.4. Review of the Newport Harbor Art Museum exhibition. Excerpt:**

The exhibition is a controversial one because it points out a drastic departure in the nature of the ideas which form the basis of "traditional" art. The artists whose works are "experienced" in the Museum are not concerned with the conversion of reality into illusion, but rather with the direct experiencing of reality in which the nature and quality of ideas dominate the media from which the objects are made. . . .

ARTISTS / ART SPACES

DAVID ANTIN

Antin, David. "Talking at Pomona," *Artforum,* **v.11, September 1972, pp. 39-47. Transcription of a talk he presented to art students at Pomona College, Claremont, California, in April, 1972.**

ELEANOR ANTIN

Antin, Eleanor. *The King.* **1972. Videotape, 52 mins., b/w.**

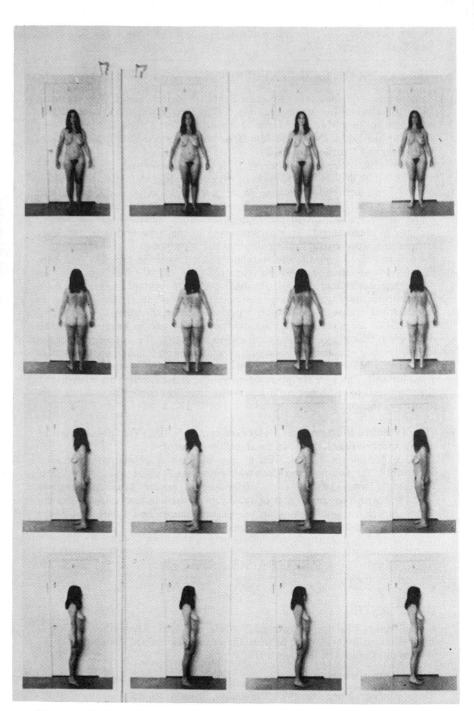

Eleanor Antin. *Carving—A Traditional Sculpture.* **1972. Detail from**

58

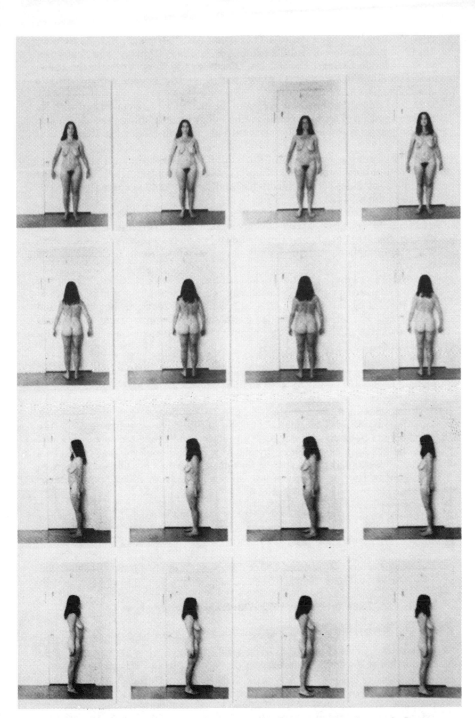

Carving depicting a weight loss over 36 days. Photo shows 8 days.

59

Nix, Marilyn. "Eleanor Antin's Traditional Art," *Artweek*, v.3, September 16, 1972, p.3. Review of Antin's exhibition *Painting, Drawing, and Sculpture*, at the Orlando Gallery, Encino, Ca. Discusses the three works in the show: *Representational Painting, Carving,* and *Domestic Peace*, part of Antin's *Traditional Art Series*. Excerpt:

[Antin] states that the three pieces in the exhibit . . . are concerned with "a re-investigation of art history and methodology by redefining the old terms so precisely as to throw new and relevant light and, in fact, make them useful again."

In the "Painting" segment of the exhibit, the artist shows a videotape of about 35 minutes length titled "Representational Painting." . . . She applies cosmetics, changes into a chic blouse and a perky hat, prepared to present herself to the world. . . .

The second work is "Sculpture," titled "Carving," . . . As in the classical tradition the piece is carved one layer at a time. Through a program of dieting, the artist gradually whittles down her body, a layer at a time. Antin was photographed unclothed daily for a month—front, back, and each side. . . .

In the "Drawing" portion of the exhibit, the work is titled "Domestic Peace." It consists of 15 xeroxed pages on which . . . Antin recorded manually, but almost as an oscillograph would, the reactions her mother had during conversations that had been pre-planned and were carried out without her knowledge of the under-the-table sketching that continued throughout the project.

Plagens, Peter. "Eleanor Antin; Orlando," *Artforum*, v.11, November 1972, pp.88-89. Review of Antin's exhibition at the Orlando Gallery, Encino, Ca. Excerpt:

The actions in this show are: 1) "a strict regimen of diet and exercise" resulting in the loss of nine pounds in thirty days—documented by 120 photographs, four views a day, of Antin in the nude; 2) a face-cleansing and make-up session—documented by a sharp, professional videotape; and 3) a "forced," extended psychological encounter with her mother—documented by a kind of psychic electrocardiogram, ranging from restful pleasantness (pleasant restfulness?) to hysteria.

JOHN BALDESSARI

Baldessari, John. *Choosing Green Beans*. Milano: Toselli, 1972. Artist book.

Baldessari, John. *Ingres and Other Parables*. London: Studio International, 1972. Artist book.

Baldessari, John. *Inventory*. 1972. Videotape, 30 mins., b/w.

CHRIS BURDEN

"Rumbles; Chris Burden," *Avalanche*, no.4, Spring 1972, p.6. Brief discussion of Burden's performances presented during 1971. Excerpt:

You'll never see my face in Kansas City was Chris Burden's one-man show on Saturday, November 6, at Kansas City's Morgan Gallery. Wearing a knitted snow mask which he donned about 50 miles outside the city limits "for safety's sake," Burden entered the gallery and sat bolt upright in a wooden

kitchen chair so that his face was completely hidden behind a painted plywood panel attached to the ceiling. . . . During the past year he has executed a number of body-oriented performance pieces in Northern and Southern California. . . . For his *Five-day locker piece* at the University of California, Irvine, he had himself sealed up in a three foot square gym locker. His contribution to the graduate group show at Irvine was *Bicycle riding piece*, which consisted of approximately 1600 passes through the University Art Gallery on his bicycle.

GUY DE COINTET

de Cointet, Guy. *A Captain from Portugal.* 1972. Artist book.

Howard Fried. *Sea Sell Sea Sick at Saw/Sea Sea Soar.* Videotape, 1971. Fried acting as a restaurant patron while waiters Alec Lambie and Barney Bailey try to get an order out of him. The video camera and the set are mounted on platforms swinging in opposite directions.

TERRY FOX

Fox, Terry. *Axione per un Bacile*. 1972. Super 8 film, 30 mins., color.

Fox, Terry. *The Fire*. . . . Rotterdam, 1972. Videotape, 30 mins., color.

Fox, Terry. *Washing*. Paris, 1972. Audiotape sound loop, 15 mins.

Matthias, Rosemary. "Performance Spaces; Exhibitions," *Arts Magazine*, v.46, Summer 1972, p.58. Review of exhibition, *Performance Spaces*, at the School of Visual Arts Gallery, New York, organized by Vito Acconci. Excerpt on Terry Fox's contribution to the exhibition:

Terry Fox's piece consists of a chair facing a wall. The chair is the performance space. Persons whom Fox has met in New York City, sit in the chair at 3 P.M. and attempt, by thinking of Fox, to transmit thoughts to him in California.

Plagens, Peter. "Terry Fox: the Impartial Nightmare; San Francisco," *Artforum*, v.10, February 1972, pp.76-77. Discussion of Fox's Hospital piece at the Reese Palley Gallery, San Francisco, 1971. Excerpts:

[Fox]:"I don't know exactly why the things are the shapes they are and look the way they do. They work to convey the claustrophobia of marrow in the bone. The corridor is a section of vessel. The water bowl and soap are ritual, the stretcher is claustrophobia. The action of the state of mind on the physical state. The drawings show the surface of the bread which is my wound. The breath is not self-sustaining, it relies on a system and attendants to the system in order to function. So does the chant. The wires = arterial system, the membrane, ear drum. The walls are pious and charitable; the bases are isolated from the energy of the floor and walls by electrical tape." . . .

Hospital works on many levels: elegant drawing (the wires, poles, and walls), grand sculpture (a la Serra, Andre, and Sonnier), and *teatro povero* staging. But finally and best, it's gristly poetic narration: Fox's struggle with his imperfect body, which is the artist's struggle with the world, which is our struggle with our treacherous selves. Fox says of it: "the absolute impartiality of the object and its function, the total partiality of the context, the 'drone' of experience like a recurring nightmare or dream, the base of operation."

HOWARD FRIED

Bear, Liza. "Howard Fried: The Cheshire Cat," *Avalanche*, no.4, Spring 1972, pp.20-27. Interview with Fried, includes photos from Fried's videotape, *Sea Sell Sea Sick at Saw/Sea Soar* (1972), and written documentation from his work, *The Cheshire Cat*. Excerpt:

[Fried]: My concept of *The Cheshire Cat* originated in '69 when my mother sent me a group of drawings I'd done at the age of six. In a lot of them I'd started drawing, apparently walked away to get something, and then come back to find that Billy had made his mark on them in the form of Xs or hurricanes or something. I had left some of the drawings as they were, others I'd finished. Once I put feet under a tornado cloud that Billy had drawn under one of my Indian heads and titled it: "Tornado Indian fought with whole Indian." It's another instance of a situation which I hated at the time, but to

which my attitude has changed . . . Anyway, that incident—my seeing the drawings again—brought back to mind a certain pattern that had permeated my childhood. Billy would make his mark in some way to my dissatisfaction, and then frost it with a bizarre and irritating grin. Later I related that to the Cheshire cat. So the piece began as a comment on my brother's smile, which eventually became important to me. . . . Those drawings reminded me of six specific instances in which Billy had smiled his Cheshire cat smile, and I wrote stories—straightforward recollections—relating to each of them. I wrote them margin to margin down a long sheet of paper forming a

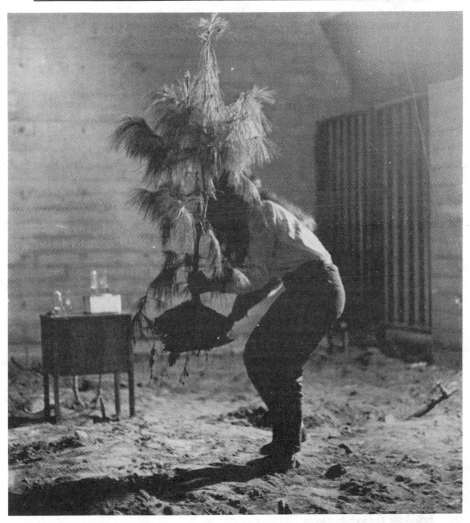

Bonnie Sherk. *Response.* **University of California at San Diego, 1971.**

rectangle—a long, solid, self-contained rectangle which I consider to be the plot of the whole thing.

Davis, Steve. "Howard Fried Installation Piece," *Artweek*, v.3, March 25, 1972, p.1. Review of Fried's exhibition at Reese Palley Gallery, San Francisco. Includes description of Fried's videotape, *Sea Sell Sea Sick at Saw/Sea Soar*. Excerpt:

This particular video piece is about a restaurant situation which gets to the roots of comedy in addition to exemplifying Fried's formal and philosophical concerns.

The setting is a table and chair on a suspended and swinging platform stage with Fried acting as patron of the restaurant (it's his studio). Alec Lambie and Barney Bailey are waiters. The video camera is also on a swing and the camera and set swing in opposite directions and are in constant motion. Two videotape viewers sit side by side on the floor and relay the dualities. The action consists of Fried trying to order (dinner, lunch and breakfast in that order). Lambie and Bailey try to get the order out of him.

Fried, Howard. *Sea Sell Sea Sick at Saw/Sea Soar*. San Francisco, 1972. Videotape, 50 mins., b/w.

Fried, Howard. "Studio Relocation," *Breakthroughs in Fiction*. New York: Something Else Press, 1972.

Fried, Howard. *Which Hunt*. San Francisco, 1972. Videotape.

McCann, Cecile N. "Howard Fried at Documenta," *Artweek*, v.3, July 29, 1972, p.5. Description of Fried's contribution to *Documenta 5*, Kassel, Germany; a performance work entitled, *Indian War Dance/Indian Rope Trick*. Excerpt:

The first stage is a wrestling match between Howard Fried and David Sherk . . . as they wrestle, a judge rings a bell at will, ending each 'round' of the match. Naming one or the other of the artists as the 'winner' of the round, he gives him a drink of liquor. There are no guide lines for the judge's decisions, but the wrestlers abide by them. "The judge," according to Fried's intent, "is just a bell ringer. He's the manipulator of the sobriety of the participants." The match is to continue until both wrestlers are too drunk to stand.

Later, "or next day, after they recover," comes the Indian Rope Trick part. . . .a weight on a long piece of rope is attached to Fried. He will swing it out and back in an expanding and contracting spiral that centers on his body. He sees the rope as a means of control over a certain space—a control that "initially commandeers a certain amount of space and then comes back and wraps me up."

McCann, Cecile N. "San Francisco Artists," *Artweek*, v.3, November 4, 1972, p.1. Review of San Francisco Art Institute's exhibition of five San Francisco artists. Includes discussion of the videotape contributed by Howard Fried for the exhibition.

"Rumbles; Howard Fried," *Avalanche*, no.4, Spring 1972, p.4. Brief
description of two of Fried's videotapes, *Fuck You Purdue*, a 25 minute tape
shown in *The San Francisco Performance,* Newport Harbor Art Museum, and
Sea Sell Sea Sick at Saw/Sea Soar, a 55 minute tape shown at the Reese
Palley Gallery, San Francisco. Excerpt:
Fuck You Purdue is a dialogue between two confined people whose life
spaces overlap, and refers to Fried's brother Billy, whose drill instructors in
the Marines were called Purdue and Ward; their sole verbal exchanges when
off-duty were restricted to the words in the title.

JOEL GLASSMAN

Glassman, Joel. *Symbolic Logic of Now.* 1972. Videotape, 45 mins.

LYNN HERSHMAN

Chipman, Jack. "Lynn Lester Hershman/An Interview," *Artweek,* v.3, July
1, 1972, p.2. An interview with Hershman about her ideas on art and her use
of multi-media. Excerpt:
J.C.: Are you a multi-media artist?
L.H.: I don't know, I use whatever means I have access to to get my
message across. I like the idea of having freedom and flexibility in terms of
different ways of working. I don't like to be limited to only one means of
expression. I'd like to use all the types of media eventually, including video
tape. It's a vocabulary. It's like learning a different language—once you have
the facility, you can say what you want without any problem. . . .
J.C.: It sounds like you're into conceptual art. Will you ultimately abandon
the object?
L.H.: No, I think objects are important. Besides there *are* objects in
conceptual art. They're part of the documentation process. But, I don't
consider myself a conceptual artist.

ALLAN KAPROW

Kaprow, Allan. "The Education of the Un-Artist, Part II," *Art News,* v.71,
May 1972, pp.34-39.

PAUL KOS

Kos, Paul. *Mar Mar March 1972-1973.* Videotape, 12 mins., b/w.

SUZANNE LACY

Lacy, Suzanne. *Rape Is.* Valencia: California Institute of the Arts, 1972, 1976.
Artist book, a "book resembling the privacy of a woman's interior space
which is intruded upon in a variety of manners all stemming from the attitude
of rape." —from Women in the Printing Arts catalog, 1977.

TOM MARIONI

Hershman, Lynn and Lambie, Alec. "Tom Marioni on Record," *Artweek,*
v.3, May 6, 1972, pp.2-3. Two interviews with Tom Marioni; the first by Lynn
Hershman, the second by Alec Lambie. Excerpts:
[Hershman]: What's Conceptual Art?
[Marioni]: Idea oriented art that's not directed toward the production of a

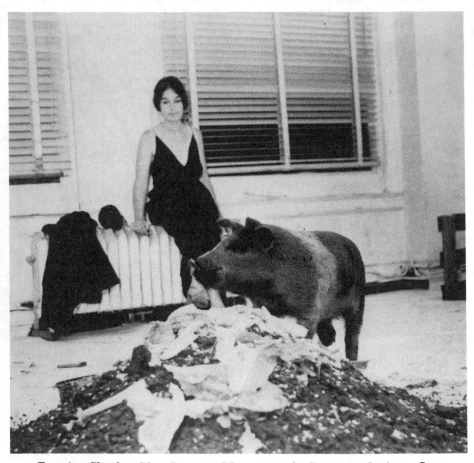

Bonnie Sherk. *Pig Sonata.* **Museum of Conceptual Art, San Francisco, Ca., 1971.**

static object. There are three kinds of conceptual art. There are language artists, who use language to create imaginary space; there are artists who use mathematics to do the same thing (those are purists) and then there is conceptual art (that's performance sculpture where the element of time has been added to sculpture).

[Lambie]: How do you feel about the personal narrativeness of the West Coast conceptual?

[Marioni]: The subject of my work a lot of the time is similar to a lot of the other people who are into performances. Like humor is an element, and I found a lot of people can't take something serious about humor, because I'm serious about the humor.

[Lambie]: I wasn't really referring to the content but the use of yourself as

the medium.

[Marioni]: How do I see myself as an element? Oh, I'm very conscious of the relationship to the objects that I'm using. All the same problems that have always been there remain. The only difference is that the work only remains for a shorter time. It really has all the traditional sculptural problems with the possible exception of the time element added.

Juris, Prudence. "The Newer Art: Tom Marioni in Conversation with Prudence Juris," *Studio International,* **v.183, May 1972, p.191. Excerpt:**

PJ: How is performance different from theatre?

TM: For a lot of reasons. One is that in performance sculpture the interaction of artists with their materials is direct. He relates forms to himself or other forms in performance in a way that traditional sculpture related one form to another. The difference is that the forms aren't static. They are changing. That element of time is there too. In theatre it is compressed time. A period of six months can take place in two hours, but in sculpture, two hours is two hours. It is real time, it isn't an illusion. Time is the difference. Also, it can't be repeated. If it's repeated then it becomes theatre.

PJ: Do you think the public is becoming more receptive?

TM: Art is more philosophical. It demands that the public be more philosophical about their perceiving art. It seems less visual and more idea-oriented, and requires more thought process. You learn about the time. Like in minimal sculpture. People related to that like they did to music. Before rock music you heard only with your ears. Then rock music developed at the same time as minimal sculpture, and people listened with their whole bodies. The volume was so intense you took it into your skin. The same thing happened to sculpture. You felt it with your whole body.

PJ: So you think that conceptual art is a revolutionary aspect.

TM: Yes. Conceptual art is a major break in the beginning of modern art. Because it leaves the object. It is the most significant jump in art in the history of art.

BRUCE NAUMAN

Pincus-Witten, Robert. "Bruce Nauman: Another Kind of Reasoning," *Artforum,* **v.10, February 1972, pp.30-37.**

ALLEN RUPPERSBERG

Allen Ruppersberg. **Claremont, California: Pomona College Gallery, 1972. Catalogue for an exhibition, October 31-November 22, 1972. Introductory essay by Helene Winer. Excerpt:**

The artist's interest in magicians, especially Harry Houdini, is evidenced by the piece, "Missing You," an homage to Houdini, and "Houdini Again." The latter Houdini piece makes use of an operative system, as did the far more elaborate projects, "Al's Cafe" of 1969, and "Al's Grand Hotel," of 1971. The cafe and the hotel were working situations that resembled and alluded to the real thing, much as the novel does, but relied upon chance occurrences within the basic structure. "Houdini Again" makes use of an established system that is thoroughly predictable. The piece is library overdue notices for five books on or by Harry Houdini. In addition to the pun indicated by the title of the piece, it also is a use of information. By keeping

each book out longer than the designated length of time, a system of action is put into play. Notices eventually arrive at Ruppersberg's address that provide a great deal of what, where, when, how much, information. In most art works other than performance pieces, the activity of the artist while executing the piece is not clear. This piece is to a great extent that action of going to the library, carrying each book off separately, keeping it around, probably reading it, eventually receiving the overdue notice, returning the book, paying the fine and checking out another book. The evidence of all this is a small paper notice.

BONNIE SHERK

Lamble, Alec. "Things Are Not As They Seem," *Artweek*, v.3, March 25, 1972, p.3. An interview with Bonnie Sherk. Includes text and photos of her performances at U.C. San Diego, San Francisco Zoo, and Museum of Conceptual Art. Excerpt:

"Include yourself," Bonnie Sherk, environmental artist, maintains. "Mix up media, deal with alternative events, environments, materials or anything else you may have in mind. As a matter of fact," Bonnie Sherk said in her studio, "one has the choice to do anything and everything or nothing." . . .

Bonnie Sherks's piece in San Diego, titled "Response," described her own response to the space, the audience response to her actions in the space and the viewers response to themselves. Descriptively, her actions amounted to boiling an egg and planting a small pine tree within an enclosed area in one of the newly completed library buildings. At ground level, where she stood, her action was viewed by a video camera and then transferred to a monitor in a separately enclosed area. It was then described mathematically by David Baxter of the physics department. Simultaneously her action was observed from a promenade directly above by Chuck Hankins of the biology department who related what was taking place to a group of viewers. Neither Hankins or Baxter was able to see the other.

1973

GENERAL LITERATURE

Art-Rite, New York, no.1, 1973. Editors, Edit deAk and Walter Robinson.

Artists Books. Philadelphia: Moore College of Art, 1973. Catalogue for an artists' book exhibition at Moore College of Art, March-April 1973, and the University Art Museum of the University of California, Berkeley, January-February 1974.

Belard, A. "All Night Sculptures," *Artweek*, v.4, May 26, 1973, p.3. Review of a performance event sponsored by the Museum of Conceptual Art, San Francisco, which took place April 20, 1973 from sunset to sunrise. Nine artists participated in the event: Joel Glassman, Stephen Laub, Paul Kos, Mel Henderson, Bonnie Sherk, Frank Youmans, Barbara Smith, John Woodall, and Terry Fox. Curated by MOCA director, Tom Marioni. Excerpt:
Nine artists worked throughout the night. Joel Glassman drew a virtual volume of light in the shape of a wedge by constructing a tent for the central third of two neon gas tubes. Steve Laub constantly vanished and reappeared, changing dimension, sex, character and identity. Paul Kos materialized a geometric reduction of the freedom of movement, demonstrating the similarities in the military and bureaucratic oppressions of the individual, by forcing the visitor to march towards a red light to the beat of a typewriter. Mel Henderson separated the light of searchlights, transfused them through the dust of window glass, from candle light in a room without surfaces. Bonnie Sherk invaded a neighboring rooftop sanctuary for pigeons with media and displaced animals in an aggressive series of acts, including the scrambling of eggs before the nesting birds. Frank Youmans worked throughout the night to realize an example of the simple beauty of the master craftsman, without ideals or ambitions exterior to itself. Barbara Smith exposed herself in a series of one to one relationships with all who would impose their egocentric needs upon her naked open body. John Woodall appeared as the machinated man, constricted by his geometry, tracing his own one-dimensional shadow as he rotated on his axis. Terry Fox created a room permanently installed in the Museum in the form of a Memento Mori.

Joel Glassman, Carlos Gutierrez-Solana, Paul Kos. La Jolla: La Jolla Museum of Contemporary Art, 1973. Catalogue for an exhibition, October-December, 1973.

Lippard, Lucy R. *Six Years: the Dematerialization of the Art Object from 1966 to 1972.* New York: Praeger, 1973. "A cross-reference book of information on some esthetic boundaries: consisting of a bibliography into which are inserted a fragmented text, art works, documents, interviews, and symposia, arranged chronologically and focused on so-called conceptual or information or idea art with mentions of such vaguely designated areas as minimal, anti-form, systems, earth, or process art, occurring now in the Americas, Europe, England, Australia, and Asia (with occasional political overtones)."

Selz, Peter. "Six Artists in Search of a Definition of San Francisco," *Art News,* v.72, Summer 1973, pp.34-37. The round-table discussion which took place in Berkeley was hosted by Peter Selz and included artists: Howard Fried, Lynn Hershman, William Wiley, Joseph Raffael, Harold Paris, and Victor Moscoso. Excerpt:

Different as their individual products appear, the artists who participated in the discussion all seem to show a predilection for myth, magic and metamorphosis. I found references to early experiences by some of the artists particularly revealing in relation to their current work. Moscoso recalls animated cartoons; Hershman, preachers throwing out words; Raffael, that big screen in the movies; Wiley speaks of picture books and Paris identifies with Schwitters walking down the street, picking up scraps which he filled with nostalgia.

FRIED: I don't agree with anything that has been said. I live in the city, don't have a car, feel the pressure of the city. You can't talk about the art of the area. When work is related to landscape you find divergences and you do when it's being related to people and their psychological milieu. People who live in different cities are more similar than one working in the city and one 20 miles away in the country. And the regional shows tend to look the way they do because of the way they are curated.

Smith, Barbara. "Three Womanspace Performances," *Artweek,* v.4, March 10, 1973, p.5. Review of first performance works held at Womanspace, Los Angeles, February 2-3, 1973. Reviews the performance works of Aviva Rahmani, Vicki Hall, and Barbara Smith.

Zack, David. "An Authentik and Historikal Discourse on the Phenomenon of Mail Art," *Art in America,* v.61, January/February 1973, pp.46-53.

ARTISTS / ART SPACES

ANT FARM

Ant Farm. *Inflatocookbook.* San Francisco: Ant Farm, 1973 (2nd printing; first published January 1971). The idea of an Inflatocookbook stems from Ant Farm's involvement over an eighteen month period beginning 1969 in which

the group "designed, built, and erected inflatables for a variety of clients and situations. Charley Tilford showed Ant Farm how to make fast, cheap inflatables out of polyethylene and tape and support them with used fans from Goodwill."

Ant Farm. *2020 Vision*. San Francisco: Ant Farm, 1973. A CalendarLOG for 1974, produced as the catalogue to Ant Farm's exhibition *20/20 Vision*, sponsored by the Contemporary Arts Museum, Houston, Texas. Excerpt:
In 1970 ANT FARM was commissioned to do a study of nomadic architecture. The result, TRUCKSTOP, was a city for 10,000 people that was configured as a network of villages physically dispersed around the country but interconnected by a computer controlled communications system that allowed a resident to travel between the truckstops as he might between neighborhoods. To research TRUCKSTOP we went on the road for 5 months in the Ant Farm media van and self contained life support unit.

ELEANOR ANTIN
Antin, Eleanor. *Caught in the Act*. 1973. Videotape, 39 mins., b/w.

JOHN BALDESSARI
Baldessari, John. *Throwing Three Balls in the Air to Get a Straight Line (Best of Thirty-Six Attempts)*. Milano: Edizioni Giampaolo Prearo/Galleria Tosselli, 1973. Artist book.

Collins, J. "Pointing, Hybrids, and Romanticism: John Baldessari," *Artforum* v.12, October 1973, pp.53-58.

CHRIS BURDEN
Burden, Chris. *Chris Burden*. 1973. Videotape, 30 mins., b/w. Videoviewed by Willoughby Sharp.

Burden, Chris. *Through the Night Softly*. Los Angeles, 1973. 16 mm film. Documentation of a performance work in which, holding hands behind his back, Burden crawled through fifty feet of broken glass—Main Street, Los Angeles, September 12, 1973.

Douke, Daniel. "Burden at Newspace," *Artweek*, v.4, July 7, 1973, p.5. Review of a Chris Burden performance work sponsored by Newspace Gallery, Newport Beach. A note tacked to the wall of the gallery stated that Burden would walk from San Felipe, Baja California, southward for the two week duration of the "exhibit".

"Editor's Mail Bag," *Artweek*, v.4, February 10, 1973, p.2. Critical letters regarding Barbara Smith's review of a performance by Chris Burden at the Mizuno Gallery (*Artweek*, January 6, 1973) and Smith's response to the criticism. Excerpt:
Smith: 1. The artist tends to deal with his own feelings and concerns about this, his *life*. It would be naive to say that all artists find our times easy or rosy. So what is he to do? It is not news to say that a great many artists find it very difficult to make paintings or sculpture when there is no viable

71

Chris Burden. *Deadman.* **Mizuno Gallery, Los Angeles, Ca., November 12, 1972. "At 8 p.m. I lay down on La Cienega Boulevard and was covered completely with a canvas tarpaulin. Two fifteen-minute flares were placed near me to alert cars. Just before the flares extinguished, a police car arrived. I was arrested and booked for causing a false emergency to be reported. Trial took place in Beverly Hills. After three days of deliberation, the jury failed to reach a decision, and the judge dismissed the case."**

architecture—upon which these media depend—that adequately represents either our needs or times. So we can cite many names other than Burden's that show there is a body of work being done in this area of, simply stated, what it feels like to BE now. Vito Acconci, Terry Fox, Joseph Beuys, Joan Jonas, Paul Cotton, Jim Byars, and more all of whom show how they feel in their own being and/or in alternative ways, formalized into event-like occurrences that transcend their personal dilemmas.

"Performances," *Oberlin College Bulletin*, **v.30, Spring 1973, pp.128-30. Photographs and text about works. Brief description of performances:** *Five Day Locker Piece, I Became a Secret Hippy, You'll Never See My Face in Kansas City,* **and** *Deadman.*

Sharp, Willoughby and Bear, Liza. "Chris Burden: The Church of Human Energy," *Avalanche*, **no.8, Summer/Fall 1973, pp. 54-61. An extensive interview with Chris Burden. Excerpts:**

[Avalanche]: What do you see as your central concerns?

CB: Well, in some of the pieces I'm setting up situations to test my own illusions or fantasies about what happens. *The Locker* piece, for instance . . . I didn't know what it was going to feel like to be in that locker, that's why I did it. I thought it was going to be about isolation; it turned out to be just the opposite. I was seeing people every single minute for thirteen, fourteen hours a day, talking to them all the time. In *Secret Hippie*, I thought I was gonna get hurt when I got that stud hammered in my chest, but it didn't hurt at all, there was absolutely no feeling. In *Shoot* I was supposed to have a grazed wound. We didn't even have any band-aids—the power of positive thinking. It's not that I consciously decided *not* to think about what might happen. . . . I had no plans of going to the hospital. . . .

WS: So it doesn't matter much to you whether it's a nick or it goes through your arm.

CB: No. It's the idea of being shot at to be hit.

WS: Mmmmm. Why is that interesting?

CB: Well, it's something to experience. How can you know what it feels like to be shot if you don't get shot? It seems interesting enough to be worth doing it. . . .

WS: What about the *TV Hi-Jack*? There you were putting someone else's life in danger.

CB: I wasn't really putting her life at stake. In my head it was just an example of what I could have done in the TV studio. I had already decided that I wasn't going to slit her throat; I wasn't going to make her do obscene things on live TV but we were on live, and I was holding a knife at her throat, so they had a flash that I was really doing it. . . .

WS: Why is your work art?

CB: What else is it?

WS: Theatre?

CB: No, it's not theatre. Theatre is more mushy, you know what I mean? Uhhh . . . it seems that bad art is theatre. Getting shot is for real . . . lying in bed for 22 days . . . there's no element of pretense or make-believe in it. If I had just stayed there for a few hours or went home every day to a giant dinner it would be theatre. Another reason is that the pieces are visual too.

Smith, Barbara T. "Artpiece Brings Arrest," *Artweek*, **v.4, January 6, 1973, p.3. Discussion of Burden's performance work,** *Deadman*, **for the Mizuno Gallery, Los Angeles, in which he placed himself under the rear wheels of a parked car on the street outside the gallery. He was arrested by the police during the event and subsequently went on trial. Excerpt:**

. . . we discovered that the 'piece" was just on the other side of the vehicles parked in front of the gallery. We saw a "body" beneath the rear wheels of a car, covered by a heavy tarpaulin. Two road flares had been struck and were lying nearby. Immediate thoughts of accident and death came to mind. A large crowd gathered in a semi-circle around the 'accident' and into the street. Wondering what was going to happen next, the possibility of police intervention crossed my mind just as in fact a police car drove up.

Two officers came forward, scanned the scene and began to ask what had

happened; did anyone see what had happened? After some pause one approached Chris and uncovered him, asked if he was OK and what he was doing. He told them he was an artist doing his "piece." They arrested him.

Smith, Barbara T. "Burden Case Tried, Dismissed," *Artweek*, v.4, February 24, 1973, p.2. A report on the Burden trial; Chris Burden was arrested November 12, 1972, during a performance at the Mizuno Gallery, Los Angeles (see Artweek, January 6, 1973, p.3 and February 10, 1973, p.2).

Spear, A.T. "Some Thoughts on Contemporary Art," *Oberlin College Bulletin*, v.30, Spring 1973, pp.92-93.

Wortz, Melinda Terbell. "An Evening with Chris Burden," *Artweek*, v.4, December 22, 1973, p.5. Descriptive article about Burden's work; includes a review of his December 5, 1973 work at Newspace Gallery, Newport Beach, in which the gallery was transformed into a livingroom atmosphere and two lithographs were unveiled, *If You Fly* and *If You Drive*.

LOWELL DARLING

"Advertisement / 'An Interview Between Lowell Darling and Dudley Finds in Hollywood, 1973,' " *Avalanche*, no.8, Summer/Fall 1973 [p.74].

Sharp, Willoughby. "'Shuck & Jive': Lowell Darling," *Avalanche*, no.7, Winter/Spring 1973, pp.24-29. An interview. Excerpts:
 LD: I started my school two years ago. My art school. Fat City School of Finds Art. . . . That's what I do. I run the world's largest degree granting art school. Didn't you know that? That's why I'm so rich. Everything else I do is just to support the school. It's hard to run a big school, you know, budget, physical plant. We give master's degrees to whoever wants them. . . .
 WS: How long have you been doing the school?
 LD: Well, the school about two years ago, but I started giving out degrees with my friend Dana Atchley, of Ace Space Co. in Oakland, California, The College of Arts and Crafts and we held our first commencement a year ago last November. Since then Dana's been travelling all over the country and Europe and Canada, and I've been travelling around, and we've graduated ten thousand people between the two of us and we hired them immediately too. You know, the employment problem.

GUY DE COINTET

de Cointet, Guy. *Espahor Ledet Ko Uluner*. 1973. Artist book.

TERRY FOX

Marioni, Tom. "Terry Fox: Himself," *Art and Artists*, v.7, January 1973, pp.39-41. Excerpt:
 Fox has said: 'All my life I've regarded objects with fear . . . but everything—a cigarette, a rock has always been beautiful to me if I just look at it.' . . .
 In the daily life of Terry Fox every act of life is an act of art. The objects of routine life are potential works of art. A work table is covered completely with flour and water and allowed to dry. The light cords in his studio are heavy

Bonnie Sherk. *Pretending to Be a Gargoyle*. Museum of Conceptual Art, San Francisco, Ca., 1973. For the series *All Night Sculptures*, Sherk occupied a rooftop and assumed the attitude of a gargoyle while looking down.

wrinkled wire that run from hanging bulbs onto and across part of the floor. The floor of his Third Street studio last year was covered with white paper. At the end of several months the surface of the paper had taken on a painterly quality that was an actual record of all of his movements and actions. There were sweepings of rusty piles of bits of wire and purple splotches of spilled wine. The wall, too reflected this attitude to objects for it was covered with nails and indentations from the blows of a hammer.

McCann, Cecile. "Terry Fox: The Shape of Thought," *Artweek*, v.4, September 22, 1973, pp.1,16. A descriptive article on the work of Terry Fox, includes information regarding his first one-man exhibition at the University Art Museum, Berkeley, September-October 1973.

Richardson, Brenda. *Terry Fox*. Berkeley: University Art Museum, University of California, 1973. Catalogue for Fox's exhibition at the University Art Museum, September-October 1973. Excerpts:
 Fox has explored in his work an astonishing number and variety of means of evading or rising above the limitations of body or corporeality: energy transformations and transference; sleep and dreaming; levitation; reincarna-

tion; music; fasting; religious chants or mantras; melting, dissolving, dissolution (wax, liquids, smoke, dust); hypnosis; automatic writing and "accident"; hallucination. Even in his earliest performance pieces, he pushed at walls (in an energy exchange, as if his body could go through material, or to "test" the substantiality of material), skipped, shuffled, and dragged across a floor (as if to test the limits of the pull of gravity on his body), or physically removed himself from the "action" site (as if to lend his presence only as the designing mind and spirit).

(*Untitled*), September 1973.

From March through August of 1973 Fox worked on the various elements of the Berkeley exhibition. He built a model of the Berkeley space, and kept it in his studio, photographing through a plastic dime store magnifying glass the various objects and actions that he might perform in the actual space at the time of the exhibition. The model was complete, including a gray-painted floor, concrete walls, and a hanging curtain to indicate the fabric and ultimate

Terry Fox. *Cell*. Museum of Conceptual Art, San Francisco, Ca., 1973. Fox created a room permanently installed at MOCA in the form of a memento mori for the series, *All Night Sculptures*.

placement of the finished drapery. Among the elements he photographed in the model were a labyrinth (which he constructed out of plaster to duplicate the labyrinth in Chartres), a dried half apple imbedded with his own eye tooth, a silver spoon with its finish oxidized, a spool of black thread, and a tin bowl filled with vinegar and flour (the same bowl he used to mix the concrete).

Edge of the bowl of vinegar.

Active flour on the surface of the vinegar.

Edge of the bowl of vinegar with remnants of concrete.

North entrance to the curtain (cul-de-sac).

South entrance to the curtain (alley).

Building blocks on the labyrinth.

The center of the labyrinth.

Spool of thread in the labyrinth.

Still from the videotape, "Incision," which Fox made of the labyrinth.

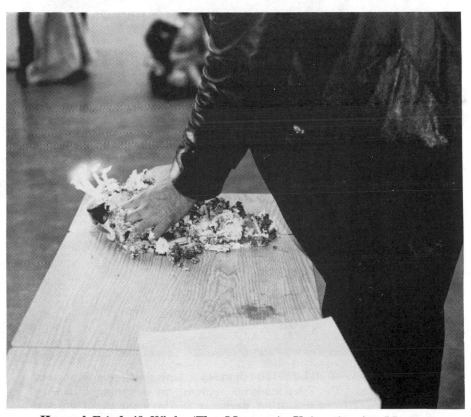

Howard Fried. *40 Winks* (The Message). University Art Museum, Berkeley, Ca., 1971.

Howard Fried. *40 Winks* **(The Journey). University Art Museum, Berkeley, Ca., 1971. Fried leads his audience on an extended journey through the city streets from Berkeley to Hayward expecting his audience to free themselves and go home to their respective promised lands.**

HOWARD FRIED

Fried, Howard. "Synchromatic Baseball," *Arts Magazine*, v.47, April 1973, pp.60-63. In this lengthy article, Fried describes his works, *Synchromatic Baseball* (1971), *Indian War Dance*, and *Indian Rope Trick* (1972), and *40 Winks* (1971). Includes photos. Excerpt on *40 Winks*:

On December 10, 1971 I staged a piece called *40 Winks* for a show of free live performances at the Berkeley Museum. The piece had two parts. The first was a long involved message which was posed as a riddle and delivered by me. It began as I destroyed a candled birthday cake by eating it or kneading it with my hands. Among those topics dealt with in riddled form were the Biblical use of the number "40" and the history of corporate and communal abuse of the individual in the name of larger social configurations. At the message's conclusion I posed the riddle's specific directive, "Who is they?" At this point I cut the tablet I was reading from in half and walked out of the museum. A narrator told the audience that the second part of *40 Winks*, "The Journey" was about to begin. It would progressively add information possibly leading to the comprehension of the riddle. Those who wished to participate were asked to follow me. I began walking. A crowd followed. I answered no questions. The large group gradually dissipated. After about six hours of walking everyone had left except one person, Robin Winters. At about 2:00 A.M. we were stopped by the police in Hayward, California. They made me tell them the answer to the riddle. We went into a parking lot so Robin couldn't hear.

The number "40" was used twice by Executive decree to wipe out specific generations of people. Agent Moses presided over one job for 40 years while agent Noah presided over another for 40 days. I based my strategy on Agent Moses's performance. . . .

I planned to walk until everyone had freed themselves and gone home to their respective promised lands.

"Howard Fried in Conversation with Joel Hopkins, Marsha Fox and David Sherk," *Art & Artists*, v.7, January 1973, pp.32-37. Interview; also includes text and photo documentation for *Sea Quick* (1972), *Synchromatic Baseball* (1971), *Long John Silver vs. Long John Servil* (1972), *Which Hunt* (1972), and *Sea Sell Sea Sick at Saw/Sea Sea Soar* (1972). Excerpt:

The above piece [Fried in conversation], written by Howard Fried, is a script for an interview of Howard Fried. It was organised by reconstructing an interview of Howard Fried conducted by Joel Hopkins. The transcript of this original interview was incomplete and imperfect due to tape recorder malfunction. This script was then based on the remaining questions in the original transcript augmented by excerpts of recent conversations with Marsha Fox and David Sherk and Fried's own fore and afterthoughts. The 'interview' was then performed on videotape from the rewritten script. Fried played Hopkins and Sherk played Fried.

MEL HENDERSON

Zane, Maitland. "A New Commuter Image," *San Francisco Chronicle*, February 22, 1973, p.3. Review of Henderson's project which took place February 21, 1973; cutout cardboard cows were placed over Interstate 280 and other thoroughfares near the Golden Gate Bridge in San Francisco.

LYNN HERSHMAN

Albright, Thomas. "A Ghostly Hotel Room Tableau," *San Francisco Chronicle*, December 22, 1973, p.32. Review of Lynn Hershman and Eleanor Coppola's environments at the Dante Hotel, San Francisco.

Minton, James. "Trespassing at the Dante," *Artweek*, v.4, December 22, 1973, p.3. Descriptive article about the environmental works produced by Lynn Hershman and Eleanor Coppola at the Dante Hotel, San Francisco. Excerpt:

Lynn Hershman and Eleanor Coppola have entered the Dante with intent to commit art. . . . They have each entered a room, numbers 47 and 50 respectively, and have installed or made in each room a sculptural piece or environment. . . .

[An] air of illegal entry is heaviest in Hershman's room. In the bed, tangled, nearly buried in the sheets and blankets, are two of her "ladies," locked together in penultimate exhaustion. A single eerie green lightbulb burns in the fixture hanging from the center of the cracked, stained ceiling; a similar light leaks out from around the closed closet door accompanied by a woman's voice, recorded, the voice of Siobhan McKenna reciting Molly Bloom's soliloquy from "Ulysses." But, the playback volume is so low her words are nearly indistinguishable from one another. It could be the voice of a tenant next door, mumbled into her pillow, the body of another person, or the still flat air.

ALLAN KAPROW

Kaprow, Allan. *Time Pieces*. Berlin: Neuer Berliner Kunstverein Videothek, 1973. Videotape, approx. 30 mins.

MARLENE KOS

Kos, Marlene. *One Bite*. Self-published, [1973]. Artist book.

PAUL KOS

Kos, Paul. *Battle Mountain*. 1973. Videotape, approximately 20 mins., b/w.

TOM MARIONI

Futterman, Hilla. "Activity as Sculpture; Tom Marioni Discusses His Work with Hilla Futterman," *Art & Artists*, v.8, August 1973, pp.18-21. Excerpts:

In 1969 I had to have a way to exhibit because I felt like exhibiting. It was too politically complicated to try to exhibit my work and be a curator at the same time for a combination of reasons which are probably obvious. So I had to exhibit under another name. I created a fictitious character, Allan Fish. And when it was no longer necessary to be concerned about those things, then I announced, by way of a transformation piece, that I was Allan Fish.

'The Act of Drinking Beer With Friends is the Highest Form of Art' was the first Allan Fish one man show. It took place at the Oakland Museum. I invited 21 of my friends to come and drink beer at the museum. And 16 people were there. All of the people were sculptors except for Werner Jepson, the music composer. We got drunk in the museum together and the debris that was left over was exhibited as documentation of that

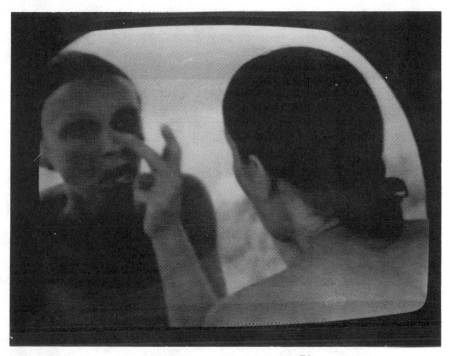

Paul Kos. *Battle Mountain.* **Videotape, 1973.**

activity—empty beer cans and cigarette butts, just morning after kind of debris. It was to exaggerate the concept of the act being the art and the documentation being just a record of the real activity.

Then there was a piece in Walnut Creek in a group show of sculpture that was based on the dimension 6' x 6' x 6'. . . . It so happened that they had $25 budgeted for me to do my piece there in that show. And that had a lot to do with determining the piece. You could get a good meal for four people for $25. So we just went there on the day that the event was going to take place. The table was set up with four chairs and a table cloth, nice silver, and nice dishes. When people tried to talk to us during the dinner, we ignored them because we were there just as though we were in a restaurant. All the activity outside of that six feet imaginary boundary was not art gallery activity. It was just blank space. The meal took about an hour and a half. And we left afterward. The table and the dirty dishes were left on exhibition as the record of the act. After about a week there was a row of ants that had come in the gallery through the door, and had gone up, and were getting the food on the plates.

Last summer I did a piece called 'Allan Fish Drinks a Case of Beer,' which had to do with creating a situation, an environment, while becoming increasingly more intoxicated over about an eight hour period. . . .

I did a piece in the gallery at the University of Santa Clara in February [1972] called 'My First Car.' It was a spoof on Don Potts but the gallery didn't know that. I asked them how much money they had budgeted for the show,

(cont'd, p.85)

and I used that money to buy myself a car. I exhibited the car as the documentation of that act. . . .

And then I had a show at the Reese Palley Gallery. That was called 'The Creation—a Seven Day Performance.' I spent the week in the gallery. I lived there. And I learned a lot about myself. . . .

I went to Scotland in May and did five pieces, one each day for five days at the Demarco Gallery in Edinburgh. I amplified the sound of making drawings. . . . I did a violin piece. I played my violin and did a drawing with

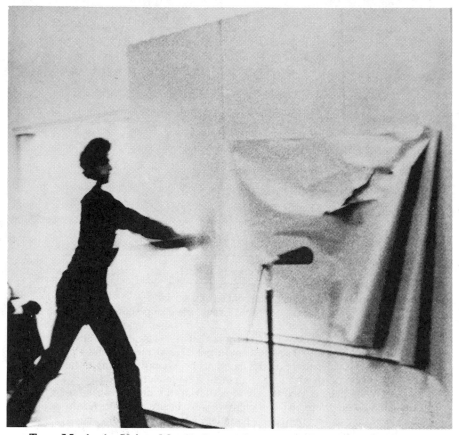

Tom Marioni. *Using My Body to Control Feedback.* **Whitechapel Gallery, London, England, 1972. "The concussion created by the whipping and tearing of paper caused an amplifying system to sound-feedback, suggesting screaming with pain. I discovered during this action that if I moved my body between the paper and the amplifier I could decrease or increase the sound of the feedback. This action was the aggressive half of a two part work. The other was passive."**

Tom Marioni. *My First Car*. De Saisset Gallery, Santa Clara, Ca.,
1972. Marioni when offered an exhibition at the gallery used the
budget to buy a car. "I was going to give them the car for their
permanent collection, although I was going to keep it because I
lettered on the side of the door De Saisset Museum and the dates of
the show and my name, so that as I drove the car around, I was
driving around one of the objects from the collection of the De Saisset
Museum. And even so the car was in my name because I went out and
bought it, with the money they gave me. So then I exhibited the car
and it was a small Fiat, one of those little small 500's like everybody
drives in Europe, and I drove it up the steps, through the double
door, into the gallery and parked it on this nice 19th century rug . . . I
parked the car in there with paper under it so that the rug didn't get
ruined and at the opening I sat in the car and drank champagne and
there was a microphone in the back seat and in the corner of the
gallery was a video camera. People would come up and talk to me in
the window of the car and I could listen to the radio in the car, and
they got in and we talked and everything. . . ."

Paul McCarthy. *Press*. Videotape, 1973.

Tom Marioni. *Allan Fish Drinks a Case of Beer*. Reese Palley Gallery, San Francisco, Ca., 1972. Marioni creates a situation and environment while becoming increasingly more intoxicated over an approximately 8 hour period of time, and simultaneously playing a congo drum, tape recorder, radio, television set and record player to make a barrage of sound.

the rosin from the bow. I cut a piece of brown paper to fit underneath the strings, and I bowed one harmonic note for 25 minutes. . . . I did a vertical line drawing until the pencil was used up.

PAUL MCCARTHY

McCarthy, Paul. *Meat Cake*. 1973. Videotape, 30 mins., b/w.

McCarthy, Paul. *Press*. 1973. Videotape.

Linda Montano. *Handcuffed to Tom Marioni for Three Days*. Museum of Conceptual Art, San Francisco, Ca., 1973. Montano as "Living Art" was handcuffed to Tom Marioni for 3 days; everything that occurs during that time was framed as art.

Paul McCarthy. *Meat Cake*. Newspace Gallery, Los Angeles, Ca., 1972. Performed for video in one room while the audience could watch the event on a monitor in another room.

Susan Mogul. *Dressing Up*. Videotape, 1973.

JAMES MELCHERT

Melchert, Jim. *Autobiography*. Oakland: Self-published, 1973. Artist book.

"Rumbles: Attack and Counterattack, Jim Melchert," *Avalanche*, no.8, Summer/Fall 1973, p.66. Brief description of Melchert's untitled 3-minute film which consisted of 5 attacks and counterattacks; shown at the Stedelijk Museum, Amsterdam.

SUSAN MOGUL

Mogul, Susan. *Dressing Up*. 1973. Videotape.

Mogul, Susan. *Road Test Score Sheet*. Self-published, [1973]. Artist book; laminated, 4 pages. Excerpt:
 I have distanced myself from an event in my life in order to examine it.

LINDA MONTANO

Montano, Linda. *Handcuffed to Tom Marioni*. San Francisco, 1973. Videotape, b/w.

87

MOTION

Evans, Carolyn. "Women's Movement Collective," *KQED Newsroom*, August 30, 1973. Script of broadcast on Motion: the women's movement collective.

Loud, Carol. "Motion," *The Daily California Arts Magazine*, February 16, 1973.

BRUCE NAUMAN

Harten, J. "T for Technics, B for Body," *Art & Artists*, v.8, November 1973, pp.28-33. Excerpt:
Nauman has made it clear that he has no use for participation pieces in

Susan Mogul. *Mogul is Mobil*. Los Angeles, Ca., 1973. "It gives me great pleasure to announce that after three feminist tries I was issued my first driver's license on June 4, 1973 and am now the proud owner of a 1967 Volvo."

which the visitor can play around as he likes. He programmes the spectator, he induces him to react as he, Nauman, reacts. Here one can see the result of a consistent development. It begins with the first organic-anthropometric sculptures, takes in then the impressions, 'body traps' and wax casts which lead to the questioning of objective reality. And it leads finally to manipulations of his own body, to dance-like performances which he first carries out himself and then hands over to others. The more the living body becomes the subject of his plastic researches, the less important the 'appearance of things' becomes, the more intense becomes the secret, the mysterious element and the more abstract the sensual impression. But Nauman is never concerned with emotional expression. When he paces in a special rhythm round his studio, when he puts on make-up or plays with his testicles, he views himself from the outside just as he does when he models himself from hand to mouth in wax. What goes on within us can be shown outside only in action; Nauman invents an action in order to see what inner processes it will release. He hopes that the attentive spectator will add, by 'Metacommunication' whatever is lacking in the outward form. The grimaces, the dislocated body movements which he produces in the video and hologram works are anything but ecstatic. They are a fresh attempt, through physiognomical manipulation, to undermine the meaning of the body as a sign.

Livingston, Jane and Tucker, Marcia. *Bruce Nauman.* **New York: Los Angeles County Museum of Art and Praeger Publishers, 1973. Catalogue for Nauman's one person retrospective exhibition at the L.A. County Museum of Art, December 19, 1972-February 18, 1973, entitled** *Bruce Nauman/Work from 1965 to 1972.* **Excerpt:**

Most of Nauman's work focuses directly on activities, first those of the artist, then those of the spectator himself. "An awareness of yourself," Nauman says, "comes from a certain amount of activity, and you can't get it from just thinking about yourself." Interior events, which are non-physical, must be expressed by relations or operations. In 1966 Nauman made the following list, which was titled CODIFICATION:

1. Personal appearance and skin
2. Gestures
3. Ordinary actions such as those concerned with eating and drinking
4. Traces of activity such as footprints and material objects
5. Simple sounds—spoken and written words
 metacommunication messages
 Feedback
 Analogic and digital codification

Codification, a term used by computer engineers, is "transformation in the mathematical sense of the word," the substitution of one type of event for another, which is made to stand for it. Analogic codification uses a recognizable model, in a machine, to stand for those external events which are to be thought about. Since the human central nervous system has no moving parts, only the whole moving body may be used as an analogic component. Nauman's codification listing includes certain tangible aspects of the total body that can be used as external "models" in terms of art.

McCann, Cecile N. "Bruce Nauman," *Artweek*, v.4, January 6, 1973, p.1. Review article of Nauman's exhibition at the Los Angeles County Museum of Art.

Plagens, Peter. "Roughly Ordered Thoughts on the Occasion of the Bruce Nauman Retrospective in Los Angeles," *Artforum*, v.11, March 1973, pp.57-59.

ALLEN RUPPERSBERG

Ruppersberg, Allen. *Allen Ruppersberg*. Amsterdam, Netherlands: Stedelijk Museum, 1973. Text and photo documentation of two works, *Between the Scenes* (1973) and *The Fairy Godmother* (1973) for an exhibition at the Stedelijk Museum, October 5-November 25, 1973.

Ruppersberg, Allen. *A Lecture on Houdini (for Terry Allen)*. Los Angeles, 1973. Videotape.

Winer, Helene. "Scenarios/Documents/Images," *Art in America*, v.61, May 1973, pp.69-71.

VAN SCHLEY

Sharp, Willoughby. "Different Strokes for Different Folks: An Interview with Van Schley," *Avalanche*, no.7, Winter/Spring 1973, pp.22-23 with insert. Excerpt:

VS: My sensibility isn't serious; there are few things that I can take very seriously.

WS: Why not?

VS: I can't take external things seriously because they aren't very real to me.

WS: What is?

VS: Personal experience.

WS: Perhaps that's why you are so interested in videotapes.

VS: Sure

WS: Which was your first one?

VS: Well, it was a five-minute tape of me imitating Wilson Pickett singing "In the Midnight Hour." I used a golf club as a microphone, lipsyncing into it.

WS: And why did you do such a ridiculous thing?

VS: Why did I do it then or looking back now why did I do it?

WS: Well, I guess you can't answer why you did it then, but why do you think you did it then? When did you do it?

VS: I did it in 1967 because I liked the music and the media. I used to watch American Bandstand and no one ever really sang on the show; they used to lipsync. So my idea of watching somebody perform was somebody lipsyncing. Chuck Berry was my idol in the 50's and I used to imitate him in front of a mirror, so I did my Wilson Pickett number in the video mirror.

BONNIE SHERK

Dunham, Judith L. "The Four," *Artweek*, v.4, January 27, 1973, p.1. Review of an exhibition featuring four women artists (Judy Chicago, Linda Benglis,

Bonnie Sherk. *Living in the Forest—Demonstrations of Atkin Logic, Balance, Compromise, Devotion, etc.* De Saisset Art Gallery, Santa Clara, Ca., 1973. Environmental work by Sherk replete with trees and living animals presented in the group exhibition, *The Four.*

Miriam Shapiro, Bonnie Sherk) at the De Saisset Gallery, University of Santa Clara. The article includes a description of Sherk's environmental performance work, *Living in the Forest—Demonstration of Atkin Logic, Balance, Compromise, Devotion.*

Sherk, Bonnie. *AKTIN LOGIC.* San Francisco: Self-published, 1973. Artist book.

Sherk, Bonnie. *Living in the Forest.* 1973. Videotape, b/w.

IRVIN TEPPER

Keller, Kathryn. "Irvin Tepper—Documents and Videotapes," *Artweek,* v.4, November 24, 1973, p.13. Review of Tepper's exhibition at the University of Santa Clara's De Saisset Art Gallery; includes a description of Tepper's videotapes, *Starting a Diet* and *Alphabet.* Excerpt:
In "Starting a Diet" Tepper strings together a sequence of three palatable contrivances including a session with a doctor discussing his "condition," repeated visits to the icebox that allow us to witness the ultimate crime of the dieter, and the final sequence which begins, "When you start a diet, foods

(cont'd, p.93)

Bonnie Sherk. *Cleaning the Griddle.* **Andy's Donuts, San Francisco, Ca., 1973.**

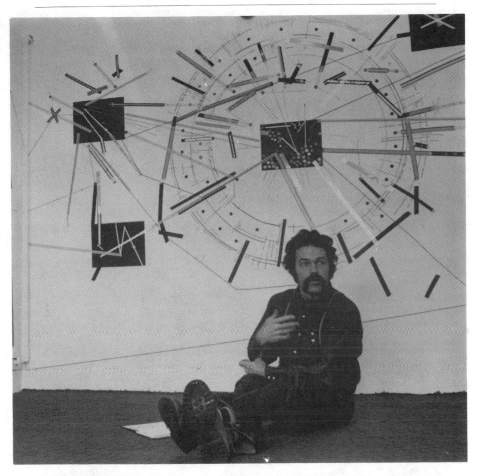

John White. *Watts Performance.* **A series of three performances in Los Angeles during 1973-74, for the Watts Community Housing Corporation.**

you should stay away from. . . ." In this last segment we are offered the gamut of dieter's no no's, from the Kentucky Colonel's Chicken to Banana Dreams. By throwing the food onto a plate with seemingly equal abhorrence and delight, an action in which the now you see it, now you don't occurs, the oral suggestion is restated through the "devouring" technique of the editing. It is all "staged," exaggerated, one-dimensional theater in which Tepper walks aloof and distracted through his self-portrait as the compulsive food addict.

JOHN WHITE

Simon, Leonard. "John White—Watts Performance," *Artweek*, v.4, October 6, 1973, p.5.

Richard Alpert. *Strategy for a Dance*. University of California, Davis, Ca., 1974. "In the front of the entrance to the room in which the performance took place was a container dripping water onto a hot plate, and a video monitor showing an overview of the interior of the room. I began the performance by writing a statement about the relationship between the different parts of the performance in chalk on the floor. After I finished writing, I picked up the hammer and began to strike a lead ball which was suspended from the ceiling. As I continued to hit it, small fragments of lead were thrown about the space. The performance ended when the ball had disintegrated."

1974

GENERAL LITERATURE

Americans in Florence: Europeans in Florence. Florence: Centro Di, 1974. Catalogue to a video exhibition organized by the Long Beach Museum of Art. Allan Kaprow and John Baldessari were among the participants in the exhibition.

Avalanche Newspaper, New York, May/June 1974. First issue with new tabloid format and title change from *Avalanche* to *Avalanche Newspaper*. Editor, Liza Bear; Artist-in-residence, Willoughby Sharp. "Special issue that focuses on a series of events presented at 112 Greene Street as the *Video Performance* exhibition on nine successive evenings in January, from the 13th to the 21st [1974]."

Burnham, Jack. *Great Western Salt Works: Essays on the Meaning of Post-Formalist Art.* New York: George Braziller, 1974.

Data, no.12, v.4, Summer 1974. Body Art issue. Contains several articles about body art and performance/body art artists. In Italian with English parallel texts. Articles include: "Gilbert &George, Gli Scultori Umani," "La Scuola Superiore Libera di Joseph Beuys," "Let's Talk About Body Art," "Il Corpo, l'Umanismo, l'Arte." "I Nuovi Adami," "Vito Acconi," "Chris Burden," "From the Open 'Cage' to the Closed Door of the Perception, etc."
..

DECCADANCE

Art's Stars in Hollywood: The Deccadance. Los Angeles, 1974. Videotape, 1 hour. On the ceremonial dinner, awards presentation, and the Deccadance event. Produced by Chip Lord and Megan Williams with the assistance of Willoughby Sharp, Environmental Communications, ACE Space Co., and Willy Walker.

The Deccadance. **Snapshots of activities. Los Angeles, February 2,**

1974. (From *Hollywood Edition Art's Birthday*].

Art's Stars Interviews. Los Angeles, 1974. Videotape, 1 hour. Features Willoughby Sharp video views with some of the Canadian Deccadance participants: Marcel Idea, Mr. Peanut, A.A. Bronson, Dr. Brute, Lady Brute, Granada Gazelle and others.

Hollywood Edition Art's Birthday. February 2, 1974. A newsprint tabloid, produced on the occasion of the Deccadance event. Excerpts:

ELK'S BUILDING, LOS ANGELES, FEB. 2

The Decca Dancers, with approval in principal from Robert Filliou and the *Eternal Network*, celebrated the one million and eleventh Anniversary of the birth of art. There was no worldwide school vacation or paid holiday for all the workers of the world, but for the eight-hundred people who attended there was an evening of all-round festivities and spontaneous funmaking as the Canadian dancers saluted the network and opened the doors of a *New Era* with the presentation of the *Sphinx D'Or Awards.*

SPHINX D'OR AWARDS

BEST ANIMAL IMPERSONATION—Irene Dogmatic for *Mildred Doggerel* Oakland.

ART'S DEAD BUT GOSSIP'S STILL ALIVE—Noah Dakota Toronto.

BEST CONTRIBUTION IN A RAPID OFFSET ZINE—John Dowd N.Y. and Bum Bank Vancouver for *Fanzine Fanzani.*

BEST GLOSSY ZINE—*Ifel* Toronto and *Fanzini Goes To The Movies* Vancouver.

ROOKIE OF THE YEAR—David Young, Toronto.

BEST ALIAS—Willoughby Sharp, N.Y. for *Mighty Mogul* and Lowell Darling Hollywood for *Dudley Finds.*

BEST NEW TALENT—Gilbert and George, England.

BEST MAJOR WORK—Flakey Rose Hip for *Great Wall of 1984* Vancouver.

MS. CONGENIALITY—Anna Banana, San Francisco.

I NEVER PROMISED YOU A RROSE GARDEN MOSTLY FLOWERS AWARD—the judges were unable to reach a decision so there was no winner.

TOM OF FINLAND BULDGE EVENT FOR BUDDHA UNIVERSITY—Pablo Picasso posthumously.

BEST CONTRIBUTION TO ART DECO IN 1984—Ms. Rhonda, Vancouver.

BEST ZEROX ART—Les Petites Bonbons Los Angeles for *Meet Andy and David.*

BEST CAMOUFLAGE—Dr. Brute, Vancouver for *Spots in Front of Your Eyes.*

BEST BUSINESS WOMAN—Sandy Stagg, Toronto for *Amelia Earhart Originals.*

THE SPHINX D'OR AWARD—Count Fanzini, Vancouver for *Bum Bank.*

Minton, James. "Decca Dancing in the City of Angeles," *Artweek*, v.5: part 1, February 23, 1974, p.7; part 2, March 2, 1974, p.6; part 3, March 9, 1974, p.2. An extensive three part article on the international Deccadance event, to celebrate Art's one million and eleventh birthday, held at the Elks Hotel, Hollywood, California.

..

Intermedia, Los Angeles, no.1, v.1, 1974. Editor, Harley W. Lond; Publisher, Century City Educational Arts Project. Quarterly publication covering the arts, communications, resources.

Journal of the Los Angeles Institute of Contemporary Art, Los Angeles, no.1, 1974. First issue. Hereafter referred to as LAICA *Journal*.

Lippard, Lucy R. "More Alternate Spaces: The L.A. Woman's Building," *Art in America*, v.62, May 1974, pp.85-86. Article describing the L.A. Woman's Building, the organizations affiliated with the feminist center and projects involving the different groups.

Der Lowe, Bern, Switzerland, Nr.1,31, May 1974. "Aktionismus" issue (in German) devoted to Actions and Performance art. A large part of the issue, pp.22-52, covers California artists: Chris Burden, Paul Cotton, Terry Fox, Howard Fried, Ken Friedman, Allan Kaprow, Stephen Laub, Tom Marioni, Anthony Ramos, Barbara Smith.

Plagens, Peter. *Sunshine Muse: Contemporary Art on the West Coast*. New York: Praeger, 1974.

Vile, San Francisco, no.1, 1974. Editors, Anna Banana and Bill Gaglione; Publishers, Banana Productions.

Ant Farm at the Opening of the Cadillac Ranch, Amarillo, Texas, 1974. Left to right: Hudson Marquez, Roger Danton, Stanley Marsh III, Doug Michels, Chip Lord.

ARTISTS / ART SPACES

ANT FARM

Ant Farm. *The Cadillac Ranch Show*. 1974. Videotape, 30 mins., color.

"Cadillac Ranch: Home Home on the Range," *San Francisco Magazine*, August 1974.

ELEANOR ANTIN

Antin, Eleanor. "Autobiography of the Artist as an Autobiographer," *LAICA Journal*, October 1974.

Antin, Eleanor. *The Ballerina and the Bum*. 1974. Videotape, 54 mins., b/w. The artist's Ballerina Self, here represented as a "would-be ballerina from the sticks," plans to walk across the United States to "make it in the Big City." She meets a bum in a freight train and together they dream of success.

Antin, Eleanor. *Black Is Beautiful*. 1974. Videotape, 10 mins., b/w.

Antin, Eleanor. "Dialogue with a Medium," *Art-Rite*, no.7, Autumn 1974, pp.23-24. Video issue. Excerpt:
 As an artist attracted to working with my own skin, I also needed a mythological machine; but one capable of calling up and defining *my* self. I finally settled upon a quadripolar system, sort of a magnetic field of 4 polar charged images—the Ballerina, the King, the Black Movie Star and the Nurse. The psychoanalytic method of mythological exploration is a conversational one, a dialogue in which 2 people over a period of time share a history which they can hold each other responsible for. A certain narrative constancy lies out there in the world between them into which they can place new material and to which they can always refer. Since my dialogue is with myself, my method is to use video, still photography, painting, drawings, writing, performing as mediums between me and myself so we can talk to each other. It is a shamanist theatre which remains out there as proof of itself after the seance is over.

Antin, Eleanor. "On Self Transformation," *Flash Art*, March/April 1974.

Kessler, Charles. "Los Angeles: Eleanor Antin at Womanspace," *Art in America*, v.62, July 1974, pp.95-96. Review of Antin's performance entitled, *Eleanor 1954*, presented at Womanspace gallery, Los Angeles.

ANNA BANANA

Banana, Anna. "Manifesto," *Intermedia*, no.1, v.1, 1974, pp.6-7. Excerpt:
 DADA CONSCIOUSNESS is a state of mind that enables a person to withdraw from his immediate, personal involvement in the world around us.
. . . to suspend his belief in the currently touted "system of values"—to

Chris Burden. *Trans-fixed*. Venice, Ca., April 23, 1974. "Inside a small garage on Speedway Avenue, I stood on the rear bumper of a Volkswagen. I lay on my back over the rear section of the car, stretching my arms onto the roof. Nails were driven through my palms onto the roof of the car. The garage door was opened and the car was pushed half way out into the speedway. Screaming for me the engine was run at full speed for two minutes. After two minutes, the engine was turned off and the car pushed back into the garage. The door was closed."

observe how very ridiculous and futile most of those values and those activities so generated, really are.

CHRIS BURDEN

Bear, Liza. "Chris Burden . . . Back to You," *Avalanche Newspaper*, May/June 1974. An interview on Burden's first New York performance; at 112 Greene St., *Video Performance* events. Excerpt:

Liza Bear: On the video monitors during the performance it looked as though Larry Bell had stuck several pushpins into your stomach. But after the show I heard a rumor that the tips were broken off and covered with gum.

CB: Well, that's a good one! They were standard pushpins, folks that I bought down on Canal Street, 5/8" tips! But I did sterilize them in alcohol. And you could smell that in the elevator . . . I didn't even know it was Larry because his face was upside down. I thought he was in New Mexico. Then he said—"Where do you want me to stick these?" and I recognized his voice.

LB: That wasn't audible to the audience on the monitors.

CB: I know. I didn't say anything, so he tried to poke one into my arm and his hand was shaking so bad that the pin rolled right off. Then he started sticking them into my stomach, but my head was back so I couldn't see what was happening and I thought they were going all the way in. And I thought, "Gee, that's great, they don't even hurt."

LB: They seemed to stay in for a while. They didn't fall out.

CB: No, no. He stuck them in all right but he didn't push them in to the hilt.

LB: Had you expected him to do that?

CB: Yeah, it never occurred to me that a person would do it half-way. Either you don't put them in or you do put them in.

Burden, Chris. *Chris Burden 71-73*. Los Angeles: Self-published, 1974. A catalogue documenting Burden's performance work from 1971 through 1973; photographs and text.

(PHOTO RIGHT)

Chris Burden. *Sculpture in Three Parts*. Hansen Fuller Gallery, San Francisco, Ca., September 10-21, 1974. "I sat on a small metal stool placed on a sculpture stand directly in front of the gallery entrance, an elevator door. A sign on the stand read: 'Sculpture in Three Parts. I will sit on this chair from 10:30 am 9/10/74 until I fall off.' About 10 feet away, a camera was constantly attended by changing photographers waiting to take a photograph as I fell. I sat on the chair for 43 hours. When I fell, a chalk outline was drawn on the floor around my body. I wrote 'Forever' inside the outline. I placed another sign on the stand which read: 'I sat on this chair from 10:30 am 9/10/74 until I fell off at 5:25 am 9/12/74.' The chair, stand, and outline remained on exhibit until September 21."

102

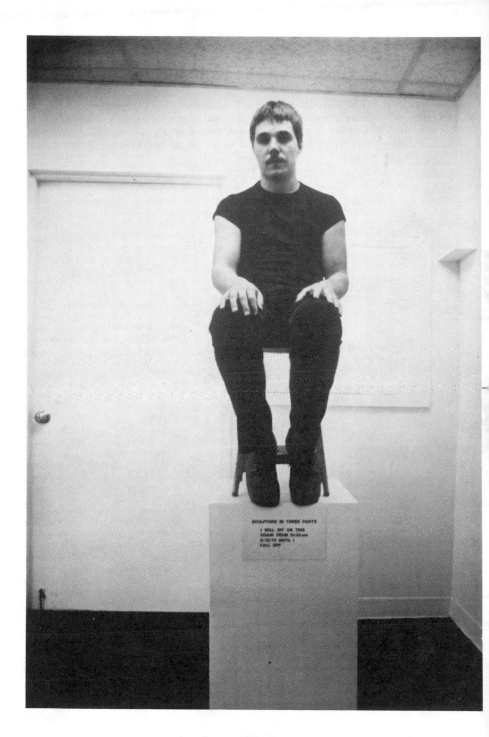

103

Radice, Barbara. "Chris Burden," DATA, v.4, no.12, Summer 1974, pp.106-109. In "Practice and Theory of Art" issue. Article on Burden with text (in Italian) and photo documentation of several performance works (photo captions in Italian and English).

Sowers, M.L. "Chris Burden Performs," *Artweek*, v.5, October 5, 1974, p.3. Review of Burden's duration piece at the Hansen-Fuller Gallery, San Francisco. Burden sat on a chair that was raised on a stand and situated in front of the gallery's elevator doors until he fell off, 43 hours later.

Guy de Cointet. *The Paintings of Sophie Rummel.* Cirrus Gallery Los Angeles, Ca., 1974. Performed by Viva.

GUY DE COINTET

Ballatore, Sandy. "Paintings, Puzzles and Performance," *Artweek*, v.5, April 27, 1974, p.7. Review of de Cointet's show/performance with Viva at Cirrus Editions, Los Angeles.

de Cointet, Guy [Dr. Hun]. TSNZ CZYV A7ME. Venice, Ca.:Sure, Co., 1974. Artist book; a play in a pseudo language.

TERRY FOX

Fox, Terry. *Children's Tapes*. San Francisco, 1974. Videotape series, b/w.

Fox, Terry. "Children's Tapes," *Arts Magazine*, v.49, December 1974, pp.54-57. Text and photo documentation of Fox's series of videotapes entitled, *Children's Tapes*. Excerpt:

Each silent tape involves the same elements (spoon, fork, bowl, cloth, candle, fire, and water) in new situations of accord with each other as well as in transformed physical states. The tapes were made on a table using a single light source and I both operated the equipment and performed the actions. . . .

[Scenario for one of the tapes]: Pressure on the skin, combustion, silver rests on the skin, soft radius, forked, the skin pulsates, the spoon is warmed, hot wax falls on the skin, fire tunnels to the fork, solid to liquid to solid to form the bridge, the spoon falls and the skin rises, wall of water rises around the spoon, skin mirror reflects the falling flame, skin surrounds the fallen wax. (11 minutes).

Sharp, Willoughby and Bear, Liza. "Terry Fox: Children's Videotapes," *Avalanche Newspaper*, December 1974, pp.32-33. Terry Fox interview, conducted after his *Children's Tapes* were shown for the first time, May 25-June 25, 1974, at the Everson Museum, Syracuse, New York. Excerpts:

WS: Why did you choose those objects?

TF: Because they're objects I'm familiar with. I really get off on certain situations and objects that have their own substance and reality. But it's not so much an interest in those particular objects that the tapes convey, it's more an attitude. . . .

LB: I like watching what was happening, though.

TF: Well, amazing things are happening. That's why I shot them really close up, to focus in on all the minute events. But besides that, there's a kind of attitude that's communicated by the tapes.

LB: What attitude?

TF: An attitude of contemplation . . . of wonderment, of relating to something real . . . without having to take sides. . . .

WS: So the tapes are demonstrations of phenomena.

TF: Phenomena and their worlds. Like all the different shapes the candle can assume, all the kinds of things you can do to it, things that happen to it. Like with the flame, you can skin the flame, take away all its color and make it invisible with a fork. There were constant variations on those objects together—the fork and the candle, or the candle and the water, or the water and the bowl. . . .

HOWARD FRIED

Minton, James. "Kos and Fried," *Artweek*, v.5, April 20, 1974, p.4. Review of an exhibition featuring Howard Fried and Paul Kos, at the University Art Gallery, San Jose State University.

KEN FRIEDMAN

Friedman, Ken (ed.). *Source, Music of the Avant-Garde*, no.2, 1974. A participation issue guest edited by Ken Friedman with "intermedia" orientation. Some California participants included in issue: Tom Marioni, Allan Kaprow, Jock Reynolds, and Ken Friedman.

Friedman, Ken.*Source, Music of the Avant-Garde*, reviewed by Judith Hoffberg, *Artweek*, v.9, September 7, 1974, p.15. Review of the second issue of *Source*, guest edited by Ken Friedman.

McCann, Cecile. "Ken Friedman's Subtle Art," *Artweek*, v.5, September 21, 1974, p.4. Review of Friedman's exhibition at the Phoenix Gallery, San Francisco. "His work often takes the form of actions, performances or events, as well as communicative objects that can more easily be presented in a gallery situation."

Thomas, Radford. *Ken Friedman: Sightings*. Cheney, Wa.: Eastern Washington State College, 1974. Description of a project by Ken Friedman.

NEWTON HARRISON

Harrison, Newton. "Sea Grant Second Narrative and Two Precedent Works by Newton Harrison," *Studio International*, v.187, May 1974, pp.234-37. An article about Harrison's works, *Lagoon* and *Portable Fish Farm*, includes photographs and photocopies of drawings.

LYNN HERSHMAN

Hershman, Lynn. *Forming a Sculptured/Drama in Manhattan*. Self-published, 1974. Documentary artist book; text and photo documentation of *Chelsea Hotel* piece, New York, October 21-December 15, 1974. Excerpt:
TENTATIVE PROPOSAL FOR PROJECT IN CONJUNCTION WITH STEFANOTTY GALLERY
DATES: NOVEMBER 23, 1974 TILL JANUARY 5, 1975 24 hours a day
PROPOSED PLAN: A rented bus will depart from the gallery at various intervals during the day, transporting viewers to the installations. At this point, rooms or walk in tableaux will be incorporated within the structures of the St. Regis Hotel, The Central Y.W.C.A., the Chelsea Hotel and Roosevelt Hospital.
Individual Curators for each room will be hired through N.Y.U. and Cooper Union. These individuals will let viewers into the rooms and care for the installation.
The catalogue/brochure will be a fold out postcard with photographs and a map of each site. This will be made available and distributed by the Gallery, as well as be on the bus and at each location.
It is hoped that the installations will take into account the potential and

actual energies of each building and render an awareness of the social ecology, balanced by each individual's experiences.

Gallery's responsibilities: To act as an interpreter for the project and in my absence discuss and explain the project to various media.

Each room will incorporate sound, light, wax sculpture, and a fixed tableaux made of materials found inside each building. The dates were selected in order to take advantage of the nostalgia of the Thanksgiving and Christmas season.

Hershman, Lynn. *Plaza Hotel/November 2-3, 1974.* Self-published, 1974. A documentary artist book on a work that took place at the Plaza Hotel, New York. Includes one-page text with nine pages of photos.

Hershman, Lynn and d'Agostino, Peter. *Dante Hotel Documentary*, San Francisco, 1974. Videotape.

Selz, Peter. "San Francisco; Lynn Hershman at the Dante Hotel," *Art in America*, v.62, March/April 1974, p.119.

DOUGLAS HUEBLER

"Heubl, Heubler, Heublest," *Art-Rite*, no.5, Spring 1974, pp.4-6.

ALLAN KAPROW

Kaprow, Allan. "The Education of the Un-Artist, Part III," *Art in America*, v.62, January/February 1974.

Kaprow, Allan. "Hello: Plan and Execution," *Art-Rite*, no.7, Autumn 1974, pp.17-18. Excerpt:

A global network of simultaneously transmitting and receiving "TV Arcades." Open to the public twenty-four hours a day, like any washerette. An arcade in every big city of the world. Each equipped with a hundred or more monitors of different sizes from a few inches to wall-scale, in planar and irregular surfaces. A dozen automatically moving cameras (like those secreted in banks and airports, but now prominently displayed) will pan and fix anyone or anything that happens to come along or be in view. Including cameras and monitors if no one is present. A person will be free to do whatever he wants, and will see himself on the monitors in different ways. A crowd of people may multiply their images into a throng.

But the cameras will send the same images to all *other* arcades, at the same time or after a programmed delay. Thus what happens in one arcade may be happening in a thousand, generated a thousand times. But the built-in program for distributing the signals, visible and audible, random and fixed, could also be manually altered at any arcade. A woman might want to make electronic love to a particular man she saw on a monitor. Controls would permit her to localize (freeze) the communication within a few TV tubes. Other visitors to the same arcade may feel free to enjoy and even enhance the mad and surprising scramble by turning their dials accordingly. The world could make up its own social relations as it went along! Everybody in and out of touch all at once!

Kaprow, Allan. *Routine*. Portland, Ore: Portland Center for the Visual Arts, 1974. 16 mm film with sound, approx. 20 mins., b/w.

Kaprow, Allan. *2nd Routine*. New York: Stefanotty Gallery, 1974. Artist book.

Kaprow, Allan. *The 2nd Routine*. New York: Stefanotty Gallery, 1974. Videotape, 15 mins., b/w.

Kaprow, Allan. *Then*. Firenze, Italy: Art/Tapes, 1974. Videotape, 30 mins., b/w.

PAUL KOS

Kent, Tom. "Paul Kos—Videotapes and Sculptural Residue," *Artweek*, v.5,

Paul Kos. *Pilot Light, Pilot Butte*. Videotape, 1974. Kos shaping ice to make a lens in order to build a fire at Pilot Butte.

November 2, 1974, p.5. Review of Kos' exhibition at the DeYoung Museum, San Francisco, featuring his Pilot Butte, Wyoming piece; includes videotape of performance and documentation/objects related to the work. Excerpt:
"It seemed Pilot Butte needed a pilot light to extend its visibility," says Paul Kos, "So I lit a fire on top using a block of ice after first fashioning a magnifying lens out of it." The laying of the fire, the making of the lens, the ignition, burning and eventual extinguishing of the fire by the melting ice comprise a spare, ironic ritual performed by Kos in August of this year, recorded by his wife Marlene on a videotape . . .

Minton, James. "Kos and Fried," *Artweek*, v.5, April 20, 1974, p.4. Review of an exhibition featuring Paul Kos and Howard Fried at the University Art Gallery, San Jose State University.

SUZANNE LACY

Lacy, Suzanne. *Three Works from the Teeth Series*. 1974. Videotape with sound, 7 mins., b/w.

STEPHEN LAUB

Sharp, Willoughby. "Stephen Laub's Projections," *Avalanche Newspaper*, December 1974, pp.24-25. An interview. Excerpts:
WS: What actually takes place during one of your projection pieces?

SL: First of all I project the image on the screen, as close to my actual size as possible. I wear white pants, shoes and shirt. I stand in front of the projection and look into a mirror changing my expression and position so that it resembles the image as closely as possible.

WS: What are the images that you project?

SL: Originally the images were old photographs of my family. My parents are from Central and Eastern Europe and I went through my mom's and dad's old photo albums and recopied a lot of the pictures—of my mom as a kid, of her old boyfriends, her parents and grandparents. I've also taken photos from my baby picture book, pictures of strangers, money, the constellations . . .

WS: And you try to assume as exactly as possible the whole posture of the body and the facial expression.

SL: Yeah, if they're smiling then I try to smile. It starts out as me trying to assume their position but then I find I don't have to try—I know how my dad smiles, or I know what a lot of my mom's expressions are like. It's more like falling into it than trying to get into it. And because I want to do it as perfectly as I can, while I'm looking at my image or the image in the mirror, I think, "Oh wait, that nose isn't right!" And then I move, but it's not my nose, it's the image's nose.

WS: So you really become this other person you're trying to become.

SL: Oh yeah. I get lost. . . .

LOS ANGELES INSTITUTE OF CONTEMPORARY ART

Ballatore, Sandy. "L.A.I.C.A.—a Promising Alternative," *Artweek*, v.5, August 24, 1974, pp.1,16. Article on the Los Angeles Institute of Contemporary Art, preceding its opening, Fall 1974. Among the first alternative spaces in Southern California. LAICA Director, Bob Smith.

(cont'd, p.111)

Stephen Laub. *Relations.* 1972-73. Detail of "My father and a friend from school."

Excerpt:
L.A.I.C.A. will function as an institute composed of three parts: 1. exhibition space at 2020 Avenue of the Stars, Los Angeles; 2. a bi-monthly journal which is not meant to be a mouthpiece for the institute, but a publication reflecting Southern California's art activities, voices, etc.; 3. a slide registry open to all artists and acting as an information center for Southern California art.

TOM MARIONI

Moore, A. "Tom Marioni; Everson Museum of Art, Syracuse, N.Y.," *Artforum*, v.12, June 1974, pp.77-78. Review of a conference, "Video and the Art Museum," and video installations mounted in conjunction with the conference by Peter Campus, Andy Mann, Ira Schneider and Tom Marioni. Excerpt on Marioni:

Tom Marioni's tape—a tour of the Museum of Conceptual Art in San Francisco shortly after the 1973 "All Night Sculpture Show" there—partakes of the form, but it is not a simple sampling of work, rather it is subsumed within a narrative context as history.

A handheld camera records a walk down a street and up a flight of stairs to the deserted MOCA premises. Museum director Marioni narrates and directs the camera ("Get a shot of the refrigerator"). Voice and camera together

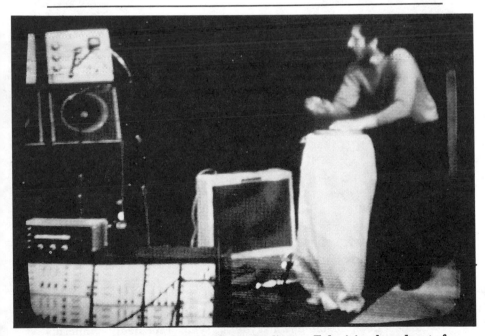

Actions by Sculptors for the Home Audience. **Television broadcast of actions by sculptors, organized by Tom Marioni, Director of the Museum of Conceptual Art, San Francisco, 1974.**

explore the many rooms—floors, walls, and fixtures—of MOCA, which Marioni explains in terms of the former use of the space as a printing shop.

PAUL MCCARTHY

McCarthy, Paul. *Heinz Ketchup*. 1974. Videotape, 30 mins., color.

SUSAN MOGUL

Mogul, Susan. *Take Off*. 1974. Videotape.

MUSEUM OF CONCEPTUAL ART

Actions by Sculptors for the Home Audience. San Francisco, 1974. Videotape. Television broadcast of actions by sculptors, organized by the Museum of Conceptual Art.

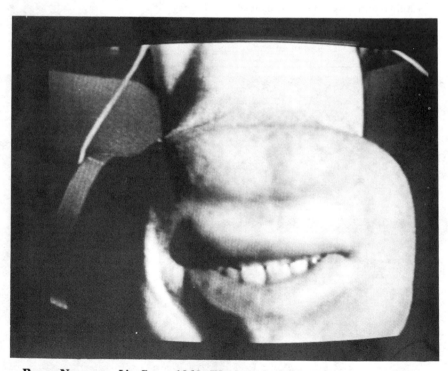

Bruce Nauman. *Lip Sync*. 1969. Black and white with sound, 55 min. Nauman framed upside down says "lip sync" repeatedly, while his lip movements move in and out of synchronization with the sound of the spoken word.

Susan Mogul. "News from Home" from *Take Off*. Videotape, 1974.

BRUCE NAUMAN

Freed, Hermine. "Video and Abstract Expressionism," *Arts Magazine,* v.49, December 1974, pp.67-68. Excerpt on Bruce Nauman:

Nauman's *Pacing Upside Down* seems, in this frame of mind, to be a performance metaphor for Pollock's painting. In this work, Nauman paces in an undefined space, with his hands touching straight over his head, for 55 minutes. The camera is upside down, and a small slice of the wall, slightly askew, is visible at the bottom of the frame. In contrast, a small rectangle is drawn on the floor with its sides paralleling the edges of the monitor. The fact that the real space is askew and the depicted shape is straight functions to dislocate the space, especially as Nauman walks toward the wall. Nauman walks in and out of the frame, although his presence is always felt by the sound of his footsteps. Extensions beyond the edge and the fact that the work has no particular beginning or end, just a constant rhythm, parallel the all over quality of Pollock's paintings with their disavowal of central focus.

Perhaps one of the closest links between video and abstract expressionism is their mutual involvement with process. Rarely is a videotape totally scripted and rehearsed before it is taped. One quality of the medium which differentiates it from film is the greater possibility of spontaneity. Often in the process of recording a videotape, ideas suggest themselves which had not been a part of the original plan. Video is organic; it can be replayed immediately and reworked. It is possible to erase or tape over unwanted segments and to redo edits until they work. In this sense, it is closer to the process of painting an abstract expressionist work.

Minton, James. "Bruce Nauman—Gunslinger," *Artweek,* v.5, June 29, 1974, p.1,16. Lengthy article on Nauman, includes a review of Nauman's retrospective, 1965-1972, at the San Francisco Museum of Art.

Nauman, Bruce. *Flayed Earth/Flayed Self (Skin/Sink).* Los Angeles: Nicholas Wilder Gallery, 1974. Written work by Nauman in conjunction with an exhibition, December 17-January 11.

Wortz, Melinda T. "Collector's Video," *Artweek,* v.5, June 15, 1974, p.1. Review of the exhibition, *Collector's Video,* at the Los Angeles County Museum of Art, consisting of tapes by more than twenty New York and California artists. Includes discussion of Nauman's contributions, *Flesh to Black to White to Flesh*(1968), and *Lip Sync*(1979). Excerpt:

Flesh to Black to White to Flesh, 1968, records the artist covering his body with cold cream and black make up and subsequently removing both layers. In *Lip Sync,* 1969, the neck and chin of the artist are shown upside down pronouncing the words "lip sync" sometimes in and sometimes out of synchronization. . . .

The sense of boredom, irritation and the frustration which result from watching a simple action, such as the movements of Nauman's lips, over an extended period of time are characteristic of Nauman's work in various media. By setting up a frustrating situation he forces the viewer back upon his own resources.

Martha Rosler. *Budding Gourmet: Semiotics of the Kitchen.* Videotape, 1974-75.

MARTHA ROSLER

Rosler, Martha. *Semiotics of the Kitchen.* 1974-75. Videotape, b/w. This and *A Budding Gourmet* are part of an ongoing body of work about consuming habits that includes not only videotapes but also performance works, dialogues and serial postcard novels. Food is treated as a necessity reinvented as commodity, and cooking is presented in its personal and political aspects as itself and as a metaphor, as an internalized value and as a colonizing strategy.

DARRYL SAPIEN

McDonald, Robert. "Split-Man Bisects the Pacific," *Artweek,* v.5, October 19, 1974, pp.13-14. Review of a performance by Darryl Sapien with Michael Hinton that took place September 24, 1974 near the Sutro Baths ruins at the ocean, San Francisco. The ritualistic event began at 8:45 p.m. when Sapien and Hinton, on either side of a giant wheel/spool placed on top of a rough 150 ft. long concrete wall, rolled the wheel out to a small island and back to shore. Excerpt:
 What was the meaning, if any, of the event? It had the appearance of ritual

Darryl Sapien. *Split Man Bisects the Pacific.* **San Francisco, Ca., 1974. Performed with Michael Hinton.**

so ancient that both participants and audience no longer remembered its significance; they simply knew that it had to be done. Perhaps it served to remind us of our origin in the sea and of our role as mediators between earth and sea. It carried the sense of a religious act to propitiate the sea and its creatures. The ritualistic aspect of the piece as enhanced by the special garb, the painted faces, the general incongruity of the situation and the vocabulary of called signals which, although banal, were transcended by the event so that they acquired a poetic, magical, incantory character. Whatever meaning the performance had had to be read into it by each spectator. This was the intent of Sapien, who subscribes to Duchamp's dictum that viewers themselves complete works of art.

McDonald, Robert. "Split-Man Reassembled," *Artweek,* v.5, November 9, 1974, p.6. Review of exhibition at the Hansen-Fuller Gallery consisting of video, photo, slide, and poster documentation of the performance event, *Split-Man Bisects the Pacific.*

Sapien, Darryl with Michael Hinton. *Split-Man Bisects the Pacific.* 1974. Videotape, 22½ mins., b/w.

VAN SCHLEY

"Van Schley," *Flash Art*, nos.48-49, October/November 1974, pp.48-49. A description with photos and captions of a work by Van Schley and Billy Adler entitled, *World Run: A Globular Piece.* "In a two month period spanning 14,000 miles, Schley ran the Olympic distance of 1500 meters in various locations in eleven world cities."

ALLEN SEKULA

Sekula, Allen. *Talk Given by Mr. Fred Lux at the Lux Clock Manufacturing Company Plant in Lebanon, Tennessee, on Wednesday, September 15, 1954.* San Diego, 1974. Videotape, b/w. *Lux.* . . . is part of a larger work, or series of works, dealing with the manner in which Americans articulate their economic lives and the manner in which these representations collide with each other. The work occupies a terrain between 'documentary' and 'fiction,' shifting self-consciously between the artifice of one modality and the artifice of the other."—from The Kitchen Catalogue, 1974-75.

Allan Sekula. *Talk Given by Mr. Fred Lux.* Videotape, 1974.

BARBARA SMITH

Barbara Smith. **La Jolla: San Diego Art Gallery, University of California, [1974]. Catalogue for an exhibition, November 7-December 4, 1974. Excerpt from "Interview with Barbara Smith by Moira Roth:"**

R: Can we begin by talking about the *Feed Me* piece which you did earlier this year for the San Francisco Museum of Conceptual Art? How was it set up? It lasted all night until dawn and you spend the time sitting nude in a room?

S: Yes. There was a mattress and a rug and pillows and many things around me, and incense was burning, and it was warm. There was a heater.

R: As the piece was called *Feed Me,* what sort of feeding did you get out of it?

S: On a lot of levels. There were body oils and perfume in the room so that one person gave me a back rub. There was food and wine they could give me. There was music, flowers, shawls and beads and things like that. There was tea, books and grass. That is about all. And so as a person came into the room, he could choose anything he wanted to use as a medium of interaction, and it was all a source of food—food meaning sustenance. This could include conversation and affection.

R: Did you have any limits on what you would allow to happen?

S: I didn't want anyone who wasn't positive, whose emotions weren't positive towards me. I would have felt very defensive about that, and I would prevent any action which I did not consider food.

R: Did you check with people afterwards about how they felt?

S: A few. But since it lasted all night, virtually everybody but the other artists were gone in the morning. The other artists were very supportive of my piece. I heard afterwards about at least one or two people who didn't like it. They were women and they didn't like it because they felt it was compromising to women's lib.

R: How do you feel about the piece in terms of images of women? The courtesan and odalisque are obvious images that come to mind.

S: Well, for one thing that's an image that either has been real to some people, or in one way or the other has been part of their fantasy life. And then there are so many levels of real life that border on that kind of activity. So the question is, not only if it exists in anybody's mind, but the fact that it exists on so many levels. So that's how I feel about it in terms of women's lib. It's a reality which one must confront. For me my art accomplishes my own liberation. It makes me stronger. For others it acts as any art does, a confrontation that they must face on their own terms. I am pointing to things that are real, which people may or may not like to face. . . .

(cont'd, p.120)

(PHOTO RIGHT)

Barbara Smith. *Feed Me.* **Museum of Conceptual Art, San Francisco, Ca., 1973. Performed in the MOCA series,** *All Night Sculptures.* **Smith created a boudoir environment and invited individuals one at a time to enter and interact with the artist. This could include conversation and affection.**

118

R: Shortly after the MOCA piece, you did a very different type of piece—
Pure Food.

S: Yes. Out in a vacant lot in Costa Mesa—a large field really. I sat in one spot. I just sat there for eight hours. For as long as I was able to, I meditated, which turned out to be maybe two, two and a half hours. And from then on it was a matter of passing the time and noticing the different directions my attention would take. One span of time, I slept.

Smith, Barbara. *Moving Monument* (excerpt from Heizenburg's Uncertainty Principles). 1974. Videotape with sound, 30 mins., color and b/w.

Wortz, Melinda T. "Barbara Smith's Dimensions," *Artweek*, v.5, September 14, 1974, p.3. Lengthy review of Smith's performance/happening, *Dimensions*, at the John Gerard Hayes Gallery, Los Angeles.

NINA SOBEL

Sobel, Nina. *Breakdowns*. 1974. Videotape, 23½ mins., b/w.

TRANS-PARENT TEACHER'S INK. PAUL COTTON. MEDIUM

Transparent Teachers Ink., Paul Cotton, Medium. *33 Footnotes by Osmosis.* 1974. Paul Cotton substantiating the self-reflexive form as a book.

JOHN WHITE

Plagens, Peter. "John White," *Artforum*, v.12, March 1974, pp.65-66. An interview. Excerpt:

[White]: I like to reveal the whole insane background that brought you to the work, what's behind the piece that gave you that idea, etc. I get weird ideas from strange little things, like hearing somebody tinkling in the toilet, and I go around thinking about that for a while. In a performance, there'll be something folksy, then something serious, something about the artist, then something about the audience, etc. Working in the hospital has given me most of my material lately, humor as well as the serious stuff. Some of the idiosyncratic things people will do to hide their feelings in a group, which are dead serious in therapy, become quite funny when removed from the context. . . .

(cont'd, p.122)

(PHOTO RIGHT)

Trans-Parent Teacher's Ink., Paul Cotton, Medium. *33 Foot-Notes, By Oz Moses.* University Art Museum, Berkeley, 1974. "In a Spatial Projection at the *Books by Artists* exhibition The Astral-Naught Rabb-Eye purrformed. A tape of 33 footnotes wispered from Zippily Boo-Duh's Tale substantiating the self-reflexive form of the Astral-Naught Rabb-Eye as a book in itself. With each footnote the blindfolded medium (Love is Blind), Paul Cotton, re-shaped Hymn-Self in one of 33 stations of the Cross(roads)."

I'm very interested in bringing my experiences at the hospital and my art situation very close, very tight. I feel like I integrate the golf part of it, too. I use an 8mm film of me playing golf in some of the performances, as if to say, "O.K., this is an important part of my lifestyle, too."

Simon, Leonard. "John White Performance II," *Artweek*, v.5, January 12, 1974, p.3. Review of the second performance by White at Westminster Neighborhood Association, in relation to the Watts Community Housing Corporation.

Simon, Leonard. "John White's Third Watts Performance," *Artweek*, v.5, December 7, 1974, p.4. Review of the third performance for the Watts Community Housing Corporation which took place at the Ruth Schaffner Gallery, Los Angeles. White's work included a film and drawing, with narrative by White about his involvement with the Watts project.

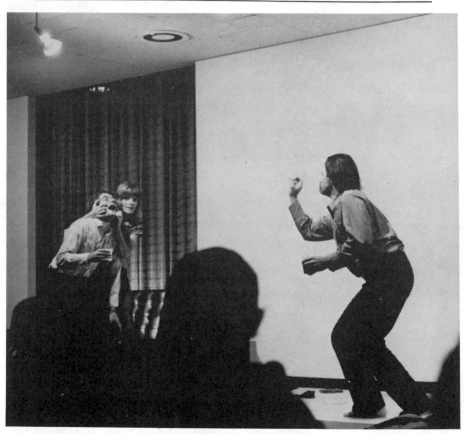

John White. *Bomb Those Dirty Japs.* 1972.

1975

GENERAL LITERATURE

Antin, David. "Television: Video's Frightful Parent—Part I," *Artforum*, v.14, December 1975, pp.36-45.

Art-Rite, no.10, Fall 1975. Guest Editor: John Howell. Performance issue.

Bodyworks. Chicago: Museum of Contemporary Art, 1975. Catalogue for the exhibition, *Bodyworks*, at the Museum of Contemporary Art. Excerpt from the catalogue essay by Ira Licht:
Distinct from the theatricality of Happenings and the formality of contemporary dance, by both of which it has been influenced, and unlike performance art, with which it has certain similarities, Bodyworks is primarily personal and private. Its content is autobiographical and the body is used as the very body of a particular person rather than as an abstract entity or in a role. Action oriented artists such as Acconci, Beuys, Burden, and Schwarzkogler, whose attitudes are extrapolations from the physical activity of art-making into performance situations, may admit audiences; nevertheless the content of the "performance" is intimately involved with the artist's psychological condition and personal concerns. Those artists—Luthi, Nauman and Samaras, for example—who are in the tradition of the cult of the self, pose privately just for the photographic record. In either case it is the artist's physical being which bears the content and is both subject and means of aesthetic expression.

Dadazine, San Francisco, no.1, 1975. Editor and Publisher, Bill Gaglione.

Floating Seminar #1 / "Art as Theory as Art". **San Francisco: Paul Kagawa, 1975. "The complete, unedited transcription of the meeting held on May 5, 1975, at Malvina's Coffeehouse, San Francisco, with additional comments by the organizer [Paul Kagawa]." Excerpt:**

PROPOSAL FOR "FLOATING SEMINAR"

In order to promote communication in the Bay Area art community and to provide an informal public situation for airing opinions about various issues, I propose to organize a "Floating Seminar" series. The program is designed to supplement the vast amount of visual and conceptual art being produced and shown in the area, and to promote personal confrontation and dialog between artists and interested individuals in a non-institutional setting.

The seminars will take place on the first Monday of each month at a specified location. (Since most galleries and museums are closed on Mondays, this would seem to be a good time to talk about art rather than look at it.) Seminar #1 is scheduled for Monday, May 5, 1975 at Malvina's Coffeehouse, 512 Union St., (near Grant) San Francisco, from noon to 3pm. Suggestions for the locations of future seminars as well as topics for future discussion will be appreciated. The topics should be loosely descriptive yet specific enough to provide a basis for dialog. The topic for Seminar #1 is tentatively scheduled to be "Art as theory as Art."

Floating Seminar #2 / A survey of Alternative Art Spaces in San Francisco. **San Francisco: Floating Seminar, 1975. "A revised transcription of the meeting held October 2, 1975 at The Farm, San Francisco," edited by Paul Kagawa. Excerpt:**

PAUL KAGAWA: This is Floating Seminar #2, "A Survey of Alternative Art Spaces." First of all I think I'd better define what we mean by "alternative art space," because we don't want any confusion (about that). We had a group discussion about the subject of this before it was proposed, and we decided that the term "alternative art spaces" would include exhibition spaces or publications which were accessible to local artists. The term "alternative," very loosely defined, would be "non-commercial," with varying degrees of institutionalization. They don't necessarily have to be "anti-establishment," although some of them might be.

Freed, Hermine. "In Time, Of Time," *Arts Magazine*, **v.49, June 1975, pp.82-85. Discusses the element of "time" in art, as seen through video, performance, musical works, etc. "The artist necessarily works in and of time—movement in space and time, recollection and advance in memory and history, passage of experience, and time as subject." Excerpt:**

In many cases, performance art arranges a specific time slot for the work so that the viewer puts himself in a theatrical context. So long as a contract is made between the performer and the viewer to spend time, there seems to be no anxiety about it. Performance art in a gallery context is frequently more anxiety-producing on the part of the viewer than the other art forms which demand time, but for other reasons. It is the anxiety of confrontation with the performer, doing his act, whether or not you are prepared for it, the constancy of the performance, apparently whether or not there is an audience.

Front, **San Francisco, no.1, 1975. Editor, Carl E. Loeffler. Tabloid format.**

Goldberg, Roselee. "Space as Praxis," *Studio International,* v.190, September 1975, pp.130-36. Discussion of "production of space" in art, stemming from an exhibition-publication, *A Space: A Thousand Words,* held February 1975 at the Royal College of Art Gallery, London. Goldberg discusses "a new sense of space" described under the following terms: *constructed space* and *powerfields* (Nauman, Acconci), *natural space* (Oppenheim), *body space* (Forti, T. Brown, Rainer), *spectator space* (D. Graham), *public and private space* (Buren, Dimitrijevic). Excerpts:

So while some 'conceptual' artists were refuting the art object, others saw the experience of space and of their body as providing the most immediate and existentially real alternative. Much of conceptual art, when presented as either 'land,' 'body,' or 'performance' art, implied indirectly or directly a particular attitude to an investigation of the experience of space. This experience may seem to have little to do with the intentions or the meaning of a piece, but from the viewer's standpoint the experience of the piece sets up a new set of responses to the perception of space. Whereas earlier representations of space in art have been discussed variously from the simple planes of gothic paintings to the disappearing perspectives of early renaissance and renaissance art, or from the surfaces of cubist painting to the enormous space obstructions of minimal sculpture, much recent art has insisted on the body as a direct measure of space. The relationship between the viewer, the artist and the art work then became an important one, since the viewer would have to put together the indeterminate elements of the space in order to fully perceive the piece.

. . . performance art, now as in the twenties, directly reflects spatial preoccupations in the art world. But unlike the twenties, when the separation between theory and practice (in a dialectical form or not) was absolute, it is difficult to separate where 'conceptual' art ends and performance begins. For conceptual art contains the premise that the idea may or may not be executed. Sometimes it is theoretical or conceptual, sometimes it is material and performed. So to with performance art. It even uses a 'conceptual' language (photograph, diagram, documentation) to communicate ideas. So on the one hand, the language of conceptual art has expanded that of performance art to a point where the medium of communication is very similar. On the other hand, and in reverse, performance has altered the way that conceptual artists were working.

Grobel, Lawrence. "Performance Live: The California Artist as the Medium and the Message," *California Magazine,* November 1975, pp. 62-64. Article on Southern California artists Barbara Smith, Suzanne Lacy, Paul McCarthy, and Chris Burden; includes group photo.

"The Hollywood Deccadance Art's Birthday, February 2, 1974," *Mondo Artie, Episode No.1681/IS.,* no.17, Fall 1975. Special issue of *IS.,* edited by Vic d'Or for The Eternal Network; documents the Deccadance held in Los Angeles, 1974. Excerpt:

[Marcel Idea (Michael Morris)]

Friends, we are from Canadada to celebrate the one million and eleventh anniversary of the birth of art. We plan to have a marvelous time tonight. Don't worry about art, there will be plenty, there will be art coming out of your ears, nose and Private Partz. Art was life and in the next decade we hope it will be the same again.

Kent, Tom. "Second Generation," *Artweek*, v.6, March 29, 1975, p.5. Review of MOCA's fifth anniversary celebration entitled, *MOCA: Second Generation*, which included works by Richard Alpert, Jim Pomeroy, Darryl Sapien, Irv Tepper, and Stefan Weisser. Excerpt:

In a wedge-shaped space with large rectangular grids painted on opposing walls, Sapien and Mike Hinton worked at re-creating a relatively simple drawing by following instructions delivered via headphone from Cyd Gibson. Sapien and Hinton were on MOCA's second floor, Gibson on the third floor. The drawing was presented to Gibson in grid sections on slides projected on the wall in front of her. Television monitors fed by cameras fixed to helmets worn by Sapien and Hinton showed Gibson what was going on downstairs and also provided the only means of seeing available to Sapien and Hinton. Another monitor downstairs showed the audience what Gibson looked like. Off in a dark corner Craig Schiller mixed feeds from all the various cameras and monitors into a dense video sandwich.

Kent, Tom. "Winning Video," *Artweek*, v.6, September 27, 1975, pp.1,16. Article on video works presented as part of the 1975 San Francisco Art Festival. Among participants included in exhibition: Terry Fox (*Children's Tapes*) , Joel Glassman (*Dreams*), Darryl Sapien (*Splitman Bisects the Pacific*), Max Almy and Barbara Hammer (*Superdyke Meets Madame X*).

Kozloff, Max. "Pygmalion Reversed," *Artforum*, v.14, November 1975, pp.30-37. Major article on body art. Excerpt:

An extended literature has grown in support of efforts that include bodyworks. But we only tentatively understand such art, even at this mature stage in its development, because the criteria for separating it from other forms are not clear. An artist may do an ephemeral "piece" for a necessarily small audience, an event often completely dependent on media transmission for broadcast to the art world. Or the artist may conceive a media-form—photos,optionally accompanied by words—as the prime stimulus for the viewer. In one instance, the evidence is fragmentary and, in the other, exclusive and sufficient. This reliance on graphic cum literature permits the enlargement of extremely small-scale incidents, such as Dennis Oppenheim running a sliver through his thumb. Photos sometimes become records of occurrences the artist felt no need to have presented to an initially present audience. And they may even be of situations that never existed, such as William Wegman's and Vicenzo Agnetti's face mutations. So the literature, heavily contributed to by the artists themselves, invariably reverts to a reportorial discourse. Most typically it carries bibliographical entries, compiled data, scenario descriptions; and it comes in the form of interviews, catalogues, and informative materials published by galleries and museums. To leaf through these documents is simultaneously to be impressed by the richness of their ideas and frustrated by their lack of any felt need to evaluate the convergences of such art. Neutral in the extreme, the tone of this literature would appear detached from its object, until we recognize its characteristic cool as a publicity function. Just as the body is artistically dissociated from the person, so critical regard is isolated from warmth, in a reading too close to serve as cultural perspective.

Richard Alpert. *Hand Generated Light.* Museum of Conceptual Art, San Francisco, Ca., 1975; performed in MOCA's *Second Generation* series. "The performance was situated in a room adjacent to the main exhibition space. Attached to the front of the door, the only entrance to the room, was a small light-bulb. For the duration of the three-hour show, I was in the room with the door locked from the inside generating electricity from a hand-crank generator to the lightbulb. The amount of electricity that I could produce varied over the length of the exhibition, causing the light emitted from the bulb to fluctuate, going from intensely bright to barely visible, but never completely going out. Corresponding to the degree of light intensity were the changing rhythms of the generator's mechanical sound and the accompanying vibrations felt in the floor outside the room."

La Mamelle Magazine: Art Contemporary, San Francisco, no.1, Summer
1975. Editor and Publisher, Carl E. Loeffler. Excerpt from the Introduction:
La Mamelle is a space for ART. And is ART, but not as object. It is my
work. I offer its unsolicited use to West Coast artists and those in support of.
No reviews or critical interpretation. It is an artists' medium. A space for
ART: ART.

I further offer *La Mamelle* as a support network. An open channel for the
condition of ART energy and project manifestation; the support of projects
introduced and those previously manifest: ART.

Marioni, Tom. "Out Front," *Vision,* no.1, September 1975, pp.8-11. The
introduction article for the first issue of *Vision,* covering California art;
Marioni gives a brief history of California art, with emphasis on performance
artists. Excerpt:
The sculpture of the '60s reacted against the anti-intellectualism of
abstract expressionism, and created an intellectual art. Sculpture stood on
the floor and concerned itself with reductiveness. Later, a materials
consciousness developed, until by the late '60s the materials of the sculptor
included light, sound, language, social and political activities, and the artist's

Jim Pomeroy. *Composition in D.* 63 Bluxome St., San Francisco, Ca.,
1974. Performance presented for the series, *South of the Slot.*
Participants included: Howard Fried, Jim Pomeroy, Paul Kos.

body. Because the work of the sculptor became so much like scientific experimentation, using aesthetics as its form, the process became the art, and time, the fourth dimension, became a factor. Sculptors began to make installations or environments, temporarily installed in a space. And they began to make actions, not directed at the production of static objects but rather at itself as its activity. The action is directed at the material rather than at the audience as in theater.

The spiral of art movements and life in general before 1970 had become increasingly tighter and faster. In T.V. the commercial of 1960 was sixty seconds long and in 1970 it took thirty seconds to convey the same information. The culture in ten years had learned to use up products, information, and personal relationships in half the time. Post-object-art creates a slowing-down process, a real-time consciousness, because the artist knows it is necessary for the culture to become reflective.

1975 Biennial Exhibition. **New York: Whitney Museum of American Art, 1975. Catalogue for the Whitney Biennial exhibition, January-April 1975. California video artists included: Billy Adler; George Bolling** (*Generations,* **1971); Terry Fox** (*Children's Tapes:A Selection,* **1974); Joel Glassman** (*Rattling Outside, Banging Inside,* **1972); Paul Kos** (*Pilot Butte/Pilot Light,* **1974); Allen Ruppersberg** (*A Lecture on Houdini (for Terry Allen),* **1972); Ilene Segalove** (*The Professional Retirement Home,* **1974); John Sturgeon** (*Nor mal/Con verse; Shirt; Hands Up,* **1974).**

Jim Pomeroy. *Composition in D.* (target)

129

Popper, Frank. *Art-Action and Participation*, New York: New York University Press, 1975.

Rush, David. "Visual and Verbal," *Artweek*, v.6, October 18, 1975, pp.1,16. Review of an exhibition focusing on language entitled *Visual/Verbal*, at the University of California at Santa Barbara Art Galleries. California artists in the group exhibition: Ilene Segalove, Suzanne Lacy, Chris Burden, Douglas Huebler, Jim Pomeroy, Ken Friedman, John Baldessari, Bruce Nauman, Allen Ruppersberg, and Terry Allen, among others.

SOUTH OF THE SLOT

Alpert, Richard. *South of the Slot*. San Francisco: Richard Alpert, 1975. Catalogue of photo documentation for the *South of the Slot* series that took place at 63 Bluxome St., San Francisco, during October-November 1974. Among the participants who presented performances: Richard Alpert (*Probe*), Joel Glassman (*Prisoners*), Pat Ferrero (*Mirror Reflections*), Stephen Laub (*My Father in 1974 Standing Still, My Mother in 1974 Standing Still*), Terry Fox (*Halation*), Tom Marioni (*Drum Brush Lecture*), Paul Kos (*Battle Mountain*), Jim Melchert (*Points of View Series*), Irv Tepper (videotapes *Alpha-bet, Sheldon*), Bill Morrison (*Solo at the Sink*), Jim Pomeroy (*Composition in D*), Paul DeMarinis (*C.K.T.*), MOTION (*Performance Relay*), Linda Montano (*Death and Birth: A Crib Event*), K.P. Costello (*Analogy/Installation*), Mills College Center for Contemporary Music, Alan Scarritt (*Flow*), Vaea (*Music is Dangerous*), John Gillen(*Down Hill Slide*), Jack Ogden and Jimmy Suzuki (*Blank Space*), Jeffrey Weiss (*One or the Other or Both that Makes Three Possibilities; a Visual Score for Samuel Beckett, Albert Ayler, and Martha Reeves*), Simone Forti (videotapes *Grizzlies, Solo No. 1*). Excerpt, Introduction from catalogue:

SOUTH OF THE SLOT was a group show that took place in San Francisco during the months of October and November in 1974. It was a show that was organized by a group of artists as a much needed forum for a particular type of work.

Organized around a loose structure, the artists that participated were asked to choose a date and time at which they would present their work. The space at 63 Bluxome Street in San Francisco was made available to them throughout the two month period with no stated restrictions as to how the space was to be used.

The work that was presented differed widely with each individual, but in general relied on real-time presentation for transferring information from artist to audience. The directness of this type of transference sets up a field of variables very different from traditional forms of art. Each artist dealt with these variables by finding a mode which best suited the ideas inherent in the design of the presented situation. The twenty-two presentations included such various modes as: video performance and live performance, projections and photo-documentation, dance and music, tableau and environmental situation.

Linhares, Phil. "South of the Slot," *Artweek*, v.6, January 11, 1975, pp.6-7. Text and photo documentation of the *South of the Slot* performance series at 63 Bluxome St., San Francisco.

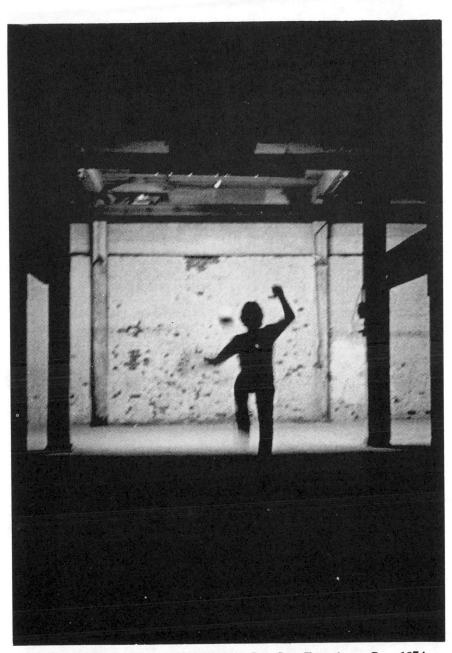

Richard Alpert. *Probe*. 63 Bluxome St., San Francisco, Ca., 1974.
Performance presented for the series, *South of the Slot*.

Linda Montano. *Death and Birth: A Crib Event.* 63 Bluxome St., San Francisco, Ca., 1974. Performance presented for the series, *South of the Slot.*

Irv Tepper. *Sheldon.* Videotape shown at 63 Bluxome St., San Francisco, Ca., 1974, for the series, *South of the Slot.*

SOUTHLAND VIDEO ANTHOLOGY

Askey, Ruth. "On Video: Banality, Sex, Cooking," *Artweek*, v.6, August 9, 1975, p.5. Review of the videotape contributions made by women to the *Southland Video Anthology* exhibition, Long Beach Museum of Art. Of the 65 participants, 17 were women. In the review, coverage is given to works by California artists Susan Mogul and Ilene Segalove, also Lynda Benglis and Eileen Griffin. Excerpt on Mogul:

Susan Mogul's pieces take the banal and by seeming to make it important make it funny instead. In the first work she plays with a vibrator (under a table—she is seen only from the chest up) saying, "There is no man under this table; there is no woman under this table; there is only a vibrator." In between masturbatory interludes, she becomes the smiling, advice-giving "girl-from-Pacific-Plan," cheerfully discussing her problems with the vibrator batteries. In the second piece, *Dressing Up*, Mogul appears nude and as she dresses (all the while munching corn nuts) describes her wardrobe in terms of the bargains she was able to get, with references to the frugality her mother inspired in her.

Tom Marioni. *Drum Brush Lecture*. 63 Bluxome St., San Francisco, Ca., 1974. Performance presented for the series, *South of the Slot*.

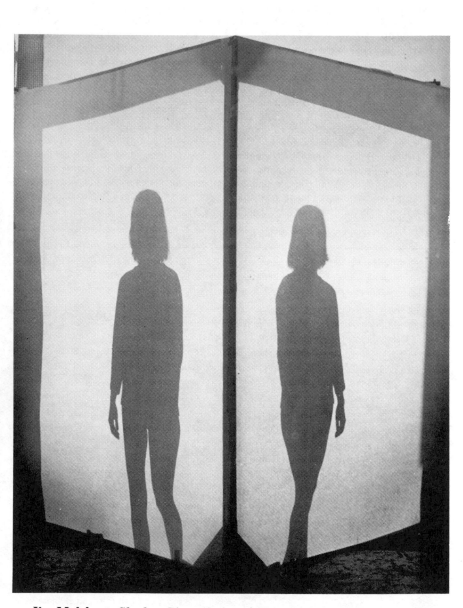

Jim Melchert. *Shadow Piece (Point of View Series)*. 63 Bluxome St., San Francisco, Ca., 1974. Performance presented for the series, *South of the Slot*. Participant: Mary Ann Melchert.

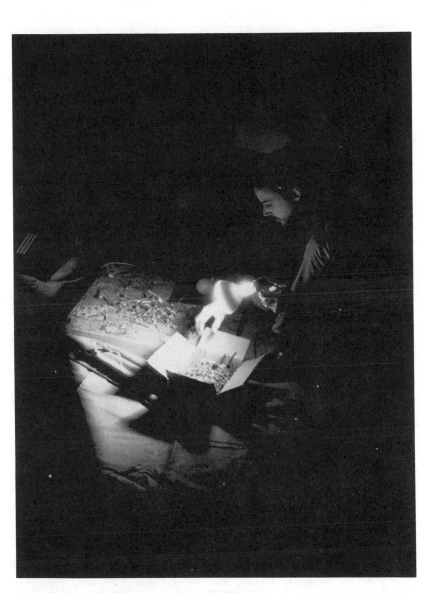

Bill Morrison. *Solo at the Sink.* **63 Bluxome St., San Francisco, Ca., 1974. Performance presented for the series,** *South of the Slot.*

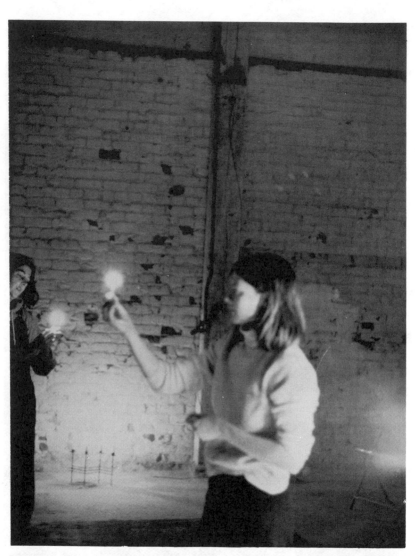

Motion (Suzanne Hellmuth, Joya Cory, (not shown) Muniera Christensen, Brigitte Hotchkiss). *Performance Relay.* **63 Bluxome St., San Francisco, Ca., 1974. Performance presented for the series,** *South of the Slot.*

Terry Fox. *Halation.* 63 Bluxome St., San Francisco, Ca., 1974.
Performance with music and candle presented for the series, *South of
the Slot.*

Southland Video Anthology. Long Beach: Long Beach Museum of Art, 1975.
Catalogue to the first *Southland Video Anthology* exhibition, June
8-September 7, 1975. The exhibition included approximately 30 hours of
videotape by 65 artists from Southern California. The catalogue provides a
video still with brief information about the video work and biographical
information for each participating artist.

Wortz, Melinda. "Going to a Restaurant and Eating the Menu [Southland
Video Anthology]," *Art News,* v.74, October 1975, p.76. Review of the
Southland Video Anthology exhibition organized by the Long Beach Museum
of Art.

Triquarterly 32, Evanston, Illinois, Winter 1975. Published by Northwestern
University. Anti-Object Art issue.
..

University of California Irvine 1965-75. La Jolla: La Jolla Museum of
Contemporary Art, 1975. Catalogue for exhibition with same title,
November-December 1975. Among the participants: Chris Burden (*Photo-
graphic Book*), Nancy Buchanan (*Twin Corners*), Bruce Nauman (*Untitled
Metal Sculpture*), Barbara Smith (*The Art/Life Question*), Eleanor Antin

(from *Carving: A Traditional Sculpture*), Richard Newton (photo still from performance, *Crypt Revealed*).

Video Art. Philadelphia: Institute of Contemporary Art, University of Pennsylvania, 1975. Catalogue for the exhibition with same title held January 17-February 28, 1975. Includes brief biographical sketches of the participants, a catalogue to the exhibition, and selected essays on video art by David Antin, Lizzie Borden, Jack Burnham, and John McHale. Includes bibliography. Among the international group of participants, California artists included: Ant Farm (Chip Lord, Hudson Marquez, Doug Michels, Curtis Schreier), Eleanor Antin, John Baldessari, Terry Fox, Howard Fried, Allan Kaprow, Paul Kos, Bruce Nauman, Nina Sobel, Skip Sweeney, Telethon (Billy Adler and John Margolis), TVTV.

Stephen Laub. *My Father in 1974 Standing Still.* 63 Bluxome St., San Francisco, Ca., 1974. Performance presented for the series, *South of the Slot.* Super 8 film loop projections.

K.P. Costello. *Analogy/Installation*. 63 Bluxome St., San Francisco, Ca., 1974. Mixed media presentation for *South of the Slot.*

Vision, Oakland, no.1, September 1975. Editor, Tom Marioni; Publisher, Kathan Brown, Crown Point Press. The first issue is on California art. Excerpt by Marioni, p.11:

It is the purpose of *Vision* to make available information about idea-oriented art. It is an artist-oriented publication, presenting works and material only from artists, each issue devoted to a particular region of the world. In this first issue we have included California artists who have had an influence on the region of the world, and have created work that has the character of the region as well as an individual style. This section of the publication functions like an exhibition space where the artists were invited to show whatever they wanted to represent themselves.

Willison, Jeanette. *11 Video Interviews*. San Francisco, 1975. A series of eleven videotaped interviews, sponsored by the Museum of Conceptual Art, San Francisco, and exhibited at MOCA on May 12, 1975. Each artist was interviewed for ½ hour. Participants included: Kevin Costello, Bonnie Sherk, Stephen Laub, Richard Alpert, Linda Montano, Jim Melchert, Irv Tepper, Terry Fox, Tom Marioni, and Howard Fried.

ARTISTS / ART SPACES

RICHARD ALPERT

Alpert, Richard. Text and photo documentation of works *Women: On Our Way* (1974) and *Stretch* (1975). Published in: Kostelanetz, Richard and Korn, Henry (eds.). *7th Assembling.* New York.

ANT FARM

Ant Farm with T. R. Uthco. *The Eternal Frame.* 1975. Videotape, 23 mins., color.

Ant Farm. *Media Burn.* San Francisco, 1975. Videotape, 16 mins., color.

Carroll, Jon. "Watching the Media Burn," *The Village Voice*, July 14, 1975. Excerpt:
 At 2:30 in the afternoon on July 4, a man introduced as President John F.

Ant Farm. **Artist Dummies at the** *Media Burn.* **San Francisco, Ca., 1975.**

Ant Farm. *Media Burn*. San Francisco, Ca., 1975. Artist dummies drive the Phantom Dream Car through flaming wall of television sets.

141

Kennedy appeared in a long black car with an American flag on each front fender. Well-groomed men in dark suits trotted alongside. The car stopped behind the bunting-draped speaker's platform, and the man introduced as Kennedy bounded up the stairs. He looked like Kennedy, and he walked with his hands thrust in his coat pockets, thumbs protruding. . . .

Kennedy gave a speech to 500 curiosity seekers assembled behind yellow barricades in the huge concrete parking lot. His speech seemed to be loosely based on a McGovern campaign document. While Kennedy spoke, some 50 cameras—still, video, movie—recorded the event, while a smaller number recorded the cameras recording Kennedy. "Mass media monopolies control people by their control of information," said Kennedy. "I ask you, my fellow Americans, haven't you ever wanted to put your foot through your television screen?" A roar went up from the crowd.

Below Kennedy, in front of the platform, lurked the Cadillac dream car, a customized 1959 Biaritz with a sleek canopy surmounted by two clear Plexiglass bubbles. Rising behind the bubbles, on what would ordinarily be the trunk, was a spire on top of which was mounted a television camera. Kennedy finished, was applauded, sped off. A blue van moved forward and disgorged two men dressed to resemble astronauts, complete with opaque helmets. After acknowledging the cheers of the crowd, they crawled into the dream car. The clear Plexiglass bubbles were replaced with stronger black ones. The daredevils would steer the car, using a monitor on the floor and a camera in the spire.

A hundred yards away, Uncle Buddy poured kerosine on a stack of 15 television sets. He lit a match. The kerosine burned with a bright orange flame and thick black smoke. The wood cabinet on some of the older television consoles caught fire. The Cadillac accelerated toward the wall of burning television sets. Another roar went up. The car hit the wall at 55 miles per hour. Televisions wreathed in flames were hurled forward. The spire of the car was sheered off entirely. The Cadillac came to a halt at the far edge of the parking lot. The drivers emerged, stood on top of the car, and waved their hands over their heads. The crowd cheered.

The television sets continued to burn, punctuated by an occasional howl as another picture tube imploded.

Fox, Frank. "Ant Farm Hosts 'Horn and Lights' Bash," *Michigan State News*, **April 17, 1975. Excerpt:**

Ant Farm distributed scripts to the score of more "musicians" who waited in the cars for Schreier to signal the beginning of the symphony with a blast from an air horn. . . .

The air horn was pathetically weak. Schreier and Michels had to wave their arms like frenzied Leonard Bernsteins while the people across Farm Lane blew their horns, flashed headlights, ran around the cars, slammed hoods and trunks and generally behaved like greasers in a drive-in on Saturday night. . . .

Finally came the triumphant climax as the horns joined together in a strident screech that absolutely delighted the spectators with a blast of energy and joyously mindless noise.

Frank, Sheldon. "Smashing Your TV and Needing It Too," *Chicago Reader*, **October 1975.**

Ant Farm and T.R. Uthco (Artist President - Doug Hall, Artist Jacqueline - Doug Michels). *The Eternal Frame: an Authentic Remake of the JFK Assassination*. Dallas, Texas, 1975.

Krassner, Paul. "The Naked Emperor/Fiddling While the Media Burns, or: Nero, My God, to Thee." *Crawdaddy*, October 1975, p.14.

Liss, Carla. "Art Politics Interview: Ant Farm," *Berkeley Barb*, July 11-17, 1975. Excerpt:
 . . . the whole point of *Media Burn* is producing art in the public domain. When you do that it becomes a political statement, because it's setting up a reality. Just the way the media reported it and put it into some kind of format to explain it to people: like Kennedy they could say was an actor and the event was quasi Evil Kneival. But if you were actually there you know that the experience was between reality and performance.

McDonnell, Terry. "Media Matadors," *City Magazine*, August 1975.

"Media Burn," *Studio International*, v.190, September 1975, p.157. Brief description of *Media Burn*, a work executed by the Ant Farm in collaboration with T.R. Uthco on July 4, 1975.

"Media Burn/Ant Farm," *TeleVisions*, v.3, August/September 1975.

Smith, Howard and Van der Horst, Brian. "Doing It Again in Dallas," *The Village Voice*, **November 3, 1975, p.24. Description of** *The Eternal Frame*, **produced by Ant Farm and T.R. Uthco. Excerpt:**

. . . bought a 1963 Lincoln Continental limousine and modified it with a roll bar and other presidential accoutrements. They researched every photograph of the original event they could find for spatial relationships. They obtained a copy of the Zapruder film and studied it for hours.

"Then we consulted makeup artists so each of us could play the necessary parts, such as JFK, Connally, and Secret Service agent Hill," says Michels, who portrayed Jacqueline in the re-creation. "We practiced and timed the event like a ballet. We made it look exactly like the original." Finally the two bands of artists arrived in Dallas and in front of their own photographers, video and film cameramen, proceeded with their plans.

"We found that tourists still come there every day," says Curtis Schreier. "They line up on the streets just like in 1963—except they wear pink shorts instead of suits. They loved us. People rushed up with their Instamatics. We were doing it every hour—20 times during that day—and they thought we were a government reconstruction squad or from the Chamber of Commerce."

Eleanor Antin. *The Little Match Girl Ballet.* **Videotape, 1975.**

Eleanor Antin as the King. San Diego, Ca., 1975.

DAVID ANTIN

Antin, David *"Libra Piece,"* LAICA *Journal,* no.7, August/September 1975, pp.14-16.

Antin, David. "Warm-Up," *Art-Rite,* no.10, Fall 1975. Text "from a performance at st. marks in the bouwerie march 10 1974."

ELEANOR ANTIN

Antin, Eleanor. "Eleanor Antin: from 'the King's Meditations,' " LAICA *Journal,* no.6, June/July 1975, pp.22-23.

Antin, Eleanor. "From the King's Meditations," *Vision,* no.1, September 1975, pp.52-53.

Antin, Eleanor. *The Little Match Girl Ballet.* Huntington Beach, Ca.: KOCE-TV, 1975. Videotape, 27 mins., color.

Liss, Carla. "Eleanor Antin as Ballerina," *Artweek,* v.6, November 29, 1975, p.6. Review of Antin's performances, as the King (November 6) and as the Ballerina (November 7), performed at the California Palace of the Legion of Honor, San Francisco, as part of the opening of Lynn Hershman's Floating Museum.

Nemser, Cindy. *Art Talk: Conversations with 12 Women Artists*. New York: Scribners, 1975. Eleanor Antin is among the 12 women artists interviewed for the book, pp.267-302. Extensive interview; includes several photographs. Excerpt:

E.A. When I started moving out of those more plausible or expectable transformations like dieting, putting on street make-up, or changing my regular artist's self into a more bourgeois image, all these things we do all the time, I moved into perfectly plausible but less expected and perhaps more exotic transformations. I got interested in the transformational nature of the self and the possibilities of defining my limits, such as age, sex, space, time, talent, what have you, all the things that restrict our possibilities. I mentioned the slave before and how restricted his novel of himself would be. Well I wanted perfect freedom.

C.N. To transcend space and time.

E.A. Why not? If autobiography is fiction—and it is because it is history, the past—you don't have to be restricted to your own past. You might come up with someone else's fiction. One of my selves is a king.

C.N. Does that refer to your piece *The King and the Ballerina*?

E.A. I have been putting those two together.

C.N. Which did you do first?

E.A. Well they all started with *Carving* and the naturalist transformations and then they went into exploring the limits of my possibilities.

Nemser, Cindy. "Four Artists of Sensuality," *Arts Magazine*, v.49, March 1975, pp.73-75.

CLAYTON BAILEY

Bailey, Clayton. *Wonders of the World Museum: Catalog of Kaolithic Curiosities and Scientific Wonders*. Port Costa, Ca.: Wonders of the World Museum, [1975].

BAKER/RAPOPORT/WICK

Flanagan, Ann. "Collaboration as Process," *Artweek*, v.6, May 17, 1975, p.6. Article on the collaborative work of Mary Winder Baker, Debra Rapoport, and Susan Wick. Excerpt:

Last month, [Baker/Rapoport/Wick] . . . occupied the Special Events gallery at Berkeley's University Art Museum for Interplay, a spontaneous exchange between the artists and the public, "giving the public a chance to relate to the artist working instead of just the dead object" (Wick). The museum collaboration was much more structured and formal in terms of activities and space because of museum restrictions. . . . As in the studio, each woman had her own work area but there were also joint projects. . . . Together they worked on a huge, transparent plastic scrapbook with a page for each day, a fiber/plastic/wire grid tapestry and a monumental twisted paper rope. On the last day surrounded by friends and visitors, they fashioned a great knot out of the rope, a symbol of their shared lives and concerns.

Baker, Mary Winder, Wick, Susan and Rapoport, Debra. *Transformation*. San Francisco: La Mamelle, Inc., 1975. Videotape, approx. 49 mins., b/w.

Mary Winder Baker, Debra Rapoport, Susan Wick. *Interplay.*
University Art Museum, Berkeley, Ca., 1975.

Flanagan, Ann. "Interchange," *La Mamelle Magazine: Art Contemporary,*
no.1, v.1, Summer 1975, pp.9-12. A collaborative interview conducted by
Ann Flanagan with Mary Winder Baker, Debra Rapoport, and Susan Wick.
Includes photos of collaborative works: 1)*Interplay*, an event that took place
April 1975 at the University Art Museum, University of California, Berkeley;
2)Fiberworks Gallery Live-In, Berkeley, March 1975; 3)*An ARThritic
Experience*, June 1975. Excerpt:

INTERCHANGE

Purpose: By exchanging identities and answering questions as each other
and as themselves, the interviewees might reveal new perspectives about
their work and relationship. Baker, Rapoport and Wick were not permitted to
consult each other about their answers.

Question: The public collaborations and performances have been largely
spontaneous. Do you ever feel vulnerable, leaving so much to chance?

Mary Winder Baker:

as Mary Winder Baker—Creative people energize one another. Just let
me feel an energy level connection and trust and I'm off. The spontaneous
experience happens and happens fully. No room for uneasiness.

as Debra Rapoport—No. Basically I trust and flow with the feelings that
are built out of performance.

as Susan Wick—I don't feel there is much risk. I know my own
assertiveness. The group wants to experience its self-will and I can sense
that.

Mary Winder Baker, Debra Rapoport, Susan Wick. *Fiberworks Gallery Live-In.* **Berkeley, Ca., 1975.**

Debra Rapoport:

as Mary Winder Baker—No, there is enough conversation, planning, understanding and trust among those initially involved that we can rely on each other's energies. If a lull should occur, we can always pull from past conversations.

as Debra Rapoport—I don't feel vulnerable leaving things to chance. There's a fear of being rejected which lasts a short time. I trust in the process and in the people involved so I don't preoccupy myself with failure. Before doing any performance, I feel strongly about what I am doing and my relationship with the others. I enjoy the challenge of using the positive energy to influence the other participants/spectators.

as Susan Wick—It's not the chance that leaves me vulnerable. At first, it's the exposure of self—will I be rejected? There are always enough degrees of energy and trust of each other to keep us going.

Susan Wick:

as Mary Winder Baker—Yes. Amount changes depending on how much preplanning we've done. Vulnerable but definitely worth taking the risk as there is much to gain and all we ever have to work with is ourselves.

as Debra Rapoport—Yes, I feel vulnerable, but it is exciting; I believe in it and all of it has value on one level or another, at one time or another for each of us—more for some than others, that's all. The spontaneity and the

including others into my process makes it more enjoyable.

as Susan Wick—I feel vulnerable, more or less depending on my sureness, my own self image, who is present, the reason for the event. It is risk taking—what will I learn about myself in this spontaneous fashion, and what will the others learn about me at the same time? It's exciting, stimulating. I'd hate to have everything planned. I like the feeling of trusting the situation, myself, the others.

Flanagan, Ann. "Live-in Art at Fiberworks Gallery," *Craft Horizon*, v.35, June 1975, p.9. Excerpt:

Much of the "live-in" was devoted to woman's traditional nurturing activities—hostessing, serving, cleaning up after guests during an assortment of brunches, tea parties, and dinners. Homemaking and gardening took various forms: lettuce leaf "living tapestries" which carpeted the floor and embellished a "paper forest" of hanging paper panels; buckets of wild growing grass were brought in; and the room was filled with piles of various fibers and paper on another occasion.

JOHN BALDESSARI

Baldessari, John. *Four Events and Reactions*. Florence: Centro di, 1975. Artist book. The Events: 1. Putting finger in milk. 2. Touching a cactus. 3. Putting out a cigarette. 4. Pushing a plate off a table. The reactions—as recorded by close-ups of a beautiful young woman.

Baldessari, John. *Throwing a Ball Once to Get Three Melodies and Fifteen Chords*. Irvine: Art Gallery of the University of California, 1975. Artist book.

Baldessari, John. *Throwing a Ball Once to Get Three Melodies and Fifteen Chords*, book review by Jim Welling, *Artweek*, v.6, March 1, 1975, pp.13-14. Excerpt:

Throwing shows, in fifteen sequenced photographs, a man throwing a ball. Overprinted on each photo are red, yellow and blue horizontal lines. The red line passes over the left throwing hand; the yellow line over the right hand; and the blue rests on the left foot. These primaries plot the thrower's movements. As the ball becomes airborne, the red line follows the ball rather than, as we expected, the hand. The final image almost startles; the red line leaves the body, travels down slightly and seems to emphasize the movement of the ball back into the pages of the book.

Three melodies form as the lines follow hands and foot through the pages. Chords take shape according to the vertical arrangement of lines on each page.

ANNA BANANA

"Art for Free Spirits/Crazy 'Banana Olympics,' " *San Francisco Examiner*, March 31, 1975, p.5. Short article and photos published the day after the Banana Olympics took place at Embarcadero Plaza, San Francisco.

Banana, Anna. "Art for Free Spirits. . . . Crazy 'Banana Olympics,' " *Sometimes Yearly Banana Rag*, v.11, May 1975. Special report on the 1975 Banana Olympics in San Francisco, organized by Anna Banana.

Anna Banana and Bill Gaglione. *Dada Shave*. San Francisco, Ca.,
1975.

Banana, Anna. *Banana Olympics*. 1975. Videotape, color.

Banana, Anna. "Untitled," *Intermedia*, no.2, v.1, June 1975, p.50. Includes four photos documenting Dadaland with shaved "DADA" torso, by Anna Banana.

Banana, Anna and Gaglione, Bill. *Dada Shave*. San Francisco: La Mamelle, Inc., 1975. Videotape, approx. 13 mins., b/w. The editors of *Vile* magazine in private performance in homage to Dada. Banana shaves a Dada message across the chest of Gaglione (aka Dadaland).

"The Banana Olympics!," *San Francisco Bay Guardian*, March 8-21, 1975, p.3. Full page ad announcing the Banana Olympics; includes photo, program of events, general rules, and information about events to take place.

"Embarcadero Center Goes Bananas: Yes We Have No 'Bananology,' " *The Centerview* (San Francisco), v.3, March 1975, p.10. Article announcing Banana events organized by Anna Banana at Embarcadero Center, San Francisco, March/April 1975.

DIANE CALDER BELSLEY

Belsley, Diane Calder. "Excerpts from Nine Fantasy Projections," *LAICA Journal, no.7*, August/September 1975, pp.25-26. Excerpts from a proposal in which Belsley would attempt to live for one day each, the lives of 9 other women artists.

Belsley, Diane Calder. *Mother Heard*. Northridge: Self-published, 1975. Artist book that grew out of a Mother's Day performance celebrated by Belsley at the Woman's Building, Los Angeles, in 1975.

NANCY BLANCHARD

Blanchard, Nancy. *Memoirs*. 1975. Audiotape, 15 mins.

Blanchard, Nancy. *Screen Stories 1950*. 1975. Audiotape, 15 mins.

CHRIS BURDEN

Burden, Chris. "Chris Burden," *Flash Art*, nos.56-57, June/July 1975, pp.39-41. Photo documentation and text by Burden on his performance works: *Dreamy Nights—Art as Living Ritual* (1974), *Kunst Kick* (1974), *Velvet Water* (1974), *Sculpture in Three Parts* (1974), *Action . . . etc.* (1975).

Burden, Chris. *Documentation of Selected Works, 1971-74*. 1975. Videotape, 36 mins., b/w and color.

Burden, Chris. "Oracle," *Vision*, no.1, September 1975, pp.50-51. Explanation of his performance, *Oracle*.

Burden, Chris. "Sculpture In Three Parts," *La Mamelle Magazine: Art Contemporary*, no.1, v.1, Summer 1975, pp.15-19.

Burden, Chris and Butterfield, Jan. "Chris Burden: Through the Night Softly," *Arts Magazine*, v.49, March 1975, pp.68-72. Separately, Burden and Butterfield describe the following works by Burden: *Five Day Locker Piece*(1971), *Prelude to 220 or 110*(1971), *Bed Piece*(1972), *Icarus*(1973), *Through the Night Softly*(1973), *Doorway to Heaven*(1973), *Transfixed*(1974), *Sculpture in Three Parts*(1974), and *Oh Dracula*(1974). Excerpts:

[Chris Burden]: "To be right the pieces have to have a kind of crisp quality to them. For example, I think a lot of them are physically very frontal. Also, it is more than just a physical thing. I think of them, sense them that way too. When I think of them I try to make them sort of clean, so that they are not formless, with a lot of separate parts. They are pretty crisp and you can read them pretty quickly, even the ones that take place over a long period of time. It's not like a Joan Jonas dance piece where you have a lot of intricate parts that make a whole. With my pieces there is one thing and that's it."

[Jan Butterfield]: That physical or mental danger is possible in many of Burden's pieces cannot be denied. It is the presence of this danger, the fear of it, and the resulting apprehension around which his works are structured. The pieces are highly controlled, however, and the actual risks are minimal. . . .

His works do not make a deliberate attempt to terminate life or to maim the body but, rather, set up situations where *but* for the control, these things could happen.

Ferrari, Corinna. "Chris Burden: Performances Negli U.S.A. e a Milano," *Domus*, no.549, August 1975, pp.50-51. An interview with Burden in Milano, May 1975. Text in Italian and English. Also includes a list of performance works from 1971-73 with brief explanations of the pieces. Excerpt:

C.B. A lot of the pieces that I do are fantasies acted out and realized. The reason that they involve people, or have meaning for people is that they are common fantasies. My acting them out breaks down the barrier between fantasy and reality and makes people question what kinds of experiences are possible.

C.F. What importance do you attach to the space in which you do your performances?

C.B. I see myself primarily as a sculptor. My individual pieces are almost always generated by the spaces where they happen. In other words, I never know what I am going to do until I see the space. . . .

C.B. Like most California artists, I am very much concerned with the visual content of my work. The pieces are primarily visual experiences, and I try to make the experiences as rich as possible. Most people do not perceive this aspect, but it is what gives the pieces their impact.

CLAUDIA CHAPLINE

Chapline, Claudia. "Performance Notes," LAICA *Journal*, no.7, August/September 1975, pp.34-35. Notes and photos from *Marlin Line*, Part 2, performed at Santa Monica Beach, 6-10 a.m., December 28, 1974. Excerpt:

Paul brought the black plastic down by the sea and everyone became excited and joyfully played with this huge wave of material in the wind. The sun was high now and the sky was clear and blue. Eventually they brought it down to the sand and we crawled under it and sat quietly for some time. It

was like being in a soft warm cave. The light was a bluish grey with golden highlights. Looking at the sun through this slate-colored skin was a strange and beautiful experience. We didn't want to leave this place.

Chapline, Claudia. *The Telephone Book*. Los Angeles: Self-published, 1975.

Chapline, Claudia. "Telephone Book," *La Mamelle Magazine: Art Contemporary*, no.2, v.1, Fall 1975, pp.20-21.

Chapline, Claudia. "Two Performances," *Intermedia*, no.3, v.1, December 1975, p.6. Notes on two performances: *Object-Object*, performed at the Kieran Gallery, Riverside, January 12, 1975, and *As Is 1975*, a work for George Washington's birthday, one of a number of holiday (Holy Day) events.

JUDY CHICAGO

Chicago, Judy. *Through the Flower: My Struggle as a Woman Artist*. Garden City, N.Y.: Doubleday, 1975.

LOWELL DARLING

Darling, Lowell. "Lowell Darling," LAICA *Journal*, no.4, February 1975, p.23.

GUY DE COINTET

de Cointet, Guy. *A Few Drawings*. Self-published, 1975. Artist book.

de Cointet, Guy. "Guy de Cointet," LAICA *Journal*, no.4, February 1975, pp.29-30. Documentation/script for *Sophie Rummel*, played by Viva, at Cirrus Gallery, Los Angeles, April 1974. Excerpt:
The scene is at the "World Bookstore", on Cahuenga between Selma and Hollywood. Joyce N. is a journalist and she is interviewing the artist Sophie Rummel. It is 8 o'clock at night.
—How are you Sophie?
A sensual Santa Ana has been blowing all day. Now on the clear sky with moon, the capricious forms of buildings, palm trees, stand out in black relief. Not waiting for an answer Joyce can't hold her admiration.
—What a majestic sight! What a serenity! I wonder what makes it all so impressive?
—"Here she comes! . . . Suddenly a slim figure . . ."
Sophie Rummel is reading aloud from a book she just picked up at random: ". . . a slim figure in a green silk dress appeared . . . Her long auburn hair glistened under the bright, colored lights. Her smile was captivating, entrancing. Electricity seemed to crackle from her. The crowd burst into thunderous applause, a spontaneous demonstration of their love for her. The ovation ceased abruptly as she led the standing people in her theme song:
He touch me! Oh, he touched me!
And oh, the joy that floods my
soul! Something happened,,,

Welling, James. "Linking Dream Structures and Images," *Artweek*, v.6, June 28, 1975, p.16. Review article comparing performances by Guy de Cointet with John White, both performed in May 1975 at the Los Angeles Institute of Contemporary Art (LAICA). See also, John White. Excerpt on de Cointet:

In Guy de Cointet's performance a lithe woman recounts a fantastic adventure which goes something like this: The narrator's dying father bequeaths a booklike object, his "diary," to her. He dies and war erupts. The narrator's fiancee hastens off the battle, leaving her alone with the book. Escaping to the street amid exploding buildings, our heroine is forced into the crush of evacuees fleeing out of the city. After an all-night march, the rabble arrives in the threatening countryside. Miraculously, at daybreak, the war ends. Troops disperse, and the narrator is reunited with her lover. The tumultuous and contracted force of events imprints itself into the pages of the book, and the entire performance revolves around this farcical telling and showing. A burning timber singes one page; bloodstains mar, but improve, a drawing on another. Enemy bullets complement a design. The construction of plot is much like connecting numbered dots to arrive at a pattern; here the pattern is in time—and continuously providing explanations for the localized appearance on each page. The implausible glosses move the narrator from one page to the next. The book is seemingly acted upon by the same figurative events that propel the frantic narrative.

80 LANGTON ST.

"80 Langton—An Alternative," *Artweek*, v.6, May 3, 1975, p.7. Short article announcing the opening of alternative space, 80 Langton St., by the San Francisco Art Dealer's Association. Excerpt:

For artists who use such media as video and performance which, for varied reasons, the galleries are unable to accommodate, the space will offer a means of exposure for their work. Music and dance performances, poetry readings, lectures and panel discussions, as well as art exhibitions, will also be presented.

TERRY FOX

Five Artists and Their Video Work. Seattle: AND/OR Gallery, 1975. Catalogue for an exhibition. Excerpt on Terry Fox:

Fox enters from the back of the space and begins lighting what becomes evident as a structure of 12 white candles, one at a time, each time with a new match, putting each used match in his jacket pocket. . . . The pendulum ball hangs in the center of the room, the center of the labyrinth. The *and/or* space is of nearly the same diameter as the Chartres labyrinth—40 feet. After lighting the candles and setting the pendulum ball in motion, Fox places himself at the entrance to the structure and makes sound with a cello and violin bow across a large metal bowl shaped like a caldron and a shallow bowl, the earth digging part of a plow—both found instruments. The rhythm of Fox's breathing, the rhythm of the labyrinth.

Fox, Terry. "552 Steps Into the Labyrinth at Chartres Cathedral," *Vision*, no.1, September 1975, pp.22-23.

Fox, Terry. *Two Turns*. 1975. Videotape, 42 mins., b/w.

Radice, Barbara. "Visibilia: Firenze, Terry Fox," *Data*, nos.16/17, June/August 1975, p.36. Review in Italian of Terry Fox's performance at the Galleria Schema in Florence, Italy.

Welling, Michael. "Terry Fox Videotapes," *Artweek*, v.6, March 15, 1975, p.16. Review of five videotapes shown at the Long Beach Museum of Art: *Turgescent Sex*(1974), *Clutch*(1971), *Children's Tapes*(1974), *Incision*(1972), and *Two Turns*(1975).

HOWARD FRIED

Fried, Howard. *The Burghers of Fort Worth*. Fort Worth, Texas, 1975, work in progress. Film, color. Fried's first golf lesson.

Fried, Howard. "Untitled," *Vision*, no.1, September 1975, pp.30-31.

KEN FRIEDMAN

Friedman, Ken. *Paik's Third Symphony*. San Francisco: La Mamelle, Inc., 1975. Videotape, approx. 8 mins., b/w. Private performance of the third symphony written by Nam June Paik subtitled, *Young Penis Symphony*.

Friedman, Ken. "Perspective: Brief Notes on an Exhibition," *La Mamelle Magazine: Art Contemporary*, no.2, v.1, Fall 1975, pp.6-10. Excerpts of Friedman's events in Fluxus notational form:

10,000
Mail to friends, people chosen by random
processes, etc. 10,000 objects, papers,
events, etc., over the span of a pre-
determined time.
1971
(Which recipients are to receive which items
and on what dates may also be selected at
random. First performed in 1971 over the span
of one year).

Ken Friedman at the Slocumb Gallery. Johnson City, Tenn.: Department of Art, East Tennessee State University, [1975]. Catalogue for a one person exhibition at the Slocumb Gallery, October 13-November 1, [1975].

SUSAN GRIEGER

Grieger, Susan. *Friends/Artists*. Pasadena: Self-published, 1975.

LYNN HERSHMAN

Hershman, Lynn. *Re: Forming Familiar Environments*. Self-published, 1975. An artist book documenting a work by Lynn Hershman with Eleanor Coppola that took place May 16, 1975 in a three-story home.

ALLAN KAPROW

Bandini, Mirella. "Allan Kaprow: A Happening and a Conversation with Allan Kaprow," *DATA*, nos.16/17, June/August 1975, pp.60-67 and insert. History of the Happening and discussion with Kaprow on his involvement with the happening—past and present. Includes photos of happening events from the early 1960's. Text in Italian with an English translation by Rodney Stringer. Excerpts:

Kaprow, for example, in talking about the birth of his first happening, states that he moved on from his first paintings and assemblages, done in 1952, to a sort of agglomeration of action-collage and finally to their structural arrangement in environments with sounds and lights; and he at once realised that "every visitor became a part of it, which, to tell the truth, I hadn't expected. So I entrusted those who came in with unimportant duties, like moving something, turning on switches, etc. Towards '57-'58 this need grew more intense and prompted me to attribute an increasingly marked responsibility to the visitor, whom I entrusted with more and more things to do. So the happening was born. My first happenings were staged in quite different kinds of places: attics, shops, classroom, gymnasiums, on a friend's (George Segal) farm, and so on. The combining of all the elements in my work—compositions, environment, time, space and people—was my biggest technical problem right from the start. . . . Most of all, I wanted the audience not so much to watch, but to 'take part' in my work, and I had to find a practical way of accomplishing this aim. So I devised a system of very simple situations and images, with elementary mechanisms and implications . . . I generally elaborate my works on the basis of four points:

I) the action's simple or complex 'being,' that's to say, without any other meaning beyond the physical and sensitive immediacy of whatever happens. II)The actions are fantasies carried out not exactly in the model of life, though they are derived from it. III) The actions constitute an organised structure of events. IV) Their 'meaning' is readable in a symbolic and allusive sense."

[Bandini]: Since 1965, or since "Calling," to be precise, the number of people taking part in your happenings has grown steadily smaller, with the exclusion of spectators. What determined this new position?

[Kaprow]: In the beginning, because I wasn't a professional actor and nor were my friends, I was looking for an experience similar to that of actors so that I could really try out this unknown dimension to me. This was the reason why the people were involved in an almost theatrical way. But as soon as I experienced this I stopped moving in that direction. I just gave very objective direction-notes as coldly and flatly as possible, leaving you with the fullest scope for action.

[Bandini]: However, in this way participation in your events becomes an aleatory thing.

[Kaprow]: No, it implies no kind of superiority over anybody. Besides, our knowledge and yours was left to chance. This position of freedom is important. You were absolutely free to put on the piece, in that it is a proposal which the participants could perfectly well refuse if they wished. So these efforts of mine to research certain aspects of human institutions are experiments on a minor scale, which could however be done on larger one. After the sixties my happenings stopped being on a large scale and became steadily smaller and more intimate. Maybe it's the effect of the times. Certainly, after '68, which we all learnt something from, one is more inclined

156

towards a more inward-looking dimension. This doesn't upset the research in the slightest, because it is simply the study of models that can later be blown up again on a larger scale as soon as the occasion arises and the situation is riper.

Occasionally I can call what I do 'art,' but I can also say that it is a form of sociology and has a psychodynamic aspect.

Hayum, Andree. "Notes on Performance and the Arts," *Art Journal*, v.34, Summer 1975, pp.337-39. Report on the "Performance and the Arts" session held at the 1975 College Art Association conference in Washington, D.C. The session was coordinated by Allan Kaprow with Vito Acconci, Joan Jonas, Yvonne Rainer and Allan Kaprow as panel participants. Excerpt:

To define Performance through the work of these artists is to arrive at a kind of crossbreed. Here, for instance, form exists in space but also establishes itself through time so that certain musical expressions as well as video and film can become shifting parts of this overall category. Presentations generally consist of small groups of performers or, at times, the "choreographer" alone. Relatedly, the performance area is more often like a work space than a formal theatrical setting. Initially avoiding the dramatic structure and psychological dynamics of traditional theater or dance, bodily presence and movement activities have been central elements in the work of these artists.

Kaprow, Allan. *Air Condition*. Los Angeles: Self-published, 1975. Artist book. An activity; "*Air Condition* is a 'privacy piece' meant for an individual alone, which was carried out by seven persons in the hills around the California Institute of the Arts, Valencia, in October of 1973."

Kaprow, Allan. *Comfort Zones*. Madrid: Galleria Vandres, 1975. Artist book. "*Comfort Zones* plays with what the social sciences call 'territorial bubbles' and 'eye contacts.' seven couples . . . carried out *Comfort Zones* in Madrid, Spain, on June 10th and 11th, 1975 . . . sponsored by Galleria Vandres, S.A., Madrid."

Kaprow, Allan. *Comfort Zones*. 1975. 16 mm film with sound, approx. 15 mins., b/w.

Kaprow, Allan. "Easy Activity." In *Art Studies for an Editor: 25 Essays in Memory of Milton S. Fox*, pp.177-182. New York: Harry N. Abrams, 1975. Description with photos of a Kaprow activity entitled, *Loss*.

Kaprow, Allan. *Echo-Logy*. New York: D'Arc Press, 1975. Artist book. An Activity concerned with natural processes; the activity, commissioned by the Merriewold West Gallery, took place in Far Hills, NJ, on May 3-4, 1975.

Kaprow, Allan. *Likely Stories*. Milano: Galleria Luciano Anselmino, [1975]. Artist book. An Activity that took place in Milan, Italy, November 1975.

Kaprow, Allan. *Match*. Wupperthal, Germany: Kunst-und Museumsverein, [1975]. Artist book. An Activity that took place August 29-31, 1975, sponsored by Kunst-und Museumsverein, the von der Heydt-Museum, and

the Berliner Kunstlerprogramm of the DAAD.

Kaprow, Allan. *Rates of Exchange*. New York: D'Arc Press, 1975. Artist book. An activity that took place in New York City, March 1975, sponsored by the Stefanotty Gallery, NY.

Kaprow, Allan. *Rates of Exchange*. 1975. Videotape, 45 mins., b/w.

Kaprow, Allan. *Routine*. Self-published, 1975. Artist book. "Routine was the first of three related Activities with the same title. . . . The idea was prepared in November, 1973 and was realized the following December 1st, 2nd and 3rd, under the sponsorship of the Portland Center for the Visual Arts in Oregon."

Kaprow, Allan. *Time Pieces*. 1975. Videotape, 30 mins., b/w.

Kaprow, Allan. *2 Measures*. Torino: Martano Editore, 1975. Includes Activities: *Affect*, that took place in Torino, October 15, 1974, sponsored by Galleria Martano; and *Take-Off*, sponsored by Galleria Martini-Ronchetti, Genova, on October 19, 1974.

Kaprow, Allan. *Useful Fictions*. Firenze: Galleria Schema, 1975. Artist book of an Activity.

Kipper Kids (Harry and Harry Kipper).

ROUTINE

ROUTINE was the first of three related Activities with the same title. Each of them alludes to the deadpan stylizations of vaudeville routines, and to routinized behavior in everyday life.

The idea was prepared in November, 1973 and was realized the following December 1st, 2nd and 3rd, under the sponsorship of the Portland Center for the Visual Arts in Oregon. About twenty couples (mostly of opposite sexes) took part. A briefing to begin and a review afterwards brought the participants together, while between these sessions we carried out the program printed here in places of our own choice.

Although the basic operating unit of the Activity was a pair, it turned out that most of the transactions involved self-reflection. This was nothing new, to be sure. As we later "reflected", people generally devote themselves to mirroring who they are in others. But there was, or seemed to be, the promise of some kind of relationship contained in the images and formality of the program. The use of the telephone underlined that possibility.

A few couples carried out their routine in crowded public places to learn that hardly anyone else paid attention; others sought isolated car lots and backyards and had ample opportunity to pay attention solely to their own appearance or feelings. Annoyances and amusements resulted. Partnerships do not always serve the members equally. Yet several couples actually thought they got to know each other better. A few rediscovered an ancient way to flirt. Still others concluded they liked their eyes better than their mouths. The prevailing mood, I recall, was ironically surreal.

The photos here do not document ROUTINE. They fictionalize it. They were made and assembled to illustrate a framework of moves upon which an action or set of actions could be based. They function somewhere between the artifice of a Hollywood movie and an instruction manual. The pictures explain the words as the words explain the pictures. Thus the conversion of an event into an exhibit or magazine article becomes a species of mythology.

ALLAN KAPROW

Allan Kaprow. *Routine*. An artist book describing the "first of three related Activities with the same title" carried out on December 1-3, 1973; sponsored by the Portland Center for the Visual Arts.

1

standing somewhere
facing a friend holding a large mirror

trying to catch one's reflection

signalling to tilt the mirror variously
until the reflection is caught

both moving apart a few steps
repeating process

moving apart again and again
repeating process
until it's no longer possible
to see oneself

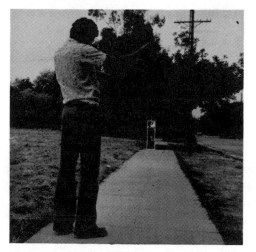

2

phoning a friend
saying something
asking that it be repeated
hearing the reply

holding the phone at arm's length
saying something else
asking that it be repeated
listening for the reply

stepping away from the phone a bit
saying something else a bit louder
asking that it be repeated
listening for the reply

moving off farther and farther
each time saying something more loudly
asking that it be repeated
listening for the reply
(asking again that it be repeated if one can't hear)
until it's impossible to hear

planning to meet a friend
both approaching from a distance
turning around, walking backwards
toward each other, looking into a pocket mirror
until the reflection of both faces are very clear

making an eye movement making a mouth movement
the other copying it the other copying it
copying again and again copying again and again
until tired until tired

moving apart (still looking into mirrors)
repeating process

moving apart again and again
copying until face movements are no longer clear

4

phoning a friend
saying something
repeating it once or twice
saying "OK, now let's say it together"

saying it, together, again and again
until no longer possible

being phoned by a friend
hearing something said once or twice
being asked to repeat it together

saying it, together, again and again
until repeating is no longer possible

looking at one's eyes and mouth
in a pocket mirror

describing them to a friend*
on the phone
friend doing same

each staring at his/her reflected eyes without blinking
staring at his/her opened mouth without closing it
saying nothing

hanging up when the eyes must blink
when the mouth must shut

*Note: Friends may, but need not be, the same
throughout the five sections.

Kaprow, Allan. *Warm-ups*. [Self-published], 1975. Artist book. An activity that took place in Boston, October 1975, sponsored by the Center for Advanced Visual Studies, the Massachusetts Institute of Technology.

Kaprow, Allan. *Warm-Ups*. 1975. 16 mm film with sound, approx. 14 mins., color.

KIPPER KIDS

Clothier, Peter. "The Kipper Kids: An Endless Ritual," LAICA *Journal*, no.5, April/May 1975, pp.47-49. Excerpt:

The performance is gross, obscene, irreverent and unbeautiful. It is a deliberate and unremitting distortion of the niceties of our social behavior, our beliefs, our intimacies and our art into the grotesque. It's hard, for example, to imagine anything more innocent and warmly human than a child's birthday party: in the hands of the Kipper Kids it becomes an obscene, piggy ritual, without joy or love, which includes the perfunctory exchange of rubber ducks as "gifts," a lunatic scoffing match as the two stuff "cake" into their mouths (actually a dinner roll which must have been several weeks old), and a final regurgitation of the remains into the faces of the audience. Hideous-and hideously funny. Each of the successive food ceremonies which form the tri-partite structure of the action—the birthday party, a tea ceremony and a dinner—is a ritual which becomes the occasion for fetishism, obscenity, and a series of sounds and gestures ranging from the low- to the clearly sub-human: burping, gobbling, squealing and squawking, poking, pulling, pinching, goosing, and so on. In short, a Freudian nightmare-comedy of oral and anal obsession.

KITCHEN CENTER FOR VIDEO AND MUSIC, N.Y.

The Kitchen 1974-75. New York: The Kitchen, 1975. Catalogue documenting events sponsored by the Kitchen Center, New York, during 1974-75. Among the California artists presenting works at the Kitchen: Ant Farm (*Cadillac Ranch Show*, videotape and slide presentation), Eleanor Antin (*The Ballerina and the Bum* and *The Little Match Girl Ballet*, videotapes), John Baldessari (*The Italian Tape*, videotape), Virginia Quesada (*Sound Imagery*), Martha Rosler (*Semiotics of the Kitchen* and *A Budding Gourmet*, videotapes), Allen Sekula (*Talk Given by Mr. Fred Lux at the Lux Clock Mfg. Company Plant in Lebanon, Tennessee, on Wednesday, September 15, 1954*, videotape).

PAUL KOS

Junker, Howard. "Video Installation: Paul Kos and the Sculptured Monitor," *Arts Magazine*, v.50, November 1975, pp.64-66. General essay on the video work of Paul Kos with lengthy descriptions of *Cymbols/Symbols: Pilot Light/Pilot Butte*(1974), *rEVOLUTION: Notes for the Invasion—mar mar march*(1975), and *Tokyo Rose*(1976). Excerpt on *Tokyo Rose*:

Tokyo Rose (1976, taped but not installed at this writing) will be a trap, easy to enter, hard to escape. It will be an environment that mirrors for the viewer the content of the tape: Marlene Kos (who is credited with script and performance), in Oriental make-up as Tokyo Rose, is shown behind the meshes of a flytrap (similar to the trap the viewer has entered); she seductively repeats: "Come in. I want to be your friend. Do not struggle..."

Paul and Marlene Kos. *Tokyo Rose.* Video installation at the San Francisco Museum of Modern Art, 1975/76. A steel mesh environmental trap easy to enter contained a monitor depicting Marlene Kos as Tokyo Rose seductively repeating "come in, I want to be your friend . . . do not resist . . . I want to be your friend."

Kos, Paul. *Lightning.* 1975. Videotape, 2 mins., b/w.

Kos, Paul. *Riley, Roily River.* 1975. Videotape, 2 mins., b/w.

Welling, James. "Landscape Video," *Artweek,* v.6, October 25, 1975, p.16. Review of *Landscape Video* exhibition at the Long Beach Museum of Art. Of the eight participants, "Paul Kos takes a position which activates landscape through performance." Kos' contributions included his videotapes, *Riley, Roily River*(2 mins.), and *Pilot Butte, Pilot Light*(14 mins.). Excerpt:

Every other tape looks at landscape as something to be observed. *Pilot Butte, Pilot Light* transforms landscape. The tape begins with a shot of a butte in the middle distance. The shot cuts to a dry tree stump, presumably on the butte just pictured. A man's hands enter the frame and construct a small wooden lattice on the stump. The shot moves off to the side, and the man/performer spins a disc of ice in an overturned lid. The ice is held over

the wood for a moment and then is spun again. The ice is held over the lattice a second time. The shot cuts to another angle, and the activity becomes more apparent. The globe of ice has been shaped into a lens to focus the sun's rays on the wood. After a few moments, smoke begins to rise, and in a minute, incredibly, a flame shoots up. Eventually the lattice/pyre catches fire completely, and the lens of ice is placed on the fire. The structure collapses into ashes, and the tape cuts to the final image—the butte of the first shot, this time at twilight.

SUZANNE LACY

Lacy, Suzanne. "Gothic Love Story," *La Mamelle Magazine: Art Contemporary*, no.2, v.1, Fall 1975, pp.18-19.

LOS ANGELES INSTITUTE OF CONTEMPORARY ART

Auping, Michael. "Issues and Information: An Interview with Bob Smith, Director of the Los Angeles Institute of Contemporary Art," *La Mamelle Magazine: Art Contemporary*, no.1, v.1, Summer 1975, pp.40-43. Excerpt:

MA: A number of artists [Kaprow and Smithson in particular] have speculated that the museum, as a relevant institution to contemporary art, is dead, simply because the kind of art that fits into a museum is dead [i.e. "precious objects"]. What is your reaction to artists of that philosophy?

BS: I see that as being a real possibility. Art is evolving in that direction. Fewer and fewer material objects are being created, and more and more people are working with performance, video and that kind of thing. The situation I see as being kind of interesting for galleries and museums is that art librarians will become increasingly more important. Museum people are really trained in storing and taking care of things. Librarians are trained at storing things and making them available, taking care of information. As artists deal more and more with information, the people who are trained to retrieve data will be the ones taking care of it. In other words, museums may become libraries.

Plagens, Peter. "A Short Unofficial History of the Los Angeles Institute of Contemporary Art as Extracted from Semiofficial Documents," *Artweek*, v.6, March 15, 1975, pp.6-7. A "brief psychic history"/chronology of events related to LAICA from Plagens' file which includes minutes, clippings, press releases, informal communiques, etc. Excerpt:

April 1973—The dehydration of the Southern California art world is not an evaporation of physical facilities (Los Angeles County Museum of Art, Pasadena Museum of Art, Newport Harbor Art Museum, University of California at Los Angeles Galleries, and several other college spaces), but rather dissipated or flagging energy; the last *thing* we need is another shiny shell. (What might seem like a local problem is only too easily extended. The trouble with art patronage outside the Eastern seaboard lies not with the easy stuff—fanfare and new hardware, new executive appointments and fund-raising campaigns—but with the *hard* things—catalogued shows of difficult art, collection of same, hard-nosed criticism of same, and circulation of art and artists into the greater intellectual community.

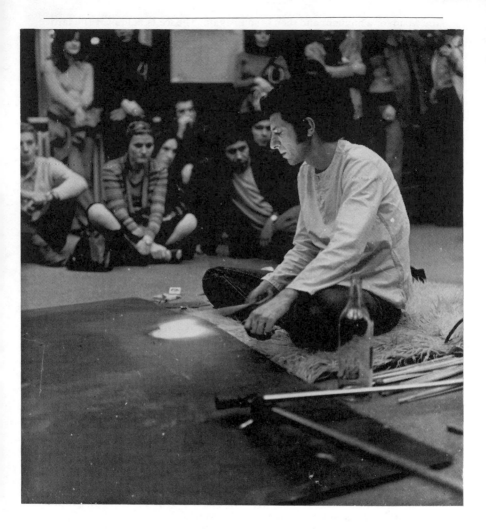

Tom Marioni. *A Sculpture in 2/3 Time.* Student Culture Center, Belgrade, Yugoslavia, 1974. "After polishing a smooth and reflective spot on an old rusted piece of steel I moved a wooden drumstick back and forth across the spot. On the underside of the spot was a contact microphone to amplify the sounds of all activity on the surface of the metal. The pendulum-like movement of the stick suggested a visual 1-2 rhythm, but the sound was 1-2-3 as in a waltz, because the stick moved from the rusted part of the metal across the polished spot and to the rusted metal on the other side. The sound superimposed on the action was 2 on 3."

TOM MARIONI

Marioni, Tom. "Conceptual Art: Idea Oriented Situations Not Directed at the Production of Static Objects," *La Mamelle Magazine: Art Contemporary*, no.1, v.1, Summer 1975.

Marioni, Tom. "Listen, Too," *Vision*, no.1, September 1975, pp.20-21.

Tom Marioni: Thinking Out Loud. Warszawa: Galeria Foksal PSP, 1975. Catalog with photo documentation and text (in Polish and English) for an exhibition at Galeria Foksal, October 1975. Excerpt from the introduction, by Wieslaw Borowski:

Tom Marioni has recently reduced his artistic procedures to simple actions with the use of sound emerging by the striking/rasping with drumsticks or wire brushes, not on an instrument, but on a plank, desk or metal plate. The uniform noise and monotonous rhythm is synchronized with the pulse of the heart or the measure of breath so as to situate the actions on the purely biological level. In this sense Marioni's rhythmical sessions belong to such tendencies in modern art which strive to reach to the primary intensity of the interaction of man with his environment and thus turn towards the elementary impulses, reflexes and bodily gestures and rhythms. When we see Marioni in action, we can't help to get fascinated with his ascetic procedure, or even, as the artist wants us to, we may be vulnerable to some suggestions analogous to the state of hypnosis. Some role may be played by the oriental implications of the artist's attitude, present in his circle, although only indirectly. It seems, however, that the suggestive appeal of those sessions and their essential meaning is by no means limited to the magical operation and is something more than an expression of the mystical faith, able to produce the states of hallucination or illumination.

PAUL MCCARTHY

Dymkowski, Greg. "Glass, Video by Paul McCarthy," *Artweek*, v.6, August 23, 1975, p.6. Review of *Glass*, McCarthy's videotape contribution to the Long Beach Museum of Art's *Southland Video Anthology*. Excerpt:

Fade-in, Paul McCarthy (I hope he's not going to throw up). Between Mr. McCarthy and the camera spans a pane of glass. We are viewing Paul's face, distorted by the pressure of his lips and open mouth against the glass. Rather unhoped for squirting noises announce a flood of saliva, now slowly drooling down the glass (Paul, please don't throw up). . . .

McCarthy, Paul. *Sailor's Meat*. 1975. Videotape with sound, 30 mins., color. "A male figure in black panties and a platinum wig approaches a moth-eaten mattress on a brass bed frame. There is a period of testing the bed, jumping and pushing. Then he rips into the bed, assaulting it sexually. The scene gets gory and lurid as various convincing props come into play: a dildo, dark, viscous fluid, white foamy ectoplasmic goo. At the end we see bare feet standing on glass fragments. Is this purification through pain?"

JAMES MELCHERT

Dunham, Judith L. "Jim Melchert: Ways of Seeing," *Artweek*, v.6, December 6, 1975, pp.1,16. Review of Melchert's exhibition at the San

Francisco Museum of Art. Excerpt:

The works in the museum installation involve one, two or more participants, usually friends and family, who carry out actions structured but not necessarily tightly scripted by Melchert. Their movements are photographed serially by Melchert or by a friend. Therefore, Melchert assumes various roles—choreographer, director, recorder and participant. Similarly, the situations he sets up, once enacted and filmed or photographed, are a fascinating sandwich of performance, dance, film and sculpture, in their multilevel implications, all contained within a two-dimensional rectangular field—either a series of flashing slides or the slow-moving frames of a film.

Jim Melchert: Points of view/Slide projection pieces. San Francisco: San Francisco Museum of Art, 1975. Catalogue for Melchert's exhibition, November 14-December 21, 1975.

Lambie, Alec and Pomeroy, Jim. "Enzyme Action," *Work*, San Francisco, no.1, 1975. An interview with Jim Melchert. Excerpt:

. . . a big change for me was in making the switch from clay objects to the

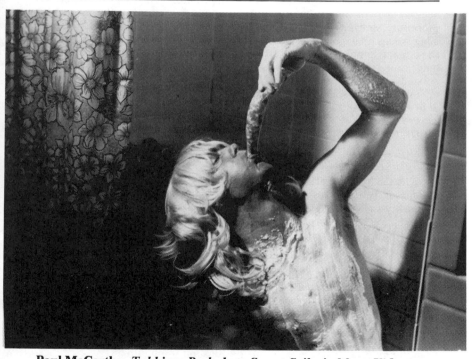

Paul McCarthy. *Tubbing: Prelude to Sweet Sailor's Meat.* Videotape, 1975. This piece was performed for video and a small audience in a cheap hotel.

170

slide projections. It started one summer when I was sitting in a warehouse where I had nothing to do but watch the wall. I decided I'd go over and get to know it. I collided with it, rolled across it, fell through the door, that sort of thing. I really got off on it. Once a pattern began forming I asked a girl to come over and try what I was doing. I got a camera and took slides of her and the wall and later projected them on the same wall exactly to size. It was fantastic what the replay of light was doing with the place. I can't imagine any medium affecting me more at that time. It introduced me to a lot of possibilities. Working with a score, for one. Thinking in terms of a particular person or persons moving in a certain space and how that could help me deal with some issue, it was easy to go into slide sequences or into performances or any of a number of areas.

SUSAN MOGUL

Mogul, Susan. "Susan Mogul," LAICA *Journal*, no.4, February 1975, p.40. Includes brief explanation of work with photograph. Excerpt:
Document from an East Coast—West Coast Introductory Piece I did with Suzanne Lacy. We breakfasted together at 9:00 AM at the Saugus Cafe (a popular student hang-out at Cal Arts) while in Cambridge we arranged for our 2 best friends, who didn't know each other, to meet at 12:00 PM at a popular cafe there. Each had her own letter of introduction from either Suzanne or myself, and after presenting these credentials, they dined together.

LINDA MONTANO

Montano, Linda. "Untitled," *Vision*, no.1, September 1975, pp.34-35. Newspaper clipping and family photo of Montano when she received the Missionary Communities habit at the Maryknoll Sisters Motherhouse, Ossining.

STEPHEN MOORE

Moore, Stephen. *Destination Death Valley*. Self-published, 1975. Artist book.

Moore, Stephen. *Destination Yucca Valley*. Self-published, 1975. Artist book.

Moore, Stephen. *Portable Lecture on Conceptual Art*. San Jose: Self-published, 1975. Artist book.

MOTION

"MOTION/Reynolds Collaborate," *Front*, no.1, 1975, p.1.

BRUCE NAUMAN

Butterfield, Jan. "Bruce Nauman: The Center of Yourself," *Arts Magazine*, v.49, February 1975, pp.53-55. Major Interview. Excerpt:
JB: I am interested in examining some of your attitudes about "art." There has to be some common ground, some societal overlap for pieces to be "visible" to others besides yourself. How little of that can we have and still have an "art form," rather than individual exercise on your part? I am interested in determining whether or not you are conscious of where the

boundaries are?

BN: Not consciously. I don't necessarily think consciously aware. I am sure that I think about that, and would really like to be working at the edge of that. What I am really concerned about is what art is supposed to be—and can become. It seems to me that painting is not going to get us anywhere, and most sculpture is not going to, either, and art has to go somewhere. . . . Everybody is going about looking for what is going to be "next" in terms of art, and it will probably turn out that it is something that has been going on all the time.

RACHEL ROSENTHAL

Danieli, Edie. "Rachel Rosenthal: A Life History," *Artweek*, v.6, December 13, 1975, p.13. Review of Rosenthal's performances at the Orlando Gallery, Encino, November 14, 1975, and at Wilshire West Plaza, Westwood, Los Angeles, November 25, 1975. Excerpt:

Rosenthal announces that this will not be a performance as was scheduled, and that we have been invited here under false pretenses. That moment is incredibly exciting; that is the phrase that breathes life into the event. She sits in a chair and slowly and very stiffly, like a marionette, begins to move her arms, and then, as if connected by string, her knees follow. She slowly rises and rotates her body to the sound of a dialogue between herself and her doctor as he examines her knees. We see slides of the X-rays, and she shows us her knees and draws in dotted lines the possible corrective surgery. She pours red liquid from a container to show us the amount of blood extracted from her knees in one examination. Now we see slides of all the activities she has had to give up: yoga, ballet, swimming, tai chi, bicycling, jogging. And to each one (outrageously staged) she says, "Of course, this is a simulation," and they are hilarious, and the situation is very sad.

Rosenthal, Rachel. "Rachel Rosenthal," LAICA *Journal*, no.4, February 1975, pp.11-15. Rosenthal's essay is in the form of a letter to Eleanor Antin, guest editor for this issue of LAICA *Journal*. Excerpt:

You asked me to give you my "best recollection" of emigre days in Southern California. As a professional emigre (WWII refuge from France via Portugal, Brazil and N.Y.C.), daughter of emigres (Father, then age 14, from the Caucasus to Paris in 1888 and Mother from the Bolcheviks to Paris in 1920), and with an atavistic hunch that there were roaming Scythians and perhaps Amazons in the remote past of my genes, I am ready to recount my very personal colonization of early L.A. . . .

MARTHA ROSLER

Rosler, Martha. "Martha Rosler," LAICA *Journal*, no.4, February 1975, p.34. Autobiographical statement describing the period when Rosler first moved to California.

Rosler, Martha. "McTowersmaid: Food Novel 2," LAICA *Journal*, no.7, August/September 1975, pp.36-37. Reprint of 14 postcards containing text of novel, *McTowersmaid: Food Novel 2*.

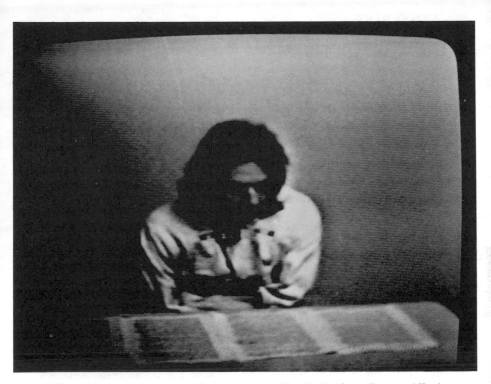

Allen Ruppersberg. *A Lecture on Houdini (for Terry Allen)*.
Videotape, 1973.

ALLEN RUPPERSBERG

Plagens, Peter. "Wilde About Harry," *Artforum*, v.13, April 1975, pp.68-69.
Excerpt:

Houdini begins with Ruppersberg, attired in a straight-jacket and seated behind a long table which exits screen left, announcing: "Good morning. Today's talk concerns a man whose name has been a household word for almost three-quarters of a century. . . ." He then proceeds to read—the sheets of text laid out side by side, and Ruppersberg scooching his chair over periodically to gain the next page—his enthralling account of the great "mysterious entertainer's" career, with particular emphasis on Houdini's love-hate struggle with spiritualism. . . .

Meanwhile, Ruppersberg plays Lacoon with the straight-jacket. Will he burst the bonds before he finishes the lecture? No. Puffing, straggle-haired, he looks up at the camera after recalling Houdini's final, aborted performance in Montreal, and concludes softly, "Thank you," still bound.

DARRYL SAPIEN

McDonald, Robert H. "Darryl Sapien's Search for Totality," *Artweek*, v.6, May 3, 1975, pp.15-16. An overview of Sapien's performance works from 1971-75. Includes photos.

VAN SCHLEY

"Van Schley and Billy Adler: World Run Completed," LAICA *Journal*, no.4, February 1975, p.43. Excerpt:

During an eight-week period, Schley ran the Olympic distance of 1500 meters in eleven cities around the world. Each run was documented by Adler.

BONNIE SHERK

Sherk, Bonnie. "AKTIN LOGIC, volume two, the farm, life, work," *Vision*, no.1, September 1975, pp.32-33.

BARBARA SMITH

Smith, Barbara. "Buddha Mind Performance: Pinched Cheek Mudra," *Vision*, no.1, September 1975, pp.54-55.

Smith, Barbara. "Of What Use Are They: Women in Industry?," LAICA *Journal*, no.7, August/September 1975, pp.17-19. Excerpt:

What *are* women here for? I could package super side products, like the ear plugs with your finely tuned installations; or what probably would work would be to take over the place and run it; that is, the business. That means a clever war so they never realize what happened until one day Bill is sweeping out behind #2, and what's his name is scouring your porcelain basin and toilet *commode*, and Terry is on the streets looking for work! However, it's the diabolics of that that bothers me, clever but so snide and sneaky. And if we tried an all out confrontation, what would come out? Probably great love. For what are we going to do? Who is the boss? What are we here for? We ought to try it! But it scares me to think because I fear the really unknown consequences and the work, cuz I don't want to win!

Wortz, Melinda. "Art Is Magic," *Artweek*, v.6, August 9, 1975, p.7. Review of Barbara Smith's work, *A week in the Life of. . . .*, an auction event; the artist's contribution to a week of benefit performances for the Pasadena Artists' Concern Gallery.

BRADLEY SMITH

Lutjeans, Phyllis. "Bradley Smith Performs," *Artweek*, v.6, May 3, 1975, p.4. Description of Smith's performance, *Steamer*, at CARP, Los Angeles. Excerpt:

All of Bradley Smith's pieces suggest a strong, formalistic, animal ritual, whereby the body is used to characterize God, man and animal, or all three at once. In addition, Smith's implementation of branches, flowers, water, fir, scent, smoke, feathers and leaves conjures up images of vaguely remembered biblical learning, probably rejected long ago by most of the viewers.

JOHN STURGEON

Sturgeon, John. *Shapes From The Bone Change*. 1975. Videotape with sound, 4 mins., b/w.

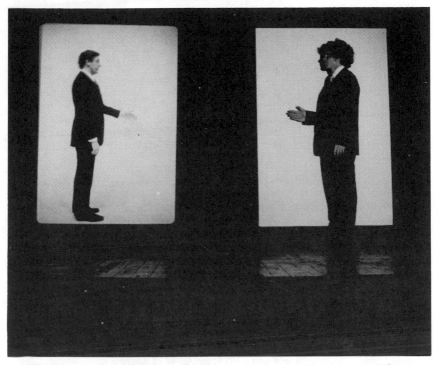

T.R. Uthco (Doug Hall, Jody Procter). *Great Moments*. California Palace of the Legion of Honor, San Francisco, Ca., 1975. A "slapstick" parody "revue" of all the great masters of performance art in general.

TRANS-PARENT TEACHER'S INK. PAUL COTTON MEDIUM

Cotton, Paul. "Trans-parent Teacher's Ink," *Vision*, no.1, September 1975, pp.28-29. Excerpt:

The Astral-Naught Earth Work is a Meta-Physical Sculpture-Poem. The Astral-Naught "space suits" or "envelopes" are designed to symbolize and re-establish the innocence of body and mind as seen through the eyes of a child. Each suit incorporates electronic radio, headphones, speaker and third-eye light thus integrating within, and illuminating the existent communications *network*. This *network* is the architectural substructure of "The Temple of the Human Mind" in which the Astral-Naught Rabb-Eyes exist as present-ions + of the Mystical Body of Christ.

T.R. UTHCO

Kent, Tom. "T.R. Uthco: The Theatrics of Performance Art," *Artweek*, v.6, January 4, 1975, p.16. An article describing a forthcoming work by Doug Hall, Jody Procter and John Hillding entitled *Great Moments by T.R. Uthco*; presented at the California Palace of the Legion of Honor, San Francisco,

January 4-5, 1975. Excerpt:
Great Moments by T.R. Uthco . . . is their ironic, parodic, at times almost slapstick "revue" of performance art in general, the trademarked moves and strategies of its better-known practitioners in particular.

Nearly every major performance artist from Acconci to Wegman receives a tasty conceptual pie in his or her face before the last *Great Moment* has passed: not even the Perfect Master Himself, Marcel Duchamp, escapes an occasional, punning dart. Obviously, the work is designed primarily for an audience of art magazine readers. Much of the humor is generated by speculation about Who's Going To Get It Next, followed by a little shock of admittedly malicious pleasure when the target is identified and properly skewered.

STEFAN WEISSER

Weisser, Stefan. "Chance Chants," *La Mamelle Magazine: Art Contemporary*, no.1, v.1, Summer 1975, pp.35-39. Artist's note for private performance, May 24, 1975, Los Angeles; with 4 pages of language permutations.

JOHN WHITE

Newton, Robert. "John White—Technicians' Theatre," *The New Art Examiner*, v.2, January 1975. Review of a performance presented at the John Doyle Gallery, Chicago.

Trimble, Pat. "John White—Performance—LAICA May 25, 1975," LAICA *Journal*, no.7, August/September 1975, pp.45-47. Excerpt:
The performance begins with the audience observing a solitary audio

John White. *Tape Recording.* A performance at the Los Angeles Institute of Contemporary Art, May 25, 1975.

recorder hanging on the wall. White enters and stands looking at the recorder first on one side, then the other, then in front of the recorder with his back to the audience. He starts the machine and the interaction begins. The recorder proceeds to give White instructions for personal location and situation. It's a reversal of artist and material role.

Welling, James. "Linking Dream Structures and Images," *Artweek*, v.6, June 28, 1975, p.16. Review article comparing performances by John White and Guy de Cointet; both performed in May,1975 at the Los Angeles Institute of Contemporary Art. See also, Guy de Cointet. Excerpt on White:

John White's performance goes something like this: A tape recorder instructs White to stand before the audience during a description of a demonstration and its subsequent destruction by police, which took place near the LAICA site. This is followed by a description of the physical sensations of boredom, during which White appears to nod off and fall asleep. The tape recorder then shuts off, and White begins a series of actions and subsequent diagrams which relate to eyeglasses; melon heads; headlessness, a bird with no head; a sheeted, ghostlike costume. Following this disjointed series of skits, White seems to lose his place. Yet he retrieves a set of instructions elaborately taped to his chest, and this paper guides him throughout the remainder of the piece. Moving to a blackboard, White reminisces on childhood experiences, and early experiences with the sale of his works and their unconscious alteration by owners, and lastly he offers a rumination on his feelings about winos.

White, John. "Direct Experience Into Art Experience," LAICA *Journal*, no.8, November/December 1975, pp.30-31. Explanation and diagram for a performance situation. Excerpt:

The following day I stopped by the same golf course for some early coffee and to read the morning paper. Stapled to the wall of the clubhouse was a tournament diagram that showed competition brackets between golfers. This diagram is used as a method to record eliminations. The two golfers who remain then play for a championship. I then decided to make a bracket diagram with the same design but using words in place of golfers' names. In this way I was able to narrow down the multiple images to the two that I then used as a basis for a performance work.

White, John. "Influencing Events #4/Putting Surface," LAICA *Journal*, no.7, August/September 1975, pp.20-21.

White, John. *Performance Notes*. Self-published, 1975. Artist book documenting a performance at Los Angeles Institute of Contemporary Art, May 25, 1975. Includes photographs, dialogue script, drawings, notes, etc., related to the performance.

BOB WILHITE

Lewallen, Connie. "Two Occurrences: Jones and Wilhite," *Artweek*, v.6, September 13, 1975, p.3. Reviews a telephone performance work by Bob Wilhite. A musical concert was performed on a stringed instrument over the telephone to anyone who responded to an advertisement in the L.A. Times announcing the event and giving the phone number.

T.R. Uthco (Doug Hall, Jody Procter). *Walking Mission Street.* **San Francisco, Ca., 1975.**

1976

GENERAL LITERATURE

Abouaf, Jeffrey. "Performer's Rights in Performance Art," *La Mamelle Magazine: Art Contemporary*, no.4, v.1, Spring 1976, p.26.

Askey, Ruth. "Southland Video Anthology, 1976," *Artweek*, v.7, October 9, 1976, p.1. Review of the first part of the 1976-1977 *Southland Video Anthology* exhibition, at the Long Beach Museum of Art. Artists included in the first part: Billy Adler, Eleanor Antin, Peter Barton, Robert Cumming, Charles Frazier, Alexis Smith, and John Sturgeon.

Askey, Ruth. "Women Artists on Art," *Artweek*, v.7, May 1, 1976, p.6. Review of a series of 10 lectures at LAICA, sponsored by Double XX (feminist artist group). Some women performance artists included in panel discussions: Eleanor Antin, Martha Rosler, Suzanne Lacy, and others.

AUTOBIOGRAPHICAL FANTASIES

Ballatore, Sandy. "Autobiographical Fantasies," *Artweek*, v.7, February 14, 1976, pp.1,16. Review of *Autobiographical Fantasies* exhibition at the Los Angeles Institute of Contemporary Art. Excerpt:

The artists shown here . . . use themselves as subject matter—some visually, some obliquely. They employ photography, language, drawing and collage, performance and environmental assemblage to reconstruct their particular individual fantasies.

"Catalog: Autobiographical Fantasies," LAICA *Journal*, no.10, March/April 1976, pp.32-37. The "catalogue" for the exhibition *Autobiographical Fantasies*, organized by Marcia Traylor for the Los Angeles Institute of Contemporary Art, January 13-February 20, 1976. Includes an essay and photo documentation of works by the eight artists included in the show: Eleanor Antin (*Meditation #XVIII*, 1975), Carole Caroompas (*Dragon Lady*, 1975), Jennifer Griffiths (*Animation Madness*, 1975), Barry Markowitz (*A Continuation*, January 31, 1976 performance), Allan Sekula (*This Ain't*

China: A Photo-novel, 1974), Ilene Segalove (*Close, But No Cigar*, 1975), Alexis Smith (*Gentlemen Prefer Blondes*, 1975) John White (*20 Years (Part One)* "*Acme John and the Mastery of the Fence,*" 1975). Excerpt:

The artists chosen for this exhibition combine the elements of the self-portrait and conceptual art to create work which I choose to refer to as "autobiographical fantasy." Works such as these have been categorized by a variety of terms including "body art," "self-transformational art," and "post-conceptual art." All deal with the same issue—the artist expanding, exploring, discovering and creating their idea of their "self" through their art.

It is a movement which has been gaining momentum for the last several years, during a period when our culture has been on its own search for "self." The women's movement, the war in Vietnam, political upheaval, etc. have created an environment of reevaluation by the individual of his or her own identity and the identity of our society as a whole. Artists and their work have always reflected the society in which they live. So it is that these artists reflect the complex nature of human behavior, along with their unique, individual realities and fantasies, by using their most readily available subject matter—themselves and their environment—to create intimate and personal statements. Each is different . . . incorporating images and information which are specific to each artist . . . The viewer understands and is affected by the work to the extent that he or she can associate with the realities and fantasies the artist is expressing.

Marmer, Nancy. "LAICA (review)," *Artforum*, **v.14, April 1976, p.77. Review of the LAICA exhibition,** *Autobiographical Fantasies.*

Perlmutter, Elizabeth. "Autobiographical Fantasies: Los Angeles Institute of Contemporary Art; Exhibit," *Art News*, **v.75, April 1976, pp.67-68. Review of LAICA's exhibition, "a show by seven Southern California Artists 'in search of themselves.' " Among the participants: Eleanor Antin, Carole Caroompas, J. Griffiths, Ilene Segalove, Alan Sekula, Alexis Smith, and John White.**

·····················

Choke, **Los Angeles, no.1, v.1, September 1976. Publisher, Choke Publications—Barbara Burden and Jeffrey Gubbins. First issue. Excerpt from "Editorial," p.2.:**

Choke is a magazine format providing possibilities for expression not usually available to artists. Choke also features documentation of current work, as well as writing including poetry, fiction and articles of general interest. Another function of Choke is to allow first-hand experience of work.

Criss Cross Double Cross, **Los Angeles, v.1, Fall 1976. Publisher, Paul McCarthy. Using a "publication as exhibition space" format, the one issue published featured over 37 artists, mainly California artists who work in the area of performance.**

Dumb Ox, **Northridge, California, no.1, v.1, Fall 1976. Editor, James Hugunin.**

Dunham, Judith L. "A Flood of Art Mags," *Artweek*, v.7, November 27, 1976, pp.7,13. Excerpt:

Two new magazines on the roster are *La Mamelle* and *Vision*, published in San Francisco and Oakland, respectively. In spite of their differences, they have a couple of things in common. Both are highly supportive of artists' concerns, and both avoid focusing primarily on criticism and art historical theory. Instead, they devote their pages chiefly to artists' works—as narrative, as documentation, as interview, in pictorial form and in verbal or conceptual form—allowing the artists much control over what each one presents. In effect, the magazines become exhibitions delivered by second class mail and are a fair substitute for the artwork. In some cases, an artist's representation in either magazine *is* the work, not merely reproduction or documentation.

Frank, Peter. "Auto-Art: Self-Indulgent? And How!," *Art News*, v.75, September 1976, pp.45-46. Extensive article on artists who work in autobiographical terms. "All kinds of auto-artists are asking who they are and how they got that way. Evoking memories and fantasies in confessional, even narcissistic terms, they begin with the man or woman they know best and least." Discusses work of Eleanor Antin and mentions other California artists such as John Baldessari, Stephen Laub, Bruce Nauman, Chris Burden; emphasis is on New York and European artists.

Futurist Synthetic Theatre Catalog. San Francisco: La Mamelle, Inc., 1976. Exhibition catalogue for a performance series entitled *Futuristic Synthetic Theatre*, directed by Christopher Lyon and sponsored by La Mamelle, Inc., in 1976.

Gale, Peggy (ed.). *Video By Artists*. Toronto: Art Metropole, 1976. A book on video, divided into 3 parts: 1) Artists' section includes a list of past exhibitions and brief bibliography as well as documentation of selected works for each artist, primarily Canadian artists; 2) Essays on Video art, 3) Bibliography of books, catalogues, periodicals and essays about Video art and artists.

Grant, Lynn. "The Printed Work," *Artweek*, v.7, April 3, 1976, pp.15-16. Review of an exhibition entitled, *The Printed Work*, an artists' book show at the Union Gallery, San Jose State University, organized by Stephen Moore.

Kent, Tom. "Five Video Artists," *Artweek*, v.7, March 27, 1976, p.7. Review of *Five Video Artists*, an exhibition at L.A. Louver. Artists included: John Sturgeon, Joel Glassman, Joel Hermann, Rodger Klein, and Joan Logue.

La Mamelle Magazine: Art Contemporary, no.3, v.1, Winter 1976. Special "Video Art" issue. Includes articles, interviews, video stills, photo and written documentation of performances, related to the subject of art video. Included in this issue: Joel Glassman, George Bolling, Alan Shepp, Ilene Segalove, Linda Montano, Lowell Darling, Billy Adler, Mary Ashley, Ant Farm, Darryl Sapien, David Ross, Eleanor Antin, Rodger Klein, Anthony D'Arpino, Richard Kostelanetz, Richard Lowenberg, etc.

La Mamelle Magazine: Art Contemporary, no.4, v.1, Spring 1976. Special "Performance Art" issue. In a "publication as exhibition space" format, the following California artists contributed to this issue: Tom Marioni, Nancy Buchanan, Terry Fox, Bonnie Sherk, Lynn Hershman, Soon3/Allan Finneran, Linda Montano, Anna Banana, Daddaland, T.R. Uthco, Monte Cazazza, etc.

Lippard, Lucy R. "Pains and Pleasures of Rebirth: Women's Body Art," *Art in America*, v.64, May 1967, pp.73-81. General essay on women's body art with examination of differences between women's and men's work in the genre. Lippard states, "I have no strict definition of body art to offer, since I am less interested in categorizing it than in the issues it raises and in its relationship to feminism."

N.E. Thing Co., Ltd. *Celebration of the Body*. Kingston, Ontario: Agnes Etherington Art Centre, 1976. Catalogue for an exhibition organized by N.E. Thing Co., Ltd., June 19-July 31, 1976. The exhibition included video, films, live performance, athletic demonstrations, workshops, lectures, etc. "The total objective throughout the *Celebration of the Body* will be to demonstrate the place of the body in Athletics and the Visual Arts."

O'Doherty, Brian. "Inside the White Cube, Part II: The Eye and the Spectator," *Artforum*, v.14, April 1976, pp.26-34. Excerpt:
The gestures are precise and could be briefly interpreted—"I am a dog, a sneezer, a pamphlet." Like pieces of Merz they are collaged into a set situation (environment), from which they derive energy. The indeterminacy of that context is favorable ground for the growth of new conventions, which in the theater would be smothered by the convention of "acting."
Happenings were first enacted in indeterminate, non-theatrical spaces— warehouses, deserted factories, old stores. Happenings mediated a careful stand-off between avant-garde theater and collage. They conceive the spectator as a kind of collage in that he was spread out over the interior—his attention split by simultaneous events, his senses disorganized and redistributed by firmly transgressed logic. Not much was said at most Happenings, but, like the city that provided their themes, they literally crawled with words. *Words*, indeed, was the title of an environment with which Allan Kaprow enclosed the spectator in 1961; *Words* contained circulating names (people) who were invited to contribute words on paper to attach to walls and partitions. Collage seems to have a latent desire to turn itself outside-in; there is something womblike about it.

Preisman, Fran. "U.C. San Diego Faculty," *Artweek*, v.7, April 17, 1976, pp.1,16. Review of Part I of the University of California San Diego faculty art show at UCSD Art Gallery, Mandeville Center. Part I included artists: Helen and Newton Harrison, Eleanor Antin, David Antin and others.

The Printed Work: An Exhibition of Artist-Produced Books. San Jose: Union Gallery/Student Union, San Jose State University, 1976. Catalogue for artists' book exhibition, March 22-April 9, 1976, organized by Stephen Moore.

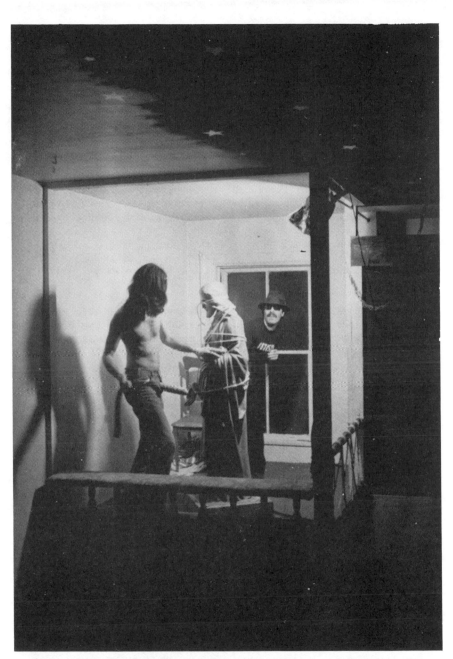

Monte Cazazza with Bill Gaglione, Ron Illardo and Joel Rossman.
Futurist Sintesi. **591 Gallery, San Francisco, Ca., 1976.**

Ross, David. "Provisional Over-view of Artist's Television in the U.S., *Studio International*, v.191, May 1976, pp.265-72. Article in the "Video Art" issue. Includes a description of Terry Fox's *Children's Tapes*, Bruce Nauman's *Lip Sync* (the first artist to show video in an exhibition in the U.S.), Paul McCarthy's *Sauce* and *Glass*, Paul Kos' *Cymbals/Symbols: Pilot Butte* and *Tokyo Rose*.

Studio International, v.192, July 1976, pp.2-68. Special "Performance Art" issue. Articles focus primarily on performance art in Europe, with some coverage of New York artists.

Videozine, San Francisco, Ca., no.1, 1976. Publisher, La Mamelle, Inc.; Editor, Carl Loeffler. A "Periodical" on videotape format. *Videozine One* (approx. 30 mins., b/w) is an anthology of contemporary new art activity including sculpture, sound poetry, language, and political works.

Weinstein, David. "Art on Tape," *Artweek*, v.7, July 3, 1976, p.5. Review of audiotape exhibition, *The Recorded Work*, at La Mamelle Inc., San Francisco, organized by Carl Loeffler, which included artists and over forty hours of tape.

Weinstein, David. "Video Overview," *Artweek*, v.7, April 10, 1976, pp.1,16. Review of *Video Art: An Overview*, an exhibition at the San Francisco Museum of Modern Art. Among the 35 participating artists, Weinstein discusses works by Paul and Marlene Kos, Ant Farm, T.R. Uthco, and others.

ARTISTS / ART SPACES

BILLY ADLER

Adler, Billy. "Billy Adler and the Charmin Toilet Paper Squeeze," *La Mamelle Magazine: Art Contemporary*, no.3, v.1, Winter 1976, pp.12-13.

TERRY ALLEN

Copley, Claire. "The Art of Terry Allen: A Personal Evaluation," LAICA *Journal*, no.12, October/November 1976, pp.12-16. Excerpt:
 It was at this time, and through this work, that the possibility of using theatre to combine visual and narrative elements arose. Theatre is an umbrella term. Under it, Terry can collect and use anything he wishes. The work can thus be seen as a stage on which something occurs. The something can be anything. Whether it occurs between people or objects or both is a coincidence of time and location. It is the sense of the coincidence of things existing separately in the world, in a given time and place that is the core of Terry's concept of theatre. By virtue of this coincidence, the elements take on new meaning and are endowed with new reality. Time added to this process, creates the constant motion that is integral to the work.

RICHARD ALPERT

Bahadur, Mir. "Richard Alpert: Illuminating the Art Process," *Artweek*, v.7, December 18, 1976, p.5. Review of Alpert's performance, *Sylph*, at La Mamelle Arts Center, San Francisco, November 1976.

NANCY ANGELO

Angelo, Nancy. *Nun and Deviant*. 1976. Videotape with sound, 15 mins., b/w. Two aberrant female archetypes—nun and deviant—reveal themselves in a close-up, confessional mode. These alter egos manifest themes of guilt, anger, unworthiness, conflict, struggle, survival. In the background, the tinkle and crash of breaking dishes provides autobiographical white noise.

ANT FARM

Ant Farm. *Automerica: A Trip Down U.S. Highways from World War II to the Future*. Written by Chip Lord; book design by Chip Lord and Curtis Schreier. New York: E.P. Dutton, 1976. Excerpt:
 This book examines the automobile in the post-War years in America from

Ant Farm. *T.V. Radiation Survey*. San Francisco, Ca., 1975. On July 25, 1975, Ant Farm (Curtis Schreier, Chip Lord and Doug Michels) made random visits to 40 homes in San Francisco to check T.V. sets for levels of X-radiation emission.

our own perspective. The design of cars, the romance of car culture, the business of Detroit, and the paradox of the sometimes misty, sometimes piercing eyes. For us it's an ambivalent relationship, which this book expresses. The freedom of movement that has been genetically programmed into our blood is as old as the human quest for knowledge and new experience. The funny, deluxe, bulbous cars that have been sold to us to satisfy that need are still funny and beautiful, but their chaotic legacy seems basic to riddles that ask: Can man control technology's domination of nature? Can man control the products of his own collective mind? Today the automobile stands at the center of these contradictions. Did the automobile and the men who made it hijack America into a dead-end freeway?

This book is not a picture book of cars, although it is full of pictures. Nor is it an academic indictment of our prevalent system of transportation based on private mobility; other authors have done that quite well. It is a book that courts ambiguity and admits to the unpredictability of man's needs—like the car itself: once it was a gadget, now it is a way of life, in the future it may be merely a strange anachronism.

The book was fun to do because the vast amount of research material—from ads in *Life* and car brochures to the ARCO idea campaign and energy crisis news clippings—all of it was entertaining. Maybe there's the solution: to remove cars from the realm of function and fix on them a sole future role of entertainment. It will be hard for the guy who lives in an isolated suburb, forty miles from his office and connected to the outside world only by his car and his television set, but it may have to be done. We must "make way for progress" and the myth of the automobile is taking up too much room in our culture.

Happy motoring!

Richard Alpert. *Sylph.* **La Mamelle Arts Center, San Francisco, Ca., 1976. "This piece took place in a darkened gallery space. Around two of the corners that protrude into the space there were two green tape lights that circumscribed 270-degree circular areas on the floor. In the larger circle the tape light was facing inward and in the smaller one it was facing outward. A small monitor was placed on the floor within the smaller. During the performance it showed a close-up view of my hands and arms cranking a generator while drawing with it against a white panel. In the larger circle, a tiny light bulb connected to the generator behind the wall illuminated the color photograph on my driver's license. The rhythmic sounds of the drawing process were audible from behind the wall. An invisible element of the piece took the form of several women having been asked to come to the performance heavily perfumed giving the space a scented odor. A perfumed card was sent as an announcement for the piece."**

Ant Farm. "The Eternal Frame: An Authentic Remake of the Original JFK Assassination," *La Mamelle Magazine: Art Contemporary*, no.5,v.2, 1976, pp.30-31. Excerpt:

In August 1975, members of Ant Farm and T.R. Uthco went to Dallas to video tape their re-enactment of the assassination of John F. Kennedy. Fearing that their desecration of an American myth could result in an unpleasant confrontation with the citizens and authorities of Dallas, the artists' motorcade made its first pass through Dealey Plaza at 7 a.m. By two in the afternoon, the artist-President had been assassinated 17 times. Dealey Plaza had become jammed with tourists who eagerly photographed the event for family and friends back home. Even the Dallas Police were cooperative, allowing traffic to be stopped for the motorcade. The reaction of the tourists ranged between amusement and being sincerely moved by the spectacle. The only confrontation occurred when the artist-Presidential party entered the Kennedy Museum just off Dealey Plaza. The impromptu speech by the J.F.K. look-alike was cut short by the curator of the museum, who demanded that he leave the premises. The event ended with the artists and tourists gathered on the grassy knoll singing "The Eyes of Texas Are Upon You."

Ant Farm. "T.V. Radiation Survey," *La Mamelle Magazine: Art Contemporary*, no.3, v.1, Winter 1976, pp.16-17. Excerpt:

Color television sets may be dangerous to your health.

On July 25, 1975, Ant Farm (Curtis Schreier, Chip Lord and Doug Michels) accompanied by Dr. Rolin Finston, Senior Health Physicist of Stanford University's Health Physics Office, made random visits to forty San Francisco homes to learn if any of the local television sets were leaking X-radiation (X-rays).

The findings were startling. Ten of the sets leaked radiation and one was leaking at a level which exceeded the government standard.

"Ant Farm," *Video By Artists*, ed. Peggy Gale. Toronto: Art Metropole, 1976, pp.10-23. Text and photo documentation related to several Ant Farm projects. Includes select bibliography and description of Ant Farm video works.

ELEANOR ANTIN

Antin, Eleanor. *The Adventures of a Nurse*. 1976. Videotape, 64 mins., color.

Antin, Eleanor. "Untitled," *Criss Cross Double Cross*, v.1, Fall 1976, pp.39-40.

Ballatore, Sandy. "Eleanor Antin: Battle of the Bluffs," *Artweek*, v.7, February 7, 1976, p.7. Review of Antin's performance as the exiled King of Solana Beach, at the Los Angeles Institute of Contemporary Art, January 17.

Crary, Jonathan. "Eleanor Antin; Clock Tower Gallery, New York; exhibit," *Arts Magazine*, v.50, March 1976, p.8. Review of Antin's live performance and videotape, *The Adventures of a Nurse*, presented January 15-31, 1976, at the Clock Tower. Excerpt:

For the past few years most of Antin's work has been connected with her creation of four alter egos for herself and the elaboration of the lives of these

Eleanor Antin. *Adventures of a Nurse.* 1976. Nurse Eleanor is the heroine of a paper-doll melodrama, in which she has a succession of romantic encounters with a dying poet, a biker, a doctor, a French ski bum, and an anti-war Senator. In photo, Antin rehearses with her cast of paper dolls.

invented "selves" through a variety of media, particularly live performance. The four roles which she alternately assumes are a King, a Ballerina, a Black Movie Star, and a Nurse. Each role is an actualization of some fantasy which she amplifies with successive presentations, creating an episodic narrative structure of indeterminate length. One feature of the work is its duration over a period of years and part of its content is how her ongoing articulation of the fictive roles contends with and modifies her identity as Eleanor Antin, California artist. A kind of congruence emerges between this narration of her fantasies, the detailing of these imaginative portraits, and her own autobiography.

Stofflet, Mary. "Eleanor Antin: An Interview by Mail," *La Mamelle Magazine: Art Contemporary*, no.3, v.1, Winter 1976, pp.22-23. Excerpts:

MS: Do you do performances specifically for the purpose of making a video piece? For example, *The Ballerina and the Bum* as a videotape gives no sense

of an audience nearby. On the other hand, *The King's Meditation*, which I saw recently at the California Palace of the Legion of Honor, was clearly *not* done as a performance meant for taping.

EA: I do live performances for a particular space, time and audience. I do my performances on video only for an audience that will subsequently look at it on a small TV screen, probably in a dark, or semi-dark room, hopefully sprawling comfortably on the floor or on pillows. Once I used an audience on video (in *The Little Match Girl Ballet*) but I used them deliberately to set up a Degas-like space from which the narrative I was spieling out would eventually take me far away. So the story I was telling overflowed its banks and flooded the screen, taking over, not unlike Terry's spoons and faucets. . . .

MS: Your videotapes are among the most widely accessible I've seen. They provoke laughter, sadness, pity—a whole range of human reactions. Is this a conscious effort to stay away from the elitism and mysteriousness often found in performance and video art?

EA: No, people often consider me a didactic artist but I don't. I'm only doing what seems reasonable to me. My interests in making video are primarily narrative. I do think the narrative experience is a basic human need. I think sometimes that it acts on the same principles as dreams, as a kind of re-ordering of the world, putting it together in different ways, just for the hell of it, to try out those ways and paths we discarded in favor of the ones we took. For every step you take in this world you could have taken several others instead. They sit there haunting us, those discarded steps. Narrative is a kind of exorcism, a trying-on of the "might-have-beens," the discards, the losers. You let them in for a while and they stop haunting you. Maybe. . . .

MS: How do you see your involvement with video developing over the next few years, if you plan that far ahead?

EA: Narrative, and more narrative. At this time, I'm making my Nurse Tapes. She, the nurse, plays with paper dolls she's made herself. They are the actors in these videotapes. They have adventures, fall in love with the Eleanor doll, get discarded by her, kill themselves or whatever. You might say it's narrative starting on a course of regressions. My invention (the nurse) invents her own inventions (the paper dolls).

NANCY BLANCHARD

Blanchard, Nancy. *Encounters with Michael Caine*. 1976. Audiotape, 15 mins.

BOB & BOB

Brennan, Barry. "It's Bob & Bob: Calling Beverly Hills!," *Evening Outlook*, July 24, 1976, p.8A. Text and 4 examples of Bob & Bob's "memorandum" work.

NANCY BUCHANAN

Aber, Buchanan, Holste. Newport: Newport Harbor Art Museum, 1976. Catalogue for an exhibition.

Buchanan, Nancy. "Rock 'n' Roll Piece," *La Mamelle Magazine: Art Contemporary*, **no.4, v.1, Spring 1976, pp.8-9. Documentation with text and photo of performance work presented in August 1974 at the Gerard John Hayes Gallery, Los Angeles. Excerpt:**

In preparation for this performance, I had multiple photographs made of myself wearing a long, blonde wig, which I signed and numbered; these were sold as raffle tickets.

The audience was greeted by Blue Cheer, a rock 'n' roll band, who introduced me. Together we performed a song entitled "Union Oil Company's annual report to shareholders," which I composed from the same, written by Fred Hartley, Jr. (Union Oil). I was then blindfolded and drew two winners of the raffle. While seated at a small table, a performer drew a syringe full of my blood. I announced that the raffle prize was four shares each of Union Oil stock, which I had inherited from my family some years previously. I read the latest Dow Jones averages for Union Oil from the "Wall Street Journal," and signed away ownership with the blood.

Buchanan, Nancy. "Wolfwoman," *Criss Cross Double Cross*, **v.1, Fall 1976, pp.67-68. Photo and text documentation of work,** *Wolfwoman.*

Nancy Buchanan (with Ransom Rideout). *Rock 'n' Roll Piece.* **Gerard John Hayes Gallery, Los Angeles, Ca., 1974.**

Nancy Buchanan. *Rock 'n' Roll Piece.* **Gerard John Hayes Gallery, Los Angeles, Ca., 1974. Band: Blue Cheer.**

CHRIS BURDEN

Burden, Chris. "B-Car," *Choke*, no.1, v.1, Fall 1976, pp.23-26. Photos and statement by Burden regarding his B-Car. Excerpt:

During the two-month period between August 24 and October 16, 1975, I conceived, designed and constructed a small one-passenger automobile. My goal was to design a fully operational four-wheel vehicle, which would travel 100 miles per hour and achieve 100 miles per gallon. I conceived of this vehicle as extremely light-weight, streamlined and similar in structure to both a bicycle and an airplane. Details similar to bicycle design include spoke wheels, adjustable wheel bearings, and space frame construction. Cable-operated controls, fabric covering, skeletal structure, and careful consideration for weight distribution are found in light-weight airplane construction. . . .

Driving the car as a performance was not important after the ordeal of bringing it into existence.

Burden, Chris. *Chris Burden 71-73*, reviewed by Roselee Goldberg, *Art-Rite*, no.14, Winter 1976/77, p.40. Excerpt:

Burden's book is a pictorial documentary of private rituals, not unlike those of ancient Indian sects who hang themselves from palm trees suspended only by metal hooks pierced into the skin of their backs, or who run barefoot through burning ashes and broken glass. Burden's painful exercises are there for the record. . .

Burden, Chris. *Chris Burden Promo*. 1976. Videotape, 30 secs. Intended as a tongue-in-cheek piece. Series of famous names in art history flashes on screen, culminating with "Chris Burden."

Burden, Chris. "100 M.P.H. / 100 M.P.G.," *Criss Cross Double Cross*, v.1, Fall 1976, pp.37-38.

Burden, Chris. *Poem For L.A.* 1976. Videotape, 30 secs. Titles and reading of poem alternate on the screen: "Science has failed," "Heat is life," and "Time kills."

Burden, Chris. Untitled composite tape including 3 pieces for television broadcast, 1973-76. 1976. Videotape, 4 mins., color.

"Do You Believe in Television?" Calgary, Alberta: Alberta College of Art Gallery, 1976. Catalogue documenting Burden's work performed at A.C.A. Gallery on February 18, 1976. Introductory essay by Brian Dyson. Description of event, excerpt:

The event 'Do You Believe in Television' took place in a stairwell connecting different levels of the parking lot adjacent to the College of Art. Three television monitors were suspended from three levels as indicated. A fixed television camera and two quartz lights were suspended at the lowest level. In addition a microphone was connected to the speaker on one of the monitors. Chris Burden instigated the event from the bottom of the stairwell, sitting underneath the first intermediate level and completely hidden from the public. The camera was focused on a black tape cross stuck to the floor at Burden's feet. This image was visible on all three monitors when the public

was admitted. The only source of light on the upper levels was provided by the television monitors. A trail of straw about three inches deep started from just in front of the black cross and wound its ways up the staircase to the top level. The audience was admitted at 7:45 p.m. About 100 people attended, gathering around the television monitors on the three levels. At 8:00 Burden picked up the microphone and asked 'Do You Believe in Television?' He then struck a match, held it over the centre of the cross for a few seconds and then proceeded to light the straw. The flames slowly spread along the trail leading up the stairwell. The image on the television monitors remained unchanged. As the straw continued to burn the stairwell began to fill with smoke and breathing became very uncomfortable. The audience remained, watching the image on the monitors. At about 8:30 p.m. the Fire Department arrived.

Horvitz, Robert. "Chris Burden," *Artforum*, v.14, May 1976, pp.24-31. Major article on Chris Burden, includes several photo illustrations of his works.

Seiberling, Dorothy. "The Art-Martyr," *New York Magazine,* May 24, 1976, pp.44-46. Lengthy article on Chris Burden with photo documentation of works. From a historical perspective, discusses Burden's work from 1971 to 1976.

CARP

Nix, Marilyn and Burden, Barbara. "Carp: Documentation," LAICA *Journal*, no.12, October/November 1976, pp.8-11. Calendar of past events that were sponsored by Carp from March 21-August 11, 1976, with photo documentation of selected works.

Chris Burden. *Art and Technology*. De Appel, Amsterdam, Holland, October 16, 1975. "During the two month period of August 24 to October 16, 1975, I conceived, designed, and constructed a small one passenger automobile. My goal was to design a fully operational four wheel vehicle which would travel 100 miles per gallon. I conceived of this vehicle as extremely lightweight, streamlined, and similar in structure to both a bicycle and an airplane. Details similar to bicycle design include spoke wheels, adjustable wheel bearings, and space frame construction. Cable-operated controls, fabric coverings, skeletal structure, and careful consideration for weight distribution are found in light weight airplane construction.
The completed 'B-Car' was disassembled and air freighted to Holland. I re-assembled the car in four days as a performance for the De Appel Gallery in Amsterdam."

Kevin Costello. *A Sojourn in the City*. San Francisco, Ca., 1976.

KEVIN COSTELLO

Costello, Kevin. "A Sojourn in the City," *La Mamelle Magazine: Art Contemporary*, no.5, v.2, 1976, p.35. An idea by Kevin Costello.

LOWELL DARLING AND ILENE SEGALOVE

Darling, Lowell and Segalove, Ilene. *Cauliflower Alley Tapes*. 1976. Videotape, color.

Darling, Lowell and Segalove, Ilene. "Hollywood Anthropology/'Two Subjects from the Cauliflower Alley Tapes,' " *La Mamelle Magazine: Art Contemporary*, no.5, v.2, 1976, pp.20-21.

GUY DE COINTET

de Cointet, Guy. "Aimee S. McPh.," *Criss Cross Double Cross*, v.1, Fall 1976, pp.57-58.

Frank, Peter. "Performance Diary," *The SoHo Weekly News*, April 1, 1976, p.18. Review of de Cointet's work *At Sunrise a Cry Was Heard*, for his New York debut.

Richard Alpert. *Finger*. 80 Langton St., San Francisco, Ca., 1975.
"This piece was a static installation. The room was in general
darkness except for lights aimed at several areas in the space. An
unidentifiable sound could be heard from the rear of the room. The
first illuminated area approached upon entering the space showed the
sentence "Chris-I went to the hospital-I think I cut my hand bad"
alongside a knife and some bread. In the second spot was found a
photograph placed on the floor. At the rear of the room was a
spotlighted door out of which protruded my two fingers as my only
visible presence in the room. As this area was approached, the sound
in the space could be heard coming from an adjacent room through an
open doorway, and could be identified as that of a ball bouncing in a
confined space. The lighting was set so that it was difficult to see into
the room without entering it. Upon entering, the source of the sound,
a tape recording playing, could be seen in the almost totally dark
room."

JOHN DUNCAN

Duncan, John. *Free.* 1976. Videotape with sound, 9½ mins., color. Readings from the Marquis de Sade counterpoint the image of a knife blade slicing across the palm of a hand, back and forth until blood flows.

Duncan, John. *Right.* 1976. Videotape with sound, 14 mins., color. Images of crisis. Man paces a small room like a trapped creature, alternately cringing and shouting. Soundtrack accompanies with readings from noted works on liberation.

Duncan, John. "Untitled," *Criss Cross Double Cross,* v.1, Fall 1976, pp.21-22.

80 LANGTON ST.

80 Langton St. Documentation / The First Year—1975-76. San Francisco: 80 Langton St., 1976. 34 postcards documenting video performances, music, film, poetry, dance, photography, installations, sponsored by 80 Langton St. during 1975-76. Among the artists included: Irv Tepper, Eleanor Antin, Jack Micheline, Nancy Blanchard, Alan Shepp, Richard Alpert, Peter d'Agostino, Linda Montano and Nina Wise, Stephen Moore, MOTION (Joya Cory, Suzanne Hellmuth, Nina Wise), Jock Reynolds, and others.

ALAN FINNERAN

Di Felice, Tom. "Soon 3: An Interview with Alan Finneran," *La Mamelle Magazine: Art Contemporary,* no.4, Spring 1976, pp.17-19. Includes photos. Excerpt:

TD: The progression from painting to Soon 3 is of interest to me. You exercise the same control over a piece as a painter over a canvas.

AF: That's certainly what gives Soon 3 the character it has—the fact that I come from a visual orientation as opposed to a theatrical background. To make every image, every sound, every piece of sculpture accountable so that it's not just there. There's a reason for every motion, for every change in the image so that it will create a natural structure of its own as it happens. Many times people have used this type of input of projections and sound and actors, the use of it being a textural thing creating an overall flowing audio-visual environment. That I see as a major aesthetic difference from the work I do. It's not my interest at all. At the same time I don't want to tell stories with it. I want each piece to create its own existence at the moment it's happening. Not at all arbitrary. As you've seen, everything is very, very precise. It's funny because what happens in the show is always extremely clear but why it happens is never clear at all. And that's intentional. A lot of people have worked the opposite way: what happens is very unclear but why it happens they'll write you volumes about; the visual information is vague but the literal bullshit behind it will go on for days. I work exactly oppositely in that I make things extremely clear and I don't even claim to know why they're happening.

TD: The scale on which you operate seems to put you in a very different position from most other performance artists.

AF: The scale of the work is important because the audience you're dealing

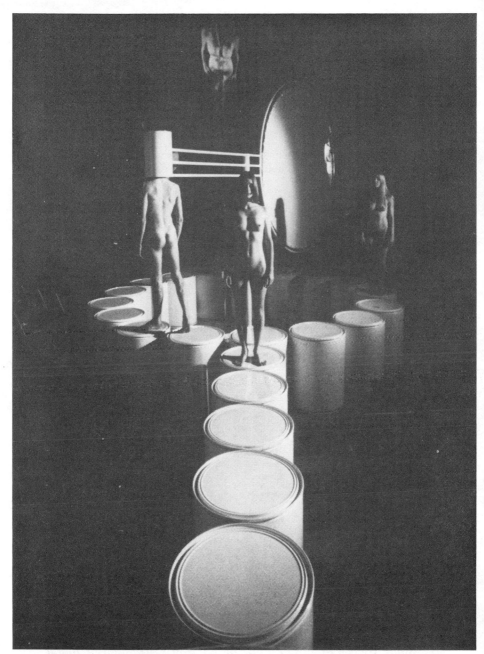

Soon 3. *Cinemasculpture*. Directed by Alan Finneran, 1976.

with is so filled and bombarded every day as they drive down freeways, in and out of elevators, and through supermarkets that I think it's very difficult for people to look at an etching. I have nothing against etchings, but most people would feel more comfortable with my scale of work, because physically it's in a more naturally relatable state to their environment—a frame in a museum is not a natural part of the environment we all live in. When we set up a show, the feeling, the scale, the simultaneity of it feels like a natural physical presence to exist in for an hour as you watch the show.

LELAND FLETCHER

Hett, David. "Leland Fletcher: Dept. of Art Works," *Heirs*, no.10, v.6, Winter 1975/76, pp.8-13. Photos with text in English, Spanish, and Japanese.

"Leland Fletcher: Department of Art Works," *La Mamelle Magazine: Art Contemporary*, no.5, 1976, pp.36, 72-73. Excerpt:

The Department of Art Works serves to function as a means of confrontation by changing an area and defining that change in a unique and unusual manner. Fletcher's choice of construction as his medium reflects the way society tends to relate to the earth—as a construction site, to be rearranged, built upon, and shaped to fit a view of the world and our place in it.

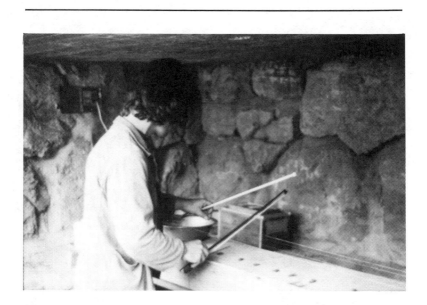

Terry Fox. *Timbre*. Mt. Tamalpais amphitheater, Ca., 1976. Fox performing from a prompter's box on a string instrument of found objects. Fox hired an airplane to fly over the performance and tuned his instrument to the propeller pitch.

PAUL FORTE

Forte, Paul. "Solar Transfer, 1976," *La Mamelle Magazine: Art Contemporary*, no.5, v.2, 1976, pp.46-47. Four photographs from a performance, *Solar Transfer*.

Forte, Paul. *Something Without Time* San Francisco: La Mamelle, Inc., 1976. Videotape, b/w.

TERRY FOX

Fox, Terry. *The Labyrinth of Chartres*. 1976. Full stereo audiotape, 95 mins.

Fox, Terry. *Lunar Rambles*. New York, 1976. Videotape, 4½ hours, color.

Fox, Terry. *Timbre*. 1976. Videotape, 30 mins., b/w.

Fox, Terry. "Timbre," *La Mamelle Magazine: Art Contemporary*, no.4, v.1, Spring 1976, pp.10-11. A brief explanation by Fox about his work, *Timbre*, with photos by Tom Marioni. The text:

"Timbre": A performance for two instruments: a homemade instrument strung with piano wire, and a Cessna 172 single engine airplane. During a period of two hours the airplane made six passes over the performance area out of sight of the spectators. The instrument emitted a continuous drone for four and one half hours and was tuned to the propeller pitch of the airplane. March 1976. Sponsored by the San Francisco Museum of Modern Art.

The stone amphitheatre on Mount Tamalpais is nineteen hundred and fifty feet above the ground floor of the San Francisco Museum of Art, and approximately twenty miles to the Northwest of my studio, which is six blocks from the Museum. The amphitheatre was built in the thirties by the Conservation Corps on a natural, acoustically rich meadow which had been the site of open theatre since the early nineteen hundreds. The theatre is near the top of Mount Tamalpais, a State Park Preserve, and overlooks the San Francisco Bay. The stage area is a semicircle of earth with a flat stone in its center and small trees as a backdrop and reflecting surface. The stage prompter's box is hidden from view, recessed under the first tiers of seats, four feet below the surface of the stage. It is designed so that sound issuing from it is directed to the rock in the center of the stage and is inaudible from the seating area of the theatre.

I'm looking at the model of the prompter's box next to my typewriter. It's made of the same stone as the actual box, only scaled down. It's ten inches long, six inches wide and six inches deep in the center, with a two inch stone bench running around three walls of its interior, the fourth wall open and facing me. The ceiling is flat and made of concrete. There is a drain in the recessed floor, but it is plugged by a small rubber mat and the bottom has been filled with an inch of water to create a smooth, flat, reflective surface. A thin wooden box, eight inches long, rests with each end on a stone seat so that it is suspended over the water. It has four metal wires stretched taut along its length, passing over wooden bridges, creating an instrument. A tiny figure is standing in the water and plays the box instrument, striking the strings with a stick the size of a sliver. As I watch, my heart makes my body rock back and forth. I can feel a low pulsating in my stomach. I begin to hear

an engine idling on the street below my open fire door. I live in the middle of the City. I live on a wood floor, smooth and tight. The brick walls, compressed by their own weight, vibrate with the low pulsations from the idling engine. I can hear other objects in the room moving in sympathetic vibration with the pulses from the engine. The spilled salt on the table forms itself into small, writhing mounds. The wooden floor is strung with piano wires stretched taut over wooden bridges. The wires begin to hum, one the overtones of the other. My floor is a resonating box. My brother's room, below, is a sound box, reflecting and amplifying the pulses back against his ceiling, my floor. The windows rattle, the empty glass on the table begins to sing a low, deep note. As I watch the figure in the model, the rumbling of the idling engine becomes a low but discernable note and an object enters my field of vision from the left, just behind my shoulder. A tiny airplane makes a pass over the model, far behind it, under the shelf and near the wall. The drone from the instrument in the model is in tune with the propeller pitch of the airplane and for a few seconds they synchronize. Then, as the plane moves through the overtones of its fundamental and disappears from my field of vision, I once again become involved in the sound of the instrument. The sound hole of the model, of the prompter's box, is directed toward me, toward the central city. It is surrounded by tiny people, all making so much noise that it is difficult to hear the instrument. As I lean forward and strain to catch the sound, I again perceive a low pulse in my stomach and again I am aware of a tiny object moving into my line of vision, this time from the right, near my ear. My mind is in the empty drawer of a wooden dresser, I don't need it. The sound vibrates my eardrum, disturbs the labyrinth of my inner ear, vibrates my abdomen, rattles my skeleton, physical and beyond my will. The object enters my field of vision and I can see that it's a fly.

Loeffler, Carl. "Terry Fox Performance," _Front,_ no.3, v.1, March 1976, p.1. Text with photo describing Fox's work, _Timbre,_ performed at Mt. Tamalpais amphitheatre, March 13, 1976 at 3 p.m. Text:
Timbre: 1. the characteristic quality of sound that distinguishes one voice or musical instrument from another: it is determined by the harmonics of the sound and is distinguished from the intensity and pitch; 2. in phonetics, the degree of resonance of a voiced sound, especially of a vowel.

Terry Fox: physical trauma/dreams of the blind/steer manure, white strings, fish, levitation/Dusseldorf and Beuys/winos in doorways with tattooed bellies/Chartres Cathedral/burning candles dripping wax/rituals/transcendental homage.

Timbre Performance: Mountain amphitheatre-Fox standing in prompter's box. His back facing the audience. Unassuming. Before him a stringed instrument of found objects: wooden bench, box, clamps, bowl (stainless), and steel strings. Fox is playing the internal space-generating sound on sound on sound. This basic action continues for five hours. Subtitles: Fox hired an airplane to fly over the performance six times and tuned his instrument to the propeller pitch; the prompter's box attempts to duplicate the acoustics of a nearby cistern.

Wiegland, Ingrid. "The Lunar Rambles of Terry Fox," _Soho Weekly News,_ June 17, 1976.

KEN FRIEDMAN

Friedman, Ken. *Five Events and One Sculpture*. Sacramento: Stan Lunetta, 1976. Broadsheet provides brief notes for events by Friedman.

Friedman, Ken. *Sociology of Art: An Aspect of the Special Reality of the Art World*. San Diego: Unpublished Ph.D. dissertation for United States International University, 1976.

Ravicz, Marilyn Ekdahl. *Ken Friedman: The World That Is, The World That Is To Be*. Self-Published, [1976].

HELEN AND NEWTON HARRISON

Harrison, Helen and Newton. "Meditations," *Criss Cross Double Cross*, v.1. Fall 1976, pp.33-34. "A proposal to the Floating Museum at San Francisco entitled, *Meditations on the Condition of the Sacramento River, Its Delta and the Bays at San Francisco*, a work in three parts, five mediums and three time frames."

LYNN HERSHMAN

Hershman, Lynn. *Lady Luck: A Double Portrait of Las Vegas*. Self-Published, 1976. Documentary artist book for a work that took place at Circus Circus Casino and Spa in Las Vegas, Nevada, March 2, 1975. Excerpt:
On March 2, 1975, the ritual celebration was performed. Lisa [Charles] and her wax altered ego matched wits at the roulette table of Circus Circus. Sixteen curious spectators flew to Las Vegas from San Francisco to share the experience. Lisa and Lady Luck each began with $1500.00 worth of chips. While Lisa based her bets on intuition, Lady Luck was aided by an amplified tape of prerecorded numbers. By the end of the game, Lisa had $40.00 while Lady Luck had won $1620.00.

Hershman, Lynn. "Roberta Breitmore: An Alchemical Portrait Begun in 1975," *La Mamelle Magazine: Art Contemporary*, no.5, 1976, pp.24-27. Text and photo documentation regarding the identity of Roberta Breitmore. Excerpt:
Brief Statement
ROBERTA BREITMORE is a portrait of alienation and loneliness. Her performance takes on the form of a real life drama based on real life, in real time. Her alteration is kept to a minimum. As Roberta becomes more real, the people she meets become fictionized types. The identities of the people Roberta meets are never revealed. She operates as would a sociologist, interviewing and noting reactions of the people who respond to her. She is, in effect, a mirror-magnet for a sector of San Francisco's community.

Larkin, Kitty. "Window Stopping," *New York Daily News*, October 29, 1976, p.56.

Stofflet, Mary. "Some Notes on a Conversation with Lynn Hershman, Director of the Floating Museum," *La Mamelle Magazine: Art Contemporary*, no.4, v.1, Spring 1976, p.17. Excerpt:
The floating museum recycles space. The idea involves recycling, using

Lynn Hershman. *Lady Luck: A Double Portrait of Las Vegas Personification of a Myth*. Circus Circus, Las Vegas, Nevada, 1975. Lisa Charles and Hershman's *Lady Luck* played roulette. Lisa used intuition, Lady Luck used a pre-recorded tape. Each began with $1500. At the end of the game, Lisa had $40.00, Lady Luck $1,600.20.

found environments in ways that they haven't been used.

Artists are commissioned and paid. The artist finds a site and the floating museum makes the arrangements for the site, the materials and the publicity

The floating museum is museum expansion without the cost of facilities. We are interested in investigating ideas attitudes of all kinds.

DAVID IRELAND

David Ireland. Bellingham, Washington: Whatcom Museum of Art and History, 1976. Catalogue for Ireland's exhibition at the Whatcom Museum of Art and History, September-November 1976. Includes photo documentation, chronology, and interview by Trudi Richards.

ALLAN KAPROW

Activity Dokumente. Bremen: Kunsthalle, 1976. Catalogue for an exhibition; contains photos of earlier works and programs of *Refills, Basic Thermal Units, Sweet Wall, Sawdust, Meteorology, Third Routine, 7 kinds of Sympathy*, and *Durations*.

David Ireland. *Reconstruction of a Portion of the Sidewalk at 500 Capp St*. San Francisco, Ca., 1976. Ireland restoring the sidewalk in front of his home with great gusto and in the art spirit.

David Ireland. *The Restoration of a Portion of the Back Wall, Ceiling, and Floor of the Main Gallery of MOCA.* **Museum of Conceptual Art, San Francisco, Ca., 1976. Tom Marioni commissions Ireland to restore a portion of MOCA. "It was making a painting, a very large painting, where the idea was clear . . . We had a photograph and all we had to do was make a photorealist painting."**

Ballatore, Sandy. "The 'Un-Artist' Observed," *Artweek,* **v.7, March 13, 1976, pp.1,16. Review of an exhibition at Los Angeles Institute of Contemporary Art in which Kaprow's works reveal recent "activities"; included, Pasteups for 5 booklets (done between 1973-76), a videotape and 2 films (***Routine*** and ***Warm-Ups***). Excerpt:**

Kaprow's booklets and films, as he explains it, "were made and assembled to illustrate a framework of moves upon which an action or set of actions could be based. They function somewhere between the artifice of a Hollywood movie and an instruction manual. The pictures explain the words and the words explain the pictures. Thus the conversion of an event into an exhibit or magazine article becomes a species mythology.

Crary, Jonathan. "Allan Kaprow's Activities," *Arts Magazine,* **v.51, September 1976, pp.78-81. Article on Kaprow's "Activities" since 1971; discussion of several "Activities" (***Time Pieces, Routine, On Time, Take-Off, Satisfaction, Comfort Zones, Maneuvers***) in relation to interactions that take place between participants during these "Activities." Excerpt:**

Kaprow calls them "Activities" to distinguish them qualitatively from Happenings. Intrinsic to his conception of them are: the absence of an

audience of any kind, that it is carried out in a physical environment without art world or institutional associations, and that there be no documentation of the event. Each Activity has been performed only once, although there is no major reason why they couldn't or shouldn't be repeated. The scripts of many of the Activities have been released in book form with accompanying photographs of a simulated enactment of the work.

Kaprow, Allan. *Maneuvers*. Napoli: Framart/Studio, 1976. Artist book. An activity "carried out by a small number of couples in the environ of Napoli, Italy, in March of 1976 . . . sponsored by Framart Studio.

Kaprow, Allan. "Non-Theatrical Performance," *Artforum*, v.14, May 1976, pp.45-51. Kaprow discusses the difference between theatrical and non-theatrical performance. Describes a Happening entitled, *Berlin Fever*, arranged by Wolf Vostell in West Berlin, 1973, and a work by Kaprow entitled, *7 Kinds of Sympathy*, that took place in Vienna, 1976. Excerpt:

To understand non-theatrical performance as an idea, it might be worthwhile to consider the current state of the art profession in the West. Every artist has at her or his fingertips a body of information about what has been done and what is being done. There are certain options. Making performance of some sort is one of them. Making non-art into art is another. Non-art art, when applied to performing, means making a performance that doesn't resemble what's been called art performance. Art performance is that range of doing things called theater. An artist choosing to make non-art performances simply has to know what theatrical performances are and avoid doing them, quite consciously, at least in the beginning. The value in listing one's options is to make things as conscious as possible; experimenters can experiment more when they know what's what. Accordingly, here is the ball game I perceive: an artist can

1) work within recognizable art modes and present the work in recognizable art contexts
 e.g. paintings in galleries
 poetry in poetry books
 music in concert halls, etc.
2) work in unrecognizable, i.e. non-art modes but present the work in recognizable art contexts
 e.g. a pizza parlor in a gallery
 a telephone book sold as poetry, etc.
3) work in recognizable art modes but present the work in non-art contexts
 e.g. a "Rembrandt as an ironing board"
 a fugue in an air conditioning duct
 a sonnet as a want-ad, etc.
4) work in non-art modes but present the work as art in non-art contexts
 e.g. perception tests in a psychology lab
 anti-erosion terracing in the hills
 typewriter repairing
 garbage collecting, etc. (with the proviso that the art world knows about it)
5) work in non-art modes and non-art contexts but cease to call the work art, retaining instead the private consciousness that sometimes it may be art, too

(cont'd, p.214)

MANEUVERS

*B*audelaire, writing of his friend the painter Delacroix, said admiringly that he was one of those men who could say "mon cher Monsieur" twenty different ways.

Within the forms of polite behavior there is enough room to transmit numbers of complex messages. For instance, holding open a door for someone to pass through first is a simple kind of social grace that is learned almost universally. But between persons of the same sex or rank, there may be subtle jockeying for first or second position. Each position may signify the superior one in a particular circumstance.

In cultures which are facing changes in women's and men's roles, the traditional male gesture of reaching for and holding open a door for a woman can meet with either rebuke or knowing smiles. In another vein, one can be "shown the door" (be ordered to leave) with almost the same gross body movements as when being invited to go first. But there is never any doubt about what is meant.

MANEUVERS is an exaggerated arrangement of such competitive, often funny, exchanges between two individuals as they go through doorways. With repeats and variations resembling slapstick movies that are played backwards and forwards, it may become unclear which side of a door is "in" or "out". After finding fifteen different doors to carry out these moves, the initial question of being first or second might seem problematical. Other levels of communication may become apparent to the partners.

MANEUVERS was carried out by a small number of couples in the environs of Napoli, Italy, in March of 1976. Each couple was independent of the others, but when the program was completed they met together to discuss their experiences. The Activity was sponsored by Framart Studio.

ALLAN KAPROW

Allan Kaprow. *Maneuvers*. An artist book describing an activity "carried out by a small number of couples in the environ of Napoli, Italy in March of 1976 . . . sponsored by Framart Studio."

1 A and B
passing backwards
through a doorway
one before the other

the other, saying you're first

passing through again
moving in reverse
the first, saying thank me
being thanked

locating four more doors
repeating routine

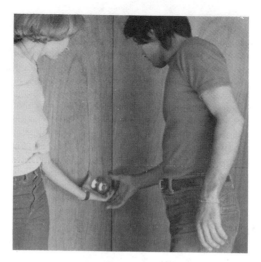

2 A and B
locating still another door

both reaching to open it
saying excuse me

passing through together
saying excuse me

both reaching to close it
saying excuse me

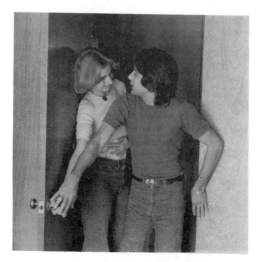

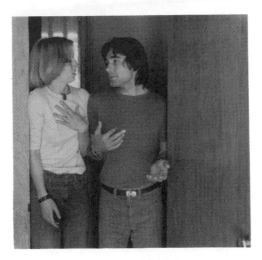

backing in reverse to door
both reaching to open it
saying after you
passing through together

both reaching to close it
saying after you

locating four more doors
repeating routine

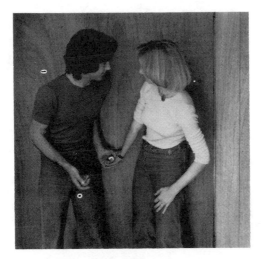

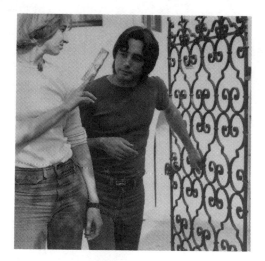

3 **A and B**
 locating still another door

 passing through
 one before the other
 the first, saying I'll pay you
 the second, accepting or not

 locating four more doors
 repeating routine

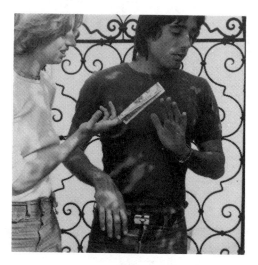

e.g. systems analysis
 social work in a ghetto
 hitchhiking
 thinking, etc.

Any artist can locate him-or herself among these five options. Most belong to the first, very few occupy the fourth, and so far, I know of no one who fits the fifth who hasn't simply dropped out of art entirely. (One runs into such post-graduates from time to time, but their easy testimonials to the good life lack the dense ironies of doublethink that would result from simultaneous daily participation in art and, say, finance.)

Performance in the non-theatrical sense that I am discussing hovers very close to this fifth possibility, yet the intellectual discipline it implies and the indifference to validation by the art world it would require, suggest that such a person would view art less as a profession than as a metaphor. At present such performance is generally non-art activity conducted in non-art contexts but offered as quasi-art to art-minded people. That is, to those not interested in whether it is or isn't art, but who may be interested for other reasons, it need not be justified as an artwork. Thus, in a performance of 1968, which involved documenting the circumstances of many tire changes at gas stations in New Jersey, curious station attendants were frequently told it was a sociological study (which it was, in a way), while those in the cars knew it was also art.

Kaprow, Allan. *7 Kinds of Sympathy*. Self-published, arranged in cooperation with Gallerie Baecker, Bochum, Germany, 1976. Artist book. An Activity that took place in Vienna, March 1976, sponsored by Vienna's Museum of the 20th Century.

Kaprow, Allan. *Seven Kinds of Sympathy*. 1976. Videotape, 8 mins., color.

Kaprow, Allan. *Sweet Wall/Testimonials*. Berlin: Edition Rene Block, 1976. Artist book. Description of two Activities. For *Sweet Wall* a handful of people built a free-standing cinder block wall mortared with slices of bread and jam in a desolated area of Berlin close to the real Berlin Wall; the event took place November 1970 and was sponsored by Galerie Rene Block. *Testimonials* took place June 1976, in Berlin, sponsored by Galerie Rene Block in cooperation with the Deutscher Akademischer Austauschdienst.

Kaprow, Allan. *Testimonials*. Self-published, arranged in cooperation with Gallerie Baecker, Bochum, Germany, 1976. Artist book. An Activity "carried out by a small group of couples in Warsaw, in April of 1976 . . . sponsored by Galeria Foksal."

HARRY KIPPER

Kipper, Harry (of the Kipper Kids). *Up Yer Bum with a Bengal Lancer*. 1976. Videotape, 25 mins., b/w.

TESTIMONIALS

*E*veryone knows how often people try to accommodate each other and do not help at all.
The results are comical, frustrating or even insidious. Although the participants in such exchanges
maintain a semblance of politeness, questions of intention hover in the backs of their minds: what
did he really mean by that?, why did I agree to do this?, is she flattering me?, am I using my friend
deviously? Perhaps, after all, such occasions are only pretexts to ask for attention.

In "Testimonials" partners scrape, press, daub and print their marks on the environment and on
one another. They also smooth them over, blow them away or sweep them up. Little is overtly ac-
complished by their simple and slightly absurd engagements, but they must pay attention to each
other in some way. When this happens, information of another kind may be exchanged.

"Testimonials" was carried out by a small group of couples in Warsaw, in April of 1976. They chose
their own sites in the city, used their own apartments, scheduled their own time, and afterwards
assembled together to share their experiences. The Activity was sponsored by Galeria Foksal.

ALLAN KAPROW

**Allan Kaprow. *Testimonials*. An artist book describing an activity
"carried out by a small group of couples in Warsaw, in April of 1976 .
. . sponsored by Galeria Foksal."**

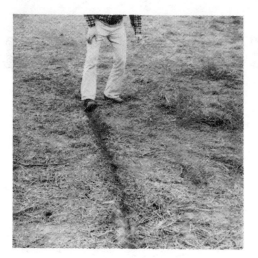

A, scraping a line in the ground
(with the edge of the shoes)

extending it for a considerable distance

B, following, smoothing it

A, asking occasionally is it deep enough
B, asking occasionally is it smooth enough

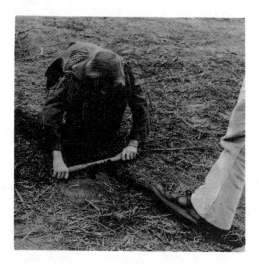

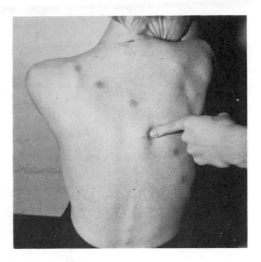

A, pressing into B's back
a track of finger marks

B, then asking are they gone
asking until A answers yes

B, dotting on A's back
a track of wet fingerprints

blowing on each print
asking A if it's dry

progressing when A answers yes

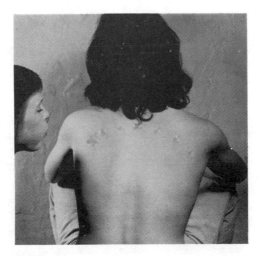

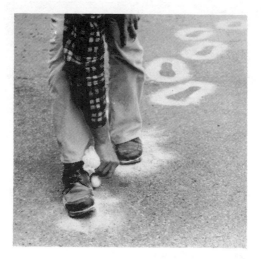

A, leaving a trail of footprint negatives
(dusting white powder around shoes)

extending it for a considerable distance

B, later, following tracks
brushing up each print
until trail is erased

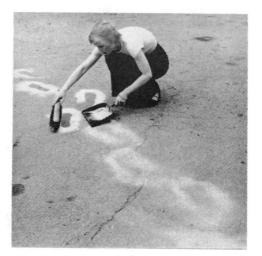

KITCHEN CENTER FOR VIDEO AND MUSIC, NY.

The Kitchen Center for Video and Music 75-76. New York: The Kitchen, 1976. Catalogue documents activities sponsored by The Kitchen, New York, during 1975-76 with an appendix listing additional services provided by the Kitchen. California artists/events documented in the catalogue include: Terry Fox, *Lunar Rambles; Southland Video Anthology* tapes; TVTV (Top Value Television), *Superbowl* and *Super Vision.*

LAUREL KLICK

Klick, Laurel. "Untitled," *Criss Cross Double Cross,* v.1, Fall 1976, p.73.

PAUL KOS

Kos, Paul. *Sirens.* 1976. Videotape, 5 mins., color.

SUZANNE LACY

Lacy, Suzanne. "Cinderella in a Dragster," *Criss Cross Double Cross,* v.1, Fall 1976, pp.15-16. Excerpt:

The point I'm driving at is that everything continues to move including these words and even the memory of these changes and sometimes it is not as clear what something or someone is as where they are going or at least how they are getting there. In a dragster or a pumpkin? You see it doesn't really matter whether Cinderella was a princess or a scullery maid except for the sake of the image you're creating at the time, for soon that same image or the structure around which you have built your work collapses for you or you destroy it in order to build another up and the process repeats itself. In fact the sign of viability for an artist and that might include anybody is the ability to go through the collapse of one fairy tale and the creation of the next, that is, to not get stuck in the myth. It's a time honored quotation in art which goes, "Don't ever forget: what is a carriage today might be a pumpkin tomorrow."

Lacy, Suzanne. *Falling Apart.* Los Angeles: Self-published, 1976. Artist book. "A handmade book which weaves incidents of childhood injury, references to violence, and language into a search to uncover the personal sources of violence."—from the *Women in the Printing Arts* catalog.

STEPHEN LAUB

Laub, Stephen. *Bodies of Water.* Berkeley: Self-published, 1976. Artist book.

Young, Geoffrey. "Stephen Laub Talking with Geoffrey Young, July 26, 1976," *La Mamelle Magazine: Art Contemporary,* no.5, v.2, 1976, pp.13-16, 74. Excerpt:

Y: "Dog" performance utilizes what bodies of imagery?

L: The performance uses slides of dogs which I took at a dog show so most of them are pure-bred show dogs. During the performance, I project them on the wall and, like my other pieces, try to fit into each image. This piece is a self-analysis of my performance process. The slide projections have been determining the boundaries of my activity as well as the light in which I see

Suzanne Lacy. *Cinderella in a Dragster*. **Los Angeles, Ca., 1976.**

Stephen Laub. *Starring.* **San Francisco Museum of Modern Art, 1976. Performance using the Hollywood film, "The Moon and Sixpence." Life size scale is maintained by varying the distance between the projector and the screen by projecting the film from a mobile cart.**

myselt. Dogs are involved in a similar process of socialization by being trained to obey certain rules of behavior. I wanted to draw that parallel. . . .

Y: I like that aspect of self-reflection as an artist. Your work can also be seen as a continual comment on what it means to be an artist making art. It seems like you hit this "reflective surface" head on in "Starring" which you performed at the San Francisco Museum of Art in March.

L: Head on and head in. "Starring" is a dialogue with a whole set of problems. What is the artist's life, and where does that life come from? Am I living the artist's life, and am I living up to that life, especially in terms of the Museum? I was interested in how the artists' lives are processed into a narrative form. In the performance I use the film "The Moon and Sixpence" as an example of how the artist's life is portrayed. George Sanders plays the role of an artist named Charles Strickland in a Hollywood film based on Somerset Maugham's novel, which itself is based on historical information about the life of Gauguin.

Y: So we're dealing with the artist's life at several significant romantic

removes. It's like you're dealing with the perfect cliched situation, playing the artist's role in a museum! How did you keep in step with the "artist" as projected on the screen?

L: I built a cart with wheels for the projector that could move back and forth as well as tilt up and down. . . . The film was projected at ¾ speed for the scenes in which Sanders was present. In the scenes in which he didn't appear, she covered the lens and projected at normal speed. I wanted those parts to be like a radio program in which the audience imagines the action. The sound was on during the whole film so it changed from normal to a slow, drunken-like speech. . . .

. . . I was more involved with manifesting certain connections between myself and historical precedents and the boundaries that that dialectic imposes on an artist. During the performance, when I could keep in step with Sanders' actions, I was, in effect, playing the part well and performing well in terms of the Museum as an artist. But when I couldn't keep up, and there were a lot of fast cuts even at ¾ speed, I wasn't measuring up to the part and, in effect, I was failing in my role.

Stephen Laub. *Bodies of Water.* **1970-73. Published as an artist book, 1976.**

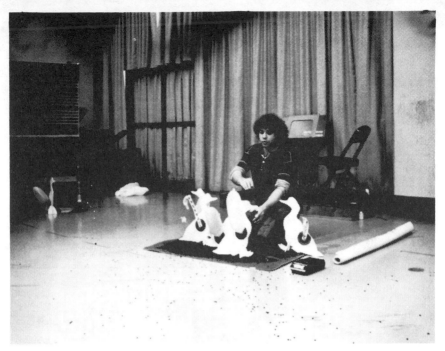

Barry Markowitz. *Gift of the Rabbit*. California State College, Dominguez Hills, Ca., 1976. "Each duck reveals the boy's growing anxiety. The gunman points his pistol and shoots the balloons."

Susan Mogul. "Work Prints" from *August Clearance*. Los Angeles, Ca., 1976.

CARL LOEFFLER

Loeffler, Carl E. *Sanding Circles*. May 24, 1976. Audiotape.

TOM MARIONI

Loeffler, Carl. "Tom Marioni, Director of the Museum of Conceptual Art (MOCA), S.F., in Conversation with C.E. Loeffler," *La Mamelle Magazine: Art Contemporary*, no.4, Spring 1976, pp.3, 5-7.

BARRY MARKOWITZ

Markowitz, Barry. "Gift of a Rabbit," *Criss Cross Double Cross*, v.1, Fall 1976, pp.69-70.

PAUL MCCARTHY

McCarthy, Paul. *Class Fool*. 1976. Videotape, 50 mins., color.

Buster Cleveland with Mendo Dada and Bay Area Dada. *Event at Christo's Running Fence*. 1976.

McCarthy, Paul. *Experimental Dancer*. 1976. Videotape, 60 mins.

JAMES MELCHERT

Tarshis, Jerome. "Melchert on Film," *Art News*, v.75, January 1976, p.62. Review of Melchert's exhibition at the San Francisco Museum of Art. Performance-oriented, the exhibition included 7 slide-projection pieces and one film. In one slide work entitled, *Changing Walls*, Howard Fried covered a wall-sized sheet of white paper with red paint. Excerpt:

Location Project #5, a slide projection, gave us successive photographs of Wayne Campbell and Sybil Meyer making horizontal cuts in a seven-foot-high sheet of white paper. When they begin to remove sections of the paper, we see that on the other side is a corridor at the de Young Museum, at the end of which hangs an El Greco. When the two stars have prepared their egress, they escape to the other side of the paper and thence out of the camera's field of view.

MENDO DADA

Hagofen, B.P. "Another Roadside Infraction: Dadaists Crack Running Fence Security and Have Fun," *Still*, October 1976. Text and photos, pp.1, 5-8.

SUSAN MOGUL

Mogul, Susan. *Big Tip, Back Up, Shut Out*. 1976. Videotape with sound, 10 mins., b/w. Monologue in a standup comic delivery. Comments on the life of an artist who works as a waitress, waiting for the big tip. When it comes, it's from a gallery director, and not quite what she had in mind.

Mogul, Susan. "Mogul's Semi Annual Clearance," *Criss Cross Double Cross*, v.1, Fall 1976, pp.76-77.

Rosler, Martha. "Susan Mogul: Moving the Goods," *Artweek*, v.7, August 28, 1976, p.5. Review of *Mogul's August Clearance*, exhibition at Canis Gallery, The Woman's Building, Los Angeles. Excerpt:

Mogul hangs her work—photos and photo collages—on wire hangers and puts it in bins. The logic of the producer-consumer transaction has led her to price each piece according to its degree of "Finish" (shades of nineteenth century Academicism!). She arrived at a hierarchy running from "sketch," or work print, to full-scale work, in which only a finished item is seen as fully worthy of her "signature." The monetary value then is a function of the labor invested (and "self" reflected)—but the show, of course, represents an attempt to capitalize on *all* labor invested, just as an outlet allows manufacturers and shopkeepers to recover some of their investment even from slightly damaged, shopworn or poorly selling goods.

Rubinfien, Leo. "Susan Mogul; Anthology Film Archives, New York; exhibit," *Artforum*, v.15, December 1976, pp.64-65. Review of four videotapes presented at Anthology Film Archives, October 17, 1976. Excerpt:

In the tapes she talks a blue streak directly to the camera, usually with a few small props—her bargain clothing, her vibrator, her billboards, for example—whose importance in her life she relates to us in a flexible mixture

Linda Montano. *Dead Chicken/Live Angel.* Rochester, N.Y. 1971.

of Yiddish comedy, feminist sincerity and pseudo-conceptual art self-consciousness. She kept her audience in stitches with her raucous monologues, through which are filtered the intense autobiographical issues of Mogul's Jewish upbringing, her sexuality, her desire for recognition as an artist and her effort to match herself to a stereotyped artist's persona.

LINDA MONTANO

"Linda Montano," *La Mamelle Magazine: Art Contemporary*, no.4, v.1, Spring 1976, pp.20-23. Includes "A Conversation with Mildred Montano by Trudi Richards" and "A Conversation Between Linda Montano and Tom Marioni After Having Been Handcuffed Together for Three Days," a life chronology, and photographs.

MOTION

Kleb, William. " 'Motion' In San Francisco," *Alternate Theatre*, 1976, pp.4-5, 10.

Loeffler, C.E. "Motion/Reynolds Collaborate," *Front*, no.2, v.1, February 1976, p.1. Excerpt:
HOSPITAL: An objective sketch by C.E. Loeffler
Limited seating lining walls/Reynolds environment scattered throughout center/3 beds/sawdust floor/handsaw suspended from ceiling/bathtub/

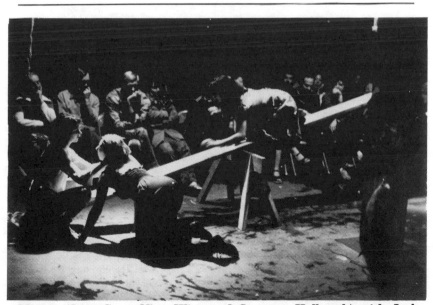

Motion (Joya Cory, Nina Wise and Suzanne Hellmuth) with Jock Reynolds. *Fish.* 80 Langton St., San Francisco, Ca., 1976.

scraps of lumber/black medical bags/rollerskates/Venetian blinds/swing music/enter performers/environment activated/beds moved about/dancing with saws/wheelchair tracking up sawdust/mimicry/I'm ill . . . my heart is beating . . . I'm ill/collaborative dance with handsaw/assault with handsaw on near objects/I could cut the bed, my leg, my heart out/Do not destroy anything tonight . . . I promised/It's impossible not to destroy/Let us look at your morals/can opener waving/Open my can/It's your heart I want . . . not your genitals/I'll seduce you/riding in wheel chair/serious organ music/Is it fun/you get used to it after a while/from a bed: Nurse . . I want color television . . . water . . . a telephone . . . a can of water kicked/from the bed: Better conditions or else/ceiling outlet fills bath with steaming stream of water/bubble soap added/hair washed/two in tub splashing/It's time to explain the whole thing . . . it all started with a heartbeat/teapot whistles, steaming/steam breathing ritual/You better be careful/10 cent pony ride brought in/Grandma . . . do you have a message/Your grandmother is disappointed in you/I'm afraid of dying/I want a baby/I don't remember where to put the money in the horse/She's afraid of horses/If we had a little more money everything would be all right/I wanted to be a cowgirl/Spare change man/I want a baby and I'll cut your belly open to get it/exit horse enter steel bed frame and mattress, skeleton suspended above/lights out/skeleton: I want to dance with you/continued dance animates skeleton/phosphorescent applied to skeleton/space illuminated with greenish glow/dance continues to reclined position/Death is like a falling leaf . . . I'm ready to die now/white sheet covering skeleton/glow emanating thru/I'm ready to die now/end.

Ross, Janice. "Motion and Jock Reynolds: Patterns of Mystery and Discovery," *Artweek*, v.7, February 14, 1976, p.13. Review of a series of four performances presented at 80 Langton St., San Francisco, by Motion, a women's performing collective (Nina Wise, Suzanne Hellmuth, and Joya Cory) in collaboration with Jock Reynolds. Excerpt:
Each of these four performances resulted in the production of a unique 'theatre piece.' Sculptor and environmental artist Jock Reynolds collaborated with the three motion performers, Nina Wise, Suzanne Hellmuth and Joya Cory, by supplying them with a different surprise environment each night. The performance piece that resulted was the product of Motion's improvisatory, kinetic and vocal reaction to Reynold's set.

Weiner, Bernard. "Women's Collective: Conceptual Pieces for the Theater," *San Francisco Chronicle,* February 6, 1976.

MUSEUM OF CONCEPTUAL ART

A Tight Thirteen Minutes. San Francisco: MOCA and Henry Rosenthal, 1976. Videotape. One minute color video works by Richard Alpert, Dianne Blei, Kevin Costello, Terry Fox, Howard Fried, Mel Henderson, Paul Kos, Stephen Laub, Tom Marioni, James Melchert, Masashi Matsumoto, Suzanne Spater, and Irv Tepper.

BRUCE NAUMAN

Nauman, Bruce. "Left or Standing, Standing or Left Standing," *Criss Cross Double Cross*, v.1, Fall 1976, pp.51-52 .

RICHARD NEWTON

Newton, Richard. "2 29 Black," *Criss Cross Double Cross*, v.1, Fall 1976, pp.74-75.

JOSEPH REES

Rees, Joseph. "Joseph Rees at Lake Merritt, 1976," *La Mamelle Magazine: Art Contemporary*, no.5, v.2, 1976, p.43.

MARTHA ROSLER

Rosler, Martha. "Losing. . . A Conversation with the Parents," *Criss Cross Double Cross*, v.1, Fall 1976, pp.9-10.

SAM SAMORE AND BARRY BLOOM

Samore, Sam and Bloom, Barry. "The Athlete as Artist? An Interview with Kareem Abdul Jabbar," *La Mamelle Magazine: Art Contemporary*, no.5, 1976, pp.17-19. The first in a series of interviews entitled, *The Athlete as Artist*. Excerpt:

BB: I grew up about twenty blocks from you off Dyckman Street. In that area just across the bridge in the Bronx.

KA-J: Marble Hill?

BB: Yeah. And, ah, I see you coming from the same sort of city ideology that I'm from. How do you describe the term art?

KA-J: Expression.

BB: So you really believe that art, then, is not a colloquial term, that it's open?

KA-J: (in scoffing tone) 'Course.

BB: So you define yourself as an artist within those boundaries because you're expressing yourself in basketball?

KA-J: Somewhat. You know, people express themselves baking cakes and pies, and you would have to say they are culinary artists. I would think so.

SS: What kind of artists do you admire?

KA-J: I admire anybody that's intelligent and can express themselves.

BB: Are you still into jazz as much as you were?

KA-J: Yes, 'fact I went out to the Lighthouse last night. Saw Bobby Hucherson.

(Pause. Balls bouncing)

KA-J: I got to get going. If you want to talk to me some more, you can talk after the game tonight.

DARRYL SAPIEN

Martin, Fred. "Fred Martin: Art and History—Scraps from a Conversation," *Artweek*, v.7, September 4, 1976, p.2. Martin recounts a discussion with Sapien about several of his works and how he became interested in art. Excerpt:

[Sapien] said, "It is important to align the performance with the geometry of the space; you extend yourself so much further working within it." (And I have so often thought of each of us as a node in some vast tissue, or a point of infinite radiation, the center and circumference of all things.)

229

Darryl Sapien. *Splitting the Axis.* **University Art Museum, University of California, Berkeley, Ca., 1975. Performed with Michael Hinton.**

Sapien, Darryl. "Splitting the Axis," *La Mamelle Magazine: Art Contemporary*, no.3, v.1, Winter 1976, pp.18-19. The text:

PERFORMANCE PROPOSAL: SPLITTING THE AXIS

This performance will consist of a single action on a vertical axis at point A on the diagram. Two men will climb a wood pole using metal lineman's spurs and beginning at the top, thirty-five feet above the floor, they will begin driving wedges into the pole simultaneously from opposite sides. The performers will continue to drive the wedges while descending the pole at intervals of about one and one-half feet until they reach the floor. The performers should rotate around the axis as they descend, always remaining on opposite sides of the axis' diameter.

The men and the pole will be monitored for sound by six small microphones attached to different sound-producing elements such as voices, metal spurs, the pole itself, etc. The recorded sound will be transmitted to six locations around the museum. There will be three video cameras and four monitors. The cameras will be furnished with zoom lenses and focused on various visual elements of the actions. The recorded images will be transmitted to monitors directly opposite the cameras on the other side of the museum, providing the viewer a glimpse of the other side of the performance. The fourth monitor will display a live mix of the three images through the S.E.G. (Special Effects Generator). There will be six locations in all for the cameras, speakers, and monitors; all six of these stations will be on a different level of the museum. The stations will be located at an equal radius from the axis and will be placed to interfere with the normal flow of traffic through the museum. The spectators will encounter them as they wander through the upper and lower levels of the structure. The audience will have the opportunity to see the performance live as a unit or electronically transformed as a visual fragment or disembodied sound. The audio and the video systems will be used to shatter the shell separating performers from audience and fling its pieces throughout the multiple elevations of the museum, to surround the spectators and envelope them within the resonance of the performers' dance. Even as the performers are busily splitting the grain of the pole, the electronic hardware will function to simultaneously disassemble the performers. Lastly, the diagram determining the layout of the axis and stations is derived from both the radially symmetrical architecture of the museum itself and a geometric symbol delineating the basic vectors of action within the performance . . . two wedges penetrate a circle.

Sapien, Darryl. *Within the Nucleus.* 1976. Videotape, b/w.

VAN SCHLEY

Schley, Van. "Memories of Overdevelopment," *Criss Cross Double Cross*, v.1, Fall 1976, pp.43-44.

World Run. Long Beach: Long Beach Museum of Art, 1976. Catalogue of Van Schley and Billy Adler's project, *World Run*, with color photographs, text and introduction.

ILENE SEGALOVE

Darling, Lowell and Segalove, Ilene. "Hollywood Anthropology/'Two Subjects from the Cauliflower Alley Tapes,' " *La Mamelle Magazine: Art Contemporary*, no.5, v.2, 1976, pp.20-21.

Darryl Sapien. *Within the Nucleus*. San Francisco Museum of Modern Art, San Francisco, Ca., 1976. Performed with Michael Hinton.

Segalove, Ilene. "An Artist/His Opening, A Guest/The Punch," *Criss Cross Double Cross*, v.1, Fall 1976, pp.11-12.

Segalove, Ilene. "Video Infirmities," *La Mamelle Magazine: Art Contemporary*, no.3, v.1, Winter 1976, pp.10-11.

JOYCE CUTLER SHAW

An Interview with Joyce Cutler Shaw by Moira Roth. Sorrento Valley, Ca.: Self-published, 1976.

Shaw, Joyce Cutler. *We the People: Proposal for an Artwork*. La Jolla: Self-published, 1976. Artist book.

BONNIE SHERK

Sherk, Bonnie. "Excerpt from: Aktin Logic—Volume II, Chapter 42, 'Life Work,' page 3," *La Mamelle Magazine: Art Contemporary*, no.4, v.1, Spring 1976, p.12.

Sherk, Bonnie. "The Farm," *La Mamelle Magazine: Art Contemporary*, no.5, v.2, 1976, pp.32-35. Text and photos regarding the Farm. Excerpt:

Bonnie Sherk. *The Farm.* **San Francisco, Ca., 1976.**

The Farm is a multicultural art and life center located adjacent to a major freeway interchange where Potrero Hill, Bernal Heights, and the Mission converge. The Farm presents a strong, visual contrast to the technological monolith of the freeway and serves as a graphic demonstration because it frames life. In addition to visual imagery, the Farm is involved in making actual and conceptual connections. This is done by joining land masses through landscaping, providing an open forum for different aesthetics and styles, and involving children and others with life processes.

Sherk, Bonnie. *Raw Egg Animal Theatrc*. 1976. Videotape, b/w.

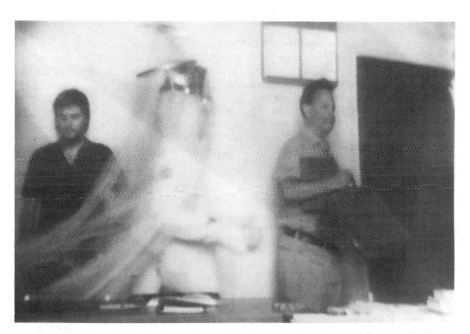

Trans-Parent Teacher's Ink., Paul Cotton, Medium. *The SECOND Norman Invasion.* **University of California, Santa Cruz, 1976; sponsored by the** *Floating Museum.* **"Riding on a donkey, led by a pregnant fool and a retinue of clowns, Truth presented Hymn-Self, Messenger of the Gods, outside of Norman O. Brown's class room in Greek Drama at U.C., Santa Cruise. Since Nobby had dis-owned/forgotten his WORD VISION and his search for the WAY OUT, the God of Doors called to climb through the window to commit** *The SECOND Norman Invasion.* **No! Brown remained true to character and scurried from the class-room like Claudius from Hamlet's play within a play:** *The Mousetrap.* **"**

BARBARA SMITH

Smith, Barbara. *I Am Not Lost But Hidden*. 1976. Videotape with sound, 15 mins., color and b/w. Videotape of a performance at Johnston College, University of Redlands, 1976. "Strong sense of a psychic interior to this play of images."

Smith, Barbara. "Vogue View," *Criss Cross Double Cross*, v.1, Fall 1976, pp.5-6.

BRADLEY SMITH

Smith, Brad. "Untitled," *Criss Cross Double Cross*, v.1, Fall 1976, pp.31-32.

JOHN STURGEON

Sturgeon, John. *Conjunct*. 1976. Videotape with sound, 5 mins., b/w.

Sturgeon, John. *Two Aspects*. 1976. Videotape with sound, 4 mins., b/w. "A primal figure arranges groups of bone fragments on a mirror, moves triangles in patterns, pours water and wine, draws geometric diagrams on the desert's parched surface. He is naked, silent, mythic, and the acts have a shamanistic quality. They are Magic, locating the artist in a world order expressed by a very personal vocabulary."

Sturgeon, John. *The Two of Triangles*. 1976. Videotape with sound, 2 mins., b/w.

TRANS-PARENT TEACHER'S INK., PAUL COTTON, MEDIUM

Cotton, Paul. *The Second Norman Invasion*. 1976. Videotape, b/w.

Cotton, Paul and Beth Anderson. *Transparent Teachers Ink. Presents the Bride Groom Is Hear / The Bride Groom Is Here*. Self-published, 1976. Artist book.

"Paul Cotton: Poem O'Granite," *La Mamelle Magazine: Art Contemporary*, no.5, v.2, 1976, pp.38-41. Text and photo documentation of Transparent Teacher's Ink's "The Second Norman Invasion," an event which took place at Cowell College, University of California Santa Cruz (Santa Cruise), on May 18, 1976. Excerpt:
SCENE: Zippily Boo-Duh Hymn-Self, a Seed sculpture and Messenger of the Gods sits on a donkey led by the Pregnant Fool onto a sunny midday Cowell Plaza where students and faculty are casually eating lunch. Thunder is broadcast from the Seed. A small dog named God follows with a handful of clowns and concerned citizens carrying demonstration signs: "Artists Unite," "No. Brown Unfair to Hymn-Self," "Neuro-Logical Proof of the Existence of God," and "The Letter Killeth but the Spirit Giveth Life." The demonstration is aimed at the atrocities committed against Hymn-Self by Norman O. Brown's seven year denial of kinship with the work of Trans-Parent Teacher and The Word Made Flesh.
"It cannot be put into words because it does not consist of things. Literal words always define properties. Beyond the reality-principle and reification

is silence, the flesh. Freud said, "Our god Logos; but refrain from uniting with words, in order to unite with the word made flesh."

Norman O. Brown, *Love's Body*, Random House, 1966, p.265.

As Brown made no attempt to meet with the entreaties of Trans-Parent Teacher's Ink. in Cowell Plaza, the retinue proceeded to gather outside of the classroom where Brown's class on Classic Greek Literature was in process. When he further refused to *come out of doors*, Zippily Boo-Duh Hymn-Self got off her ass, handed *The Caduceus* to the Zen Monk and lept thru the open window of the classroom. Brown, in a repetition of his negativity and

T.R. Uthco. *The Avant Guard in Action.* San Francisco, Ca., 1975. The Avant Guard (second from right-Jody Procter) stands at attention with members of the San Francisco Police Department. Shortly after this photo was taken a shot was fired at President Ford as he left the St. Francis Hotel.

inhospitability upon the occasion of "The First Norman Invasion" (1969) gathered up his books, turned his back to *LIFE* and walked silently out of the room.

To complete the delivery of the message intended for those eyes that don't see and those ears that don't hear, Zippily bounded *out of doors* onto the lawn under the *Class* window. There, amidst that small circle of friends, Zippily Boo-Duh Hymn-Self Conducted Beth Anderson's "The Messiah is Come." The poetry of that mythic vision was astral-projected for a few short minutes and recorded by videotape before it was interrupted by an irate administrator and the campus police. No charges were filed.

T.R. UTHCO

"Ancora per Assurdo; '32 Feet Per Second' Performance a San Francisco," *Domus*, no.563, October 1976, pp.54-55. Description of the T.R. Uthco work *32 Feet Per Second Per Second*, which took place on the building facade of La Mamelle Inc., San Francisco, April 1976. Article in Italian, French, English.

T.R. Uthco. "The Avant Garde in Action," *La Mamelle Magazine: Art Contemporary*, no.5, v.2, 1976, pp.28-29.

"Verbal Muzak from Beyond the Edge," *La Mamelle Magazine: Art Contemporary*, no.4, v.1, Spring 1976, p.25. Text and photo documentation from their work, *32 Feet Per Second Per Second*. Excerpt:

Doug Hall and Jody Procter of T.R. Uthco, a San Francisco art performance group, sat 60 feet above the pavement in chairs bolted to the masonry wall outside the east windows of the third floor La Mamelle Gallery. Both are afraid of heights. They sat from 9:00 in the morning to 3:00 in the afternoon, and during this time they talked continuously. The two performers were clearly visible to spectators on the street below, and the sounds of the amplified voices as well as video images from two nearby cameras were fed into the gallery space. For two days prior to their appearance on the wall they worked from a swing scaffold, setting the heavy welded steel braces and chairs in place, and drilling through 14 inches of brick with a roto hammer to be certain that the bolts holding their braces were solidly anchored. Their monologues, performed previously, but never for longer than two hours, were restricted only in one way—both presented a narrative description in the third person, male gender, past tense. They conceived of their voices as verbal muzak, and maintained a constant babble like water running over rocks, an endless stream of consciousness. Sitting so high off the ground, and at the same time occupied with this ceaseless meaningless talk, the performers created a psychic chemistry in which both began to believe they were going crazy. They shook steadily for the last four hours, experienced tension, stress, heavy paranoid anxiety attacks, and from time to time thought they might jump. The event was called "32 Feet Per Second Per Second."

STEFAN WEISSER

Weisser, Stefan. *Hagiogrammz/Enchanted Hours*. Self-published, 1976. Artist book.

T.R. Uthco (Doug Hall, Jody Procter). *32 Feet Per Second Per Second*. La Mamelle Arts Center, San Francisco, Ca., 1976. "T.R. Uthco, a San Francisco Art Performance Group, sat 60 feet above the pavement in chairs bolted to the masonry wall outside the east windows of the third floor, La Mamelle Gallery. Both are afraid of heights. They sat from 9:00 in the morning to 3:00 in the afternoon, and during this time they talked continuously. The two performers were clearly visible to spectators on the street below, and the sounds of their amplified voices as well as video images from two nearby cameras were fed into the Gallery space."

Bob Wilhite. *Telephone Performance.* **Broxton Gallery, Los Angeles, Ca., 1976.**

PETER WIEHL

Wiehl, Peter. "Peter Wiehl: Cross Piece," *La Mamelle Magazine: Art Contemporary*, no.5, v.2, 1976, p.44.

BOB WILHITE

La Taurette, Harvey. "Telephone Performance," *Artweek*, v.7, February 28, 1976, p.6. Review of Wilhite's exhibition at the Bronxton Gallery, Los Angeles, which lasted from 10:00-10:20 pm, January 23, 1976. "Attendance by telephone only," individuals who were sent invitations were asked to call the gallery during the 20 minute period. A 12" phonograph record was produced, recording the entire event. Excerpt:

Those callers who got through heard one of two major types of phone messages. The first six callers heard a description, lasting about two minutes, and each one totally different, of a visual event and/or artifact conceived by the artist. All of these callers were falsely informed that "complete documentation" of the piece was currently on exhibit at the gallery—all, that is, except the first caller, who received a completely factual description of the piece to follow, including a statement (true) that none of the works to be described in subsequent calls existed. The last eight callers heard a forty-five second guitar solo played by Wilhite, each caller hearing the same solo, but in a different key, a progression which would not, of course, be apparent to each individual listener.

Wilhite, Bob. *Bob Wilhite in Concert*. 1976. Record. Documentation of two telephone performances. Edition of 50.

Wilhite, Bob. *Buckaroo-One for All*. Los Angeles, 1976. Record. Documentation of a performance given at Broxton Gallery, Los Angeles, 1976.

Nina Wise. *Death Meditations of Helen Brown.* La Mamelle Arts Center, San Francisco, Ca., 1976.

1977

GENERAL LITERATURE

THE ARTIST'S BOOK

The Artist's Book. La Jolla: Mandeville Art Gallery, University of California, San Diego, 1977. Catalogue to an exhibition of "one-of-a-kind or limited edition books produced by contemporary artists," April 18-May 15, 1977. Some artists included in the exhibition: Eleanor Antin, John Baldessari, Mary Winder Baker, Anna Banana, Bay Area Dadaist Group, Diane Calder Belsley, Nancy Buchanan, Chris Burden, Guy De Cointet, Paul Forte, Ken Friedman, Bill Gaglione, Susan Grieger, Irene Dogmatic, Cynthia Kelley, Susan King, Suzanne Lacy, Stephen Moore, Richard Mutt, Richard Newton, Debra Rapoport, Allen Ruppersberg, Ed Ruscha, Alexis Smith, Joyce Cutler Shaw, John White, Susan Wick, and Rachel Youdelman, among others.

Hugo, Joan. "Gutenberg in the Gallery—The Artist's Book," *Artweek*, v.8, May 7, 1977, pp.15-16. Review of an exhibition entitled, *The Artist's Book*, at the University of California, San Diego, from April 18-May 15, 1977. Excerpt:
 Out of the wide range of this survey (there are over 200 items in the show), two important categories emerge, dealing with production: the unique or few-of-a-kind book/objects and the self-published publication, here meaning capable of being mechanically reproduced in some edition larger than a few and being potentially unlimited and distributable to the global village. Within these two categories, groupings occur something like this—A. UNIQUE: 1)sketchbook/visual diary (exterior record), 2)journal/autobiography (interior record), 3)simulated incunabula (tablets and hornbooks); B. SELF-PUB-LISHED: 1)private languages (including alphabet systems, codes, wordplay, visual poetry and puns) and personal geographies (fantasy maps, personal geographies and diagrams), 2)episodic narratives and picture fictions, 3)contributive and self-assembling works.

Askey, Ruth. "Video Sampler," *Artweek*, v.8, July 2, 1977, p.7. Review of Part 4 of *Southland Video Anthology* that took place at the Los Angeles Institute of Contemporary Art, sponsored by the Long Beach Museum of Art.

Audiozine, San Francisco, Ca. no.1, 1977. Publisher, La Mamelle, Inc.; Editor, Carl E. Loeffler. A "periodical" on audiotape format.

Benamou, Michel and Caramello, Charles. *Performance in Postmodern Culture*. Milwaukee: Center for Twentieth Century Studies, 1977. Anthology of theoretical essays on aspects of postmodern performance. Excerpt from Rothenberg, Jerome, "New Models, New Visions: Some Notes Toward a Poetics of Performance," pp.11-17:

Sixty years after Dada, a wide range of artists have been making deliberate and increasing use of ritual models for performance, have swept up arts like painting, sculpture, poetry (if those terms still apply) long separated from their origins in performance. (Traditional performance arts—music, theater, dance—have undergone similarly extreme transformations: often, like the others, toward a virtual liberation from the dominance of text.) The principal function here may be viewed as that of mapping and exploration, but however defined or simplified (text, e.g., doesn't vanish but is revitalized; so, likewise, the Greco-European past itself), the performance/ritual impulse seems clear throughout: in "happenings" and related event pieces (particularly those that involve participatory performance), in meditative works (often on an explicitly mantric model), in earthworks (derived from monumental American Indian structures), in dreamworks that play off trance and ecstasy, in bodyworks (including acts of self-mutilation and endurance that seem to test the model), in a range of healing events as literal explorations of the shamanistic premise, in animal language pieces related to the new ethology, etc.

DATA, Milano, no.27, July/September 1977. Most of this issue is devoted to California artists. Included are articles written by or about: The Floating Museum, Darryl Sapien, Suzanne Lacy, Lynn Hershman, Barry Bloom and Sam Samore, Lowell Darling and Ilene Segalove, Tom Marioni, Irv Tepper, Bonnie Sherk, and Carl Loeffler. Excerpt from essay, "Artist as Context," by Carl Loeffler, p.3:

Here in California, contemporary art is increasingly becoming an art actively engaged with society and like Warhol's famed business art, that which will survive supports its own space. As the seventies push on, the expectations of art glamour learned from the sixties fade further and further away. The fact is that the art support systems are experiencing a surplus of qualified artists. Museums, galleries, and all are unable to support this multiplicity: a multiplicity of numbers and a multiplicity of ideas. The latter, however, is a result of the status of art as an exchange commodity and the unresponsiveness of officials. The new artist functions with awareness of these briefly stated conditions. And in response contemporary art generates its own support as part of its definition. More than ever before the context of art is generated by the artists—a position exemplified by the plethora of socially engaged artists and of projects such as artist-maintained support systems, galleries and magazines.

Documenta 6. Kassel, Germany: Documenta, 1977. Catalogue for *Documenta 6* exhibition that took place Summer 1977. The three volume catalogue includes: v.1, painting, sculpture, performance; v.2, photography, film, video; v.3, drawing, utopian design, artists' books. Text in German; includes photos.

"Futurist Synthetic Theatre," *Vile*, v.3, Summer 1977, pp.67-68.

Heresies: A Feminist Publication on Art & Politics, New York, no.1, January 1977. A quarterly periodical with each issue focusing on a different aspect of women's concerns regarding art and politics.

How We Met: Or a Microdemystification, Saarbrucken-Dudweiler, West Germany, AQ16, 1977.

Kleb, William. "Art Performance: San Francisco," *Performing Arts Journal*, no.3, v.1, Winter 1977, pp.40-50. Overview of performance art in San Francisco. Kleb discusses the works of 7 artists in particular: Paul Kos, Howard Fried, Bill Morrison, Stephen Laub, Linda Montano, Darryl Sapien, Terry Fox, as a "sampling of current [1977] performance art activity in the San Francisco area."

Kleb, Bill. "Three Performances—Where Did the Risk Go?," *Artweek*, v.8, February 19, 1977, p.16. Review of the first three San Francisco performances in a series entitled, *Performance Exchange*, sponsored jointly by LAICA and 80 Langton St. Performances included: Paul DeMarinis and Jim Pomeroy's *A Byte at the Opera*, Bill Morrison's *Fever Dream Remnants*, and a slide lecture by Howard Fried.

Levin, Kim. "Video Art in the Television Landscape," LAICA *Journal*, no.13, January/February 1977, pp.12-16. Excerpt:
Television offers a new kind of narrative structure, episodic and interrupted, that incorporates within itself non-sequential inconsequential interruptions. Breaks for station identification and commercials are recurring refrains, and within commercials these refrains are often in the form of mini-narratives telling us intimate details of a family's personal hygiene. In the same way the episodes of any weekly series are separated by the rest of the weekly programming, so that the viewer carries chapters of unrelated stories simultaneously in his memory.
　Life reinforces this interrupted narrative structure. Driving through the California landscape there is an endless repetition of the same man-made scenery. Taco Bell's, Sambo's, Jack-in-the-Boxes recur with predictable regularity, like commercials on the TV screen. Indistinguishable suburban streets repeat with the familiarity of altered stage sets re-used on different programs. Everything you do is punctuated by periods of being encapsulated in a car on a freeway, taking the place in life of the station break. Everyone thinks a lot about what they might have done. A lot of mental rearranging takes place. As narrative content enters art, it is taking the form that life and television have offered; as narrative time becomes a field for investigation, video is obviously an appropriate medium. Television is the real subject of video.

Mobius Video Show. San Francisco: Public Eye, 1977. Catalogue for the San Francisco Art Festival video program.

Naylor, Colin and P-Orridge, Genesis (eds.). *Contemporary Artists*. London: St James Press, 1977. Reference source, includes many performance artists.

Information for each artist includes: short biographical data, lists of individual shows, selected group shows, collections, publications by and about the artist, and a statement about their art.

Painting and Sculpture in California: The Modern Era. San Francisco: San Francisco Museum of Modern Art, 1977. Catalogue for an exhibition at SFMMA, September 3-November 21, 1976. Artists included in the exhibition who work/have worked in the area of performance: William Allan, Terry Allen, John Baldessari, Chris Burden, Terry Fox, Howard Fried, Robert Hudson, Tom Marioni, Jim Melchert, Bruce Nauman, Allen Ruppersberg, Darryl Sapien, William Wiley.

Quesada, Virginia. "The Fabulous Reno Hotel," *La Mamelle Magazine: Art Contemporary*, no.8, v.2, Spring 1977, pp.58-59. An account of the one night party/performance event hosted by Virginia Quesada, Vivien LaMothe, and Tom Zahuranec on February 21, 1976 entitled, *A Night at the Reno Hotel, Slum Palace of the Arts.*

Ratcliff, Carter. "Report from San Francisco," *Art in America*, v.65, May/June 1977, pp.55-60. Much of this article focuses on post-object art; includes discussion of San Francisco alternative spaces, 80 Langton St., Museum of Conceptual Art, La Mamelle Arts Center, 63 Bluxome St., Open Studio, Floating Museum, Site, The Farm. Includes mention of San Francisco artists: Terry Fox, Tom Marioni, Lynn Hershman, Howard Fried, Bonnie Sherk, Paul Kos, Darryl Sapien, Jock Reynolds, Jim Pomeroy, Irv Tepper, Alan Scarritt, and Stephen Laub, among others.

Rosler, Martha. "Private and the Public: Feminist Art in California," *Artforum*, v.16, September 1977, pp.66-77. Survey article reviewing the history of feminist art, particularly performance art, in California; includes discussion of artists, Suzanne Lacy, Judy Chicago, Eleanor Antin, Bonnie Sherk, Laurel Klick, Eileen Griffin, and Lynn Hershman, among others.

San Francisco Art Institute. *The Annual.* San Francisco: S.F. Art Institute, 1977. The catalogue covers exhibitions presented by SFAI from September 12, 1975-August 27, 1976. The introduction by Tom Marioni:
The 1975-76 Art Institute Annual took place in a politically and visually neutral space: a rented storefront in the industrial part of San Francisco (16th and Folsom). The exhibition was conceived as a year-long show, each artist in the show using the space for one week. Every Friday night was set aside as the opening for a show—usually the shows were only open Friday nights. The key to the space was passed from artist to artist. . . . "The annual" was designed to run itself (more or less). It provided an ongoing artist-curated situation. There was always something to do on Friday nights.

Silliman, Ron. "Art With No Name," *State of the Arts*, publication of Cultural News and Services, Sacramento, no.10, v.1, November 1977. General survey on post-object, non-static, contemporary art. Excerpt:
In a sense, the new art reflects the whole of American society in this era which is post-60's, post-Vietnam, post-Watergate and not yet anything intelligible in its own right. Yet obviously it is more than just that, since this

art has in one form or another been with us since the '50's. If the role of art in a so-called primitive or tribal society is to pass on the content of the community, its myths and cultures, possibly the content of modern life is just this uncertainty and anxiety as to one's place in the larger role of things. If nobody feels very certain as to their context in life, then "decontextualization" would seem to be an inevitable consequence.

Southland Video Anthology 1976-77. **Long Beach: Long Beach Museum of Art, 1977. Catalogue to the 1976-77** *Southland Video Anthology.* **Includes photographs and text. Numerous artists presented videotapes in the 4-part exhibition. Part 1, September-October 1976 included artists: Billy Adler, Eleanor Antin, Peter Barton, Robert Cumming, Charles Frazier, Alexis Smith, John Sturgeon. Part 2, October 23-January 9, 1977, included artists: Nancy Angelo/Candace Compton, John Baldessari, Lynda Benglis/Stanton Kaye, Robert Biggs, Chris Burden, Antoinette DeJong, John Duncan, Neil Goldstein, Harry Kipper, Suzanne Lacy, Gary Lloyd, Jay McCafferty, Paul McCarthy, Cynthia Maughan, Susan Mogul, Michael Portis, Barbara Smith. Part 3, January 29-March 13, 1977, included artists: Lowell Darling and Ilene Segalove. Part 4, May 14-July 3, 1977, included artists: Alan Ackoff, David Askevold, Robert Benom, Rabyn Blake, Colin Campbell, Guy de Cointet/Robert Wilhite, Joel Hermann, Allan Kaprow, Peter Kirby, Rodger Klein, David Lamelas, William Leavitt, Joan Logue, Linda Montano, Ira Schneider, Lisa Steele, William Wegman.**

Tamblyn, Christine. "A Brief History of Performance," *The New Art Examiner,* **v.4, March 1977. Overview of the history of performance art. Emphasis placed on East Coast activities.**

Videation, **Richmond, Va., no.1, Spring 1977. First issue of a periodical devoted to video art; includes a work by Gene Beery, Mark Gilliland, and Bill Farley, among others.**

Wilding, Faith. *By Our Own Hands.* **Santa Monica: Double X, 1977. A history of the women's art movement in Southern California, 1970-76.**

Women and the Printing Arts. **Los Angeles: Women's Graphics Center, 1977. A catalogue for an exhibition at the Women's Building, Los Angeles.**

Wordworks, **San Jose, [no.1], 1977. Editor, Stephen Moore; Publisher, Wordworks Gallery. A bi-monthly tabloid publication. The first issue includes an interview with George Miller by Carl Loeffler; "Weasel Words at Word Works," by Electric Weasel Ensemble; "What Is Sound Poetry? A General Introduction," by Larry Wendt, etc.**

Wortz, Melinda. "Performance Documented and Reconstructed," *Artweek,* **v.8, October 15, 1977, pp.1, 16. Review of the exhibition,** *Live From L.A.,* **curated by Chris Burden for the Los Angeles Institute of Contemporary Art. Included are objects from past performances by Richard Newton, Bradley Smith and Bob Wilhite.**

ARTISTS / ART SPACES

ELEANOR ANTIN

The Angel of Mercy. La Jolla: La Jolla Museum of Contemporary Art, 1977. Catalogue for an exhibition, September 10-October 23, 1977. Includes essays "Eleanor Antin: A Post Modern Itinerary," by Jonathan Crary and "The Angel of Mercy and the Fiction of History," by Kim Levin; also a catalog of the exhibition, illustrations of photographs from the exhibition and lists of Antin's Individual Exhibitions, Selected Group Exhibitions, and Performances.

Cavaliere, Barbara, "Nurse Eleanor; M.L. D'Arc Gallery, N.Y.; exhibition," *Arts Magazine*, v.51, March 1977, p.27.

Eleanor Antin/Matrix 34. Hartford, Conn.: Wadsworth Atheneum, 1977. Matrix leaflet for Antin's exhibition, September-December 1977. Works included in the show: *100 Boots*, 1971-73 (series of 51 b/w postcards); *Three Choreographies*, 1973 (photographs); *The Little Match Girl Ballet*, 1975 (color videotape).

Frackman, Noel. "Eleanor Antin; Ronald Feldman, N.Y.," *Arts Magazine*, v.52, December 1977, p.18. Review of Antin's exhibition/video performance, *The Nurse and The Hijackers*, at the Ronald Feldman Gallery, New York, October 1-29, 1977.

Levin, Kim. "Eleanor Antin; M.L. D'Arc Gallery, New York; exhibit," *Arts Magazine*, v.51, March 1977, p.19. Review of an exhibition entitled, *The Angel of Mercy*, in which Antin portrays "the heroic nurse of the Crimean War." Excerpt:
The gallery space is filled by a scattered crowd of painted cut-out people in period costumes, slightly under life-size. Too big to be played with like paper dolls, they become performers in a historical melodrama in which Antin is the animating spirit. Sentimental, compulsively compassionate, full of cliches and moral indignity, she takes on roles and voices like a medium at a seance, conjuring up the fiction of Nurse Eleanor in a rich confusion of past and present, that is, during the performance. For the rest of the time the cut-outs are observers, historically misplaced spectators at an exhibition of antique photographs of themselves. They are also recognizable as contemporary art world people—John Perreault, Newton Harrison, Martha Rosler, David Antin, others—cast in the roles of Victorian ladies and gentlemen, Hussars, Lancers, soldiers.

Perreault, John. "The Nurse and the Dandy: Eleanor Antin's New Trip," *The Soho Weekly News*, January 27, 1977, p.20. Review of Antin's exhibition at the M.L. D'Arc Gallery, New York, where she portrayed Grand Nurse Eleanor Nightingale in a performance, *The Angel of Mercy*.

Russell, John. "Eleanor Antin's Historical Daydream," *N.Y. Times*, January 23, 1977. Review of Antin's exhibition *The Angel of Mercy* at the M.L. D'Arc Gallery, N.Y.

BAKER/RAPOPORT/WICK

Baker, Mary Winder, Rapoport, Debra and Wick, Susan. *Interplay*. Self-published, 1977. Artist book. "Giant plastic sheets encapsulating various material, the residual by-product of a performance [at the University Art Museum, April, 1975]," entered in *The Artist's Book* exhibition sponsored by the University of California, San Diego.

JOHN BALDESSARI

"Feature Interview: John Baldessari," *Detroit Artists Monthly*, v.2, June 1977, pp.1-4, 6.

Eleanor Antin. *The Angel of Mercy*. La Jolla Museum of Contemporary Art, La Jolla, Ca., 1977.

Weinbren, Grahame. "John Baldessari on 'Work,'" *Artweek*, v.8, November 19, 1977, pp.1,16. Article on Baldessari's work, *Six Colorful Inside Jobs,* the title to a film and the six performances it took to make it. Excerpt:

The theme is simple: a house-painter paints the walls and floor of an enclosed room the six colors of the color wheel, red on the first evening, orange over the red on the second, then yellow, green, blue and violet. The activity was recorded with a ceiling-mounted camera running at a speed sufficiently slow so as to compress the whole process into approximately thirty minutes.

JEFF BALSMEYER

Balsmeyer, Jeff. *Writing Arabic, Bench/Stem and No Grand Coulee: Four Articles by Jeff Balsmeyer,* San Francisco: San Francisco Art Institute, 1977.

NANCY BUCHANAN

Buchanan, Nancy. *Meager Expectations.* Unpublished script, 1977. Script for Meager Expectations, performed by Nancy Buchanan, John Duncan, Terryl Hunter and Ransom Rideout, at La Mamelle, San Francisco, 1977.

Nancy Buchanan. *Meager Expectations.* Los Angeles Institute of Contemporary Art, Los Angeles, Ca., 1977. Participants: Ransom Rideout, Nancy Buchanan, John Duncan.

Buchanan, Nancy. "Tales of Power, Pieces of Tail, and Other True-Life Myths," *Dumb Ox,* nos.6/7, Fall 1977/Spring 1978, pp.50-51.

CHRIS BURDEN

Burden, Chris. *Full Financial Disclosure.* Los Angeles: Jan Baum-Iris Silverman Gallery, 1977. Catalogue of business expenses for each month of 1976.

Burden, Chris. "Garcon," *La Mamelle Magazine: Art Contemporary,* no.6/7 v.2, 1977, pp.14-15. Text and photo documentation of his work for the Hansen Fuller Gallery, San Francisco, August 3-7, 1976.

Burden, Chris and Smith, Alexis. *B-Car: The Story of Chris Burden's Bicycle Car.* Los Angeles: Choke Publications, 1977. Excerpt:

Once the project was conceived, I was compelled to realize it. I set the goal of completing the car for two shows in Europe. I saw building the car as a means toward the end of driving it between galleries in Amsterdam and Paris as a performance. When I arrived in Amsterdam, I knew that the accomplishment of constructing the car had become for me the essential experience. I had already realized the most elaborate fantasy of my life. Driving the car as a performance was not important after the ordeal of bringing it into existence.

B-CAR Specifications

Length: 8'10"
Height: 31"
Weight: 200 lbs.
Wheelbase: 6' ¾"
Track front: 4'
 rear: 4'
Minimum ground clearance: 7 ¾"
Frame: Pure space frame of 4130 chrome moly tubing, 5/8" O.D., .035 wall thickness, silver soldered and welded
Suspension: Independent on all four wheels
Body: Fabric, riptop nylon with silver vinyl coating
Tire: 2" x 19"
Brakes: 4" x 1" drum, on all four wheels, mechanically operated
Fuel capacity: Twin 1 gallon tanks
Engine and Drive Train: P4 Minarelli 2 stroke 50 cc. air-cooled motorcycle engine
 : 4-speed transmission, clutch, and magneto in integral case with engine
Top Speed: 50 m.p.h.
Fuel Consumption: Approximately 150 m.p.g.

"Chris Burden" *Flash Art,* no.70/71, January/February 1977, pp.40-44. Photo documentation and text by Burden on his works: *Garden* (1976), *Shadow* (1976), *Natural Habitat* with Alexis Smith (1976).

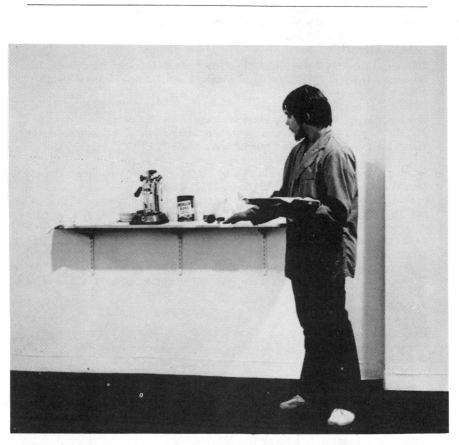

Chris Burden. *Garcon*. Hansen Fuller Gallery, San Francisco, Ca., August 3-7, 1976. "The week of August 3-7, I served capuccino and expresso to visitors to the Hansen Fuller Gallery. I did this during gallery hours, 10:30 a.m. to 5:30 p.m., for an entire week, serving more than 300 cups of coffee. The gallery made no announcement of the performance, and a group painting show opened concurrently with my piece.

I installed a white mini-bar, complete with capuccino machine, demitasse cups, expresso spoons, etc., on a wall near the entrance to the gallery. Attired in a gray cotton orderly's jacket and carrying a silver tray, I approached entering visitors and politely asked them if they would care for either a capuccino or an expresso, which I would serve them while they looked at the paintings. My attire and demeanor were such that only a handful of people out of the hundreds who attended the show recognized me as 'Chris Burden.' "

LOWELL DARLING

Askey, Ruth. "Going Down Cauliflower Alley," *Artweek*, v.8, March 5, 1977, pp.1,16. Review of Lowell Darling and Ilene Segalove's exhibition at the Long Beach Museum of Art on Hollywood's Cauliflower Alley Club. The show included a 50 minute videotape, *The Cauliflower Alley Tapes*, presenting video portraits of many club members, and an exhibition of memorabilia. Excerpt:

The tape is part of a documentary and exhibition of fighting memorabilia focusing on Hollywood's Cauliflower Alley Club, an organization of ex-boxers and wrestlers. Club members include both contenders and winners (nobody's a loser here), whose careers also involved thousands of appearances as heavies in Hollywood detective and gangster films. The fifty-minute videotape is a trilogy based on the club members' remembrances of the fight game, their Hollywood stories and their lives in general. . . .

Darling says that they are body artists who sculpted each other's bodies.

Guy de Cointet. *Ethiopia*. Barnsdall Park Theatre, Los Angeles, Ca., 1976. A play, with music by Bob Wilhite. Performer: Mary Ann Duganne.

NORMA JEAN DEAK

Deak, Norma Jean. *Travel Log.* San Francisco: La Mamelle, Inc., 1977. Videotape, b/w.

GUY DE COINTET

de Cointet, Guy. *Ethiopia.* University of California, Irvine, 1977. Videotape with sound, 40 mins., b/w. Videotaped outdoor performance. Three actors soliloquize and converse in a disjointed, literary style. The set and props are spare and geometric, contributing to the experimental, abstracted sense of the flow of language.

Frank, Peter. "Guy de Cointet and George Miller at Braathen and Freidus," *Art in America,* v. 65, July/August 1977, pp.100. Review of New York exhibitions by two Los Angeles artists.

80 LANGTON ST.

80 Langton St. San Francisco: 80 Langton St., 1977. Catalogue documenting works sponsored by 80 Langton St. during its second year of operation—May 1976 to May 1977. California artists who performed at 80 Langton St. included: John Driscoll and Paul De Marinis (*Bog Works*), Terry Allen (*Country Music*), Southern Country String Band (*Country Music,* included William T. Wiley, Charles Wiley, Richard and Maria Shaw, Perry Fly, Wilson Burrows, Gregor Weiss, Frank Kumin, and Mike Henderson), Joel Glassman, Joel Herman, Rodger Klein, Joan Logue and John Sturgeon in *Five Los Angeles Video Artists* exhibition, Peter d'Agostino (*Trans-Europ Expressed*), Deborah Slater (*Red Sneakers/Found Pieces*), Jim Pomeroy and Paul De Marinis (*A Byte at the Opera*), Bill Morrison (*Fever Dream Remnants, Remembrance, and Vocal Doodlings*), among others. Southern California artists who presented works at 80 Langton St. for the *Performance Exchange* series co-sponsored by 80 Langton and LAICA included: Barry Markowitz, John White, Guy de Cointet, Barbara Smith.

LINDA EVOLA

Evola, Linda. "Nexus II," *Wordworks,* [no.3], May/June 1977. Description with photo of a laser-mirror performance at Wordworks Gallery, May 3, 1977.

FLOATING MUSEUM

Blum, Walter. "A Museum Without Walls," *San Francisco Sunday Examiner and Chronicle,* California Living, April 3, 1977. Article discusses how Lynn Hershman set up the Floating Museum and describes some of the activities sponsored by the museum.

PAUL FORTE

Forte, Paul. "Something Without Time Reflecting the Motions of . . .," *La Mamelle Magazine: Art Contemporary,* no.8, v.2, Spring 1977, pp.100-102.

Forte, Paul. *Symbolic Reflexive.* San Francisco: La Mamelle, Inc., 1977. Exhibition catalogue featuring sculpture, artist's books, and marginal works.

Terry Fox. *552 Steps through 11 Pairs of Strings*. 16 Rose St., San Francisco, Ca., 1976. For and with Larry Fox.

TERRY FOX

Albright, Thomas. "Meditations on 11 Purring Cats," *Art News*, v.76, September 1977, pp.120-21. Review of Fox's show, *Metaphors for Falling*, at Site Gallery, San Francisco.

Fox, Terry. "552 Steps Through 11 Pairs of Strings," *La Mamelle Magazine: Art Contemporary*, v.2, Winter 1977, pp.20-21.

Keil, Robert. "Terry Fox: Variations on a Labyrinth," *Artweek*, v.8, April 2, 1977, p.5. Review of a 7-part installation at Site Gallery, San Francisco, focusing on the Chartres Cathedral labyrinth. One part includes his tape of 11 cats purring which relates to the 11 concentric rings of the Chartres labyrinth.

Stiles, Knute. "Terry Fox: Meanders," *Artforum*, v.15, Summer 1977, pp.48-50. Major article discusses Fox's exhibition at Site Gallery, San Francisco, which included works related to the Chartres Cathedral labyrinth.

MELVYN FREILICHER

Freilicher, Melvyn. *#3 History Lessons: ("Current Events")* The Anita Bryant Papers. Self-published, September 1977. Artist book. The text was

Melvyn Freilicher and Eileen Griffin. *One Too Many Ways of Looking at Anita Bryant.* 1977. Performance based on *#3 History Lessons: ("Current Events") The Anita Bryant Papers;* American Revolutionary Political Pamphlets.

used by Eileen Griffin and Melvyn Freilicher as the basis of a performance work, *One Too Many Ways of Looking at Anita Bryant.*

San Diego Bobcats. *My Travels with Mao: A Joint Experience.* Del Mar, Ca.: Crawl Out Your Window Press, 1977. Artist book.

KEN FRIEDMAN

Friedman, Ken. *Empowerment.* San Francisco: La Mamelle, Inc., 1977. Videotape, 60 mins., b/w.

Friedman, Ken. "Institute for Advanced Study in Contemporary Art," *La Mamelle Magazine: Art Contemporary,* no.8, 1977, pp.68, 115-117.

Friedman, Ken. "Notes on the History of the Alternative Press," *Contemporary Art/Southeast,* no.3, v.1, August-September 1977, pp.42-43.

CHERI GAULKE

Gaulke, Cheri. *Golden Lotus.* 1977. Artist book.

Gaulke, Cheri. *Talk Story.* San Francisco: La Mamelle, Inc., 1977. Videotape, b/w.

Ross, Janice. "Cheri Gaulke's 'Talk Story,' Deborah Slater and Dan Ake's 'Set Up and Sit Down,'" *Artweek,* v.8, November 5, 1977, p.15. Review of Gaulke's performance, *Talk Story,* at La Mamelle Arts Center, San Francisco, and Slater/Ake's work, *Set Up and Sit Down,* at the Oberlin Dance Collective, San Francisco. Excerpt on Gaulke:
Gaulke uses three fairy tales, *Cinderella, The Red Shoes* and the Chinese tale of *Wang Li,* as the basis for her performance. Gaulke really doesn't bring any unique or unusual interpretations to these three stories; instead she emphasizes their obvious antiwoman undercurrents by lumping them together and acting out some of their more blatant images. . . .

NORMAN GOULD

Gould, Norman. *Fat Man Dancing and Other Tapes.* San Francisco: La Mamelle, Inc., 1977. Videotape, b/w.

DOUG HALL

Carroll, Jon. "One Man's Fantasy: The Image of a Hero," *San Francisco Sunday Examiner and Chronicle,* Scene/Arts section, June 19, 1977, p.3. Article on Doug Hall's videotape, *Game of the Week;* prior to making the tape, Hall joined the San Francisco Giants at their Spring training camp as "Artist-in-Residence." Some Giants players, such as Willie McCovey and Ed Halicki, took part in segments of the videotape. Excerpt:
[Hall]: "The idea is that we'll take the tape we shot of me playing catch with Darrell Evans or me asking pitching coach Herm Starrette when I can get into the game with some regular Saturday afternoon baseball TV show featuring the Giants. And then we'll cut in the stuff we're shooting here today, so it looks like I'm hitting the game-winning home run, and I'm

Doug Hall. *Game of the Week.* **Videotape, San Francisco, Ca., 1977. Produced with Chip Lord and Optic Nerve. Hall plays the role of Artist-in-Residence at the S.F Giants Ball Club and intersperses himself into a real game through video editing.**

striking out Johnny Bench, and I'm making the game-saving catch against the fence. And then we'll show it at a museum, and maybe we'll find a place for it on regular TV, and that's the idea."

Doug Hall throws away the weighted bat, picks up his Reggie Jackson auto graphed Louisville Slugger, knocks the imaginary dirt off his imaginary spikes, and climbs in against the soft-throwing right-hander. Several pitches bounce in the dirt. The catcher fails to field them, and they dribble off to the backstop. Finally, Doug Hall lines a single over the shortstop's head. The crowd rustles with anticipation. The pitcher, a big rangy kid from East Texas, delivers a sinking fastball at the knees. Strike two. Three balls, two strikes, bottom of the ninth. The Giants behind by a run. Hall stands in, the bat poised like a rapier behind his right ear. The runner dances off first. The pitcher backs off the rubber, gazes out toward right field. Curt Gowdy mentions again that all the marbles are riding on this pitch. The hot dog vendors are squatting in the aisles. Even the ushers are hushed. The pitcher comes to the set position, checks the runner at first. He delivers. The pitch is high and tight. Doug Hall swings.

The ball travels 300 feet into left field, lands 60 feet short of the fence. "Trot around the bases, Doug," Chip Lord calls from the mound. "Pretend it's a home run." Doug begins his confident jog. The camera follows him around the basepaths. Coming in from third, Doug Hall doffs his cap, gracefully, modestly, yet with a hero's confidence in his own excellence.

The crowd goes crazy.

Hall, Doug. *Game of the Week.* San Francisco, 1977. Videotape. Hall plays artist-in-residence to the San Francisco Giants baseball club.

SUZANNE HELLMUTH AND JOCK REYNOLDS

Ross, Janice. "A Healthy Hospital," *Artweek,* v.8, June 4, 1977, pp.1,16. Review of a performance piece by Jock Reynolds and Suzanne Hellmuth entitled, *Hospital,* presented at the Fort Mason building, San Francisco.

LYNN HERSHMAN

Ballatore, Sandra Lee. "Lynn Hershman as Roberta Breitmore," *New Performance,* no.2, v.1, 1977, pp.27-30. Personal "biography" of Roberta Breitmore and a history of how she came into being.

David Ireland. *David Ireland's House.* Videotape produced by Tony Labat, 1977. Video documentation of David Ireland restoring his house in San Francisco.

Hershman, Lynn. "The Floating Museum Phase I and Phase II," *La Mamelle Magazine: Art Contemporary*, no.8, v.2, Spring 1977. Excerpt:
PHASE I
During its first year, *The Floating Museum* dealt with the indigenous spaces, resources and energies of the San Francisco Bay Area. Artists were invited to use the city as a site and select areas that integrated with their ideas. *The Floating Museum* arranged access, financed the work, paid artists' fees and expenses and communicated the event. All of the spaces were open and free to the public.
PHASE II: GLOBAL SPACE INVASION
Phase II will be the reverse of Phase I. Artists from California will travel to various points on the globe and create site works.

DAVID IRELAND

Ireland, David. *David Ireland's House*. San Francisco: Tony Labat, 1977. Videotape, b/w. Video documentation of David Ireland restoring his house in San Francisco.

ALLAN KAPROW

Buchloh, B.H.D. "Formalism and Historicity—Changing Concepts in American and European Art Since 1945," *Europe in the Seventies: Aspects of Recent Art*. Chicago: Art Institute of Chicago, 1977, pp.85-91. Within the article there is a section on "Klein and Kaprow," offering a comparison of the art of Yves Klein and Allan Kaprow.

Kaprow, Allan. "Participation Performance," *Artforum*, v.15, March 1977, pp.24-29. Major theoretical article. Excerpt:
Up to this point I contrasted audience participation theater in popular and art culture with participation performance relating to everyday routines. I'd like now to look more closely at this lifelike performance, beginning with how a normal routine becomes the performance of a routine.
Consider certain common transactions—shaking hands, eating, saying goodbye—as "readymades." Their only unusual feature will be the attentiveness brought to bear on them. They aren't someone else's routines that are to be observed, but one's own, just as they happen.

Kaprow, Allan. *Private Parts*. Long Beach, Ca., 1977. Videotape, 18 mins., color.

Kaprow, Allan. *Satisfaction*. New York: M.L. D'Arc Gallery, 1977. Artist book.

Restany, Pierre. "From Happening to Activity," *Domus*, no.566, January 1977, p.52. A discussion of Kaprow's work, with emphasis on performance activity from 1971-76. In French, Italian, and English. Excerpt:
As of 1971, Kaprow crossed the Rubicon: He based his research on the relationships between individuals. His work changed from "multimedia" to "intermedia." He abandoned the obsolete term, "happening," in favor of the intentionally neutral term "activity." Since then, he has carried out 40 activities, following a fixed operational scheme. The activity is the object of a written "script" containing all operational indications and premises.

JOANNE KELLY

Ross, Janice. "A Tenuous Conjugation of Video and Dance," *Artweek,* v.8, September 10, 1977, pp.4-5. Review of Kelly's performance work, *Tahmar,* presented in her San Francisco studio as well as at 80 Langton St., San Francisco.

GEORGE KETTERL

Brennan, Barry. "George Ketterl and the Focus of Performance," *Artweek,* v.8, November 26, 1977, pp.4-5. Review of Ketterl's performance, *Malevich: A Drawing Performance and Exhibition of Documentation,* presented at Mount St. Mary's College, Los Angeles, November 2-5, 1977. Excerpt:

Based loosely on a 1913 Suprematist composition, Ketterl's performance involved drawing two rectangles on the floor and walls of two adjacent galleries. The performance was open to the public day and night throughout a four-day period which was divided, for convenience's sake (and because the

Suzanne Lacy. *Learn Where the Meat Comes From.* Videotape, 1977.

Stephen Laub. *Sightseeing*. Los Angeles Institute of Contemporary Art, Los Angeles, Ca., 1977. Detail of "Pool Life on the Costa del Sol, Spain."

piece wasn't about endurance particularly), into seven thirteen-hour, eight minute segments. The performance began at 7 am on November 2 and ended at 7 am on November 5 (96 hours). The drawing was executed with ordinary pencils on particle board covered with Zellerbach meat wrap.

SUZANNE LACY

Lacy, Suzanne. *Learn Where the Meat Comes From.* 1977. Videotape, 15., color.

Lacy, Suzanne. *Rape Is,* reviewed by Debra Dunn, *The Dumb Ox,* no.4, Spring 1977, pp.54-55.

Lacy Suzanne. "Three Weeks in May," *Frontiers: A Journal of Women Studies,* v.2, Spring 1977, pp.64-70.

Rosengarten, Linda. "On the Subject of Rape," LAICA *Journal,* no.15, July/August 1977, pp.48-50. The essay discusses the subject of rape, how it has been depicted in art, historically, and currently by Suzanne Lacy who has focused on the issue of rape as a social concern.

Slater, Jack. "Helping to Stamp Out Rape," *Los Angeles Times*, View, Part IV, May 23, 1977. News article on Lacy's project, *Three Weeks in May*, anti-rape campaign; sponsored by the Studio Watts Workshop and the Women's Building, Los Angeles.

"Suzanne Lacy/Inevitable Associations," *La Mamelle Magazine: Art Contemporary*, no.6/7, v.2, Winter 1977, pp.27-29,48. Excerpt:
The audience entered the room and found chairs arranged in three circles, about twenty chairs per circle, including one large red velvet chair upon which an old woman sat. After the audience was seated lights were lowered and a slide appeared on a screen which read, "I know what I know at thirty. I know about aging, as every woman does. I know only what I see of the aged." "This is a documentation of Inevitable Associations, part One, What is seen . . ." Slides from the first part of the piece (the transformation) were shown. The final slide read "Part two, what is experienced . . ." The lights came on and in each circle the old woman began to talk about aging and her life since sixty-five, interacting with questions from the circle of people around her.

STEPHEN LAUB

Kleb, Bill. "Stephen Laub 'Sightseeing,'" *Artweek*, v.8, February 26, 1977, p.7. Review of Laub's performance, *Sightseeing*, at 80 Langton St., San Francisco, presented as part of the *Performance Exchange* series co-sponsored by 80 Langton St. and Los Angeles Institute of Contemporary Art. Excerpt:
. . . In a dark room, a series of slides (or a film) is projected on a white wall; each image contains one or more figures and these are adjusted to life-size; Laub, in white shirt and slacks, steps in front of one of the projected figures; he carefully adjusts his pose to fit as closely as possible into that of the image, watching himself in one of the two long mirrors placed at either side. Laub's body, in white, seems to disappear into the slide, leaving only a faint, ghostly outline, while his face and hands shift ambiguously in and out of sync with those of the projection. These brief "periods of adjustment" between Laub and the photographic subject are the perceptual core of his work; their changing relationship to the shifting field of the slides expands and qualifies their meaning like variations on a theme.

GARY LLOYD

"Gary Lloyd," *The Dumb Ox*, no.4, Spring 1977, p.12. "Excerpt from *Miles of Audiotape*, a three year journal on audio tape made while driving L.A.'s neverending illusion of interconnectedness, the freeway."

TOM MARIONI

Kleb, Bill. "Tom Marioni and the Sound of Flight," *Artweek*, v.8, June 4, 1977, p.7. Review of Marioni's performance and installation, *The Sound of Flight*, at the de Young Museum, San Francisco. Excerpt:
The performance consisted of Marioni standing before the lectern, drumming with silver-plated snare-drum brushes on the paper. A microphone under the drawing board picked up the sound and amplified it through an echo box, creating a syncopated counter-rhythm. Gradually, a gray impression, like a "frottage," appeared as the silver rubbed off on the gritty paper. After about an hour, Marioni displayed this "drawing" . . .

263

Suzanne Lacy. *Inevitable Associations.* **Part I. Biltmore Hotel, Los Angeles, Ca., 1976.**

Tom Marioni. San Francisco: de Young Museum, 1977. Catalogue for Marioni's exhibition at the museum, Summer 1977. Special edition with audiotape.

SUSAN MOGUL

Mogul, Susan. "Untitled," *Chrysalis, A Magazine of Woman's Culture,* no.2, 1977. Original art—3 page centerfold.

LINDA MONTANO

Montano, Linda. *Learning to Talk, Featuring Jane Gooding, R.N..* 1977. Videotape, approx. 15 minutes, color. Tape included in the video exhibition, *Southland Video Anthology.*

MOTION

Ross, Janice. "Motion's Theater of Two," *Artweek,* v.8, July 2, 1977, p.8. Review of Motion's *Clara Clara,* performed by Joya Cory and Nina Wise at the Theatre of Man, San Francisco. Excerpt:

Linda Montano. *Learning to Talk.* Videotape, 1977.

At the start of the work Cory and Wise enter the performing space in the guise of two bent old women with a shopping bag and junk-filled baby carriage. Once inside they putter around, muttering and humming softly to themselves as they hang their paraphernalia from past lives on wires that litter the ceiling. Neither Wise nor Cory is really intent on assuming a character or personality; parts of their real selves are always easily visible beneath their assumed mannerisms, clothes and postures. At one point Cory sits in a rocking chair and reads a letter from her nagging mother in the sing-song falsetto of an old woman. As she reads, Wise stands in an upstage alcove and repeats certain phrases from the letter, adding a personal and contemporary feminist interpretation.

PAULINE OLIVEROS

Roth, Moira. "An Interview with Pauline Oliveros," *New Performance,* **no.2, v.1, 1977, pp.41-52. Extensive interview; includes 10 photos. Excerpts:**
One day I finally articulated a meditation for the group based on breath. Every sound that comes out of an instrument or voice comes with the breath. The meditation sound was to be made in the involuntary mode rather than the voluntary mode. That means if you were singing, you would allow your vocal chords to vibrate, but not try to place the tone, but rather simply let whatever tone came out, come with the breath. Once I discovered that a number of meditations came out of it. I began to call my work Sonic Meditations in about 1971. Previously I had done some meditative work; one piece was a large choral work based on the points of the compass. Another piece called *To Valerie S. and Marilyn Monroe in Recognition of Their Desperation* again had a meditative feel, but not in the same mode as these new experiments in meditation. Incidentally, the Sonic Meditation group began at the time the women's liberation movement was emerging. I decided it would be good to have women only for a while. They had been held down musically so long. We worked together for two years and out of that all these meditations began to come. I began to study and come upon work that was being done on consciousness. . . .

What happened was that I began to compose with the meditations, taking them and making situations where there were different groups doing different meditations simultaneously, making a layered composition. I wrote a piece called *CROW Two: A Ceremonial Opera* (1973-74). It was quite complicated in its arrangement of meditations. It had a visual meditation: a mandala formation which was made of a large circle of people. A white-haired elderly woman was the Crow Poet and sat at the mandala center. At the four points of the compass there were two white-haired and two black-haired women—who were the four Crow Mothers. These were women chosen for their presence and the color of their hair. On the outside of the circle—at the mid-points of the compass—were four dijeridoo players. The dijeridoo is an Australian aborigine instrument. The meditation began with the drummers—there were seven drummers—doing what is called a Single Stroke Roll meditation, which is to imagine the equal alternation between hands or mallets on the instrument and to let the roll begin from the imagination. The body responds to the imagination and starts the roll rather than willing it. If that instruction is carried out faithfully, the roll does indeed begin but it is involuntary and it locks onto some internal body rhythm. They

are instructed not to change anything, but to keep it going and to continually match the imagination. That is their meditation.

RACHEL ROSENTHAL

Smith, Barbara. "Rachel Rosenthal Performs 'Charm,'" *Artweek*, v.8, February 19, 1977, p.6. Review of Rosenthal's performance work, *Charm*, presented at Mount St. Mary's College, Los Angeles, January 28, 1977.

MARTHA ROSLER

Askey, Ruth. "Martha Rosler's Video," *Artweek*, v.8, June 4, 1977, p.15. Review of Rosler's exhibition, *Foul Play in the Chicken House*, at the Long Beach Museum of Art, which included videotapes and a photo/text works installation. The videotapes included: *From the PTA, the High School and the City of del Mar, Losing: A Conversation with the Parents, Vital Statistics of a Citizen Simply Obtained*, and *Semiotics of the Kitchen*.

Rosler, Martha. *Garage Sale*. San Francisco: La Mamelle, Inc., 1977. Videotape, b/w.

Rosler, Martha. *Service: A Trilogy on Colonization*. New York: Printed Matter, 1977. Artist book; three texts, includes "The Budding Gourmet," "McTowersmaid," and "Tijuana Maid."

Rosler, Martha. "She Sees in Herself a New Woman Every Day," *Heresies*, no.2, v.1, May 1977, pp.90-91. Text from a piece originally presented as a performance.

ILENE SEGALOVE

Askey, Ruth. "Ilene Segalove's Portraits," *Artweek*, v.8, October 15, 1977, p.15. Review of Segalove's three videotapes shown at the Thomas/Lewallen Gallery, Santa Monica: *California Casual, Skin Cancer*, and *Oh, If I Could Only Draw - a Tragedy*. Excerpt:
In *Skin Cancer* Elaine Segalove [Ilene's mother] is shown by her pool explaining that due to two surgeries on her nose for skin cancer, she's been forced to use all sorts of agents—oils, creams, hats, glasses—to prevent tanning. Looking for something efficient yet easier to use, she finally finds the answer. She dons a full rubber mask—a hooker's face complete with two-tone hair (black on top and red on the sides) and a cigarette permanently dangling from its mouth. Then putting on an inner-tube/life preserver, she swims off to the tune of Debussy's *La Mer*, saying "it's a good thing I swim alone."

See also under Darling, Lowell. "Going Down Cauliflower Alley" article.

SEND/RECEIVE

Send/Receive. *Send/Receive New York Edition*. New York: Send/Receive, 1977. Videotape, color.

Alexis Smith. *Scheherazade the Storyteller.* Los Angeles, Ca., 1976.
". . . a series of readings from the *Thousand and One Arabian Nights,* was performed on five evenings, August 23 through 27, 1976, before a very small audience. Ten guests each night were admitted to a candle-lit environment furnished with Persian rugs and lattice-work screens and separated from the external world by the smell of incense and the soft gurgling of a fountain. A costumed attendant greeted the guests and offered them mint tea, cookies, and hashish. After they were refreshed, she conducted them into an inner chamber where the readings took place.

In the second chamber, the ten guests reclined on soft pillows in front of the traditional rug of the storyteller, while she read aloud by lamplight. The readings centered around a different tale each night, lasting approximately one and one half hours. The stories told included the "Prologue" to the 1001 Nights or "The Tale of King Shahriyar and his Brother Shazaman," "Alladin and his Enchanted Lamp," "The Fisherman and the Jinnee," "The Voyages of Sinbad," "The Tale of Ma'ruuf the Cobbler," and the "Epilogue."

JOYCE CUTLER SHAW

Shaw, Joyce Cutler. *The Lady and the Bird: Narrative Fragments.* Self-published, 1977. Artist book.

DEBORAH SLATER

Ross, Janice. "Cheri Gaulke's 'Talk Story,' Deborah Slater and Dan Ake's 'Set Up and Sit Down,'" *Artweek,* v.8, November 5, 1977, p.15. Review of Gaulke's performance, *Talk Story,* at La Mamelle, San Francisco, and Slater and Ake's work, *Set Up and Sit Down,* at the Oberlin Dance Collective, San Francisco.

ALEXIS SMITH

"Alexis Smith," *Flash Art,* nos.78/79, November/December 1977, pp.32-33,36. In the Post-Conceptual Romanticism issue; Smith discusses the romantic elements of her work and describes her performance series, *Scheherazade the Storyteller,* 1976.

Barbara Smith. *Ordinary Life.* **Venice, Ca., 1977.**

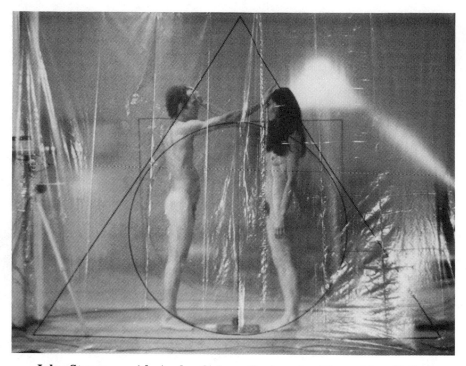

John Sturgeon with Aysha Quinn. *Conjunction/Opposition II.* L.A. Louver Gallery, Los Angeles, Ca., 1977.

Smith, Alexis. *Alone.* Venice, Ca.: Self-published, 1977. Artist book; a poem illustrated by objects.

BARBARA SMITH

Clothier, Peter. "Barbara Smith - In Search of an Identity," *Artweek,* v.8, February 12, 1977, p.7. Review of Smith's performance in Los Angeles on January 22, 1977, as part of the series, *Performance Exchange,* jointly sponsored by 80 Langton St., San Francisco, and Los Angeles Institute of Contemporary Art. Excerpt:

The development of the performance takes place in three movements, each exploring an area of the experience of "ordinary life": sexual relationships, professional activity and fantasy. Against a background of percussion accompaniment, a dialogue is enacted between "Barbara" and those around her: the latter address themselves to her in a formidable array of sexual and professional cliches, which range in tone from crude accusation and sympathy, aggression and tenderness. And alternately she herself confesses and accuses, and examines—again, almost painfully—the inner effects of what comes at her from without: a sense of physical and mental "invalidation."

Smith, Barbara. *With Love from A to B (Version I), by Barbara Smith and Nancy Buchanan.* 1977. In these unpublished explanatory notes Smith discusses Version I, a performance done for the January 1977 College Art Association Conference, and notes that Version II was made in December 1977 to correct the failings of Version I.

JOHN STURGEON

John Sturgeon. Long Beach: Long Beach Museum of Art and L.A. Louver Gallery, 1977. Catalogue for an exhibition, *Two Video Installations,* at the Long Beach Museum of Art, January 21, 1978-February 19, 1978. Introduction and essays. Photo and text documentation for videotapes: *Hands Up*(1974), *Shirt*(1974), *NOR/MAL CON/VERSE*(1974), *(waterpiece)* (1974), *Shapes from the Bone Change*(1975), *The Two of Triangles*(1975), *Conjunct*(1976), *2 Aspects*(1976), *I Will Take You*(1977), and *Opposition/ Conjunction II*(1977).

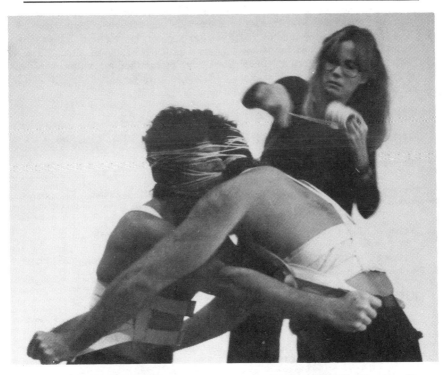

T.R. Uthco (Doug Hall, Jody Procter, and Diane Hall). *Really, I've Never Done Anything Like This Before, He Said.* La Mamelle Arts Center, San Francisco, Ca., 1977. Illustrated by a circle of flashlights, Hall and Procter grapple with one another while observed on a bank of monitors in another portion of the gallery.

271

T.R. UTHCO

Brennan, Barry. "T.R. Uthco's Dialogues," *Artweek*, v.8, December 3, 1977, p.7. Review of T.R. Uthco's performance, *Really, I've Never Done Anything Like This Before, He Said*, at the Otis Art Institute, Los Angeles; sponsored by Some Serious Business. Excerpt:

The main portion of the piece—the "live" portion—was in the rear gallery at Otis. In the middle of the space, Doug Hall and Jody Procter, naked to the waist, had their heads bound together with string. The men were illuminated by a circle of flashlights positioned around the floor. In the middle of the circle, the two men grappled with one another and carried on a dialogue that, under the circumstance, sounded remarkably reasonable. In the front gallery, this activity could be observed on a monitor flanked by two additional monitors on which tapes of three previously recorded activities were played in twenty-minute sequences. The performance was intended to last two hours.

T.R. Uthco. *Beyond the Edge*. Willits, Ca.: Tuumba Press, 1977, no.8. Artist book. Doug Hall and Jody Procter presented spontaneous monologues during their six hour performance of "32 Feet Per Second Per Second," that took place on the facade of La Mamelle Arts Center, S.F., April 1976. "They conceived of their voices as verbal muzak and maintained a constant babble, an endless stream of consciousness." *Beyond the Edge* is a transcript of 22 minutes taken from the last hour.

STEFAN WEISSER

Weisser, Stefan. *AMEHIXONUY*. Oakland: X Press, 1977. Artist book.

Weisser, Stefan. *JQV*. X Press, 1977. Artist book.

Weisser, Stefan. *REQQQNITIQNQ*. Marin/Oakland: X Press, 1977. Artist book.

Weisser, Stefan. *Source of Supply*. X Press, 1977. Artist book.

Weisser Stefan. "Special Poetics Concurrent with the Lunar Eclipse," *Wordworks*, no.2, April/May 1977.

JOHN WHITE

Clothier, Peter. "John White: The Basics of Identity," *Artweek*, v.8, May 14, 1977, p.5. Review of White's performance, *Initiator/Cover: A Performance Situation*, presented at the Los Angeles Institute of Contemporary Art, April 1977.

"Jock Strap," *The Dumb Ox*, no.4, Spring 1977, p.13.

1978

GENERAL LITERATURE

Art in America, v.66, September/October 1978, pp.70-94. Special issue on Southern California Art. Essays include: 1)Plagens, Peter. "Play It As It L.A.'s," pp.70-74; 2)Rubinfien, Leo. "Through Western Eyes," pp.75-83. Rubinfien interviews 7 artists (Eleanor Antin, John Baldessari, Billy Al Bengston, Chris Burden, Robert Cumming, Robert Graham, Alexis Smith) about life, art and the art scene in Southern California; 3)Frank, Peter. "Unslick in L.A.," pp.84-91. 4)Marmer, Nancy. "Proposition 13: Hard Times for the Arts," pp.92-94. Excerpts:

[Eleanor Antin]: I believe absolutely that the feminist movement in Southern California has affected the rest of the Southern California art world. I really think that women practically invented performance in Southern California. I know there are people who won't agree, and there are some very good male performance artists. There's quite a difference in politics between Southern California and New York. In New York people who are interested in politics have a standard Marxist line, a kind of system they place upon the world without any relation to its fit with experience reality. New York feminism is more contaminated with Marxist bullshit. In California, feminism has been more a social, political and psychological thing about what it means to be a woman in this society, a particular woman, an artist. . . . Which doesn't imply that the artwork coming out of it is necessarily better, only that very real political questions are often considered. The only kind of politics Southern California *has* is feminism.

[Chris Burden]: The younger artists out here are not dealing with drawings and paintings anymore. They're dealing more with ideas. I mean here's a media city, and the native language just isn't painting and such; it's television, films, the media. This place is *about* reality and illusion, sanity and insanity. There's just total schizophrenia as to what is real and what isn't, but it's clear here that a lot of things are make-believe. So it becomes increasingly apparent that you can affect people with intangible ideas. You can make a little 16mm film that's, say, 30 seconds long, and by running it over and over you can sell a million Chevrolets a day. Suddenly it seems a

273

little bit ridiculous to be making something like a 36-foot painting. Or take my getting shot in the arm, which is the big piece I'm famous for. I was able to do a piece of sculpture that didn't take any material except a rifle, that was over in a split second and that basically existed by word of mouth. And that's, I think, what attracted me—not getting shot particularly, but the whole conciseness of the thing. In essence that's giving the shaft to MGM, with their fancy sets and million dollar budgets. Phillip trotted across the room and shot me in the arm for one millisecond: big deal. But in terms of the media—and that includes word of mouth—it worked.

Artwords and Bookworks: An International Exhibition of Recent Artist's Books and Ephemera. Los Angeles: Los Angeles Institute of Contemporary Art, 1978. Catalogue for exhibition organized by Judith Hoffberg and Joan Hugo for LAICA, February 28-March 30, 1978.

Askey, Ruth. "Double X Curates Women's Show," *Artweek*, v.9, July 29, 1978, p.15. Review of exhibition sponsored by Double X at LACE (Los Angeles Contemporary Exhibition) Gallery, featuring 20 women artists. Participants included Suzanne Lacy, Barbara Smith, Martha Rosler, Leslie Labowitz, Nancy Youdelman, among others. Excerpt:
Barbara Smith and Suzanne Lacy's performance on opening night, July 9, was a ritualistic event surrounding a lamb dinner. They interacted together and with five designated people from the audience who came up to them as they ate and described "what is happening here."

Askey, Ruth. "Humanistic Concerns in Performance," *Artweek*, v.9, November 11, 1978, pp.6-7. Review of five performances by women sponsored by Double X, Los Angeles. Included were performances by Leslie Labowitz, Vanalyne Green, Suzanne Lacy with Nancy Buchanan, Linda Montano with Pauline Oliveros, and Barbara Smith.

Askey, Ruth. "Southland Video - Part V," *Artweek*, v.9, February 25, 1978, p.3. Review of Part 5 of the *Southland Video Anthology*, sponsored by the Long Beach Museum of Art, which included over a dozen tapes. Participants included: Nancy Buchanan, Barbara Smith, Elon Slotes, David Lamelas, Ron Clark, Robert Biggs, Kevin Boyle, Cynthia Maughan, and others.

Askey, Ruth. "Video From Sensor," *Artweek*, v.9, April 22, 1978, pp.3-4. Review of a video exhibition at the Los Angeles Institute of Contemporary Art, sponsored by Sensor, a women's media resource center, located in Santa Monica. Review of video works by Susan Amon (*Fur Cabbage*), Nancy Angelo and Candace Compton (*The Nun and The Deviant*), Nancy Buchanan (*Tar Baby*), Gaile Loren (*Death Masks*), Jean Mansour (*Balances*, and *Through the Madness/Through the Sanity*), Visual Communications (*Something's Rotten in Li'l Tokyo*), and other tapes made by collective groups.

Baker, Mary Winder, Brown, Francis and Woods, James M. *An Alternative Paper on Alternative Space.* California: Self-Published, 1978. Fourteen page work self-published and distributed free at the New Artsspace Conference,

April 1978, Santa Monica, Ca. Excerpt:
I swear it there is an art to just living and the finest pieces of art work deal with the feelings of being a human being . . . now. [Mary Winder Baker]

Barber, Bruce. "The Terms: Limits to Performance?," *Centerfold*, v.2, September 1978, pp.96-100. An excerpt from an essay entitled "Problems in the Taxonomy of Performance and Body Art," (1977). Excerpt:
To my mind "the limits," as Kirby prefers to call them, have still not been determined. This is what makes classification at the present time so difficult. The examples from the Art Index system previously given reveal how easily, on the official level at least, performance can bleed into other categories and vice versa. It is perhaps in the very nature of the word 'performance' that this be so, at least until the term becomes so convenient and 'catch-all,' like the word Happening, that it ceases to have any other than a specific historical relevance. Viz. performance in New York meant such and such to this particular group of people within this limited period of time. In fact the word performance is not like the word Happening. It has been appropriated rather than coined and has therefore already been honed down by its users to accommodate what they wish it to mean. This might sound surprising, yet I would contend that it is (or was) less open to abuse from the very start of its existence as an art term than Happening ever was. As a word with already a great deal of currency in the vernacular it is less likely to be appropriated by the world of advertising than say Pop art—Body Art or Body Language. But then it's more likely to be open to abuse in the art world—of the kind that the term alienation has had in the world of sociology and philosophy.

Battcock, Gregory (ed.) *New Artists Video.* New York: E.P. Dutton, 1978.

Centerfold, Toronto, v.3, December 1978. Special "Tele-performance" issue.

"Connecting Myths," *High Performance*, no.2, v.1, June 1978, pp.40-41. Description of a series of works coordinated by Cheri Gaulke and John Duncan, presented in Pasadena, March 23-26, 1978. Included in the series: Feminist Art Workers (*This Ain't No Heavy Breathing*), Sandra McKee (*Stories My Mother Told Me*), Cheri Gaulke (*She Is Risen Indeed*), Kathy Convention Kauffman (*Strip to Strip*), Leslie Labowitz-Starus (*Reenactments*), John Duncan (*Every Woman*), Jim Moisan (*Gender Violence and Utopia in Science Fiction*), Nancy Angelo and Jeremy Shapiro (*You Never Wanted to Be a Prick*), Jerri Allen, Leslie Belt, Anne Gauldin, Patti Nicklaus, Jamie Wildman, Denise Yarfitz (*Hands Off*), and Laurel Klick (*Cattin' Around*). Excerpts:
EVERY WOMAN , JOHN DUNCAN , MARCH 24
I wanted to feel, even for one night, the daily vulnerability to sexual attack experienced by most women. I exposed myself to sexual aggression by men—as a man one night, a woman the next, on a Hollywood street. Paul McCarthy witnessed the event both nights. Together on the 24th, we answered questions and described our perceptions to an audience.
CATTIN' AROUND , LAUREL KLICK , MARCH 26
In this performance I explored the relationship between feline and female. The histories of cats and women are curiously parallel. During times when

women have been most brutalized, cats have also been brutalized and seen as evil animals. Conversely, in cultures where women were honored, cats have been seen as goddesses. In the performance, costumed as a cat, I gave a slide lecture about the history of cats.

Flash Art, nos.80/81, February/April 1978. Special issue on "Danger in Art." Some articles include: 1) Pluchart, Francois. "Risk as the Practice of Thought." International in scope, the article includes discussion of California artist Chris Burden, and mention of Barry LeVa and Terry Fox. 2) Chalupecky, Jindrich. "Art and Sacrifice." Article includes discussion of work of Chris Burden and Terry Fox.

Flash Art, nos.84/85, October/November 1978. Fluxus/Happening issue. Includes articles: "From History of Fluxus" by Charles Dreyfus, "On Fluxus" by Ken Friedman, "Some Thoughts on the Context of Fluxus" by Dick Higgins. Excerpt from "On Fluxus:"

Over the years, I have witnessed, discovered, and participated in the offerings which Fluxus has made to the world. These offerings span an incredible range of ideas and media. Fluxus and the Fluxus participants have been engaged at significant levels in the invention, development and theory of a number of important issues in contemporary art and contemporary culture, among them: intermedia, correspondence art, communications art, book art, artists' books, new art spaces, alternative spaces, museum development, new Left political action, the anti-war movement, the development of artists' cooperative housing, arts law, arts legislation, performance, events, film, concept art, video, concrete poetry, the new music, artists' musical scores, composers' visual scores, new art periodicals, alternative publishing, the Underground Press Syndicate, floating museum projects, travelling museums (in hats, buses and portable museum kits), multiples, rubber stamp art, festivals, television, radio, the Neuer Sensibilitat, Nouveau Realisme, artists' rights, the development of the Soho in New York, the development of major archives of contemporary art now located in several important museums, universities and libraries—and many more.

"(H)errata," *La Mamelle Magazine: Art Contemporary*, no.10, v.3, 1978, pp.8,9. A strategic women's outdoor sculpture event organized by Lynn Hershman, Jo Hanson and Pat Tavenner.

High Performance, Los Angeles, no.1, v.1, February 1978. Editor and Publisher, Linda Frye Burnham. The first California art magazine devoted solely to performance art. In a "publication as exhibition space" format, the "Artist's Chronicles" section is devoted to description of performances by individual artists. Feature articles include a major interview with one artist and an overview article on an exhibition space/institution that supports performance art activity. Excerpt:

Too much performance art has been lost to art history. Therefore, HIGH PERFORMANCE is open to any artist who is organized enough to send me good black and white photographs and clear description of what occurred. I ask for material directly from the artist because we have relied too much and too long on criticism.

Johnson, Charles. "Many Forms in 'Take Form,'" *Artweek*, v.9, October 28, 1978, p.6. Review of *Take Form*, an exhibition in Sacramento which juxtaposed performing arts and performance art. Organized by Everett Wilson and Kim Scott with several artists who contributed works/performances.

Kelly, Jeff. "Rape and Respect in Las Vegas," *Artweek*, v.9, May 20, 1978, p.4. Article on California feminist performance art. Discusses works by Suzanne Lacy, Leslie Labowitz, Nancy Buchanan, and others, who were participants in *From Reverence to Rape to Respect*, an art/humanities public awareness event held in Las Vegas.

La Mamelle Magazine: Art Contemporary, no.12, v.3, 1978. Special Transmittable Book Issue, produced during La Mamelle, Inc. residency at A-Space, *A Literal Exchange*, Toronto, 1978, and designed to be re-assembled into individual artist's books. Contributors included: Anna Banana, Buster Cleveland, Paul Forte, Nancy Frank, Bill Gaglione, Kirk deGooyer, Carl Loeffler, G.P. Skratz, Mary Stofflet.

Bill Gaglione and Buster Cleveland. *A Literal Exchange*. Toronto, Canada, 1978.

THE NEW ARTSSPACE

The New Artspace. Los Angeles: Los Angeles Institute of Contemporary Art, 1978. A directory which offers a summary of historical and financial information about alternative visual arts organizations in the United States and Canada. Prepared in conjunction with *The New Artsspace* conference sponsored by LAICA in Santa Monica, April 26-29, 1978.

Stofflet, Mary. "The New Artsspace," *La Mamelle Magazine: Art Contemporary,* no. 11, v. 3, Summer 1978, pp. 14-15. A report on the New Artsspace conference, the first national conference of alternative visual arts organizations, April, 1978, Los Angeles.

Singerman, Howard. "Opting Out and Buying In," LAICA *Journal,* no.19, June/July 1978, pp.40-41. Article on alternative spaces and the New Artsspace Conference that took place April 1978 in Santa Monica, Ca.

Wortz, Melinda. "New Artsspaces - A Conference Overview," *Artweek,* v.9, May 27, 1978, pp.2-3.

Rigby, Ida K. "Narratives of Human Conditions," *Artweek,* v.9, October 21, 1978, p.6. Review of works/performances/events presented as part of the exhibition, *L.A. Women Narrations,* at Mandeville Art Gallery, University of California at San Diego, La Jolla.

Roth, Moira. "Toward a History of California Performance: Part One," *Arts Magazine,* v.52, February 1978, pp.94-103. Major essay on the history of performance art in Northern California.

Roth Moira. "Toward a History of California Performance: Part Two," *Arts Magazine,* v.52, June 1978, pp.114-22. Major essay on the history of performance art in Southern California.

Underwood, Tyson. "The Motel Tapes,"Artweek, *v.9, March 4, 1978, p.7.*

Umbrella, Glendale, Ca., no.1, 1978. Editor, Judith Hoffberg; Publisher, Umbrella Associates. A newsletter of art news, reviews, and art information of current trends.

Videozine Five, no.5, 1978. Videotape, approx. 35 mins., b/w. A "periodical" published by La Mamelle, Inc., on videotape format, *Videozine Five* is an anthology of performance art works. Artists include: Judith Azur, Anna Banana, Don Button, Geoffrey Cook, Bob Davis, Norma Jean Deak, Irene Dogmatic, Paul Forte, Margaret Fisher, Ken Friedman, Bill Gaglione, Cheri Gaulke, among others. Includes works performed during 1975-77.

Videozine Six, no.6, 1978. Videotape, approx. 35 mins., b/w and color. Special New Video Performance issue. An anthology of performance works in a live cablecast or simulated broadcast situation. Participants: Anna Banana, A.A. Bronson, Buster Cleveland, Bob Davis, Kirk deGooyer, Eldon Garnet, Bill Gaglione, Norman Gould, Paul Forte, Nancy Frank, Marien

Lewis, Raul Marroquin, Titus Muizlaar, Victoria Rathbun, Willoughby Sharp, Jorge Zontal, and others.

View, Oakland, no.1, v.1, April 1978. Publication of Point Publications, Crown Point Press. Series of interviews with contemporary artists. Each issue features one artist.

Vile International, no.6, Summer 1978. Special issue, entitled *Fe-Mail Art.*

ARTISTS / ART SPACES

TERRY ALLEN

Ross, Janice. "Wrestling with Human Relationships," *Artweek*, v.9, November 4, 1978, pp.1,20. Review of *The Embrace . . . Advanced to Fury*, performed at the University Art Museum, Berkeley, in conjunction with *American Narrative/Story Art, 1967-1977* exhibition.

ANT FARM

Loniak, Walter. "The Message: 'Smash Cars and Burn Televisions,'" *The Santa Fe Reporter*, January 19, 1978, p.1A.

Paul Forte. *Something Without Time Reflecting the Motions of . . .* From *Videozine Five*, La Mamelle Inc., San Francisco, Ca., 1978.

Carl Loeffler. *A Literal Exchange.* From *Videozine Six*, La Mamelle Inc., San Francisco, Ca., 1978.

ELEANOR ANTIN

Antin, Eleanor. "Some Thoughts on Autobiography," *Sun and Moon: A Journal of Literature and Art,* no.6, Winter 1978-79.

8 Artists. Philadelphia: Philadelphia Museum of Art. 1978. Newsprint 8 page tabloid, the catalogue to a group exhibition, April 29-June 25, 1978. Each artist is given one page coverage; included for Antin are 3 photos, a short essay about the artist, and a statement by the artist.

Knight, Christopher. "History/Art," LAICA *Journal,* no.20, October/November 1978, pp.27-29. Article on the relationship of history and art; includes discussion of the "historical biographies" explored in Eleanor Antin's work.

Rickey, Carrie. "From Balletomane to Balletomanic: Pas Deduced," *The Soho Weekly News,* May 25, 1978. Review of Antin's exhibition at the Whitney Museum, May 9-17, 1978, where Antin appears as the Ballerina in three tapes and related documents on exhibit.

BAKER/RAPOPORT/WICK

Flanagan, Ann. "Craft of Collaboration: Baker/Rapoport/Wick—Three Women Demonstrate that Working Together Works," *Craft Horizon,* v.38,

June 1978, pp.22-24. Discussion of the collaborative art process of Mary Winder Baker, Debra Rapoport, and Susan Wick with photo documentation of some of their performance works. Excerpt:

Women have always worked together on creative projects; the quiltmakers are the most obvious example among fiber artists. B/R/W calls what they are doing "post-feminism," a trust in their own talent and worth combined with the security of the relationship that makes them want to expand their essentially feminine viewpoint to men and women alike. For example, into the corporate setting, they introduce womanly skills and values—an appreciation for beauty in the day-to-day environment, for what we wear, what and how we eat, for nurturing. They emphasize an intimate connection with tools and work processes, and demonstrate how feminine ideas and customs in the traditionally masculine setting (or in any situation) can make life richer. What B/R/W sells is designed to fill whatever particular need the client may have: They have created artworks for businesses with materials discovered on location; catered lunches in San Francisco's financial district; Macy's has twice put the trio in its windows to push cookware and bridal accoutrements.

Judith Barry. *Cup/Couch.* **La Mamelle Arts Center, San Francisco, Ca., 1977.**

JUDITH BARRY

Barry, Judith. "Cup/Couch," *High Performance*, no.3, v.1, September 1978, p.10. Description of a performance by Judith Barry presented November 13, 1977, at La Mamelle Arts Center, San Francisco.

Cup/Couch explores the difference between "telling an event" and "doing an event," using cups and couches to explicate this process in 20 scenes, each set up to exhibit by example, a variety of current linguistic practices for getting at this question. The first third of the piece runs through the most prevalent methodology—scripting, point of view, matonomy, definition, syntax, punning and so on. In the second part, the contextual range inherent in an examination of this kind is explored; such as how sounds can be used, voice quality, words as containers—cups and couches are also containers—phrase repetition and metaphor. The remainder of the piece scrutinizes narrative structure, dealing with questions concerning language theory, the process involved, relationships, and information about cups and couches specifically that was uncovered in the course of the examination. And, how does the "telling" differ from "the telling?"

BDR ENSEMBLE

"Station Event," *High Performance*, no.1, v.1, February 1978, pp.38-39. An event by the BDR Ensemble (Michael Delle Donne-Bhennet, John Duncan, Thomas Recchion), sponsored by Close Radio, broadcast live on KPFK 90.7 FM, Los Angeles, December 1, 1977. Excerpt:

Station Event was intended to use radio as a medium of communication rather than one of broadcast. It was performed live over Close Radio from two separate rooms. Delle Donne-Bhennet (musician; played woodwinds and percussion) and Recchion (sound artist; played invented instruments and available materials) performed in KPFK's Studio A. Paul McCarthy joined them toward the end of the work. From the control room, Duncan (performance artist) asked for and monitored phoned-in responses to what the ensemble was doing. Telephone calls and music from Studio A were mixed at the discretion of Steve Tyler, night engineer at KPFK. The two rooms were sound-separated; Tyler alone was able to hear the complete broadcast at its source.

NANCY BLANCHARD

Ross, Janice. "Human Still Lifes," *Artweek*, v.9, December 23, 1978, pp.1,16. Review of Blanchard's performance, *Still Life*, at 80 Langton St., San Francisco.

BOB & BOB

Bob & Bob. *Simple and Effective*. Long-playing 33⅓ record, 1978. 14 songs. Lyrics to *Go to the Police*:

Go to the police, tell them all you know
Go to the police, tell them all you know
Go to the police, tell them all you know
Go to the police, tell them all you know

When I needed them
They were always there
In a minute or two
Knockin' at my door

Call 'em day or night, they are always there
Call 'em day or night, they are always there
Call 'em day or night, they are always there
Call 'em day or night, they are always there

They'll do anything, they're braver than us
They'll do anything, they're braver than us

Go to the police, tell them all you know

Kornbluth, Jesse. "Wet Behind the Ass," *Oui,* **v.7, July 1978. Article on** *Wet* **magazine and Bob & Bob.**

McKenna, Kristine. "Brace Yourself for Action," *High Performance,* **no.2, v.1, June 1978, pp.34-35. Performance work presented at Ruth S. Schaffner Gallery, Los Angeles, February 5, 1978, sponsored by Some Serious Business. Excerpt:**
Upon entering the gallery, audience members found on their chair seats party favor cups, each containing three jelly beans and a cigarette. The gallery was decorated with crepe paper which, coupled with the party favors, suggested a child's birthday party. The piece opened with a satirical documentary film that employed devices similar to those used by comedian Steve Martin to expose the foibles of the status seeking middle class: we experience a day in the life of two "Mr. Entertainment" personalities who repeatedly fall prey to slapstick mishaps. We visit them in their sumptuous home—a laughably tasteless Blue Chip Stamp environment. An off-camera narrator with an FM D-Jay voice chats with the pair, both of whom are noticeably ill-at-ease while struggling to be suave. We stroll along as they take their daily "nature walk" to their "think spot," attired as always in let's-make-a-buck business suits.
The film was followed by a live presentation of music and comedy penned by the team and closed with a rendition of "Heard It Thru' the Grapevine" that left the audience clamoring for more. The remainder of their set was a study in calculated amateurishness comprised of tunes suitable for a children's TV show:
"Mr. Personality
That's our friend the fireman
He risks his neck without public thanks
He's a modern hero
We've got just a few friends
But all of them are winners
They all help the world
By being what they are"*

*© 1978 "Mr. Personality" by Bob & Bob for M.I.T.B. Music

Milder, Cece. "Art for People Who Drive Fords," *Los Angeles Free Press*, March 2, 1978.

FRANCIS BROWN

Brown, Francis. "The Great American Worker," *High Performance*, **no.3, v.1, September 1978, p.8. Description of the artist's work posing as the great American worker taking a break, which took place across the continental U.S. during 1977. Text:**

During 1977 I traveled throughout America in costume (a printer's apron). It was a comfortable and natural form for me although others were puzzled by it and would stop me to ask, "Why are you wearing an apron?" My reply was always, "I'm posing as the great American worker taking a break." At this point a conversation would usually begin and last from a minute to an hour dealing with the American worker, workers of various types, workers from other countries (usually Mexico) and artists as workers.

The American worker is one of the best in the world. Americans work very hard and long, especially farmers. Americans are better educated, healthier and more efficient than just about any other people in the world. Most American workers are white collar workers and service workers and they contribute enormously to the technological growth of America. This is a technological society. But American workers don't know how to relax. Money and security are prime movers and until something else takes its place American workers will die working. I won't.

NANCY BUCHANAN

Buchanan, Nancy. "Deer/Dear," *High Performance*, **no.2, v.1, June 1978, pp.32-33. Slide show/narrative work performed at Santa Ana College, January 11, 1978. Excerpt:**

I think of this performance as a travelogue in fear. It was a slide show/narrative which represented the beginning of consciousness about an unpleasant state of affairs: as woman, we DO have a great deal to fear, but we are simultaneously trained to be fearful of the world AND to disregard our fears as symptoms of weakness and paranoia. . . . I was moved to make this piece when the body of a victim of the "Hillside Strangler" was found quite near my house—this reactivated my personal feelings about danger, which I usually repress.

Buchanan, Nancy. "Meager Expectations," *High Performance*, **no.1, v.1, February 1978, pp.26-27. Explanatory text for a performance work presented at the Los Angeles Institute of Contemporary Art on September 4, 1977, and at La Mamelle Arts Center, San Francisco, on October 23, 1977. Excerpt:**

Meager Expectations was an examination of the dualities created by the expectations created by a woman (her own as well as those of others), particularly with regard to romantic fantasies and the impossible self-expectations these create. The central question of the performance, insisted on again and again, "What did you expect?" is as inevitable as it is simplistic—what can be expected of life, other than death? . . .

Terryl Hunter and I appeared dressed as dolls, false eyes painted on our eyelids. The eyes functioned to complete the doll's image, assert the

Francis Brown. *The Great American Worker.* **1977. During 1977 Brown travelled throughout America posing as The Great American Worker taking a break.**

Chris Burden. *The Citadel*. Los Angeles, Ca., August 8-12, 1978. "The Citadel was a combination installation and performance dealing with outer space. A small oddly-shaped room with a rear brick wall was made completely light tight and painted black. Over five hundred extremely detailed miniature metal space ships ranging in size from one-quarter of an inch to four inches were hung from the ceiling using black thread. Four folding chairs were provided for the audience.

Each group of four was let into the pitch black room and seated by an assistant. Because they had been waiting outside in the bright sunlight, they could not see anything. I turned on two tape recorders. One tape was a recording of a steam jet on a cappuccino machine, repeated over and over. This simulated rocket noise. The other tape began with the message that 'these starships have assembled here from all corners of the universe to investigate the infinite, inexplicable citadel wall, the end of the universe.' At the same moment I lit a candle which illuminated a small portion of the spaceships. While the rocket noise continued, the audio tape related a series of excerpts from outer space war games, such as travel in

(cont'd, p.287)

286

contradiction of appearing to make constant eye contact with the audience while remaining totally closed off, and referred to several connotations, such as painted symbols to ward off the Evil Eye, Gnostic beliefs regarding inner light, etc.

CHRIS BURDEN

Burden, Chris. *Chris Burden 74-77*. Los Angeles: Self-published, [1978]. A catalogue documenting Burden's performance work from 1974 through 1977; photographs and text.

Chrissmass, Dwight. "Chris Burden's Full Financial," *Dumb Ox*, no.6/7, Spring 1978, pp.64-65. Review of Burden's exhibition, *Full Financial Disclosure*, at the Baum-Silverman Gallery, Los Angeles.

Lewis, Louise. "Actions Performed and Documented," *Artweek*, v.9, September 16, 1978, p.7. Review of an exhibition curated by Chris Burden at the Los Angeles Institute of Contemporary Art entitled, *Polar Crossing*, which included photography, video, book documentation and performances by 3 European artists: Richard Kriesche (Austria), Gina Pane (France), and Petr Stembera (Czechoslovakia).

Reak-Johnson, Bridget. "Chris Burden," LAICA *Journal*, no.20, October/November 1978, pp.68-69. Review of Burden's work, *The Citadel*, performed in a warehouse in Los Angeles, August 8-12, 1978. Excerpt:

Chris Burden waits in the dark for his audience to be ushered in. They sense his presence, although the utter darkness of the room prevents any visual contact. They grope for chairs, are settled and an audiotape is activated. Burden lights a candle to otherworldly simulated sound. Gradually eyes adjust to the dark; Burden, expressionless, illuminates the verge of a seemingly endless array of tiny space ships. These rockets, the recorded message dictates, have come from the reaches of the universe to investigate the inexplicable, infinite citadel wall. Feeling a trifle like the monk he is,

suspended animation, the use of the Jump Drive for interstellar travel, atmospheric conditions, names and uses of the different types of ships, the vast array of different types of weaponry, etc. I moved slowly back and forth through the suspended ships. Slowly, as the audience's eyes adjusted to the candlelight they could see more and more of the small ships, which are hovering in front of them, above them and on either side of them. Towards the end of each performance I moved to the rear of the room revealing the brick wall (the Citadel Wall). The candle was extinguished. The two tapes came to an end and the audience was ushered out. Each session lasted ten minutes and was repeated continuously from 11 a.m. to 1 p.m. during the day from August 8 to August 12."

Burden reveals battalion upon battalion of space equipment suspended on invisible wire, in perfectly elegant formation. The variation is endless, authentic. The recorded voice (his) drones on, a veritable manual of technological futurity: atmospheric conditions, planetary organization, life support systems, structures of commercial fleets, armadas, weaponry. By candlelight it is impossible to perceive the entire array, but the spectators, in an excruciating exercise in slow perception, gradually develop a mnemonic picture of the installation. Finally, the citadel wall is revealed—infinite, inexplicable—the incantatory monotone accompanies Burden's exploration of what the audience realizes is the rear brick wall, painted black the citadel wall!

Rubinfien, Leo. "C.B.T.V.: Ronald Feldman Gallery, N.Y.; Exhibition," *Artforum*, v.16, January 1978, pp.68-69. Review of Burden's exhibition at the Ronald Feldman Gallery which consisted of a single work, *C.B.T.V.*, a reconstruction of the first television ever designed.

THERESA HAK KYUNG CHA

Cha, Theresa Hak Kyung. "Reveille Dans La Brume," *High Performance*, no.2, v.1, June 1978, pp.26-27. Description of work presented at La Mamelle Arts Center, San Francisco, on October 30, 1977.

BUSTER CLEVELAND

Cleveland, Buster. *Cleveland Burns Chicago*. Mendocino, Ca., 1978. Videotape, b/w.

CLOSE RADIO

"Close Radio," *High Performance*, no.4, v.1, December 1978, pp.12-15. Article describes past and present activities of Close Radio, Los Angeles, an "audio space for visual artists," which broadcasts on KPFK, 90.7 FM. Directors, John Duncan and Paul McCarthy. Includes a Program History 1976-78, listing artists and works programmed by Close Radio. Excerpt:
Among the shows heard on Close was a "car opera" produced by the Ant Farm (a San Francisco group who created the Cadillac Ranch outside Amarillo, Texas, by burying Cadillacs hood-first in the ground). The opera was recorded at the Sydney, Australia, Opera House. Cars of different makes were placed in a circle and were "conducted" by a kangaroo. On cue they opened and closed their hoods, started wipers, revved engines.

Duncan, John and McCarthy, Paul. "Close Radio," LAICA *Journal*, no.20, October/November 1978, p.59.

HOUSTON CONWILL

Muchnic, Suzanne. "Ju Ju Ritual—Cycles of Life," *Artweek*, v.9, February 25, 1978, p.4. Review of a performance work written by Houston Conwill and performed by Conwill and Kinsha Sha at Space Gallery, Los Angeles. Excerpt:
Conwill exalts continuity of life and death as he recounts a tale of strength derived from adversity. Elements of African ritual—chants, dance, music and ethnic props—enhance triumphant stories of people, past and present.

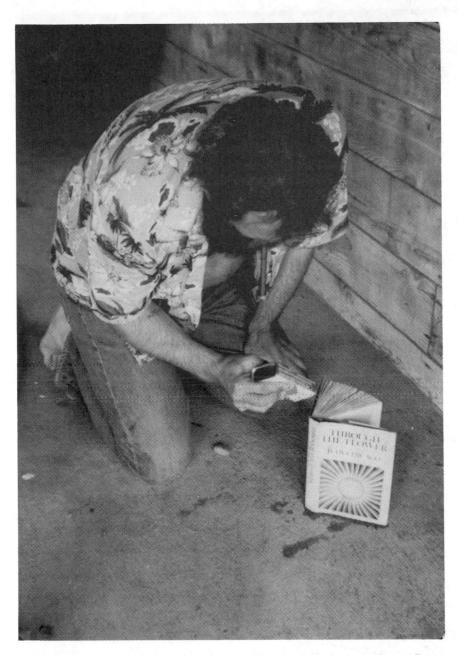

Buster Cleveland. *Cleveland Burns Chicago.* **Mendocino, Ca., 1978. Cleveland, "first of the red hot dadads."**

LOWELL DARLING

Askey, Ruth. "Barnstorming with Lowell Darling," *Artweek,* **v.9, April 29, 1978, p.4. Article on Darling's campaign for Governor of California. Excerpt:**

Darling said that if he is elected, there will be no more jobs. He'll give everyone $30,000 a year for "just being themselves." "I'll hire Jerry Brown to play Jerry Brown but he'll have to take a cut in salary." When Darling was asked where the money was going to come from, he answered, "I'm going to put Reverend Ike in charge of the state budget."

Another innovative plank in the Darling platform is his stand on parking meters. They'll become slot machines and as such will pay us money for stopping our cars and not polluting the air. He feels people should burn their parking tickets in the late 1970s much as they did their draft cards in the late 1960s. "What could the government do," Darling said, "send everybody with a parking ticket to jail?"

Darling, Lowell. "One Thousand Dollar a Plate Dinner," *High Performance,* **no.2, v.1, June 1978, pp.38-39. Description of an event that took place at Breen's Cafe, sponsored by the Museum of Conceptual Art, San Francisco, on March 8, 1978; a promotional event for Darling's campaign for California governor. Excerpts:**

WRITE YOUR OWN TICKET:

That part of the state budget presently allocated to building highways, roads, buildings and the space shuttle program will be used to hire people to be themselves for the State of California. . . .

BILLBOARD CITY:

All billboards will be put in one location rather than being spread throughout the state. Visitors will drive through it like Lion Country Safari.

BAN 1984:

To reduce the mounting paranoia resulting from George Orwell's book, we will get rid of 1984. . . .

PRESIDENTIAL TELEVISION NETWORK (PTN):

The Presidential Television Network will be started by surgically implanting a video camera in the President's forehead so that Americans will see what the President sees on their television sets at home. . . .

WEDNESDAYS OFF:

Everyone gets Wednesdays off.

THE HUMAN ZOO:

I propose that all wild animals be returned to their original homes—the jungles, forests, rivers. I recommend that in their place we commission artists to make wild animal costumes and hire the unemployed to wear them. . . .

Frankenstein, Alfred. "A Politician's Concept Platform," *San Francisco Chronicle,* **February 16, 1978, p.55. Article regarding Lowell Darling's announcement made at the University Art Museum, Berkeley, to run for Governor of California.**

Kirsch, Jonathan. "The Fine Art of Politics: Only You, Lowell Darling," *New West,* **v.3, February 13, 1978, pp.36-38. Article on Darling's campaign for California governor; with photo by Ilene Segalove.**

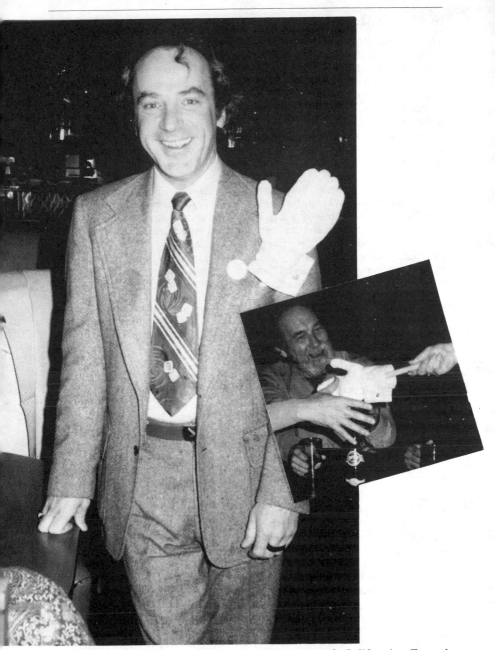

Lowell Darling. *Campaigning for Governor of California.* **Breen's Bar, Salon of MOCA, San Francisco, Ca., 1978.**

NORMA JEAN DEAK

Aloff, Mindy. "Norma Jean Deak's, 'Travel Log,' " *Artweek*, v.9, April 29, 1978, p.12. Review of Deak's performance, *Travel Log*, presented at the Portland Center for the Visual Arts, April 10, 1978. Excerpt:

. . . black-bound diary (recited in tremolo); the 8½" x 11" letters (delivered in an unconvincingly cheerful manner); a white table with a violet blotter lit by a glaring lamp; another chair positioned, prisoner fashion, under another glaring lamp; a blank wall on which a slide projector throws printed captions and color scenes of people and places (shot by Blaise Tobia, Frantisek Deak and Claudia Martinengo) to which the narrator may respond or remain oblivious.

Roth, Moira. "Moira Roth Interviews Norma Jean Deak," *High Performance*, no.1, v.1, February 1978, pp.8, 42-43. Excerpts:

NJD: . . . I was interested in diaries and letters. How valid are they really? As David Antin said, just because something is written in the first person, everyone assumes that it is true. It isn't necessarily. When I decided to incorporate letters and diaries into the performance I began reading some written by women—primarily by Simone Weil and Virginia Woolf. . . .

MR: How did you deal with this material in the actual performance?

NJD: The set for the performance was rather simple: a table and chair in the center and a single chair to the right of the table. The slides were projected on the left. During most of the performance I am seated behind the desk. The performance begins in a very relaxed manner. I begin talking to the audience in my natural voice explaining: "This is an account of a woman's visit to a foreign city. She didn't plan the visit. It wasn't on her itinerary . . . etc."

At a certain point I go into a different voice that attempts to create a romantic mood while I describe the city in which she found herself. It is a port city where "You could see the ships sailing out of the harbor for Marseilles, Istanbul, Alexandria, Odessa . . ." After that I sit behind the desk and become the observer, the narrator, for which I put on glasses. The voices are extremely important, as always, in my performances. I used an interested, enthusiastic voice, full of energy, for the letters I would go from reading a letter to reading from the diary. The diary was read without glasses and revealed a woman on the verge of a mental breakdown. I chose a particular voice, a sad, depressed, breathy voice.

MR: And then there were the slides of the Old Town in Genoa, with you in them; slides of you and a man talking and walking together in La Jolla, and of you sitting isolated among animated people.

NJD: Yes. I use slides for instant scene changes. The sets are usually simple and don't change during the performance. I use the slides to evoke different moods.

GUY DE COINTET

Guy de Cointet/Matrix 39. Hartford, Conn.: Wadsworth Atheneum, 1978. Matrix leaflet for de Cointet's exhibition at the Wadsworth Atheneum, April-June 1978.

Keeffe, Jeffrey. "Ramona: California Institute of Technology, Pasadena; Performance," *Artforum,* v.16, January 1978, p.77. Review of de Cointet and Bob Wilhite's third performance, *Ramona*. About sensory perceptions, the eight actors " 'see' sounds, 'hear' sights, and 'taste' noises" in the work.

TONY DE LAP

"Florine, Child of the Air," *High Performance,* no.1, v.1, February 1978, pp.30-31. Explanatory text, drawings and photos for a work presented at the Newport Harbor Art Museum, September 17, 1977.

80 LANGTON ST.

80 Langton Street: May 1977 thru May 1978. San Francisco: 80 Langton St., 1978. Postcard catalogue of performances/exhibitions sponsored by 80 Langton St. Information includes one photo postcard and a brief description of the work with biographical data for each artist. California artists who presented performances at 80 Langton St. included: Judith Barry (*Past, Present, Future Tense(ppft)*), Joanne Kelly (*Part Four Segway*), Jock Reynolds (*Five Habitats for Five Members,* included Suzanne Hellmuth, Jim Pomeroy, Pam Scrutton, Bill Morrison, and Jock Reynolds), Guy de Cointet (*Oh, a Bear!,* with Mary Ann Duganne, Monica Tenner, and Jane Zingale), David Antin (*Talk Series: Figures of Speech*), among others.

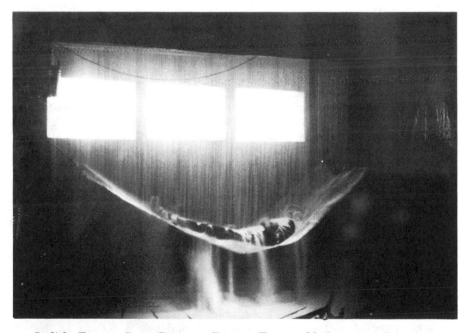

Judith Barry. *Past Present Future Tense.* 80 Langton St., San Francisco, Ca., 1977.

Trans-Parent Teacher's Ink., Paul Cotton, Medium. *Model Citi-Zen.* San Francisco Museum of Modern Art, 1978; presented by Judith Azur, Diana Coleman, Paul Cotton, Margaret Fisher, Peter Hornback, Bob Hughes, Bedonna Magid, Pravda, Michael Rossman, John Rubin, Al Verdad and Stanley Whittiker. "Speech and the silence of the body were wedded in a panel discussion/meditation upon the innocence of the nude body and its freedom of expression in Life and Art. A pre-recorded dialogue between the panelists concerning their personal attitudes towards institutional—eyes'd repression of casual nudity was broadcast into the auditorium as the 'model citizens' sat nude, mute and motionless in meditation on the veil of illusion. The group moved periodically from one attitude of innercommunication to another as projected slides of the traditional art of the nude were mixed with slides of 'model citizens' at a nude beach. To emphasize the interplay of silence, symbol, sign and language, Michelle Dayley, a signer for the deaf 'spoke' behind each mute panelist as his voice was being broadcast. A folk-us of the dialogue was representation/presentation." Sponsored by the Floating Museum for the Global Space Invasion (Phase II).

LINDA EVOLA

Evola, Linda. "Configuration," *High Performance*, no.3, v.1, September 1978, p.12. Description of a performance that took place December 12-16, 1977 at the Union Gallery, San Jose State University.

FEMINIST ART WORKERS

Angelo, Nancy. "Draw Your Own Conclusions, Know on 13," *High Performance*, no.3, v.1, September 1978, p.34. Description of a work by the Feminist Art Workers (Nancy Angelo, Laurel Klick, Cheri Gaulke), presented at the Los Angeles Music Center Plaza on May 31, 1978, in opposition to California's property tax bill, Proposition 13, which was passed by the voters the following month, June 1978.

Angelo, Nancy. "Pieta, Afloat," *High Performance,* no.3, v.1, September 1978, p.27. Description of a performance by the Feminist Art Workers (Nancy Angelo, Laurel Klick, Cheri Gaulke) at Century City, Los Angeles, on April 26, 1978.

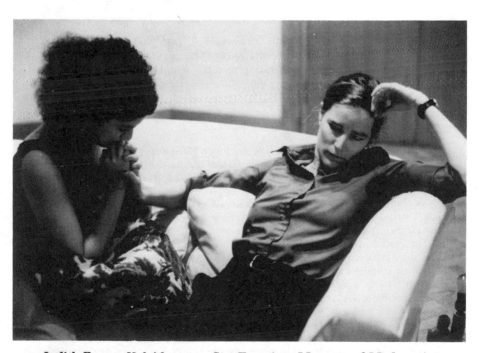

Judith Barry. *Kaleidoscope.* San Francisco Museum of Modern Art, 1978.

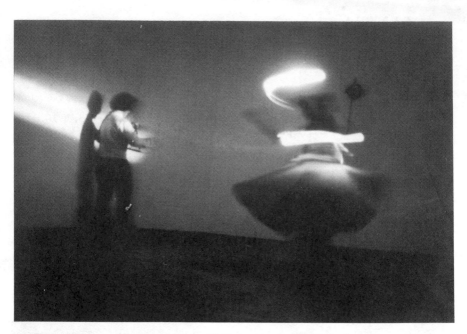

Nina Wise and Terry Fox. *Yellow Duck and Tonka Beans*. San Francisco Museum of Modern Art, San Francisco, Ca., 1978. Performance sponsored by Motion and the Floating Museum for the *Global Space Invasion (Phase II)*.

FLOATING MUSEUM

Global Passport. San Francisco: San Francisco Museum of Modern Art, 1978. Catalogue/program booklet for the *Global Space Invasion (Phase II)*, a project of the Floating Museum, organized by Lynn Hershman.

Ross, Janice. "Global Space Performances," *Artweek*, v.9, August 26, 1978, p.4. Review of performances by Bay Area women artists, part of a series for the *Global Space Invasion Phase II*. Excerpt:

The motion section of Lynn Hershman's Phase II Global Space Invasion, at the San Francisco Museum of Modern Art in August, featured two weeks of almost continuous daily performances . . .

Judith Barry's *Kaleidoscope* juggles domestic situations and relationships with cinematic vividness. Within a series of six vignettes she probes the dynamics of a couple's daily interactions. . . .

Unlike [Nancy] Karp's better known minimal dance works, *SHE* contains no physical movement other than Karp's arm motions as she chops fruit and Lynnette Taylor's incidental gestures as she relays Karp's spoken words in sign language. . . .

[Margaret Fisher's] actions . . . [in *Splitting*] appear to be gestural amplifications of a private body language. She scratches her ankle

(cont'd, p.304)

Lynn Hershman. *Roberta Breitmore* (*An Alchemical Portrait Started in 1975*). San Francisco, Ca., 1978. Roberta comics created in collaboration with Spain Rodriguez.

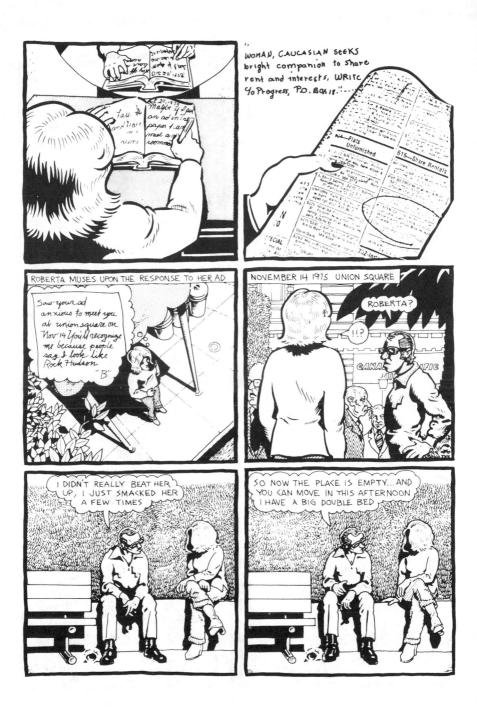

299

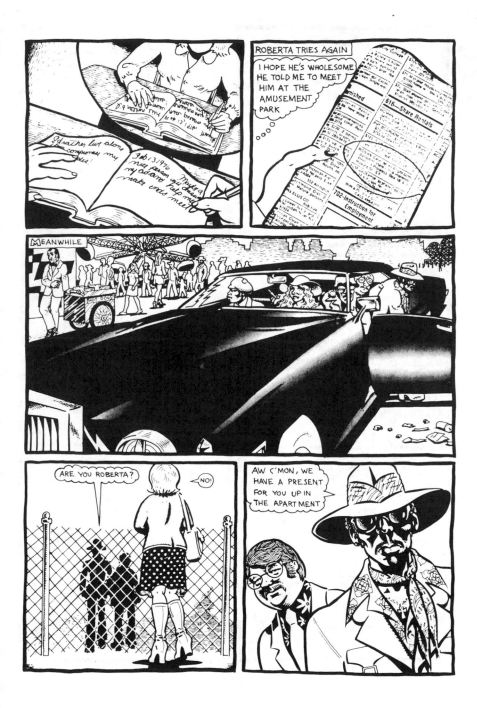

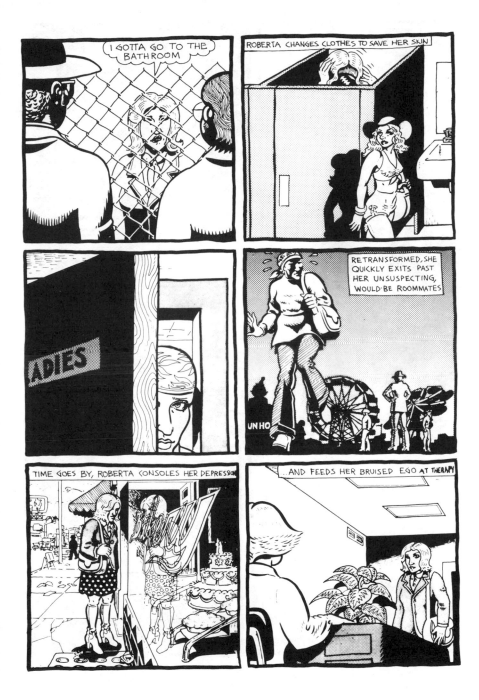

301

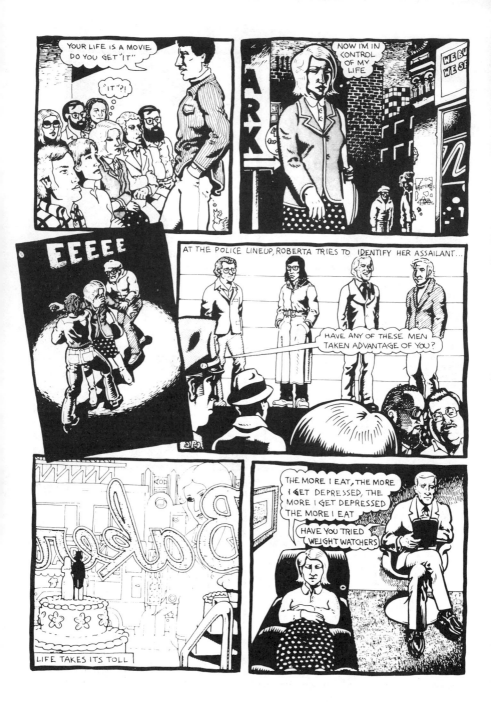

303

contemplatively with her foot, cranks her elbow and dips her head from side to side as if communicating in a full-body semaphore.

Like Barry's *Kaleidoscope,* which was performed daily for almost the entire length of the Motion series, Nina Wise's *Yellow Duck and Tonka Beans* changed its form from day to day. But where the only variation in Barry's work was the order in which it was presented, Wise's work changed from solo to duet or trio, with the content wholly improvised. . . .

Stofflet-Santiago, Mary. "Global Space Invasion," *Artweek,* v.9, August 12, 1978, p.6. Review of *Global Space Invasion Phase II,* presented by the Floating Museum at the San Francisco Museum of Modern Art.

HOWARD FRIED

Fried, Howard. *Vito's Reef (Part I).* 1978. Videotape, 35 mins., color.

FERN FRIEDMAN AND TERRI HANLON

Friedman, Fern and Hanlon, Terri. *E(L)(FF)usive.* San Francisco: 2 by 4, 1978. Jell-O-Disc, 3:27 mins.

KEN FRIEDMAN

Friedman, Ken. "On Fluxus," *Flash Art,* no.84-85, October/November 1978, pp.30-31.

CHERI GAULKE

Gaulke, Cheri. "Talk Story," *High Performance,* no.2, v.1, June 1978, pp.24-25. Description of a performance presented at La Mamelle, San Francisco, October 16, 1977.

Moisan, Jim. "McKee's Setting, Gaulke's Performance," *Artweek,* v.9, March 25, 1978, p.7. Review of Cheri Gaulke's birthday celebration; included was an installation by Sandra McKee, a performance by Cheri Gaulke, and a film of a performance by Polish artist, Tadensz Kantor. Excerpt:

Gaulke appeared in a pair of crimson ballet slippers and announced that she would carve "guilty" in the sole of each shoe and dance until the words wore off. Her allusion was, of course, to the Anderson fairy tale, and to the red shoes as symbol of vanity, hedonism and sexuality. Documentation was made by photographers Kathleen Kenyon and Ben Caswell.

HELEN AND NEWTON HARRISON

"Helen and Newton Harrison," *Arts Magazine,* v.52, February 1978, pp.126-33. A series of 3 essays include: "Helen and Newton Harrison: New Grounds for Art", by Kim Levin; "Helen and Newton Harrison: Art as Survival Instruction," by Peter Selz; "Helen and Newton Harrison: Questions," by Kristine Stiles.

ELAINE HARTNETT

Ross, Janice. "Art by Context," *Artweek,* v.9, March 25, 1978, p.6. Review of performance works by two Los Angeles artists; *Out of Necessity* performed

by Elaine Hartnett at the Los Angeles Institute of Contemporary Art and *Marla* by Sheila Orvis presented at 2815 Ocean Front Walk, Venice, California.

LYNN HERSHMAN

Frankenstein, Alfred. "Roberta's 'Artifacts': Creating a Life-Image," *San Francisco Chronicle*, April 11, 1978, p.40.

Lynn Hershman Is Not Roberta Breitmore, Roberta Breitmore Is Not Lynn Hershman. San Francisco: M.H. De Young Memorial Museum, 1978. Catalogue for an exhibition, April 1-May 14, 1978. Excerpt:

Roberta Breitmore is a portrait of a woman in San Francisco; a collage of a person experiencing her environment. She is a contemporary heroine fashioned from real life in real time. Her social identities—checkbook, licenses, handwriting and speech mannerisms are textures and testaments to her credibility.

Roberta's construction is ambiguous. She is at once fictional and real; physical and ephemeral. As she gains experience and time dimension, the people that are incorporated into her history become fictionalized archetypal characters. The articles of her life are both token symbols as well as functioning, necessary items.

Roberta Breitmore is a living tableau. Somewhere between the reality and imagination she breathes in the real spaces of existence. She participates in the world, reflects the social preoccupations of her contemporaries, attends psychotherapy and weightwatchers and generally maps passages through which many people travel.

Roberta's "mask" is achieved by using cosmetics as paint and her skin as a canvas. Her conversations reveal that everyone she meets is also wearing an "invisible" mask.

Roth, Moira. "An Interview with Lynn Hershman," LAICA *Journal*, no.17, January/February 1978, pp.18-24. (Errata - three additional photos appear in *Journal* no.19). Excerpts:

LH: [on the *Dante Hotel* piece, 1973] . . . I think that was the first interesting thing I did. I just set up a hotel room where you could go 24 hours a day, any day of the week. You could sign in at the desk, get a key, go up to the room, and trespass into this kind of alien identity that was there - to see this persona that was assumed to have lived there. There were two wax figures that were lying in the bed as you entered the room, two women. Articles of their lives were part of the environment so you got a sense of the people who inhabited the space. I used what was there, changing it as little as I could. A special record was made for the sound, and I used different kinds of lighting.

MR: We should mention that the Dante Hotel is a rather sleazy hotel, shabby and slightly ominous. After the *Dante Hotel,* you did a three-room environment in New York. Three rooms in places of highly different character: the Chelsea Hotel, the Plaza, and the YWCA.

LH: A bus went to all three places. You could get off and note the differences of what it would be like to land in New York for one day and, for whatever reason, be put into one of these situations, situations that were

profoundly different in all ways: visual, social and economic. Each room had the idea of being indigenous to each neighborhood, using materials from within a one-block radius of each place as the core medium for creating that particular portrait. . . .

MR: And then, also in 1975, you did the *Las Vegas: A Double Portrait of Lady Luck.*

LH: Yes. I again did a portrait of a city - Las Vegas - just as I had done the portrait of New York. And I wanted to do a double portrait. The first casino I went to was called "Circus Circus," and the first person I met there was called "Charles Charles." Charles Charles had a wife who was an employee of the casino, and I made a wax sculpture double of her. The real woman and the sculpture were dressed alike, wore the same make-up and looked identical. The sculpture had a prerecorded cassette tape of her gambling moves. The woman used her intuition, and the two of them played roulette at the casino. The sculpture won in the metaphorical match. . . .

Then there was Roberta, also in 1975. She was the woman who left the hotel room and went on to have her own life. . . .

MR: . . . In addition to the Floating Museum, you did all that work on getting Christo's *Running Fence* together. But back to your own work, *The Bonwit Teller Window,* which you did in 1976. . . .

LH: When you walked by on 57th Street, you would see a recreation of my Chelsea Hotel room. The 57th Street side of Bonwit Teller dealt with the past generally. So the Chelsea Hotel room window had 1973 newspapers and calendars. There were mannequins in a specially constructed bed watching television as they had in the Chelsea Hotel room. The bed had no right angles and gave a feeling of depth. There was the same wallpaper I used earlier on the walls. An X was painted on the street so that people walking by could stand on the X, and be put on the television set that the mannequins were watching. The people on the street were, in effect, put back in time. . . .

Then we started on the 5th Avenue side of Bonwit Teller, the window which dealt with the present time. The first window dealt with cosmetics and it sold cosmetics. It also was about an identity change, a twenty minute identity transformation to show how one can change . . . The next set of 5th Avenue windows dealt with aging. . . . "When I was young, I had everything," . . . "I wrapped my skin and hid my thoughts. As I grew older, I wanted more. I know now what I should have known then. Less is more." . . .

Then we came to 56th Street, which deals with time and future time. . . .

MR: You were asked out to Melbourne [Australia], and arranged to do Dream Weekend in a house that was a part of a Melbourne suburb's project homes?

LH: Well, I took the rooms in a house, used it to expand ideas of earlier works like the *Dante Hotel* or *Re: Forming Familiar Environments,* where I had invested the space of a home with a personality; each room told a story about the situation of living there as seen through the metaphors of the forms that were already there. In Australia, I wanted to deal with the dream states and various stages of consciousness.

Stofflet-Santiago, Mary. "Portrait of the Artist as Social Observation," *Artweek,* **v.9, April 29, 1978, p.7. Review of Hershman's Roberta Breitmore exhibition at the De Young Museum, San Francisco. Excerpt:**
The artifacts and documentation of Roberta Breitmore-including such

mundane articles as purse, checkbook, coat and dress—which are scarcely
the residue of performances since Roberta's activities are usually carried out
in semi(at least)—privacy, are displayed in typical museum fashion. . . .

KIM JONES

Jones, Kim. "Telephone Pole," *High Performance,* no.2, v.1, June 1978,
pp.36-37. Description of a work in which Jones climbed several telephone
poles in Los Angeles on February 6, 1978.

KAREN JOSSEL

"Artist Tattoo," *High Performance,* no.3, v.1, September 1978, p.19.
Description of a work that took place March 16, 1978 at the Trade Winds
Tattoo Studio and May 7 at the Sunset Strip Tattoo Studio, Hollywood.

ALLAN KAPROW

Kaprow, Allan. "Natural Distances," *New Wilderness,* nos.3/4, v.1, 1978.
Activity program, notes and photos.

"Robert Filliou in Conversation with Allan Kaprow," *Vanguard,* v.6,
December 1977-January 1978.

Ross, Janice. "Excursions into Behavior," *Artweek,* v.9, January 14, 1978,
pp.7-8. Review of Kaprow's lecture/film presentation at the San Francisco
Art Institute where three of his works were shown: *Comfort Zones, Seven
Kinds of Sympathy,* and *Common Senses.* Includes discussion of Kaprow's
recent work.

Roth, Moira. "Allan Kaprow Interviewed by Moira Roth," *Sun & Moon: A
Journal of Literature and Art,* no.5, Fall 1978, pp.69-77. An interview,
conducted Fall 1977. Excerpt:
AK: Performance is simply the latest word for real-time activity. Whether
or not we use one generic term or another, I think we've got to a point where
so many people are doing Performance, and there's a sufficient twenty year
history now within our immediate ken, that we can actually make distinctions
between kinds. My "kind" was and still is eccentric compared to what other
people are doing in Performance. I feel very little kinship with most of what's
going on, though I'm interested in it.
I always had a kind of social science bias. It was "parlor" anthropology in
the beginning, from reading Sir James Frazer and other people like that.
MR: Erving Goffman?
AK: Yes, surely. I was also interested in Birdwhistle, who made very
careful analyses of film and video recordings of, for instance, facial
expressions accompanying conversations, which were done with analyzers.
Reading them led me into a very different idea of human behavior as it
applied to Performance from that of my colleagues.
MR: Like Oldenburg and Dine?
AK: Yes. Or, Vostell. As much as I admired their work, and still do, it
seemed to have no particular application to my concerns. Perhaps the one
Performance artist whose interests in behavior overlap mine is Acconci.

KIPPER KIDS

Askey, Ruth. "The Kipper Kids - Food Is the Medium," *Artweek*, v.9, January 7, 1978, p.4. Excerpt:

Hanging over the stage on ropes were pots, jars, tea kettles, a large colander and a balloon. The kids poured the contents, one by one, over each other—tomato soup, rice, onion gravy, pillow flocking, chocolate milk, syrup with dayglo poster paint, and finally they sprinkled each other with glitter—a special California touch. By now they were tarred and feathered in alternating layers of indescribable color and texture. Taking off their clothes (no, they didn't throw them at the audience), they carefully hung them up on hangers with childish precision—all the while humming in high, little-kid voices. Naked again, with their faces still covered with food, the kids put on one boxing glove each and hit their own bodies as they cried "Ei-Oh, Ei-Oh."

Moisan, Jim. "Very Nice/Kipper Kids," *High Performance*, no.3, v.1, September 1978, pp.2-6. An interview with the two Kipper Kids, Harry and Harry Kipper. Includes photos of their performance at the Whiskey A-Go-Go in Hollywood, May 17, 1978. Excerpts:

HK1: . . . as part of the show we used to drink a bottle of whiskey, or some spirits, a whole quart. The show would start very precisely and would end up very violent, not towards the audience, but with that threat. The boxing would be very hard, and people used to walk out on that.

JM: So you'd hit yourself very hard . . .

HK1:Yeah, until we'd bleed, definitely have black eyes, etcetera.

JM: You wouldn't hit each other?

HK1: No, no, only one person, exactly as you saw it, but for the climax we'd be streaming with blood . . . and that looks very dramatic.

JM: It is.

HK1: He used to do it really well because his nose bleeds . . . he just has to blow his nose and it bleeds, but I have to really hit mine hard.

JM: That's why he's the boxer.

HK2: When we first did it, in fact, I used to do it every single night. I did it for a month, and he refused to do it. I'd say, "Come on, do it just once more." One night we didn't do it and did another ceremony in its place, but it just didn't have the same power. I just flatly refused to do the boxing, so he started doing it, and really liked it for awhile. We don't like doing it now, but at one point we used to fight over who wanted to have the glory. . . .

JM: What kind of places do you like to play?

HK1: Places that don't have any connotation at all—of being an art gallery, a night club, a theatre or anything—an alternative space, more or less. What I'd like to find is a place where we can have a permanent stage set—like a big studio where we could do a couple of shows a month. That way the set could progressively change and build up. When we did the three-month run in Munich, the show started very simply—with a totally uncomplicated stage set. And after three months it took a whole day to clear the set. It was like foot deep papier mache, because every night we'd put down fresh unprinted newsprint that we made look like a lunar landscape. We'd piss on it and pour things on it in performance. It would get really soggy. After three months it was like a foot of solid wood. And we had all this rubbish that we'd collected from the rubbish dump and had it all wired with contact microphones. To an onlooker, without being on stage, it just looked like a big pile of shit—but for

Kipper Kids (Harry and Harry Kipper).

us, every single thing had a function. So we brought it to life, we played the whole set. The whole set was a huge piece of percussion, attached to a bundle of microphones taped to bottles, cans, to the backs of frying pans, everything. The stuff was hanging, on the floor, on shelves. For example, we used to always use pickles. So every time we'd get through a jar of pickles we'd put the half-empty jars on the shelf. They had different amounts of pickle juice, and if you hit them with a stick they would make different types of sound.

JM: Did you have a piece involving pickles?

HK1: We used to sing "Diamonds Are a Girl's Best Friend." We'd have a pickle suspended from our necks on a piece of string, and our cocks sticking out; we'd hold the pickle up and sing—(to Harry) let's sing it—Chair chink, chai chai chink, chai chai . . . cheeeee chai chee chai Diamonds Are a Girl's Best Friend . . . 'oom! (bites end off pickle). And so we'd finish eating it. And that's what we did with "diamonds," the Marilyn Monroe song. VERY NICE!!

PAUL AND MARLENE KOS

Keil, Bob. "Marlene and Paul Kos - Video Collaborations," *Artweek*, v.9, May 27, 1978, p.13. Review of a showing at Video Free America, San Francisco where a selection of short tapes, such as *Sirens* and *A Trophy/Atrophy*, were presented, May 7, 1978. Excerpt:

One piece, perhaps visually the most striking, was titled *Sirens* and began with a close-up of smooth stones casually piled together, as if discovered on a beach. After a while the stones shifted, and you realized that they were actually placed on the face of women. When the stones fell away, the woman began to laugh with a haunting shrillness—and soon the scene shifted. . . .

LESLIE LABOWITZ

Askey, Ruth. "In Mourning and In Rage," *Artweek*, v.9, January 24, 1978, p.8. Discussion of a work organized by Leslie Labowitz-Starus and Suzanne Lacy; a memorial event that took place in downtown Los Angeles, December 13, 1977, to protest the rapes/slayings of L.A. women by the "Hillside Strangler."

Askey, Ruth. "Social Criticism in Feminist Art," *Artweek*, v.9, October 14, 1978, p.4. Review of a 24 ft. photomural entitled, *Woman's Image of Mass Media*, exhibited at the Woman's Building, Los Angeles. The work photodocuments two of Labowitz's 1977 performance/events, *In Mourning and In Rage* and *Record Companies Drag Their Feet*.

Labowitz, Leslie. "Record Companies Drag Their Feet," *High Performance*, no.2, v.1, June 1978, pp.20-21. Description of a media event organized by Leslie Labowitz and WAVAW (Women Against Violence Against Women) at the site of a billboard of the rock group, Kiss, in Los Angeles on August 30, 1977.

Labowitz, Leslie and Lacy, Suzanne. "Evolution of a Feminist Art: Public Forms and Social Issues," *Heresies*, no.6, Summer 1978. Extensive collaborative essay; the artists discuss their work of past year: *Three Weeks in May, Record Companies Drag Their Feet,* and *In Mourning and In Rage* . .

Paul and Marlene Kos. *Sirens.* **Videotape, 1977.**

Leslie Labowitz/WAVAW (Women Against Violence Against Women). *Record Companies Drag Their Feet*. Los Angeles, Ca., 1977. A collaborative performance event at the site of a billboard depicting rock group KISS in protest against the use of images of physical and sexual violence against women in mass media.

Labowitz-Starus, Leslie and Lacy, Suzanne. "In Mourning and In Rage . . .," *Frontiers: A Journal of Women Studies,* v.3, 1978, pp.52-55. Description of the event, staged for mass media coverage on December 13, 1977, at Los Angeles City Hall in protest and rage over the rape-murder incidents of the Hillside Strangler. Also includes script, statement read during the performance, and statement of purpose.

SUZANNE LACY

Deak, Frantisek. "Onvermijdelijke Associates," *Openbaarkunstbezit Kunstschrift,* Holland, January 1978. Extensive article in Dutch, describes Lacy's work *Inevitable Associations* that took place at the Biltmore Hotel, Los Angeles, during a convention of the American Theatre Association in August 1976.

Lacy, Suzanne. *Three Love Stories.* Self-published, 1978. Artist book. The three love stories include: "A Gothic Love Story," "A True Romance Story, or, She's Got Quite a Set of Lungs," and "Under My Skin: A Pornographic Novel." First edition, 500 copies. 48 pages.

Suzanne Lacy. *Travels with Mona.* 1977-78.

Suzanne Lacy and Kathleen Chang. *The Life and Time of Donaldina Cameron.* San Francisco, Ca., 1977. Performance for the Floating Museum's (H)errata Show.

Lacy, Suzanne. *Travels with Mona.* Los Angeles: Self-published, 1978. Artist book. A fold-out color postcard series showing the artist completing a Mona Lisa paint-by-number kit in front of tourist spots in Europe, Mexico and Central America. Text by Arlene Raven. Edition of 2000; 12 color images.

Lacy, Suzanne and Palumbo, Linda. "The Life and Times of Donaldina Cameron," *Chrysalis Magazine,* Winter 1978, pp.29-35. Extensive essay with photos of the performance by Suzanne Lacy and Kathleen Chang about the immigration of Chinese women into the United States.

Newton, Richard. "She Who Would Fly," *High Performance,* no.1, v.1, February 1978, pp.4-7, 44-46. A major interview. Includes descriptions of some works performed during 1977, with photo documentation: *She Who Would Fly, The Life and Times of Donaldina Cameron, Three Weeks in May, In Mourning and In Rage,* and *Bag Lady.* Also, a chronology of Lacy's performances/events and a bibliography covering 1972-77. Excerpts:
 RN: What is performance art? Are there parameters?
 SL: Performance is a definition that is rapidly changing. It is really in a

state of flux right now. It wasn't five years ago and it is now.

Five years ago it was pretty clearly defined as an offshoot of happenings—a kind of singularization of the mass environmental activity that happenings were—brought down into one person. It was very psychodynamic, very much about the experience of the artist as he or she performed.

In the last five years it's mushroomed into 100 different directions. You find people like Yvonne Rainer going into movies. You find people like Lynn Hershman who have gone in a whole other direction, one that hasn't yet been defined. An environmental performative activity in which the entire environment is considered. Generally it's in a public place and the artist acts as either a director or, if as a performer, as simply one element in the piece.

SHE WHO WOULD FLY. A three part piece. Part one, women came to the gallery over a several hour period to share with each other experiences of sexual assault. They described these in writing, leaving the notes pinned to maps on the wall.

Part two, the actresses, all of whom had directly experienced sexual assault, met to talk and provide each other with a healing experience and context in which to perform the piece.

Part three, the environment was opened to the public who entered the room three or four at a time. They encountered first a lamb cadaver with great white wings, suspended as if in flight. A poem crudely scrawled on black asphalt described a woman poet's experience of being violated. Finally the viewer's attention was drawn up toward a ledge over the door where four flesh-bared women, stained blood red, crouched like birds, intently watching the audience.

THE LIFE AND TIMES OF DONALDINA CAMERON. A collaboration between Kathleen Chang and Suzanne Lacy.

In making public in an aesthetic form the politics of oppression which created the immigration station at Angel Island in San Francisco Bay, the two collaborators enacted a meeting between a white missionary woman and an Asian woman from the turn of the century. To announce the piece, a newspaper, Angel Island Times Past, was handed out on the dock to the audience who waited to board the ferry to Angel Island.

The paper gave the history of the station and the Asian experience there. As the ferry approached the island it was met by a Tahitian ketch, an image of the past with two women in costume. At the island the two women disembarked and the audience followed them up the hill to hear a dramatic exchange between them. Each presented a different point of view on the issue of the missionary women's intrusion into the Chinese community's prostitution trade.

Following this, the artists described the process of creating the piece and the issues of racism, sexism, imperialism and aesthetics which arose in the collaboration.

Steward, D.E. "A Collaborative Interview with Suzanne Lacy," *Bachy*, no.12, 1978, pp.106-112. Extensive interview; includes photographs.

Suzanne Lacy. *The Bag Lady*. Downtown Center, The Fine Arts Museums, San Francisco, Ca. 1977.

LA MAMELLE, INC.

Grin of Vampire. San Francisco: La Mamelle, Inc., 1978. Videotape, approx. 30 mins., b/w. A collaborative performance in a live cablecast situation. Carl Loeffler and G.P. Skratz are featured in this "cowboy vampire legend" with Nanos and Katrina Valeritios.

"La Mamelle Inc.," *High Performance*, no.2, v.1, June 1978, pp.3, 42-43, 48. Article discusses past and present activities of La Mamelle Inc., San Francisco. Includes a list of performances sponsored by La Mamelle from 1976-77. Excerpts:

"What we've been about," Loeffler recently told *High Performance*, "is a very rapid high-level apprenticeship. We've wanted to be involved in as many different parameters and styles as possible. Things are changing now and we are feeling much more confident in our perception. We can typify our future style as one of corporate business. What you will see happening is a very strong emphasis on business and products. Mass marketing, that is going to be our style. . . .

"In the month of August [1978] we'll be involved in a project called 'A Literal Exchange' funded by the Canada Council. The entire staff and guests of La Mamelle will be transported to A Space in Toronto and they will be brought down here and we'll trade roles. We'll just play in each other's houses for a while.". . .

High Performance wanted to know whether Loeffler sees regional styles in performance art and whether there is a San Francisco style. He remarked:

"Five years ago there was very much a San Francisco style in performance art. It was generated mainly by those people involved with Tom Marioni and the Museum of Conceptual Art. We place a great deal of historical importance on the role that MOCA played in the West Coast style of performance art.

"But we're into fifth and sixth generation performance artists now and things get so intertwined that it becomes very difficult to see a sense of San Francisco style. The question could be broken down into major individual artists, the sense of style they've generated and what has happened to that sensibility as it's filtered down through the generations. One basic style we see functioning here in San Francisco is a kind of asceticism sensibility generated by MOCA.

"Another style we see operating here relates to the media. Some people who have really captured that are the Ant Farm and T.R.Uthco. They have learned how to manipulate the media and their sensibility is very much geared in that direction—though not the total content of their work, of course.

"Lynn Hershman has a very definite style about her, a grand corporate style. She has had gallery and museum experience as well as being assistant project director for Christo's Running Fence and developing her own Floating Museum and Artists on Loan. That sense of scale and media involvement has been infused in all her works as well as a sense of social involvement and social purpose."

When asked about the influence of MOCA on his own style, Loeffler said:

"When I started this I was very much influenced by MOCA. Tom was one of the first people who initially presented information to me and made ideas available."

Stephen Laub. *Public Relations.* **Museum of Modern Art, New York, N.Y., 1978.**

Loeffler, Carl and Skratz, G.P. *Farrow-Hamilton Report*. San Francisco: La Mamelle, Inc., 1978. Videotape, approx. 30 mins., b/w. A collaborative performance in a live cablecast situation; featuring Darrell Gray, Phil Loarie, Nancy Frank, Victoria Rathbun, and others.

Panoramica. San Francisco: La Mamelle, Inc., 1978. Videotape, approx. 45 mins., b/w. A collaborative performance for a pre-recorded cablecast situation conceived by Raul Marroquin, Editor of *Fandangoes Magazine*, Amsterdam. Produced while artist-in-residence at La Mamelle, Inc.; the videotape features A.A. Bronson, Jorge Zontal, Flavio Belli, Felix Partz, Tom Dooly, Scott Jablins, Janis Collins, Titus Muizelaar, Nancy Frank, Bonnie Sherk, and Koos De Vos.

STEPHEN LAUB

Banes, Sally. "Ain't Superstitious," *The Soho Weekly News*, October 26, 1978. Review of Laub's performance, *Public Relations*, at the New York Museum of Modern Art, October 1978.

CHIP LORD AND PHIL GARNER

Lord, Chip and Garner, Phil. *Chevrolet Training Film: The Remake*. San Francisco, 1978. Videotape, b/w.

Phil Garner and Chip Lord. *Chevrolet Training Film: the Re-make*. La Mamelle Arts Center, San Francisco, Ca., 1978.

LOS ANGELES INSTITUTE OF CONTEMPORARY ART

"L.A.I.C.A.: Los Angeles Institute of Contemporary Art," *High Performance*, no.1, v.1, February 1978, pp.2-3,47. Article discusses past and present activities of LAICA; LAICA performances from 1974-77.

TOM MARIONI

White, Robin. "Tom Marioni," *View*, no.5, v.1, October 1978. 16 pp. An extensive interview with Tom Marioni by Robin White at Crown Point Press, Oakland. Also includes: photographs; a brief biographical chronology with mention of performances and exhibitions; and a list of published writings. Excerpt:

[TM]: Right now my main activity is social, and what I'm trying to do is make art that's as close to real life as I can without its being real life. . . .

I think that Cezanne said that art is an imitation of nature. I've lately tried to imitate it as closely as possible. Picasso said that art is a lie that reveals the truth. I believe that.

[RW]: Well, you've called your Wednesday meetings "Cafe Society," and that is a term that connotes a kind of chicness and people who have a lot of time on their hands to socialize.

[TM]: Plato said that leisure is necessary to wisdom. . . . I suppose I could be criticized for calling it "Cafe Society" because it's so high-falutin'. But my concept of "Cafe Society" is drunken parties where ideas are born. . . .

When I started MOCA in early 1970, it was underground, because it dealt with something that no one else was doing . . . I mean, there weren't other places that were providing a situation for this kind of art. So, because of where it was, and the style of it, and the esoteric and ephemeral quality of it, it was an underground museum. But now, later, when there are lots of other museums and galleries that are providing space for the same kind of art, it started to become aboveground, it became real academic, and I have found myself in the position of being a kind of grandfather in this scene! So, the only way I can stay underground is to do things disguised as non-art. So that's what I'm trying to do now. Like Lowell Darling's Dinner while he was running for governor—it was seen by the people in the neighborhood as not having anything to do with art. And the same with "Cafe Society," which is just meeting in a bar. And the "Chinese Youth Alternative" and "Restoration" shows. I don't want to do any more things that are . . . overtly art. So by disguising them I can go back underground.

PAUL MCCARTHY

Burnham, Linda and Newton, Richard. "Performance Interruptus: Interview with Paul McCarthy," *High Performance*, no.2, v.1, June 1978, pp.8-12, 44-45. A major interview; includes photo documentation of many of McCarthy's performances. Excerpts:

The majority of performances by Paul McCarthy have been for videotape or for private audiences. His few public works have met with interference. . . .

POLITICAL DISTURBANCE, 1976 . . .

HP: Why were you dressed as an Arab?

PM: It just sort of came together like that. I hadn't really contrived it. It's just that I had bought this Arab mask (Puts it on).

HP: (Laughter)

Paul McCarthy. *Political Disturbance.* **Biltmore Hotel, Los Angeles, Ca., 1976.**

PM: (Wearing mask) I'd bought the mask and I had this suit that I had graduated from high school in and I looked . . . (shows photo). The day of the performance I bought these plastic crucifixes and I had had some Arab music, this chanting music. It all came together.

HP: What did you do when they approached you and asked you to stop?

PM: Well, it started off when the bellboy came up and he said, "You're going to have to stop this." I was on the stairway and was eating some raw hamburger and I had already hung these things in the stairwell. I didn't say anything but turned away so I couldn't face him. That meant he would have to come up the stairway.

He just kept telling me to stop from down in the doorway into the twelfth floor. By that time there was a crowd of people so he went to the hotel management. The manager came and started screaming at me to stop and I stayed there. I just kept facing the wall. I could hear them and I was singing

Paul McCarthy. *Grand Pop*. Videotape, 1977. Larry Grobel, observer. Performed at the University of Southern California Medical Center, Los Angeles, Ca.

and dancing, humming, groaning. I had a ketchup-covered doll on my head. I had been performing for about 30 minutes so things had sort of started collecting on me, on the floor and on the stairs. This went on for a while but they wouldn't come up the stairs. They would just yell at me. . . .

HP: What was the part they thought was obscene?

PM: I tried to put a ketchup bottle up my ass. But it wasn't overtly sexual, as some of the other stuff has been. I believe when they were saying it was obscene they were referring to the tape it showed the night before. They thought that was live too and that upset them. That I had pulled this over on them, done this live thing the first night. Also during the performance I had a doll hanging out of my pants. . . .

CLASS FOOL, 1976

PM: . . . I got down on the ground and shoved my face into a bucket of ketchup. I was spreading the ketchup around on the floor. I found that by talking to myself I could remove myself from them to where I could begin to get into the process.

I started to crawl underneath them. I had a big doll between my legs. I had coated its head with blue eye shadow with my hands. I started jumping up and down and the floor was slippery, so I would fall. And because the chairs were there I would bash into the chairs. I knew I was going to fall as long as I kept doing it and they knew it. I'd fall real hard . . . a hard fall as long as I kept jumping.

I'd done things like that before. One time I ran into a room blindfolded and I put objects on the floor that would trip me and I would run. I would slow down when I thought I was close to something on the floor or the wall. It produced an internal conflict. One part wanted me to complete it. The other part was protecting me. . . .

I would try to jump and fall and I began to wonder if someone would try and catch me. Finally two people did. They tried to catch me. . . .

Then I crawled underneath them some more. I had put a Barbie doll up my ass. I'd eaten some hand cream or something. . . .

. . . I drank some ketchup and I began to throw up.

"Grand Pop," *High Performance*, **no.1, v.1, February 1978, pp.24-25. Photo documentation of a performance at the USC Medical Center, Los Angeles, July 23, 1977.**

"Halloween," *High Performance*, **no.4, v.1, December 1978, pp.41-43.**

LINDA MONTANO

Montano, Linda. "Mitchell's Death," *High Performance*, **no.4, v.1, December 1978, pp.4-5, 46-47. Documentation of Montano's experience related to the death of her ex-husband, Mitchell Payne.**

Roth, Moira. "Matters of Life and Death: Linda Montano Interviewed by Moira Roth," *High Performance*, **no.4, v.1, December 1978, pp.2-3, 6-7. Major interview. Excerpt:**

MR: It seems that Catholic themes enter very strongly into the three live performances (and the video tape) which you did in response to your ex-husband's death—the pieces that have taken up much of your energy for the last nine months.

LM: I felt it was very important to mourn Mitchell in my work, and I wanted everyone to know him. This first piece was done shortly after his death in August of 1977, and it was a very private event where I was more in communication with Mitchell than the audience.

MR: That was where you played a chord organ for thirty-three minutes to mark the years that Mitchell had lived. In the next piece at LAICA there was more information about Mitchell with Minetter Lehmann showing slides and talking of his work as a photographer followed by you again playing the organ. Then the third version of *Mitchell's Death* was done at the UCSD Center for Music Experiment. Would you describe the piece?

LM: My Catholic background and interest in Eastern religions came together here. The piece was planned around a cross sign (Catholicism) so that things were happening both horizontally and vertically. I stood in the center of the horizontal line with acupuncture needles in my face and chanted on one note the story of Mitchell's death which I had written just after I had come back from his funeral in Kansas. The sound was amplified three times so there was a feeling of echo and expanded space (vertical axis). Al Rossi sat on my left playing an Indian sruti box which created a drone and represented my interest in Hinduism. Pauline Oliveros sat on my right and played a Japanese bowl gong (Buddhism). Next to Pauline was a video monitor with images of myself slowly applying acupuncture needles to my face. Everything worked together perfectly. It was mourning, not art.

Roth, Moira. "Mitchell's Death," *New Performance*, no.3, v.1, 1978, pp.35-40. Article and interview discusses a series of performance works by Linda Montano related to the death of her former husband, Mitchell Payne.

MOTHER ART

"Mother Art Cleans Up . . . The Banks . . . City Hall," *High Performance*, no.4, v.1, December 1978, p.32.

RICHARD NEWTON

Burnham, Linda. "Capacity Crowd," *High Performance*, no.3, v.1, September 1978, p.37. Description of a work that took place June 12, 1978 at Dodger Stadium, Los Angeles. Excerpt:

Soon it was time. "One, two, three strikes and you're out . . ." and a rain of cards fluttered into the air. The people below us in the reserved seats shouted with delight, looking up, stretching out their hands and calling for more. The throwing went on and on, while people scrambled for the cards below.

Newton, Richard. "A Cure for the Common Cold," *High Performance*, no.3, v.1, September 1978, pp.20-21. Description of a work sponsored by Close Radio that took place March 16, 1978 on KPFK 90.7 FM, Los Angeles.

"Here Come the Holidays," *High Performance*, no.4, v.1, December 1978, p.40. Photo documentation for a work performed October 25, 1978 at Washington Project for the Arts, Washington, D.C.

Newton, Richard. "Last Engagement of the Former Miss Barstow," *High Performance*, no.2, v.1, June 1978, pp.16-17. Description of a work

Richard Newton. *A Cure for the Common Cold.* **Close Radio, Los Angeles, Ca., 1978.**

performed by Richard Newton with Linda Burnham at the Floating Wall, Santa Ana, on May 28, 1977.

"Touch a Penis," *High Performance*, no.1, v.1, February 1978, pp.36-37. Text and photo documentation of a work entitled, *Touch a Penis with the Former Miss Barstow*, presented at the Los Angeles Institute of Contemporary Art, October 8, 1977.

PAULINE OLIVEROS

Oliveros, Pauline. "Rose Mountain Slow Runner," LAICA *Journal*, no.20, October/November 1978, p.47. Excerpt:

My work over the last eight to ten years has been involved with a transitional process, moving from forms of improvisation to forms of meditation. . . . My own way of meditation is personal and secular. It has evolved out of my relationship to sound. I started and continued as a musician, but I am no longer interested in the same ways of making music that I learned. As my work changed, I found myself listening to long sounds. I became more interested in what the sounds did than in what I might do to the sounds. As this work progressed, I noticed what this kind of listening did to me and my internal processes.

JIM POMEROY AND PAUL DE MARINIS

"A Byte at the Opera," *High Performance*, no.1, v.1, February 1978, pp.14-15. Text and photo documentation of a performance presented January 22, 1977 at the Los Angeles Institute of Contemporary Art, as part of the *Performance Exchange* series sponsored by LAICA and 80 Langton St., San Francisco.

RED AND THE MECHANIC

"Kidnap Attempt," *High Performance*, no.3, v.1, September 1978, p.34. Description of an attempt to kidnap Lowell Darling (first artist to run for Governor of California) outside the door of La Mamelle, San Francisco, as he arrived for a campaign party.

RACHEL ROSENTHAL

Askey, Ruth. "Rachel Rosenthal Exorcises Death," *Artweek*, v.9, November 18, 1978, p.6. Review of Rosenthal's performance work, *The Death Show*, presented October 21, 1978, at Space Gallery, Los Angeles. Excerpt:

In *The Death Show* Rosenthal explored her feelings about death, her denial of intermediate losses which caused her transfiguration into what she calls the "Fat Vampire" and finally her exorcism of that vampire.

Rosenthal, Rachel. "The Head of Olga K.," *High Performance*, no.2, v.1, June 1978, pp.14-15. Text and photo documentation of a work presented at the University of California, San Diego, May 1, 1977. Excerpt:

The material read during this piece was taken verbatim from a 1975-76 correspondence the artist carried on with her half-sister Olga, living in Africa. The sisters no longer correspond. . . .

(cont'd, p.328)

Jim Pomeroy and Paul DeMarinis. *A Byte at the Opera.* **80 Langton St., San Francisco, Ca., 1977.**

The performance weaves in and out of the following elements:
* The letter narrative.
* Rachel talking to the audience as herself or as Olga.
* The sound of improvised cello, taped African drums, a 1940s record of a "beguine."
*˙ Segments, announced by each young woman in turn as "cantos," as in Dante's "Inferno."
* Thirteen different slides of photographs of Olga at different times of her life that spans six decades, showing her gradual change from beautiful child to ugly, obese middle-age.
* Various nonverbal events wherein Rachel, in different costumes depicting Olga in different phases, goes through symbolic actions such as:
—becoming a bull in a labyrinth
—dunking a doll's head in the water bucket
—being subjected to an orgy of spray cans spraying all parts of her body
—interacting with the young women and the "Africans"
—and others

MARTHA ROSLER

Rosler, Martha. "Traveling Garage Sale," *High Performance*, no.2, v.1, June 1978, pp.22-23. Text and photo documentation of a work held in the garage of La Mamelle, San Francisco, the weekend of October 1-2, 1977.

DARRYL SAPIEN

McDonald, Robert. "Urban Drama in an Art Context," *Artweek*, v.9, September 9, 1978, p.15. Review of Sapien's work, *Crime in the Streets: A Performance About Survival in the City*, that took place August 19, 1978, in Adler Alley between Columbus and Grant Avenues, San Francisco. The work was part of the Floating Museum's *Global Space Invasion Phase II*. Excerpt:
Most significantly, the piece has a defined narrative content, with the violence of urban life as its core. Episode followed relentlessly upon episode: the murder of a John Doe, the lynching of a scapegoat, the rape of a woman, the destruction of the rapist ("Mechanomorph," representing mechanized existence) through incineration of his genitals, the rape victim's abduction by the Minotaur ("the animal within us") and the suicide of a mad woman (or "bag lady").
A narrator (Sapien), speaking from an elevated platform, commented as a chorus to both players and audience. He exhorted the players and informed the audience about what was happening.

"The Principle of the Arch," *High Performance*, no.1, v.1, February 1978, pp.16-17, 43. Text and photo documentation of a performance by Darryl Sapien and Constancia Vokietaitis, presented at PS1, New York, on March 19-20, 1977. Excerpt:
The Principle of the Arch was a performance created to mark the passage from one level to another of a deeply personal relationship between its performers. The two, who had been lovers for five years, decided to create a

(cont'd, p.331)

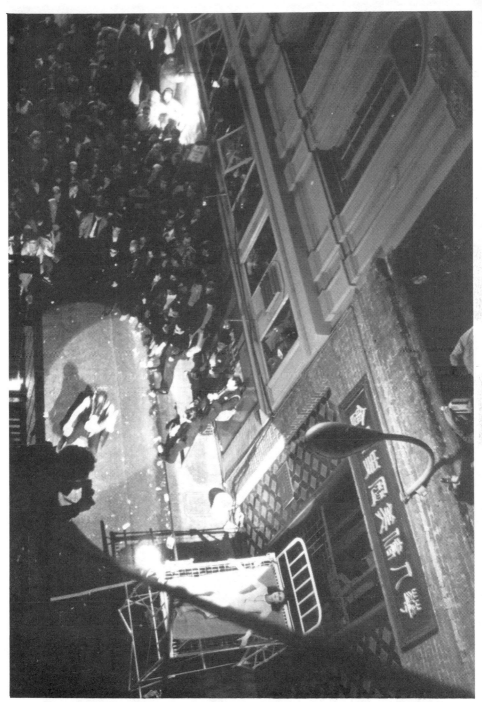

Darryl Sapien. *Crime in the Streets*. **Adler Alley, San Francisco, Ca.,
1978. Scene from "the rape."**

Darryl Sapien and Constancia Vokietaitis. *The Principle of the Arch,*
P.S.1, New York, N.Y., 1977.

performance that could function as a real rite of passage. With their love affair in ruins behind them they both realized that it was necessary to end it. Being artists they wanted to create a mutual work of art that would at one time express their close ties but also function to free themselves of each other.

Roth, Moira. "**Moira Roth Interviews Darryl Sapien,**" *High Performance*, no.2, v.1, June 1978, pp.4-7. **A major interview that includes discussion of Sapien's works:** *Tricycle: Contemporary Recreation*, **performed at the Museum of Conceptual Art as part of the** *Second Generation* **show, 1975;** *Splitting the Axis*, **performed at the University Art Museum, Berkeley, August 1975;** *Within the Nucleus*, **at the San Francisco Museum of Modern Art, March 1976; and** *The Principle of the Arch*, **at PS1, New York, March 1977. Excerpts:**

. . . at MOCA . . . I did *Tricycle: Contemporary Recreation*, a piece where I invented a video camera headmount with a built-in intercom which supported a camera at the eye level of the performer so that the performer could look through the camera but not have to hold it. It was like a big eye, it made it possible for the audience to see simultaneously with the two of us, Mike and I. The performance involved three people: Michael Hinton and I in a sort of wedge-shaped enclosure on the first floor of MOCA, and a woman, Cyd Gibson, on the floor above. We were all able to communicate through the intercom verbally and she would guide us using a code based on the clock and compass while looking through our eyes, the cameras. . . .

The audience could hear the instructions as they were being broadcast through a public address system and they could see the markings on the grid as the performers were seeing them through the two monitors which were showing what our video cameras helmets were recording. Also they could see us in our enclosure with the unaided eye. It had this whole built-in sense of irony because the process was so complicated but the result was so childish. The results weren't even as good as a child's drawing because the lines wouldn't meet from one grid square to the next. I was trying to emphasize this irony of a future disembodied humanity trying to recreate those basic processes like life and sexuality with this overly complicated process and being unsuccessful at it. . . .

. . . we did *Within the Nucleus* in March of 1976 at the San Francisco Museum of Modern Art which was [an] . . . axis-type performance but instead of destroying an axis in this case we built one. It was in the shape of a double helix, which is based on the structure of the DNA molecule. . . .

In the performance, we used this structure and made it into an architectural feature, a real stairway, using taut ropes and two by fours, red and green two by fours. They were sent down to us by assistants who lowered them through a hole in the roof of the museum's auditorium. Again, we wore these video camera helmets—so the audience could perceive the performance directly. The whole structure was enshrouded by a polyethylene curtain. What happened was that we started on the ground with nothing, it was a clean cylindrical space with just the ropes and the fasteners in place waiting for the two by fours. So we slowly progressed building this stairway which spiraled around and when everything was put together, the 36 feet of steps, it formed a green and red double spiral stairway. It took about an hour to build, and then we went through the hole at the top of the ceiling. We

switched off the incandescent lights and turned on ultraviolet lights that we had placed on the top and the bottom, they shone on the fluorescent paint of the steps. We turned these on and the curtain kind of disappeared—because it didn't hold the ultraviolet light—and what you saw were the stairs, the steps glowing. After we had lit the ultraviolet lights, we took off our head mounts and came down very quickly so we really demonstrated the double helix shape of our structure.

Sapien, Darryl. *Crime in the Streets.* San Francisco, 1978. Videotape, b/w. Documentation of Sapien's work enacted in Adler Alley, San Francisco.

JILL SCOTT

"Taped," *High Performance*, no.1, v.1, February 1978, pp.10-11. Photo documentation of a work performed January 1, 1977, at the side of a warehouse, San Francisco.

STEPHEN SEEMAYER

Seemayer, Stephen. "Wound/Facade," *High Performance*, no.3, v.1, September 1978, p.22. Description of a performance that took place March 29, 1978, in an industrial section of Los Angeles.

SEND/RECEIVE

"Send/Receive Satellite Network," *La Mamelle Magazine: Art Contemporary*, no.10, v.3, 1978. Three page documentation of a telecommunication project organized by Liza Bear and Keith Sonnier of Send/Receive in New York and Carl Loeffler of La Mamelle in San Francisco. Communication between artists in verbal, visual, dance, musical forms took place for 15 hours via NASA satellite on September 10-11, 1977, and was broadcast on cable television throughout the New York and San Francisco communities. California participants included: Terry Fox, Carl Loeffler, Margaret Fisher, Alan Scarritt, Sharon Grace, Richard Lowenberg, and others.

BARBARA SMITH

Smith, Barbara. "Ordinary Life," *High Performance*, no.1, v.1, February 1978, pp.12-13. Text and photo documentation of a two part performance; Part One was presented January 22, 1977 in a studio, Venice, Ca. Part Two was presented March 12, 1977 at 80 Langton St., San Francisco, as part of the *Performance Exchange* series co-sponsored by 80 Langton St. and the Los Angeles Institute of Contemporary Art.

Smith, Barbara. "The Vigil/Incorporate," *High Performance*, no.3, v.1, September 1978, pp.16-17. Description of performances by Barbara Smith and Suzanne Lacy; *The Vigil* was presented March 14-15, 1978 at University of California, Irvine, and *Incorporate* was presented July 8, 1978 at LACE Gallery, Los Angeles.

BRADLEY SMITH

Burnham, Linda. "Roll," *High Performance*, no.1, v.1, February 1978, pp.32-33.

Brad Smith. *Roll.* **Los Angeles, Ca., 1977.**

Send/Receive. West Coast sponsors, La Mamelle Inc., San Francisco, Ca., Fall 1977. Two-way transcontinental satellite link between New York and San Francisco. Participants in photo: Terry Fox and Margaret Fisher.

SOME SERIOUS BUSINESS

"Some Serious Business," *High Performance*, no.3, v.1, September 1978, pp.42-43, 51. Article discusses past and present activities of Some Serious Business, Venice, Ca.; includes a chronology of SSB performances from 1976-77.

THE WAITRESSES

Allyn, Jerri. "Ready to Order?," *High Performance*, no.3, v.1, September 1978, pp.24-25. Description of performances/works by The Waitresses (Jamie Wild, Denise Yarfitz, Anne Gauldin, Leslie Belt, Jerri Allyn, Patti Nicklaus) presented in various restaurants throughout Los Angeles, April-May 1, 1978.

JOHN WHITE

Muchnic, Suzanne. "John White: Golf Strategies, Art Strategies," *Artweek*, v.9, March 25, 1978, p.7. Discusses how White incorporates the game of golf into his art. Review of White's painting show, *Westchester Course*, at the Jan Baum-Iris Silverman Gallery, March-April 1978.

PETER WIEHL

Wiehl, Peter. "Arrowcatcher," *High Performance*, no.2, v.1, June 1978, pp.30-31. Description of a performance that took place at Golden Gate Theatre, San Francisco, December 13-14, 1977.

BOB WILHITE

Wilhite, Bob. "Ido," LAICA *Journal*, no.20, October/November 1978, p.47. Text, music, photo documentation of *Ido Ceremonial Music*, a Wilhite concert at the Newport Harbor Art Museum, July 14, 1978.

Wilhite, Bob. *Sounds from Shapes*. Los Angeles, 1978. Record. Documentation of a musical instrument class given at the Los Angeles County Museum of Art.

NINA WISE

Weiner, Bernard. " 'Glacier' Has Its Impressive Moments," *San Francisco Chronicle*, December 5, 1978.

Susan Mogul. *Live in San Diego.* San Diego, Ca., 1977. 20 minute
stand-up comedy routine with props.

1979

GENERAL LITERATURE

The Art of Performance. Venice, Italy: Palazzo Grassi, 1979. Catalogue to an international exhibition on performance art, at Palazzo Grassi, Venice, August 8-12, 1979. Organized by the New York University Art and Art Education Department and CAYC (Center of Art and Communication of Buenos Aires). Includes essays: "The Semiotic Achievements of Performances," (in English) by Jorge Ginsberg; "L'Art Corporel," (in English) by Gregory Battcock; "La Revanche du Corps," (in French) by Rene Berger.

Gale, Peggy and Bronson, A.A. (eds.). *Performance By Artists.* Toronto: Art Metropole, 1979.

"Ghostdances of Rosebud Hall," *High Performance*, no.6, v.2, June 1979, pp.50-52. Descriptions and photographs of a collaborative performance by Anita Green, Judith Rose, Barbara Margolies, Anne Mavor, Nancy Cutts, and Cheri Gaulke. The work was based on The Ghost Dance, a religious revival movement among the American Plains Indians during the 1890's.

Goldberg, Roselee. *Performance: Live Art 1909 to the Present.* New York: Abrams, 1979. One of the first art historical texts on performance art; by the curator of The Kitchen Center, N.Y.

Gorsen, Peter. "Theories of Performance: The Return of Existentialism in Performance Art." *Flash Art*, nos.86/87, January/February 1979, p.51. First article in a series entitled "Theories of Performance" by Peter Gorsen. Gorsen views performance in its relation to existential philosophy and how it is different from the concept ART = LIFE.

Performance Art Magazine, New York, no.1, 1979. Publishers, Bonnie Marranca and Gautam Dasgupta; Editors, Bonnie Marranca and John Howell. First issue of new quarterly published by Performing Arts Journal, Inc., New York.

Rockwell, John. "Books: The Place of Performance Art," *New York Times*, August 11, 1979, p.11. Book review for Rose ee Goldberg's, *Performance: Live Art 1909 to the Present.*

..

SOUND

Rosenthal, Adrienne. "The Shapes of Sound," *Artweek*, v.10, August 11, 1979, p.5. Review of *Sound*, an exhibition organized by LAICA Director, Bob Smith, and Bob Wilhite for the Los Angeles Institute of Contemporary Art. Among the 38 participants: Terry Fox, Tom Marioni, Jim Pomeroy, Richard Dunlap, Bob Wilhite.

Sound. Los Angeles: Los Angeles Institute of Contemporary Art, 1979. Catalogue for an exhibition of sound events, sponsored by LAICA and PS 1, New York, Summer 1979.

Wilhite, Bob. *Sound.* Los Angeles, 1979. Record album. Audio documentation for Los Angeles Institute of Contemporary Art's exhibition, *Sound*; examples of participants' sound works. Edition of 500.

ARTISTS / ART SPACES

ELEANOR ANTIN

Antin, Eleanor. *The Nurse and the Hijackers.* 1979. Videotape, color, approx. 2 hours. Narrative work; Antin is involved in a hijacking where she is the narrator and paper dolls act out the scene. Made in conjunction with installation at the Long Beach Museum of Art, January-February 1979.

Burnside, Madeline. "Eleanor Antin; Ronald Feldman, N.Y.," *Art News*, v.78, May 1979, p.167. Review of Antin's exhibition/performance at the Ronald Feldman Gallery, New York, where Antin appears as Antinova, the "black ballerina."

Cavaliere, Barbara. "Eleanor Antin," *Arts Magazine*, v.53, May 1979, pp.29-30. Review of Antin's exhibition/performance at the Ronald Feldman (Feb.17-Mar.17) and The Kitchen (Feb.23-24), N.Y.; Antin appears as Antinova, the "black ballerina," and performs the ballet *Before the Revolution* in which Antinova plays the role of Marie Antoinette as a shepherdess.

Clarke, John R. "Life/Art/Life, Quentin Crisp and Eleanor Antin: Notes on Performance in the Seventies," *Arts Magazine*, v.53, February 1979, pp.131-135. Article on the use of "biography" in art, focusing on the work of Eleanor Antin and Quentin Crisp. Excerpt:
If style is the expression of constant form, then the word 'performance' adds the dimension of action. Doing something within a given form also implies the element of time. To perform then means to act through or act out the given form of shape in a specified period of time.

Eleanor Antin. *Before the Revolution.* **The Kitchen Center for Video, Dance and Music, New York, N.Y., 1979. The Black Ballerina, Eleanora Antinova, in the role of Marie-Antoinette seen dancing with Nijinsky in the role of a soldier of the revolution.**

It is a truism to say that every art form is a time form. A poet must arrange his sounds to fit the number of lines of syllables dictated by the shape of the poem. Words like concerto, sonata, and symphony imply a similar time structure in music. Even in the so-called visual arts one speaks of composition, i.e., the time it takes for the eye to go from point to point, from color to color, from shape to shape.

Allan Kaprow's notion that Jackson Pollock destroyed painting as an art form has proven true. He spoke of the two roads open to the artist of the Sixties—either to make more "near-paintings" in Pollock's vein or simply to be an artist by channeling artistic consciousness in the direction of the sensual stuff of everyday life.

The time, therefore, of so-called performance art is the artist's own life-time. The stuff of performance art's creativity is the sensorium of the performer: how he or she sees, hears, touches, tastes, smells, moves, and so on. The success of performance, like the success of traditional painting, can be judged by the subjective experience of the artist and by that of the spectator. In a sense the critic can speak only of the form or shape in which

events happened over the time he was in contact with the artist. The performance becomes a kind of brain-tap into the consciousness of the artist executed at specific intervals in the laboratory of the gallery space.

Marranca, Bonnie. "Eleanor Antin, Before the Revolution," *Performance Art Magazine*, no.1, 1979, pp.41-42. Review of Antin's performance at The Kitchen, New York, February 1979; and compared with JoAnne Akalaitis' work, *Southern Exposure*, presented at The Performing Garage, April 1979.

Munro, Eleanor. *Originals: American Women Artists*. New York: Simon and Schuster, 1979. Extensive interview with photos, pp.417-430.

Raven, Arlene and Marrow, Deborah. "Eleanor Antin: What's Your Story," *Chrysalis*, no.8, 1979. Cover and essay.

Rickey, Carrie. "Eleanor Antin, Long Beach Museum of Art," *Artforum*, v.17, March 1979, p.72. Review of Antin's installation and videotape, *The Nurse and the Hijackers*.

ANNA BANANA AND BILL GAGLIONE

Banana, Anna. "Futurist Performance: A European Tour," *High Performance*, no.5, v.2, March 1979, pp.24-26. Text and photo documentation of a 1978 tour in which Anna Banana and Bill Gaglione (Dadaland) presented *Futurist Sound Poetry*, original works by the Italian Futurists, in major cities throughout Western and Eastern Europe. Excerpt:

THE PROGRAM:

With the exception of our first show (in which the order was reversed), we began each show with a presentation of documentation (super 8 film and slides) of my banana events and activities, as a crash-course in Bananology, with a Master's Degree in Bananology available to anyone in the audience at the end of the show.

While I was changing from my banana dress to my all-black, 40's "futurist" dress, Bill presented two of his original dada sound poems.

Bill: "Dada sound poem No. 1 D." He then places a large A on his nose. He repeats the sequence several times. "Dada sound poem No. 2." Bill slowly undoes his shirt and opens it, revealing a D shaved in the hair on his chest. He closes his shirt and says "A." He repeats this sequence several times, then leaves the stage area.

I introduced the Futurist pieces: Written by Italian Futurists between 1910 and 1920, preceding the Dadaists and Theater of the Absurd. . . .

By this time Bill was finished changing into his all-black 40's jacket, pants and shirt, and waiting on his side of the stage area for me to introduce the first piece, "Negative Act." As I walked off Bill walked out into the middle, apparently engaged in studying a letter, and remarking, "Fantastic! Incredible!" Suddenly he would look at the audience as if he's had no awareness of their presence, set a defensive stance and scrutinize them very slowly. Then, putting his letter away, he stated "I have absolutely nothing to say!" and stalked off to the left side of the stage area.

We had no backdrop or sets, and generally sought to perform with as neutral a background as possible. At the sides we had a table or chair with

Anna Banana and Bill Gaglione. *Futurist Sound Poetry.* **Europe, 1978.**

the few props we needed for some of the pieces. These were simple noise-makers and costume pieces to indicate character changes—hats, scarves, glasses, wigs.

We ended our half-hour performances with "Alternation of Character," a married-couple sequence in which each character changes disposition each time it speaks, going from soft and loving to cold and rejecting. Audiences everywhere responded to this piece, whether or not they understood the words, because it delivers such a universally understood plot.

Then we would take our bows and walk off, myself returning as the applause faded, to renew the offer of a Degree of Bananology.

PAUL BEST

Best, Paul. "Octavia Goes Out for a Beer," *High Performance*, **no.7, v.2, September 1979, pp.42-43. Text with documentary photographs of a performance in San Diego, California on March 28, 1979. Excerpt:**
Octavia woke up at about 1:30 p.m., O.S.T. (Octavia Standard Time). He was *dying* for a beer, and there was none in the apartment. He also did not feel much like getting out of bed just to go out and get a beer. But he had to make a decision: either he would be comfortable and stay in bed, like he usually does and die from alcohol starvation, or he would have to fight the crowds and get all dressed up to go out and satisfy his burning desire for a Bud.

Paul Best. *Octavia Goes Out for a Beer.* **San Diego, Ca., 1979.**

Best, Paul. "Octavia Goes Shopping in Her New Hair Color," *High Performance*, no.5, v.2, March 1979, pp.50-51. Text and photo documentation for a work that took place on November 7, 1978 at shopping centers in San Diego.

Best, Paul. "Yoko Ono Gives a Lecture," *High Performance*, no.6, v.2, June 1979, p.45. Description of Yoko Ono's performance at the University of California, San Diego, on November 28, 1978. Excerpt:

I always felt somewhat cheated because of this lack of 'real' experience of the 60's, which is why I wanted to present a 'recreation of the 60's' in a performance. All the material given, spoken and performed for the audience was taken directly from Yoko's writings. All performances were done according to her own instructions.

BOB & BOB

Frank, Peter. "Bob & Bob," *Performance Art Magazine*, no.1, 1979, pp.43-45. Review of Bob & Bob's performance at The Kitchen, January 1979; compared with The Kipper Kids performance there in November 1978.

Kurcfeld, Michael. "Bob & Bob Get Serious: Be straight with Bob & Bob & Bob & Bob will be straight with you," *High Performance*, no.6, v.2, June 1979, pp.18-22. Major interview. Excerpt:

DB: We did a piece [at LAICA] called "The School of Painting." I called Bob, who was planted out in the audience, up to the stage where I immediately taught him how to be an artist. There were two canvases set up, and I was demonstrating a still life on one. He eventually got frustrated and just taped the real fruit to his canvas. I critiqued it, saying that it was just spectacular the way it looked like it was coming right off the canvas. . . .

LB: The LAICA performance was our greatest performance. It was like Meet The Beatles all over again. We had a terrible rock band that was loud, rambunctious and off-key. Our microphones distorted our voices, and we danced around like Pop-Tarts. We had a tape of screaming girls running at full blast, and the surgical women carried around big poster blowups of Bob & Bob. It was pandemonium, just like a Beatle concert there in the little art gallery. We even had autograph hounds at the end.

DB: We closed it with fifteen minutes of chanting of "Live Your Own Life."

DB: We did a performance at the Ruth Schaffner Gallery. It opened with a film called "A Visit With Bob & Bob." It takes the viewer to our studio where we discuss our work, then to our home where we discuss how we live, then out into the woods where we philosophize, and bump into trees a lot. Then we came out and sang ten new songs, accompanied by an old Union accordion player in a tuxedo and toupee.

LB: He was like a robot, playing this ridiculous music we couldn't understand. He was always smiling, even when Bob & Bob were a mess. We had four black girls dancing on stage while we sang "I Heard It Through The Grapevine," accompanied by the accordion. . . .

MK: Your image is in everything you do. You've made yourselves the content of your art, in the flyers you send out, the films, leading up to the present series of paintings. Why?

DB: Here we are with our product, and our product is Bob & Bob. Bob & Bob is to us what the soup can was to Andy Warhol. They're our iconography.

BOB & BOB

"It's so refreshing to hear what art SOUNDS like. When I first met Bob & Bob, I couldn't believe how stupid they were — but now, i'm convinced they're the biggest, hottest property in the History of Art!"

BOB & BOB - SIMPLE AND EFFECTIVE

GEORGE BOLLING

Bolling, George. *Newport Beach Revisited*. 1979. Videotape, 35 mins., b/w. A new tape made from footage originally shot in 1972 related to the *San Francisco Performance* exhibition organized by Tom Marioni for the Newport Harbor Art Museum.

NANCY BUCHANAN

Buchanan, Nancy. "Around and About Purity," *High Performance*, no.6, v.2, June 1979, pp.48-49. Description of a performance at the Kansas City Art Institute, Kansas City, Missouri, on February 20, 1979. Excerpts:

AROUND AND ABOUT PURITY was a meditation on some of the various (often contradictory) ideas having to do with the subject of purity. The performance was built around audiotapes and slide sequences punctuated by spoken introductions, actions and tableaux. The space was an auditorium, with stage. . . .

The Part I slide/tape sequence concerned the metaphysical aspects of purity: the desire to separate the spirit from the body. . . .

Part II dealt with food and how the irony of having to put up with the body is compounded by the problem of survival; also the arbitrary idea of "Sacrifice," depending on who is considering it. . . .

Nancy Buchanan. *Around and About Purity*. Kansas City Art Institute, Kansas City, Mo., 1979.

345

Part III examined how some bodies are even more vile than others—women's bodies, of course. . . .

Part IV contained information about the social impact of the search for purity—statistics of witch-burnings and the identifying characteristics of witches. Part V was a return to the metaphysical; narration of hellfire, the flames of lust, the old myths about women originally discovering fire and hiding it in their genitals—the slides including atomic bomb explosions.

CHRIS BURDEN

Burden, Chris. *The Big Wrench.* San Francisco: La Mamelle, Inc., 1979. Videotape, approx.15 mins., color. Third in a series entitled, *Produced for Television*, a project of La Mamelle, Inc.; broadcast live on airwave television, Channel 26, San Francisco, November 1979.

Burden, Chris. "Coals to Newcastle," *High Performance*, no.5, v.2, March 1979, pp.12-13. Text and photo documentation of a work in which Burden flew a rubber-band model airplane carrying two marijuana cigarettes across the U.S. border into Mexico, December 17, 1978. Excerpt:

From each wing of the plane, like a miniature bomb, hung a cigarette of the finest seedless marijuana, "Sensimilla," grown in California. The plane bore the following inscriptions: "Hecho in U.S.A." ("Made in U.S.A."), "Fumenlos Muchachos" ("Smoke it, kids") and "Topanga Typica" ("Typical Topanga"). ·

Chris Burden. *The Big Wrench. Produced for Television* series, broadcast on KTSF-TV, San Francisco, by La Mamelle, Inc., 1979.

Chris Burden. *Coals to Newcastle.* Calexico, Ca., December 17, 1978.
Calexico, California, and Mexicali, Mexico, are actually the same city
separated by a tall steel and barbed wire fence demarking the
international border between the U.S.A. and Mexico. On the morning
of December 17, standing on the American side of the border, I flew a
small rubber-band-powered model airplane over the fence into
Mexicali, Mexico. From each wing of the plane, like a miniature
bomb, hung a cigarette of the finest seedless marijuana, 'sensimilla,'
grown in California. The plane bore the following inscriptions:
'Hecho in U.S.A.' ('Made in U.S.A.'), 'Fumenlos Muchachos'
('Smoke it, kids') and 'Topanga Typica' ('Typical Topanga')."

Chris Burden. *Big Job*. Venice, Ca. 1978

Burden, Chris. "The Curse of Big Job," *High Performance*, no.5, v.2, March 1979, pp.2-3. Description of Burden's experience with a 1952 Ford rig, "BIG JOB," owned December 14-June 22, 1978. Excerpt:

. . . I purchased an antique 1952 Ford "rig" (a tractor-trailer combination weighing 16,000 pounds empty). In large bold letters the words "BIG JOB" were stamped on the chrome strips attached to either side of the truck's hood. The thirty-five-foot black bat wing spray painted on either side of the trailer and the bent step bumper, marking where a man had killed himself by ramming the back of the trailer in a small foreign car, imbued "BIG JOB" with a power and evil which I found irresistible. . . .

With this huge truck I envisioned an almost endless series of projects that would free me from being an artist. My first plan was that I would drive to shopping centers with the B-CAR and the C.B.T.V. in the trailer and display them to members of the public for a nominal fee, much in the manner of an old-fashioned road show. Another was that I would install a satellite receiving dish and transmitter, making the truck a rolling communication command post. I fantasized that "BIG JOB" would become the world's first

mobile car factory: I would pull into a small Mexican village and produce the type of vehicle best suited for their specific local needs. . . .

The truck had turned into a giant liability rather than the fantastic asset I first envisioned. I decided to sell "BIG JOB."

Moisan, Jim. "Border Crossing," *High Performance*, **no.5, v.2, March 1979, pp.4-11. Major interview discusses recent works and activities of Chris Burden. Includes photo and text documentation for the following works produced between 1972-78:** *Working Artist*(1975); *Deadman*(1972); *Art and Technology*(1975); *The Citadel*(1978); *In Venice Money Grows on Trees*(1978); *TV Hijack*(1972); *Full Financial Disclosure*(1977).

White, Robin. "Chris Burden," *View*, **no.8, v.1, January 1979. 20 pages. Chris Burden interviewed by Robin White at Crown Point Press, Oakland, 1978. Includes a list of performances, one-person exhibitions and group exhibitions. Excerpt:**

[RW:] Well, what kind of insight do you think you have gained from doing these—these things, you know, these endurance tests? These risk situations? These isolations?

[CB:] What kind of insights?

[RW:] Yes, I mean, what have you learned?

[CB:] I don't know. I'm not sure I can—you know, spew it out in a few words or something.

[RW:] Well, I think that it's a reasonable question to ask you, because people have fears and fantasies about things like that and then you—did them. I mean, they're as extreme, in a way, as going to the moon or something like that.

[CB:] Yes, I know. I often think of myself as sort of training for some sort of—you know, outer space program. I mean, I feel like, in some way, I've done some of the same things.

[RW:] Yes, yes, that just occurred to me right now. But it seems to me that it would be impossible to do things like that and not feel that you've understood something more about human nature, or about the cosmos, or—

[CB:] I think one of the things I learned is that human beings really need other human beings. I mean, actually the thing I missed most on the platform wasn't food, or anything, it was actually seeing other people. Seeing them. Seeing other human faces. And so maybe that's the thing I think I've learned the most, is that people need people need people.

[RW:] Yes.

[CB:] In some fashion. And—also that some of the things that you can't believe you can get through, you often can.

[RW:] Yes.

[CB:] Because a lot of times, in those pieces I couldn't believe that I could actually make it through those things. I decided I would, so I was going to, but at the beginning they seemed totally gargantuan, and—you know, I had a lot of fear about being able to do them. And then I would adapt somehow to them. . . .

I think what happens is that people confuse what I do with me; what I do is separate from me as a person.

[RW:] Well, it's separate, but only so far, because you did conceive of it, and you did do it.

[CB:] Yes, but it's pretty formalized. You know I set them apart: this is art and this is life.

CAROLE CAROOMPAS

Caroompas, Carole. "Five Fables," *High Performance*, no.5, v.2, March 1979, pp.40-41. Text and photo documentation of a presentation by Caroompas with Marlene Bleich, Margaret Nielson and Alexis Smith entitled, *Five Fables;* presented at the Jan Baum/Iris Silverman Gallery, Los Angeles, September 29, 1978.

CLOSE RADIO

Burnham, Linda. "The Death of Close Radio," *High Performance*, no.6, v.2, June 1979, pp.2-3. Description of Burden's live performance in Los Angeles on Close Radio. Excerpt:

Chris Burden, Live on Close Radio, March 21, 1979, 9:30-10:30 p.m.

"I'm asking you to consider the possibility of everyone listening to me tonight sending me money, that is, money directly to me: Chris Burden, 823 Oceanfront Walk, Venice, California 90291. It would be such a wonderful thing. Paper money is preferable because it's easier to handle, but I'll accept a quarter. I'm not a member of a religious group or any organization. I'm asking you to conceive of the idea of walking to your desk, getting an envelope, putting a quarter in it and sending it directly to me: Chris Burden, 823 Oceanfront Walk, Venice, California 90291. I'm asking you to consider the 'what if?' What if you sent me money, sent it directly to me. I can't legally ask you to do this, but I'm asking you to conceive of the idea. It would be such a wonderful thing. I need money, it could make me close to rich. You probably pay bills every day, but this would be cheap."

NORMA JEAN DEAK

Deak, Norma Jean. "Writing For My Performances," *The Drama Review*, v.23, March 1979, pp.63-68. Essay describing Deak's performance activity of the past two and a half years.

GUY DE COINTET

Clothier, Peter. "Questions of Language and Meaning," *Artweek*, v.10, March 24, 1979, pp.4,13. Review of de Cointet's work, *Tell Me*, performed 14 times during March 1979 at the Rosamund Felsen Gallery, Los Angeles.

Deak, Frantisek. *"Tell Me,* a Play by Guy de Cointet," *The Drama Review*, v.23, September 1979, pp.11-20. An analysis of structure of de Cointet's *Tell Me;* special issue on Structuralist Performance.

FEMINIST ART WORKERS

Gaulke, Cheri. "To Love, Honor and Cherish," *High Performance*, no.5, v.2, March 1979, p.56. Text and photo documentation of a work presented at the Woman's Building, Los Angeles, on December 16, 1978 by the Feminist Art Workers (Nancy Angelo, Cheri Gaulke, Laurel Klick, Vanalyne Green).

TERRY FOX

Stodder, John and Natasha. "Performing with Sound," *Artweek*, v.10, August 11, 1979, p.5. Review of performances by Terry Fox and Tom Marioni presented July 20, 1979 for *Sound,* an exhibition/event sponsored by the Los Angeles Institute of Contemporary Art.

White, Robin. "Terry Fox," *View*, v.2, June 1979. 24 pages. Terry Fox interviewed by Robin White at Crown Point Press, Oakland, 1979. Includes list of performances, one-person exhibitions and group exhibitions. Excerpt:

[RW:] So the work that you're doing now still relates very much to your physical being?

[TF:] Well, I would say that everything I've done relates to the same thing, and my physical being has had a lot to do with it.

[RW:] In the past?

[TF:] In the past, and now.

[RW:] You use your body as a—as a reference, a standard of measurement.

[TF:] Sure. You and I both have the same body. So it's universal. It's personal and universal at the same time. Everybody has a liver—you could base work on the liver. Everybody would understand it. Or, the eye—what I'm starting to do now are works with the eye and the ear. . . .

It's almost impossible to talk about performance anymore. That word means something different from what it used to. There must be a better word, we could say "situation." I make a situation. The actual situation is what's going on in the space we're in. And the situation involves everybody there, and there is a blend when everybody starts participating. . . .

[RW:] And I think that's one thing that's been really hard to deal with about performance. People haven't had a clear definition of what it should be.

[TF:] Well, they should never have one. That is another thing that happened to performance; once an artist becomes known by people, they expect certain things from you, and communication becomes difficult. One reason for doing a long performance is that—sure, everybody comes with expectations. But even if you have expectations, if the performance is successful enough, you just drop all those; I mean—you'll be able to—to go to a new place that you have never been before.

[RW:] So, you have to clean out your mind.

[TF:] And one way to make it happen is by extended time. Those expectations get fuzzier and fuzzier and then maybe you go through a boredom or anxiety period, and then that goes away, and then you can really get into what's going on.

SUZANNE HELLMUTH AND JOCK REYNOLDS

Stofflet, Mary. "Suzanne Hellmuth and Jock Reynolds, 'Navigation,'" *Artforum*, v.18, October 1979, p.79. Performance review.

LYNN HERSHMAN AND REA BALDRIDGE

Hershman, Lynn and Baldridge, Rea. *Test Patterns*. San Francisco: La Mamelle, Inc., 1979. Videotape, approx. 15 mins., color. "A Factional Docudrama (in time)," created by Myth America Corporation for the series entitled, *Produced for Television*, a project of La Mamelle, Inc.; broadcast live on airwave television Channel 26, San Francisco, December 1979.

ALLAN KAPROW

Agalidi, Sanda. "Allan Kaprow: Shaping the Unnoticed," LAICA *Journal*, no.22, March/April 1979, pp.60-63. Article on Kaprow's "Activities."

STANDARDS

one and another, finding a messy place

tidying it up

photographing it before and after

photo: Phil Steinmetz

this is not a tidy situation

Allan Kaprow. *Standards.* **An artist book describing "a work of art commissioned by the Department of Art, for the Gallery of Art, University of Northern Iowa, January 16 - February 18, 1979."**

352

one and the other, finding some tidy people

photographing and tape-recording their tidiness

photo: Phil Steinmetz

this is a tidy situation

one tidying the other's place

photographing it before and after

photo: Phil Steinmetz

this is a tidy situation

one and the other, eating;

the other improving partner's manners

photographing them before and after

tape-recording instructions and results

photo: Phil Steinmetz

this is not a tidy situation

one improving the other's appearance

photographing it before and after

recording observations and results

photo: Phil Steinmetz

this is a tidy situation

one and the other, finding a tidy place

photographing it

tidying their behavior

each photographing the other's improvement

both recording why they've improved

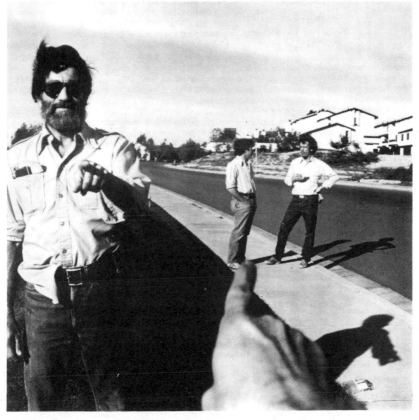

photo: Phil Steinmetz

this is not a tidy situation

Standards is an experiment with what many of us suppose are the signs of an orderly life: tidy surroundings, tidy personal space, tidy appearance, tidy manners, tidy thoughts — and the abiding desire to improve these traits. It is an experiment because we rarely question our assumptions about the value of orderliness; nor do we think much about why this or that is orderly at all.

To find out what happens when we focus on these simple issues, a small group of persons divided into pairs, carried out the preceding "program" on the weekend of December 9th and 10th, 1978, in and around Cedar Falls - Waterloo, Iowa. Each pair independently executed the six parts of the piece in the everyday environment, at their own pace, in their own way, and without audience. Following its completion, the group as a whole met and reviewed experiences.

Since these notes are being written in advance for this publication, and since *Standards* has not been done before, I can't relate what actually happened, but I can note certain speculations I had in conceiving the event. For years I have been impressed by that pervasive appearance of conventional tidiness found in Iowa and much of the American rural midwest: raked lawns, clean streets, geometrical fields, well-kept farms, open light faces, consistent friendliness, good but uncomplicated humor, relatively unchanging cultural and ethnic patterns, mild political conservatism, belief in the stable family, and desire to remain geographically close to one's birthplace.

There are exceptions of course but this picture is a truism many others have drawn, and I wondered how it would appear when probed. In contrast, this picture of order is so different from my sense of the east and west coasts where rapid change is the norm, and where feelings of disorder often color daily life. And it is also so different from big midwestern cities like Chicago through which such changes are funneled on their way across the continent.

Thus, my probe formed situations which involved confederacy (finding a messy place, some tidy persons), territoriality (tidying up a partner's appearance and table manners), and confessionality and trust (sharing thoughts of one's "improved" tidiness). Each situation is intentionally ambiguous since there are no given guidelines as to what is meant by tidiness.

Similarly, the photos accompanying the text of *Standards* are just as ambiguous: they are the same (or nearly the same) photograph. They contain both commonly considered elements of order and disorder (neat houses, a shirt tail hanging out), and less common ones (a formal, photographic order which contains *images* of untidiness (the shirt tail and a crumpled candy wrapper thrown on the sidewalk). Then, a man points at the camera (the viewer) and a hand intrudes in the foreground pointing the viewer to two men talking in the middle distance. Are they tidy? Is the photo tidy? Is the text-photo linkage tidy? Are these questions tidy?

To maintain this questioning, captions are placed under each photo stating that it is a tidy situation or that it is not. The reader is invited to examine why, and may agree or disagree, depending on what she or he looks at. This parallels the intended task of the participants in the actual piece. Any standards after all, are cultural artifacts. When they are relatively useful they assume objective value; when they no longer serve in most cases, questions arise.

Allan Kaprow
1978-1979

Hindman, James T. "Self Performance: Allan Kaprow's Activities," *The Drama Review*, v.23, March 1979, pp.95-102.

Kaprow, Allan. "Project for the Hamburger Kunsthalle," *The Dumb Ox*, Winter 1979. Account of a rejected Activity.

Kaprow, Allan. *Standards*. Cedar Falls: Dept. of Art, University of Northern Iowa, 1979. Artist book of the Activity. "A work of art commissioned by the Department of Art, for the Gallery of Art, University of Northern Iowa, January 16 - February 18, 1979."

KIPPER KIDS

Clothier, Peter. "The Kipper Kids: Illogical Conclusions," *Artweek*, v.10, February 3, 1979. Review of a performance done in collaboration with Anne Bean, at the Vanguard Gallery, Los Angeles.

Frank, Peter. "The Kipper Kids," *Performance Art Magazine*, no.1, 1979, pp.43-45. Review of the Kipper Kids' performance in November 1978 at the Kitchen, N.Y.; compared with Bob & Bob's performance there in January 1979.

PAUL KOS

Kos, Paul. *Ax*. 1979. Videotape, 25 mins., b/w and color.

LA MAMELLE. INC.

Loeffler, Carl. "A Literal Exchange/La Mamelle Inc. at A-Space August 1978," *High Performance*, no.6, v.2, June 1979, p.4. Description of an exchange program between La Mamelle Inc. and A-Space of Toronto in August 1978. Excerpt:

August 1978 La Mamelle Inc. and A-Space of Toronto traded roles in a program titled A LITERAL EXCHANGE. For the month of August, La Mamelle Inc. operated out of A-Space. Projects consisted of producing a special issue of the A-Space publication ONLY PAPER TODAY, exhibitions of La Mamelle Inc. video and California publications (exhibited were in excess of 100 artists books and artists periodicals), and a series of performance events. The performances utilized video as a main element. Introductions, presented Friday evening, re-enacted a typical Westcoast television talk show complete with multiple cameras, floor directors, pre-recorded commercials, prerecorded applause, and a live studio viewing audience. Selections, presented Saturday evening, re-enacted a cable cast broadcast to multiple cities (New York, Toronto, San Francisco, LA, and Tokyo) and consisted of pre-recorded video performances and live events. Sunday evening, The International Dance Contest, brought the town out to take a chance to win a $100.00 first prize awarded by Willoughby Sharp, Buster Cleveland, and Eldon Garnet. The dance contest utilized multiple camera video in a set resembling Hollywood Disco. All performance events were documented on video and available through La Mamelle Inc. Participating in the exchange: Carl E. Loeffler, Nancy Frank, Buster Cleveland, Anna Banana, Bill Gaglione, Paul Forte, G.P. Skratz, Linda Lemon, Norman Gould, Mary Stofflet, Kirk deGooyer, Willoughby Sharp, Eldon Garnet, and a cast of thousands.

Chip Lord and Phil Garner. *Auto Parts. Produced for Television* series, broadcast on KTSF-TV, San Francisco, by La Mamelle, Inc., 1979.

GARY LLOYD

"A Time Sharing Event (ADP)," *Dumb Ox,* no.8, Winter 1979, pp.50-51. Announcement for *They: An Answer Driving the Problem,* a time sharing event by Gary Lloyd, sponsored by Some Serious Business, October 28 and 29, 1978.

CHIP LORD AND PHIL GARNER

Lord, Chip and Garner, Phil. *Auto Parts.* San Francisco: La Mamelle, Inc., 1979. Videotape, approx. 15 mins., color. First in a series entitled, *Produced for Television,* a project of La Mamelle, Inc.; broadcast live on airwave television, Channel 26, San Francisco, September 1979.

TOM MARIONI

Marioni, Tom. *1979.* 1979. Videotape, 8 mins., color.

Marioni, Tom. "The Sound of Tooting My Own Horn," LAICA *Journal,* no.22, March/April 1979, pp.63-64.

PAUL MCCARTHY

Smith, Barbara. "Paul McCarthy," LAICA *Journal,* no.21, January/February 1979, pp.45-50.

SUSAN MOGUL

Askey, Ruth. "Susan Mogul Goes Hollywood," *Artweek,* v.10, July 14, 1979, p.4. Review of Mogul's performance/exhibition, *Waiting at Columbia,* Hollywood, July 1979.

Mogul, Susan. "Chocolate Shake Performance," *High Performance,* no.7, v.2, September 1979, pp.66-67. Description and photographs of performance at Columbia Coffee Shop, Hollywood, California on July 21, 1979.
Excerpts:
WAITING AT COLUMBIA FOR HOLLYWOOD MOGULS I DRANK 929 CHOCOLATE MALTEDS. STILL UNDISCOVERED, I DRANK MY LAST CHOCOLATE MALTED THE DAY BEFORE I TURNED THIRTY.

Columbia Coffee Shop, formerly Columbia Drugs, is located in front of the old Columbia Studios in the area known as Gower Gulch since 1928.

Susan R. Mogul, portraying a stereotyped Hollywood director, gave 13 women screen tests at the soda fountain. The women were in costume portraying women of the past five decades who have waited to be discovered.

Screen Test #6

Director: I'd like to hear how you would order a chocolate malted. Miss Margolies, please hand her the lines.

Woman-in-Waiting: I'd like to order a chocolate malted.

Susan Mogul. *Waiting at Columbia.* Los Angeles, Ca., 1979. Installation and set for "Chocolate Shake Performance." Mogul directs Cheryl Swannack at screen test. Mogul's collages in background.

Muchnic, Suzanne. "Four Offbeat Exhibitions Downtown," *Los Angeles Times,* July 19, 1979, Part IV, p.20. Short review/announcement of Mogul's work, *Waiting at Columbia.*

LINDA MONTANO

Shank, Theodore. "Mitchell's Death: Linda Montano's Autobiographical Performance," *The Drama Review,* v.23, March 1979, pp.43-48.

MUNICIPAL SOFTBALL LEAGUE

"Mister Twister/A Perfect Record," *High Performance,* no.5, v.2, March 1979, pp.14-15. Photos of players on the Municipal Softball League, Los Angeles Metropolitan Area. Included: Bob Smith, Richard Newton, and Paul McCarthy, among others.

MUSEUM OF CONCEPTUAL ART

McCann, Cecile. "MOCA," *Artweek,* v.10, June 16, 1979, p.16. Photo and brief statement regarding MOCA's installation at the San Francisco Museum of Modern Art, May-June 1979. Tom Marioni, MOCA Director, re-created MOCA's environment with refrigerator, table, and shelves for empty beer bottles. During the 6-week installation beer was available in the refrigerator and "guests" were expected to add their empty bottles to the shelf.

JIM POMEROY

Pomeroy, Jim. *Extrax/Abstrax/Artifax/1974-79.* San Francisco: Self-Published, 1979. "Miscellaneous notes on music, stereography, and performance."

Rickey, Carrie. "Jim Pomeroy, Artists Space," *Artforum,* v.17, January 1979, pp.60-61. Review of Pomeroy's performance of *Mozart's Moog, Nocturne* and *Apollo's Jest (a little night musing),* at Artists Space, N.Y.

RACHEL ROSENTHAL

Higgins, Dick. "Solo for Florence and Orchestra," *High Performance,* no.7, v.2, September 1979, p.61. A performance originally written by Dick Higgins in 1961; performed by Rachel Rosenthal and directed by Jerry Benjamin with costumes by Huck Snyder for a performance at I.D.E.A., Santa Monica, June 24, 1979.

Moisan, Jim. "Rachel Rosenthal," *LAICA Journal,* no.21, January/February 1979, pp.51-55.

Rosenthal, Rachel. "The Arousing (Shock, Thunder)," *High Performance,* no.7, v.2, September 1979, pp.22-23. Description and photographs of a performance that took place January 27, 1979, at the Los Angeles Institute of Contemporary Art.

Rosenthal, Rachel. "The Death Show," *High Performance,* no.5, v.2, March 1979, pp.44-45. Description with photo of performance at Space Gallery, Los Angeles, on October 21, 1978.

Rachel Rosenthal. *The Arousing (Shock, Thunder).* Los Angeles
Institute of Contemporary Art, Los Angeles, Ca., 1979.

MARTHA ROSLER

Rosler, Martha. "For an Art Against the Mythology of Everyday Life," LAICA *Journal,* no.23, June/July 1979, pp.12-15.

DARRYL SAPIEN

Atkins, Robert. "Celebrating Alienation," *Artweek,* v.10, September 29, 1979, p.7. Review of Sapien's work, *Portrait of the Artist x 3,* performed September 1, 1979, in San Francisco near the ruins, site of Playland at the Beach. Excerpt:

Three groups of male performers (all members of the Performance Foundation) simultaneously performed in three different locations. Michael Hinton, Henry Bridges and Jamal constructed a tall, phallic tower from sandbags. Cyd Gibson and Horace Washington used blow torches to inscribe geometric forms on a tar-covered wall on which geometric images by Jeff Vaughan were projected. Darryl Sapien and Brian Carter performed in the ruins of a cylindrical, high-walled building. Within it was a central pit lit a hellish red. One performer typed in the pit while the other manipulated the discarded lumber and junk littering the larger arena. (I found this the most engrossing of the three performances.) Sapien and Carter were futuristically garbed in white, and a dark, primitive and corporeal energy pulsated throughout the surreal, Fellini-esque environment.

McDonald, Robert. "Darryl Sapien's Drawings," *Artweek,* v.10, February 10, 1979, p.4. Review of an exhibition of drawings that developed from some of Sapien's performances, at the Gallery Paule Anglim, San Francisco.

Sapien, Darryl. "Crime in the Streets," *High Performance,* no.6, v.2, June 1979, pp.38-40. Description and photographs of "a performance about survival in the city." The work took place in Adler Alley, San Francisco, August 19, 1978.

STEPHEN SEEMAYER

"Untitled," *High Performance,* no.5, v.2, March 1979, pp.30-33. Text and photo documentation of a performance work at Close Radio, January 17, 1979. Seemayer (in a black room built outside the station) leaps over numbers that make up his social security number, wearing a burning mask, while three women (Edie Danieli, Monique Stafford and Linda Burnham) are in the radio station screaming, talking, and whispering the same numbers.

ILENE SEGALOVE

"The Mom Tapes," *Dumb Ox,* no.8, Winter 1979, pp.24-25. "Ilene and Elaine Segalove announce the birth of *The Mom Tapes,* August 25, 1978."

BARBARA SMITH

Smith, Barbara. *Just Passing.* San Francisco: La Mamelle, Inc., 1979. Videotape, approx. 15 mins., color. Second in a series entitled, *Produced for Television,* a project of La Mamelle, Inc.; broadcast live on airwave television Channel 26, San Francisco, October 1979.

Barbara Smith. *Just Passing. Produced for Television* series, broadcast on KTSF-TV, San Francisco, by La Mamelle, Inc., 1979.

SOON 3

O'Conner, Michael. "Soon 3: An Interview with Alan Finneran," *New Performance*, no.3, v.1, 1979, pp.14-22. Extensive interview; includes photographs.

JOHN STURGEON

Lewis, Louise. "Art As Alchemy," *Artweek*, v.10, July 28, 1979, pp.1, 20.

T.R. UTHCO

Procter, Jody. "T.R. Uthco Edited by Fire," *High Performance*, no.5, v.2, March 1979, pp.27-29. Text and photo documentation of a fire destroying T.R. Uthco's (Diane Hall, Doug Hall, and Jody Procter) studio at Pier 40, San Francisco, on August 7, 1978 and a subsequent exhibition of charred props from past performances, drawings and documentation of works from 1970-78, at La Mamelle Arts Center, San Francisco, November-December 1978.

VIDEO FREE AMERICA

Kelly, Joanne. *Video Free America Presents.* [San Francisco: Video Free America, 1979]. Catalogue of artists who have presented works at Video Free America, San Francisco. Includes a description of the work shown at VFA and current address for each artist.

JOHN WHITE

Lewis, Louise. "Sound as Sculpture: Observations on John White's Performance Art," LAICA *Journal*, no.22, March/April 1979, pp.53-55.

SUSAN WICK

"Susan Wick," *Bay Area Biographies*. Oakland: Modern Myths, [1979].

NINA WISE

Orr, Chris. "City-Lives and Natural Rhythms," *Plexus*, January 1979.

Ross, Janice. "Women and Wilderness," *Artweek*, v.10, January 27, 1979, pp.5-6. Review of Wise's performance piece, *Glacier*, an ecology-oriented work performed by Deborah Bucher, Suzanne Landucci, Grace Ferguson and Peggy Lutz, at Epic West, Berkeley, Ca.

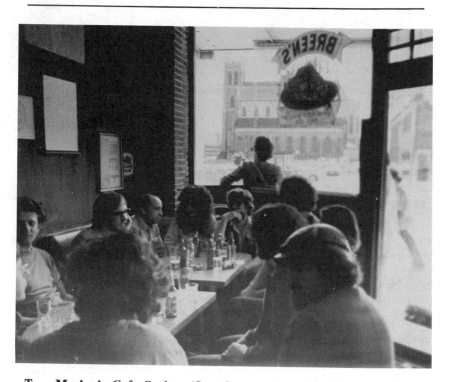

Tom Marioni. *Cafe Society (Last Day at Breen's Bar)*. Museum of Conceptual Art, San Francisco, Ca., 1979. Breen's Bar, Salon of MOCA, the site of Marioni's *Cafe Society*, where on Wednesdays from 2-4 p.m. artists would meet and exchange ideas and energy. Beer was free. Marioni's "concept of Cafe Soceity is drunken parties where ideas are born."

ESSAYS

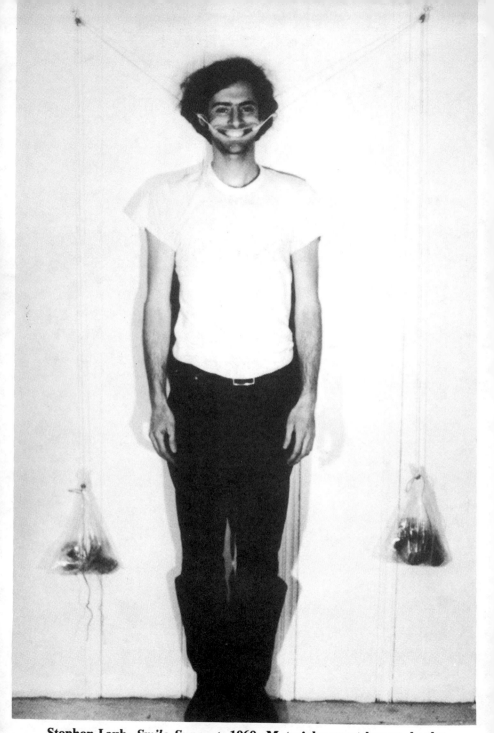

Stephen Laub. *Smile Support.* **1969. Materials: meat bones, hooks, string.**

FROM THE BODY INTO SPACE: POST-NOTES ON PERFORMANCE ART IN NORTHERN CALIFORNIA

Carl E. Loeffler

Today artists are using videotape to record unedited the stream of conscious flow of life. The hand-held camera records the movement of the artist's hand and body. Because of the use of drugs in our society, and especially in San Francisco, there has been a new art climate developing there. Since the advent of the hippies and rock music there are strong feelings to communicate in a personal way in the Area and it is definitely influencing many artists to the point that the taking of drugs is important to the execution and even understanding of the work. In the new sculpture there are no illusions as in theatre. The artist functions as an element/material and the relationships of his movement, spaces, sound, light, surface quality, presence, and so on function exactly the same as in traditional sculpture. The life span or performance of the piece is shorter and the methods for recording the artists' hand today are in keeping with the materials (technology) that are available to the artist. We approached in the late sixties a love for natural processes, raw materials and moved to the country so to speak. Museums were dealing with dealers and collectors and not the artist himself. The new sculpture demands the artist execute his work in the space that it is to be shown in. That way the artist has control over all aspects of its environment.

Tom Marioni
The San Francisco Performance, 1972

BRUCE NAUMAN, TERRY FOX, TOM MARIONI AND THE MUSEUM OF CONCEPTUAL ART

In 1921, a star shape shaved on the back of the head of Marcel Duchamp indicated that the artist and the art work produced are one and the same.[1] Bruce Nauman similarly expressed this idea in *Portrait of the Artist as a Fountain* (1966-67), in which he had a photograph taken of himself with water squirting out from his mouth.[2] Nauman featured himself as subject/object while exploring the physical attitudes directly assumable by the body through

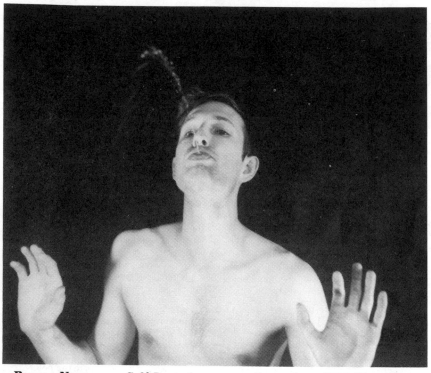

Bruce Nauman. *Self-Portrait as a Fountain.* **1966-67. Color photograph, 19 ¾" x 23 ¾.**

calisthenic-type performances of body exercises—standing, stretching, sitting, reclining, among other such movements.[3] He presented only a few of these works publicly, finding it easier to produce works privately in his studio, "to keep . . . busy," making films, videotapes, and photographs of himself walking, pacing, dancing, playing the violin, throwing balls, applying make up, etc. In a 1970 interview, Willoughby Sharp asked Nauman if he was doing this kind of work to experience sensations basically just for himself:

> BN: Yes. It is going to the studio and doing whatever I'm interested in doing, and then trying to find a way to present it so that other people could do it too without having too much explanation.
>
> WS: The concern for the body seems stronger now . . .
>
> BN: Well, the first time I really talked to anybody about body awareness was in the summer of 1968. Meredith Monk was in San Francisco. She had thought about or seen some of my work and recognized it. An awareness of yourself comes from a certain amount of activity and you can't get it from just thinking about yourself. You do exercises, you have certain kinds of awarenesses that you don't have if you read books. So the films and some of the pieces I did after that for videotapes were specifically about doing exercises in balance. I thought of them as dance problems without being a dancer, being interested in the

kinds of tension that arise when you try to balance and can't. Or do something for a long time and get tired. In one of those first films, the violin film, I played the violin as long as I could. I don't know how to play the violin, so it was hard, playing on all four strings for as long as I could. I had ten minutes of film and ran seven minutes of it before I got tired and had to stop and rest a bit and then finish it . . . My idea at the time was that the film should have no beginning or end: one should be able to come in at any time and nothing would change. All the films were supposed to be like that, because they all dealt with ongoing activities. So did almost all of the videotapes, only they were longer, they went on for an hour or so. There is much more a feeling of being able to come in or leave at any time.

WS: So you didn't want the film to end?

BN: I would prefer that it went on forever.[4]

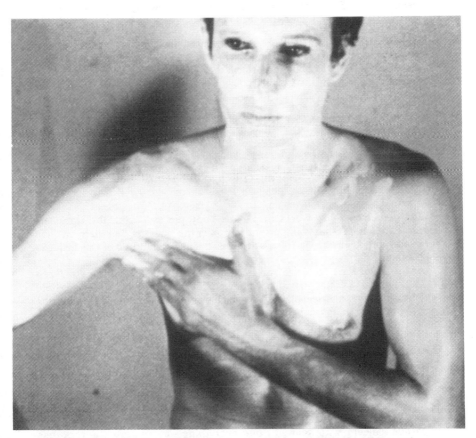

Bruce Nauman. *Art Makeup No. 1, White.* **1967-68. Color 16 mm film, silent, 10 min. Nauman engaged in the activity of applying white makeup. Additional films respectively utilize pink, green, and black makeup.**

371

In these body-type works directed toward the activity of the artist, Nauman created an "awareness" using the form, activities, gesture, and behavior of the physical body as a medium of exploration.

Terry Fox is another artist who has used his body as a performance medium, although he is not necessarily considered a body artist. In an interview conducted by *Avalanche* magazine, Terry Fox recalled the Nauman exhibition in 1969 at the Reese Palley Gallery, San Francisco:

AV: How did the Nauman videotapes and film loops affect you?

TF: What they suggested to me was the possibility of working with several different elements at once. Previously I could work with only one element at a time . . . I could never combine elements because I didn't understand the interaction. At that time I didn't want to force anything. I would start a process but not force it too much. What the Nauman show confirmed for me was the realization that I was an element equivalent to the others, that I would work with them without fear of interfering with their processes. That's what I'm doing now in the performances. I stopped trying to make pieces and instead got involved in creating situations . . . The most important aspect of it is treating the body as an element in its own right rather than the initiator of some act.[5]

In *Asbestos Tracking* (1970), Terry Fox coated his shoes with asbestos and made parallel tracks of shuffling, skipping, and dragging in a gallery environment. Using his body to perform the work, the tracks left by his body became the residue of the action.

It took the whole length of the room. I put my shoes in a pan of asbestos at one end and made three parallel tracks along the wall. The first was running. No, not running. Shuffling and skipping. Dragging, shuffling, and skipping. Shuffling was first. I kept both feet on the floor all the time, the way old men walk. I got into a slumpy posture and shuffled real slow. It was theatrical, but no one saw me. I wanted tracks of that action. If I had shuffled just for the sake of it, and if I hadn't been dejected when I did it, I don't think the prints would have been the same.[6]

Fox perceived these works in part as body pieces, "with the tracks as documentation." What is important to Fox is the body as "an element," to be used "directly as a tool." Fox attributes his understanding of this attitude to Nauman.[7]

At this point Fox "got involved in creating situations." In his *Push Piece* (1970), Fox had a dialogue with a wall by pushing on it for as long as possible and "exchanging energy with it." The wall was located in an alley where Fox would park his car. Previously, he had no contact with the wall except to look at it. On this occasion, he touched the wall and realized that he and the wall "were both and same" but up to this point had no "dialogue." When executing the piece he "felt it was somehow alive like a person." Fox says that our sense of involvement with elements is disconnected and we "just walk by these things." *Corner Push* (1970) was the negative of the wall piece in that a corner is the "opposite" of a wall, and in this work Fox "felt those walls coming together" from the dialogue he had with the corner. Fox considers every act or element of life as potential artworks; "all my life I've regarded objects with fear . . . but everything—a cigarette, a rock has always been beautiful to me if I just look at it." *Levitation* (1970) is another example in which the residue of the work documents the use of Fox's body to

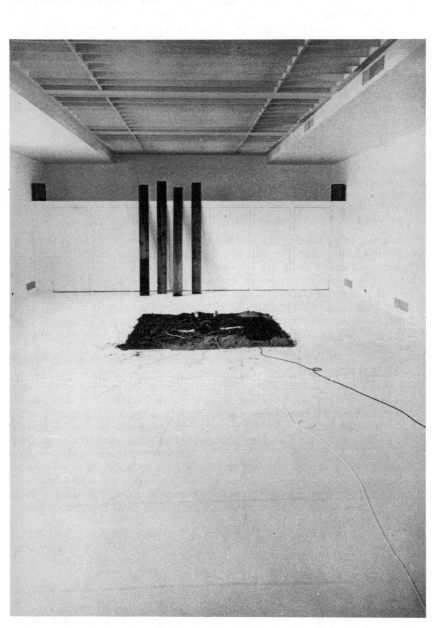

Terry Fox. *Levitation.* **Richmond Art Center, Richmond, Ca., 1970.**

make an action. *Levitation* was presented at the Richmond Art Center by Tom Marioni who was Curatorial Director at the time. Fox created a situation conducive to levitation. After covering the entire floor with white paper, he created a square mound with one and a half tons of dirt taken from a freeway construction site. Drawing a circle with his own blood and holding four tubes filled with blood, urine, milk, and water "to represent the elemental fluids" of the body, Fox lay there for "six hours . . . trying to levitate." There was no audience present in the gallery, and the doors were locked. Fox describes the experience.

I was trying to think about leaving the ground, until I realized I should be thinking about trying to enter the air. For me that changed everything, made it work. I mean, I levitated. After the fourth hour I couldn't feel any part of my body, not even my chest expanding and contracting. My legs and arms were probably asleep. I felt I was somewhere else. I'd gone, I'd left my body. Then something weird happened. A fly started buzzing around, and I thought I was the fly. That hallucination didn't last very long, but the feeling of being out of my body persisted for about two hours.

Afterwards, an imprint of Fox's body remained in the dirt, and a sense of charged energy filled the gallery. Fox says he considers *Levitation* his "strongest piece of sculpture because the whole room was energized. You didn't have to trip over the piece, you felt it the minute you walked in." The work proved to be extremely controversial, and subsequently was ordered closed by the city of Richmond's Chief of Police, Fire Inspector, and Health Inspector on the basis that it was an "obvious" fire hazard; they claimed that the paper placed underneath the dirt to protect the floor was highly flammable.

A sense of heightened awareness is recurrent in Fox's work, notably in *Defoliation Piece* (1970) where he burned a bed of rare plants in front of the University Art Museum, Berkeley, as his piece for the exhibition, *The Eighties*. Fox recalls, "This was my first political work . . . It was also a theatrical piece. Everyone likes to watch fires. It was making a roaring sound, but at a certain point people realized what was going on—the landscape was being violated; flowers were being burnt. Suddenly everyone was quiet. One woman cried for 20 minutes."[9] Fox perceives the literalness of these works as the artist-element performing elemental gestures with other elements in order to explore new levels of consciousness. In this new sense of "theatre," there are no formal controls because the elements are amorphous. Fox says he is "only conscious of how a piece looks when (he sees) the photographs" of it or the residual marks.

The documenting residue of an artist's ritual was integral to *The Act of Drinking Beer with Friends Is the Highest Form of Art* (1970), a work by Tom Marioni, who at the time was exhibiting under the name Allan Fish.[10] In an interview Marioni states:

It took place at the Oakland Museum. I invited 21 of my friends to come and drink beer at the museum. And 16 people were there. All the people were sculptors except for Werner Jepson, the music composer. We got drunk in the museum together and the debris that was left over was exhibited as documentation of that activity—empty beer cans and cigarette butts, just morning after kind of debris. It was to exaggerate the concept of the act being the art and the documentation being just a record of the real activity.[11]

Marioni regards the activity or process as a key element in this work. In this "new art" aesthetic, activity or situations could become art simply by moving the conceptual frame to include it within the definition of art. This principal is illustrated in the work *Lecture* (1970), where, in ordered sequence, Marioni had a janitor, dancer, actor and himself sweep a gallery floor. Marioni commented, "We saw the world differently . . . it was sweeping the floor for the janitor . . . a dance for the dancer . . . a performance for the actor . . . and it was a sculpture piece for me." Marioni produced works that stressed ways of perceiving other than the traditional way for the visual artist. For example, getting "stoned" and eating junk food created an interest in taste as a subject, and Marioni put different tastes together to make combinations that he equated to "something like sound." In *6'x6'x6'*, an Allan Fish work, Marioni had a dinner catered in a gallery. The participants included the artist, his wife, and Terry and Marsha Fox, who went to the gallery and ate a dinner there just as they would have done at a restaurant.

> The table was set up with four chairs and a tablecloth, nice dishes. When people tried to talk to us during the dinner, we ignored them because we were there just as though we were in a restaurant. All the activity outside of that six

Tom Marioni. *Lecture.* **University Art Museum, Berkeley, Ca., 1972/1973. Marioni with a janitor, dancer, and actor swept an area of the gallery floor. "We saw the world differently and we reacted to the world differently."**

feet imaginary boundary (the dimensions of work for the sculpture exhibition) was not art gallery activity. It was just a blank space. The meal took about an hour and a half. And we left afterward. The table and dirty dishes were left on exhibition as the record of the act. After about a week there was a row of ants that had come into the gallery . . . and were getting the food on the plates.[12]

The aspect of residue as a means of documenting performance activity became increasingly important. In 1970, Marioni founded the Museum of Conceptual Art, a museum for "actions not objects" with a permanent collection based on residue, relics, and created environments that became part of the building's architecture. MOCA was a social work for Marioni, and although it was a first in the now widely popular notion of the alternative space, he didn't regard it as alternative because it was a museum and part of the "establishment right from the beginning." In an interview with this author conducted in 1976, Marioni described MOCA:

CL: Maybe we can start from a point of defining the Museum of Conceptual Art.

TM: Well, I can't describe what it is now because it's in a phasing out kind of period. I can say what was my intention when I started it. It was to make a museum. It wasn't necessarily to make an alternative art space because I wouldn't have called it a museum if I wanted to make an alternative art space. I wanted it to be part of the establishment right from the beginning because I had come from working in museums when I was in art school in Cincinnati. I worked in the Cincinnati Art Museum as an assistant to the curator of the contemporary gallery and museum and that formed my interest in museum work. So then much later, after I had been an artist for ten years or so, I happened to get a job at Richmond Art Center as curator and that changed my whole outlook. It gave me a kind of social position, more so than a private one, like being concerned with getting things to the public. So it changed my whole attitude. After I was at Richmond for two years, I decided to start my own museum because there were things I couldn't do at Richmond. Even though I did some things that were adventurous, experimental, I still didn't do the things as far out as I wanted to, so I started my own space. Also, it looked as though I was going to get canned. So, in 1970, I started MOCA as a museum, and the reason I started it as a museum is because I was museum oriented. I was a museum person, so it was a museum for actions instead of objects. That's the difference between MOCA and traditional museums. But basically the definition of a museum is a place that houses and preserves works, you know, things. It has a collection. If it doesn't have a collection, it isn't a museum technically. So the collection consisted of documentation which I never exhibited. But the documentation was records of art activity like documents, films, videotapes, and all that, and later I moved across the street to the space we're in right now. I was over there at 86 Third Street from '70 to '72.

Since that time the collection has included relics, residues from actions taken place in here and environments built into the space, and places that were used as performing spaces. So that now the collection consists of things that have become a part of the architecture of the building. So that the works can't be moved. When the building gets torn down by the Redevelopment Agency the works of art will be destroyed too, you know, so they're public works of art. They're truly public because they can't be owned, they can't be moved. They're going to be destroyed.

CL: So you started MOCA with Terry Fox? Were you grant-funded at that time or was this a project that was entirely financed through your own means?

TM: Terry Fox was like an artist in residence. He did a show there in '70 in the summer. By the end of the year I had decided to make it a non-profit

corporation. Because I'd written to the National Endowment for the Arts to apply for a grant and they said the only way I could get a grant would be if I were a non-profit corporation. So I made it a non-profit corporation. It took about 9 months or a year, something like that to get that and then I got my first grant from them in '71 and then I had memberships and people became members and I had a few patrons. And I ran it like an art museum. I mean most people didn't take it seriously. Most people said that's impossible, you can't have a museum if it's conceptual art. Conceptual art can only be in your head. But conceptual art was people who use language, people who work with systems and people who made actions, and MOCA was a museum for that kind of conceptual art which is a real strong West Coast phenomena, a real Bay Area esthetic. Probably MOCA has a lot to do with it because it was a space for people to show, to do that kind of art before there were other places around. It was a first space for this kind of art in the country.

CL: You say that MOCA is now in a phasing out period.

TM: Well, as a performance space, it is. I doubt if I'll have any more performances here. I think that performances have become academic. They've become part of the academy. And there isn't a need to do it anymore. One of my concerns as a museum is to preserve. And what I'm doing is preserving that space, because I've kept it the same as I found it. I didn't sand the floors or paint it white or do anything like that to the space. It was a printing company for 50 years and when I moved in and saw it, it was perfect. It was like something that should be saved. People in positions to save things think they should only save Victorian houses. They wouldn't think of saving an industrial space as a relic from another age. It's got real quality to it, stained glass windows and those things here that . . . anyways, so, even though the space doesn't get used much in a traditional way like for exhibitions and stuff, it's being used and I'm saving it. It has a purpose, you know, and that's basic stuff. It's collecting energy and it has a lot of energy from past things that have happened in it. Kind of like a hill where a battle took place, you know, something you can feel the energy from, it survives. And that's part of my personal setting too (pointing). That case of empty beer bottles is a relic of an activity that I did in '72. I drank all those beers in one afternoon. It happened. It's like an object that wasn't made as an end in itself. It's an object that was used as a material, to explain something, to communicate an idea.[13]

The Museum of Conceptual Art is one of the first alternative art spaces which can be considered artwork itself and which also houses important residue as documentation. The number and quality of works and events sponsored by MOCA cannot be mentioned in this essay, but suffice it to say that the support that MOCA has offered to artists has been immeasurable. Although at this writing it is threatened with destruction by planned urban redevelopment, MOCA still exists as a museum.

Since the mid-1970's, however, MOCA as a performance space has scheduled less and less activity. The justification for this decision is based on Marioni's perception that performances have become academic, and, as he states, "it is no longer important to do them." Additionally, although MOCA pioneered the formation of alternative spaces, San Francisco presently has several artist-maintained exhibition spaces which regularly offer performances. In short, San Francisco has become a performance town, to such a degree that some people, as Marioni has noted, think of conceptual art only as performance.

MOCA has been a "social work" for Marioni and he has carried that concern into the *Cafe Society*, the principal activity of MOCA since the mid-1970's. MOCA is situated above Breen's Bar which throughout the years has served as an adjunct space for MOCA. The first video exhibition of body

works, organized by Marioni and Willoughby Sharp, took place at Breen's in 1970. The videotapes were displayed on the bar's television set. *A Tight Thirteen Minutes* (1976), a series of one minute works by 13 artists, was another videotape programmed by MOCA on Breen's television set. Marioni has programmed MOCA receptions in Breen's as well as situational works with artists. Breen's became the "saloon/salon" of MOCA, where on Wednesdays from 2 to 4 p.m. the *Cafe Society* would meet. In the MOCA tradition, beer was consumed and ideas exchanged. As Marioni has expressed, "my concept of 'cafe society' is drunken parties where ideas are born." Because of urban redevelopment plans, Breen's is now closed, despite Marioni's attempt to have the building preserved as an historic landmark. "My main activity is social," Marioni says, "and what I'm trying to do is make art that's as close to real life as I can without its being real life."[14]

LIFE AND MEDIA: HOWARD FRIED, LINDA MONTANO, BONNIE SHERK, LYNN HERSHMAN, ANT FARM, CHIP LORD, T.R. UTHCO.

In an art medium such as performance, where life often becomes the total content of the work, life can also become the form, with little or no distinction between where art stops and life begins. "It could be said that performance artists develop their ideas through conversation and readings in psychology, philosophy, etc. . . . but when one reads in these fields it is the principles and situations most like those one has personally known which influence thought."[15] Any discussion of performance must consider the lives and experiences of the artists producing the work. Tom Marioni currently thinks of art that is "close to real life" and yet remains art. The life and work are extremely close and flowing and I constantly make actions in private that are the same as my public manifestations". In performance art there is often then a blurred distinction between art and life. In many cases they are nearly the same, with the difference being a matter of perception and framing. When asked if he acknowledges that art is life, Howard Fried replied, "Art is life out of context by declaration. Definitions are fun because they're so easy to alter".[16] In a work by Fried, *Synchromatic Baseball* (1971), a baseball game which contained many extraordinary circumstances, was declared Art. The game originally was to be played on the street, but when the 20 or so players arrived they were confronted by Fried who, like an "authoritarian brutal tyrant" screamed commands and changed the game's location to the peaked roof of his studio to be played at night under blinding illumination, using rotten tomatoes instead of a ball.

> It was very dangerous. I hadn't actually planned on that. The game was full of oversights. I think what was also upsetting or puzzling to some players was the structure of the two teams. I divided the players into teams. The players weren't told my methods or motives for choosing these teams One team was made of people who took a dominant role in some relationship that affected my life. It was called the 'Dommy Team.' The other team, 'Indo,' was made up of people who took an indominant role in a relationship that affected my life. I took the part of coach and permanent catcher for both teams. As a coach I played the authoritarian brutal tyrant. I worked myself into a frenzy screaming commands. I think many people found that particularly upsetting because it violated the mental sets with which they were accustomed to approaching me. It also set the

tone for the game. One thing I was interested in was how each team would function as a unit. . . . It was complete chaos. It seemed a bit violent. The game was interrupted when I fell through a skylight chasing a foul ball. I was in a blind frenzy at the time. I called an intermission and went [to the hospital] for stitches. It wasn't serious. When I returned, the game continued but was less manic in tone. It eventually settled to a state that was about as boring as a normal baseball game.[17]

Much of Fried's work is concerned with speculative inquiries into problems dealing with behavior. *Synchromatic Baseball* was "dangerous" and "upsetting to the players," but as a performance it involved a confrontation which allowed for the study of group behavior and predictability.

The investigation of personal relationships is a primary concern of Linda Montano who, in pursuit of life change, was *Handcuffed to Tom Marioni for Three Days* (1973).

"I guess the piece was really a comment on my relationship with my husband at the time. That relationship needed some change, so I changed it the only way I was able to do at the time which was through my work. I would do anything within the context of work or art or whatever it was called; that was where all my permission was. The piece with Tom was wonderful. We moved together immediately. As soon as the handcuffs were on we started moving together. That continued for three days: going places, getting up, eating, changing, going to the bathroom. Whatever we did was absolutely synchronized at all times.[18]

The work was performed at MOCA. The public was invited, announcements were mailed out and for Montano . . . "it seemed the idea really was the piece." Montano investigated her life situation utilizing the context of art which was where her "permission" was located. In art she could be handcuffed to Marioni and explore that relationship, something she at that point was unable to do in life. Importantly, the work focused upon the two of them and their exchange as the materials of the piece, two male and female forms relating as sculpture.

Montano continued to utilize art to further investigate her life. In *Living Art Situations* (1975), she stayed home and documented her activity with neighborhood people. Montano " . . . felt (she) hadn't been available to anyone but (herself) . . . these works were about making myself more available." Soon Montano began doing works where she would live with people for periods of time, designating everything that occurred as Art. One of the first persons she lived with was Nina Wise. Shortly thereafter she lived in the desert for ten days with Pauline Oliveros, an experience which Montano described as "wonderful. Everything we did was art—exquisite— and I thought it could go on forever." In 1976, Montano, in collaboration with Wise, played drums in . . . "an attempt to change . . . consciousness." Daily they sat at 80 Langton Street wearing masks and playing drums. "It was an extremely powerful piece. It was a mutual extension of wanting to do something for a long period of time, wanting to change biological rhythms, wanting to change the chemicals of the body, and wanting to move to another place." After a move to Southern California, Montano's life took on aspects that previously she could only explore in her art, and her art "became more public and outward."[19]

379

Life as art and the art of living are themes central to the work of Bonnie Sherk, who began "performing life" in the series *Portable Parks* (1970), in which "turf, palm trees, and livestock were set down for brief periods at three unlikely places". Sherk's interest in these environmental type works stemmed from her basic disinterest in specific object art, and a desire to create an art based on confronting life. In the series, *Sitting Still* (1970), Sherk confronted the flow of life around her by sitting on a chair for extended periods of time in environments often bizarre in nature. The most striking juxtaposed image in the photographically documented series features Sherk in elegant formal attire, seated in an overstuffed armchair situated in the middle of a city dump flooded with water. *Public Lunch* (1971), has had by far the most impact of all of her confrontational works. For this piece Sherk gained access to the Lion House at the San Francisco Zoo where, situated inside her cage, she "performed lunch" amid the actual lunch performance of growling lions and tigers. The public audience watched incredulously as Sherk dined with all of the accoutrements of refined elegance.

In 1972-73, Sherk performed works at Andy's Donuts, where she continuously placed the frame of art on performing her job. She was then a short order cook and assigned titles to the work such as *Cleaning the Griddle.* Sherk regarded the pieces at Andy's Donuts as "theoretical and practical. The theory had to do with being who you are and being able to be playful in situations . . . It's a style of existence." Sherk's major work, *The Farm,* began in 1974 and can be regarded as a "series of simultaneous life vignettes" that, when seen as a whole, or as Sherk would say, "when viewed through a wide angle lens," formulates an incredibly rich "life art/theatre."

Basically The Farm is just that, but unbelievably this farm is located inside the city of San Francisco and is replete with buildings, animals, gardens, flowers and enormous amounts of activity. Sherk considers the Farm "a metaphor for civilization" that frames the "myriad of different relationships, struggles, differences, and similarities" which abound in life. The Farm functions as a sociological model enabling you to "see individuals singly and in groups: human, plant, and animal." It operates on a multitude of levels and is to be understood as total experiential life art/theatre.[20]

When perceived, or framed in a certain way, life can become art. With Lynn Hershman's *Roberta Breitmore* (1975-), however, art has become life. Roberta is a "meta-portrait;" she is a "real" person created by Hershman, whose performance "takes on the form of real life drama based on real life." The work began when Hershman was producing environmental-type pieces that attempted to convey an illusion of reality. Typically, the environments were located in hotel rooms and spoke of the former occupant whose presence remained a mystery yet could be experienced through many clues that Hershman installed.[21] The step from a living environment to an actual living person was conceived by Hershman while working on those pieces. The first task in developing Roberta was in the research of her image. Hershman began taking photographs of persons around her whom she thought Roberta might look like, and the more Hershman did this, the more she began noticing the vast number of Robertas that exist. Hershman has commented that the world is full of Robertas and that the formulation of Roberta actually became more of a "meta-portrait" of an archetypal cultural construct. Soon the sense of image was complete, and aided by make-up, a wig, specific clothing and particular language and gestures, "Roberta" ventured out in

Bonnie Sherk. *Sitting Still No. 1.* **San Francisco, Ca., 1970. Performance by the artist appearing formally dressed and seated in a stuffed chair situated in a flooded city dump.**

the world. In this "movie without film" Roberta can appear wherever decided. She has a driver's license, a checking account, a room in a boarding house, and attends therapy sessions. Roberta's exploits first took her cautiously to bars, but as her confidence grew, Roberta began to roam freely even into art events. Roberta is "real", but as art she is an "illusion."

The following is a brief chronology of Roberta activities:

June 1975: Roberta moves to San Francisco. Stays the first two nights at the Dante Hotel. Comes with one suitcase, a flight bag, and $1,800.

February 1976: Roberta visits San Diego, in hopes of finding happiness/security. She places ad in the San Diego Tribune and meets date at Belmont Amusement Park. Date arrives with five others and asks Roberta to join a prostitution ring.

July-January 1975-76: Roberta begins to establish her identity. She opens a checking account, receives a driver's license, applies for credit. Rents a room for $54 a week including 2 meals daily. Seeks a roommate to help share costs and cut loneliness. Advertises in various papers for roommate. Interviews for roommate. Ventures unsuccessful.

March-July 1976: Roberta has gained 4 lbs. Her depression is continuing. Requires abnormal amounts of sleep. San Diego trauma creates an end to her seeking a roommate. Money running out. Takes odd jobs. Begins nightly encounter session.[22]

Roberta is "real" and the events of her life are experienced in this performance work directly by Hershman. Roberta would place ads in the newspapers in order to meet men and have experiences. The following is an excerpt from a 10 minute meeting between Roberta and Mr. B. at Union Square, San Francisco, November 10, 1975:

R: Why did you move to San Francisco?
B: Well, a lot of things happened in a couple years. I owned a big contracting business in Salt Lake, and spread too far too thin . . . at the same time, I lost my family . . . my back went haywire and I spent a year in the VA hospital . . . so the whole place became nothing but a bad memory. I'd been here as a visitor. This place was as good as any.
R: Do you have any children?
B: Yeah.
R: Do you see them often?
B: Not very often. They're scattered all over.
R: What should I see here?
B: Well, there's the very best here and the very worst. Art shows, concerts . . . Oakland is full of that sort of thing.
R: You said that you might have a place for somebody to live?
B: I've got a beautiful apartment. I'm getting tired of rambling around alone . . . The only people I meet are from the tenderloin . . . I'm dumb but I'm not stupid. There is no way I'd get involved with any of them . . .
R: Would the room be expensive?
B: No. I'm paying the rent anyway. All you'd have to do is bring in a little food once in awhile. I like to have someone around. I just love to go to art shows and art galleries. Things like that . . . you know, are like watching television alone. And you could have the big double bed all to yourself. I'd sleep on the couch.

R: Well, let me think about it. I'll let you know.

B: Well, can't you come over and see it? It's right near here. You could move in today.

R: Let me think about it, I'll let you know. Thanks for meeting me.[23]

Roberta Breitmore is a "real" person created by Lynn Hershman. In this work, life is the form and the content, born from the actual experiences of Roberta. Other works by Hershman similarly have combined fantasy with reality: *The Dante Hotel* (1973), *Chelsea Hotel* (1974), *Re:Forming Familiar Environments* (1975), *The Floating Museum* (1975-78), and *Windows, Bonwit Teller* (1976). The Floating Museum was an alternative space developed by Hershman. In an interview with Moira Roth, she describes the necessity and achievements of the organization:

MR: At the same time as Roberta in 1975, you started the Floating Museum. You set it up with very little money and with the intent of inviting artists from outside the area to choose a site in which they wanted to do an event. You would arrange for that site and do the publicity and generally make the event possible. Why did you begin the Floating Museum?

LH: Why? It seemed right. I mean, there wasn't a system that existed to help artists to work outside of museum structures. I wanted to set an example of a method that would enable artists to do their own work easily in such sites. I wanted to recycle space that already existed, using what was already there, the environment, and promoting that idea. And also, I wanted to develop the idea of paying artists for such work, something that hadn't been done much before. Also, simply very selfishly, because I wanted to live in an area, the Bay Area, that had more energy. If I had this system of a museum, I could invite anyone I wanted to do works. I detest labels unless they are mischievously useful. The first year we invited artists from outside San Francisco to do works using the city as a canvas, and the second year we took artists from California who had never been outside California and put them on different points of the globe—I called it the *Global Space Invasion.* Except for the San Quentin Mural, the Floating Museum does only temporary projects and is itself only temporary. It is going to last only three years. Now it's at the end because its time is coming, its life is spent, and it did what it was supposed to do. The idea has already taken shape and is being used in other places, so there is no need to continue the museum.[24]

Hershman says that a "total experience exhibition" is planned for all the artists whom she and participating artists have met throughout the world through projects sponsored by the Floating Museum.

It has been said that today there are more television sets in America than bathtubs and that the viewing masses often equate television with a truth greater than empirical reality (e.g., "Let's turn on the T.V. to see if its raining.") Media, especially television, is a condensed form of life which, when framed, can become art. Works of art utilizing media may or may not be critical of media as a material or of the social/cultural values projected by the media. Importantly, however, such works express a sense of the media as a creative material from which art is made. Media-type works are presented within as well as outside of the domains of media, and can utilize as material the information, illusions and images conveyed, as well as the actual physical components of media.

Media as a contemporary material was applied in a number of works by the ANT FARM (1968-78), an artists' group organized to produce works in the area of architecture and the related arts. The group primarily consisted of Chip Lord, Doug Michels, and Curtis Schreier. Early works by the Ant Farm

Ant Farm in 1975 (Curtis Schreier (kneeling), Doug Michels, Chip Lord).

were architectural in nature. In 1970. while involved in a study of nomadic architecture, the Ant Farm planned a network of inflatable "truck stops" which would be spread across the entire country, allowing the "residents" to travel from one truck stop to another, assisted by an interconnection of computer-controlled communications. Research for the truck stop project was conducted in the "media van" which the Ant Farm designed, complete with a "self-contained life support system." The van was their version of what they called "nomadic truckitecture" which resembled a quasi-military rig. It looked offical with its antenna, its silver domes, and T.V. window. And on the side, instead of a government logo or motor pool ID number, it said ANT FARM. It was our version of the ultimate nomad package, a complete life-support system worthy of NASA, including a kitchen built into a small trailer and two inflatables, one a shower stall which could be inflated off the truck's 12 volt current. A solar collector heated the shower and the other inflatable, *Ice 9*, could shelter five people from the elements . . . Inside the truck was a video (tape) playback set-up so we could show people the tape we had shot of them moments before . . . "25

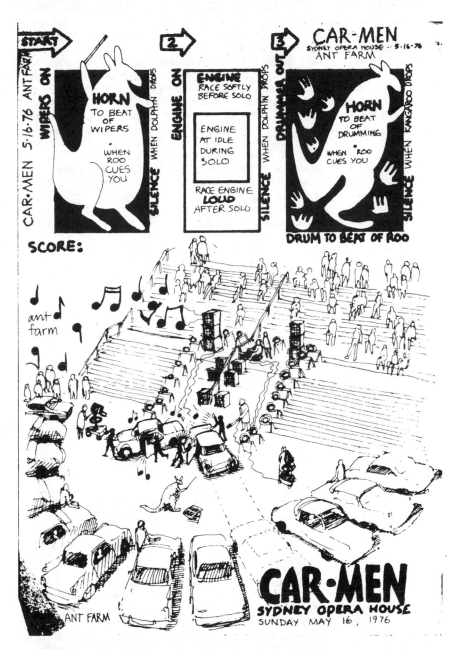

Ant Farm. *Car-Men*. Sydney Opera House, Sydney, Australia, 1976.
Ant Farm orchestrated a performance using car sounds.

The Ant Farm was "on the road" for months in the van. It was during this period that the work, *Johnny Ramao* (1970), was presented at Yale. As the story has it, while washing the van enroute to Yale University where they had been invited to give a guest lecture, the Ant Farm discovered the singing car wash attendant, Johnny Ramao; with enthusiasm, they invited him to perform with them at Yale. Johnny, whose singing performance was documented on videotape, sang something like, "Ohhhh, I need your love I need your love I need your lovvveee, I need your love I need your love I need your love, ooooh . . . " amid a myriad of finger popping, bouncing and swaying. Also in 1971, the Ant Farm published *Inflatocookbook* which contains feedback from their experience in the development of inflatables. In 1972 the group conceived of *Convention City*, a "post-automobile city for 20,000 people with two-way cable television access to the American public." The *House of the Century* (1972), is a ferro-cement residence designed by the group incorporating "post-war automobile styling and biological life forms." A *Dolphin Embassy* was also designed and was intended as a "neutral playground" for interspecies communication. It carries a crew and staff of 100, traveling the world's oceans while in communication with dolphins.

Projects of the Ant Farm have been involved with the recycling of archetypal images of American culture and the primary image of their concern is the automobile. *Cadillac Ranch* (1974), is undoubtedly their most recognized work. This outdoor "sculpture", sponsored by Stanley Marsh III, consists of a series of Cadillac cars (1946-59) buried hood deep at a 60° rake in Texas soil. The work is a documentation of the evolution and demise of the tail fin as well as a monument to post-war American culture epitomized by the Cadillac. *Cadillac Ranch* is located alongside US Route 66 just west of Amarillo, Texas.

In *Media Burn* (1975), the Ant Farm utilized images directly associated with the Cadillac car and television, and expressed the notion that "at least once in your life haven't you wanted to kick the shit out of your television set." The work was performed on the 4th of July at the Cow Palace in San Francisco.

For an audience consisting only of media personnel, the Ant Farm, amid presidential fanfare, drove a customized 1959 Cadillac Biarritz through a flaming wall of 50 television sets. Customizing the Cadillac, which was renamed the "Phantom Dream Car", had taken more than 1,200 hours of labor. "The main feature of the car [was] the dual-cockpit fiberglass impact shield that affords maximum security and safety to the two man crew and technical equipment. Other technological innovations include video-vision (an on-board image seeking guidance system), a navigation computer, and electronic digital instrumentation. All systems have been designed with a 55 MPH impact rating."[26] Prior to the launching of the Phantom Dream Car at the *Media Burn* event, a voice announced the arrival of the President of the United States. The "Artist-President," performed by Doug Hall, entered in a black Lincoln Continental decked out with American flags, presidential seals and secret service agents. He stepped up to a platform covered with bunting and in a manner of appearance and speech acutely resembling John F. Kennedy, spoke of television, the failures of America and the courage of the artists sponsoring the event.[27] Accompanied by fanfare and the tune of the Star Spangled Banner, the Artist-President returned to his motorcade and the Phantom Dream Car was unveiled. Possessing all the aura of a NASA mission, the "dream car" was launched and spirited down a designated course at 55 MPH to plow through a flaming wall of television sets. The audience howled with delight and picture tubes continued to explode until the end.

The Eternal Frame (1975), performed in Dallas, Texas, by Ant Farm and T.R. Uthco (Doug Hall, Jody Procter and Diane Hall) was in part a continuation of the images utilized in *Media Burn*—the presidential limousine the President, secret service agents. But in this case, the work reenacted the assassination of John F. Kennedy. The collaborating groups constructed a presidential limousine and consulted make-up experts to create the likenesses of Kennedy, Governor John Connally of Texas, and Jacqueline Kennedy. After studying the Zapruder film of the actual assassination, they practiced and "timed the event like a ballet . . . [to]make it look exactly like the original." The performance site was the authentic site—just in front of the Texas Book Depository. The artists enacted *The Eternal Frame* before their own video and photographic crew. "We found that tourists still come there every day . . . they line up on the streets just like in 1963—except they wear pink shorts instead of suits. They loved us. People rushed up with their instamatics. We were doing it every hour—20 times during that day—and they thought we were a government reconstruction squad or from the Chamber of Commerce."[28]

The performance culminated in a video exhibition of the documentation tapes held simultaneously in New York City and San Francisco, November 22, 1975. The following is an excerpt of the "Artist-President's" (Doug Hall) farewell address to the nation:

> . . . it is truly fitting that I am only able to talk to you tonight via television, for like all presidents in recent years I am, in reality nothing more than an image on your television sets . . . I am simply an image for the sake of image, nothing more. And as such, I function as a reflection of the myth which media manipulation creates. . . . Because as Artist-President I understand that I can and must function as an image, I have chosen in my career to begin with the end, and to be born, in a sense, even as I was dying . . . I did this to emphasize the fact, which we know to be true, that no president can ever be anything more than an image, and that no image could ever be in the past, nor can ever be in the future, anything but dead . . . "[29]

Chip Lord has continued to pursue his interests in the images and cultural associations of the automobile, and in collaboration with Phil Garner, performed *Chevrolet Training Film: The Remake* (1978). In this work, based upon an actual General Motors Corporation training film (1961) designed to acquaint salesmen with effective sales pitches and ploys, Lord plays the part of the buyer and Garner the "honest" car salesman. The performance begins with the film which features a GMC regional manager telling us we are about to see a demonstration of sales techniques. Immediately the film (actually transferred to videotape and displayed on a large-screen viewer) halts and the live performance begins. The set consists of a wooden desk and a full scale two-dimensional replica of a 1961 Chevrolet. Lord and Garner, dressed in 1960's-style attire, start to hash out a deal. The buyer, Lord, knows what he wants, and just how much he wants to spend, but the salesman, Garner, knows what he wants and, to get it, confuses the buyer. The performance closes with a return to the film where the regional manager introduces a panel of top salesmen who at this point critique the skill and technique of the salesman.

Lord's application and manipulation of media is astounding, and throughout all of his works, which are extremely humorous, is an unnerving sociological sense of who we are as post-war Americans.

In writing this essay, I have decided to concentrate on the works that have made the most striking impression on me. There are many artists and works, not included, of equal importance. I have attempted to ensure that the remainder of this anthology balances out the information offered in the essays. The anthology is directly reflexive of my continuing professional belief an interest in the idea of information as form, and in my support of an artist-based definition of, and communications network for, new art activity. I am grateful to have had the opportunity to participate in this period of art activity, and to have assisted in some of the works created therein. I am eternally grateful to all of the artists who produced the works.

NOTES:

1. This work was executed in Paris (1921) and assisted by Georges de Zayas. The actual shape of the shaved area has been described as the "pattern of a comet (with a star shaped tonsure)".

2. Bruce Nauman began producing sculpture in 1965 while a graduate student at the University of California, Davis. These early works were generally tough fiberglass strips cast from plywood molds and developed into latex wall hangings or floor heaps. In 1966 he began exploring the body, and photographed or produced films of his physical activities, e.g., *Playing a Note on the Violin While I Walk Around the Studio, Bouncing Two Balls Between the Floor and Ceiling with Changing Rhythms*. He first began working with videotape, and recorded body activity which he regarded as "problems" in 1968. These included *Slow Angle Walk, Stamping in the Studio, Walking in Contraposto* and *Lip Sync*. Central to these body-type works is the presentation of the artist executing physical activity "in a straightforward way." Nauman preferred to perform the works himself, and came to perceive of "the figure as an object." Willoughby Sharp has produced a number of significant essays and interviews which highly illuminate Nauman's activity during this period.

3. The artist as "subject-object" is a predictable development in twentieth century art and is perceptible through the continuing attempt of artists to close the gap between what they produce as work and what they subjectively perceive. Essential to the body-type works of Nauman is the assertion that "the equipment for feeling is automatically the same equipment as for doing." (James J. Gibson, *The Senses Considered as Perceptual Systems*, Boston, Houghton Mifflin Co., 1966, p. 28). Body works seemingly operate as either open or closed systems, occur in real time in a specific place, incorporate the use of a multitude of equipment and media to assist or document the work, and are most often actually executed by the artist.

4. Willoughby Sharp, "Bruce Nauman," *Avalanche*, Winter, 1971, p. 27.

5. Terry Fox, "I Wanted to Have My Mood Affect Their Looks," *Avalanche*, New York, Winter, 1971, p. 76; see also, Brenda Richardson, *Terry Fox*, Berkeley, 1973.

6. *Ibid.*, p. 70-71. *Avalanche* magazine fulfilled an important role in the dissemination of essays, interviews, and documentation reporting on contemporary new art activity. Thirteen issues of *Avalanche* were published between 1970-76. Currently *Avalanche* publisher Willoughby Sharp and editor Liza Bear are involved with telecommunications in the arts.

7. Although Nauman is a major influence on the work of Terry Fox, it remains important to clarify that Fox is not a body artist in a formalist sense of the term. Fox applies his body as an elemental tool or activator among other elements in order to create a "situation" that articulates a heightened awareness of spiritual reality. Fox's pieces lead one to an increased consciousness, making his situations seem "more real" in effect than reality, and theatrical in impact. The surrealist actor, director, poet and theoretician Antonin Artaud (1896-1948), who advocated a theatre of "extreme action . . . beyond limits" has been a continuing and potent reference for Fox's thinking and actions. Also, Fox's admiration for Joseph Beuys and subsequent collaborations in performance with Beuys has reinforced the intense seriousness which Fox has maintained throughout his work. Another major factor in Fox's work are the periods of hospitalization he underwent while being treated for Hodgkin's disease.

8. Terry Fox, *op. cit.*, p. 70-71.

9. Willoughby Sharp, "Elemental Gestures: Terry Fox," *Arts Magazine*, New York, May, 1970, p. 48. Fox regards *Defoliation Piece* as a very political piece directed

toward "extremely rich people, who obviously supported the war in some way or another. The garden was one of their favorite places to eat lunch . . . it was a real quiet, a wonderful place . . . I burned the whole thing with a flame thrower . . . so the next day when these people came to have their lunch there, it was a burned out plot . . . it was the same thing they were doing in Viet Nam . . ." (Robin White, "Terry Fox," *View*, Oakland, 1979, p. 10-11.)

10. Tom Marioni worked and exhibited art under the alias Allan Fish from 1968-1971 because he considered that "being a curator was politically too complicated—to be an artist and a curator [was also complicated] . . . because nobody sees you seriously as an artist . . . I [am] an artist who happened to be a curator rather than the other way around." (Carl E. Loeffler, "Tom Marioni . . . In Conversation," *Art Contemporary*, San Francisco, Spring, 1976, p. 3.)

11. Hilla Futterman, "Activity as Sculpture: Tom Marioni Discusses His Work . . . ," *Art and Artists*, London, August, 1973, p. 18.

12. *Ibid.*, p. 18.

13. Carl E. Loeffler, "Tom Marioni . . . In Conversation," *Art Contemporary*, Spring, 1976, p. 3.

14. Tom Marioni regarded MOCA as an "ephemeral . . . underground museum" . . . when he first started it in 1970 because "it dealt with something that no one else was doing" but when other museums and galleries began programming "the same kind of art . . . it became academic." Marioni is not interested in doing "things that are . . . overtly art" and by "disguising" his activity he can "go back underground." Presently he is doing things "disguised as non-art" . . . which he says is just the "same as in the beginning, when nobody thought direct actions had anything to do with art". (Robin White, "Tom Marioni," *View*, Oakland, 1978, p. 4-5.)

15. R. Mayer, "Performance and Experience," *Arts Magazine*, New York, December, 1972, p. 34. Mayer contends that performance art is most explicable by considering the life experience of the artists who produce the work because: 1. the relationship of the artist is to performance as subject-object. 2. the nonexistence of a traditional form. 3. most art criticism is formalist by nature.

16. Howard Fried, "Howard Fried in Conversation with Joel Hopkins, Marsha Fox and David Sherk," *Art and Artists*, January, 1973, p. 32.

17. *Ibid.*, p. 34.

18. Moira Roth, "Matters of Life and Death, Linda Montano Interviewed by Moira Roth," *High Performance*, December, 1978, p. 3 & 5.

19. Montano's current work in southern California consists of making video portraits of "characters" which she associates with the various chakras, e.g., the nun, the French woman, the country-western singer, etc. The ongoing influence of Catholicism is important in the work of Montano, who, earlier in her life was a nun. Montano says that it has "absolutely" affected her work and that her use of "elements of discipline and endurance and martydom . . . sacred spaces and energy . . . is a woman's version of Catholicism."

20. Bonnie Sherk thinks of The Farm as a "social art work" and the perception of it as art is "perplexing" to the establishment because of its diffuse form. The Farm clearly speaks to the future forms of art which perhaps function as a "life frame."

21. It should be noted that Hershman's early environmental works were highly collaborative by nature and often involved an association with Eleanor Coppola and Margo St. James.

22. Lynn Hershman's "Roberta Breitmore: An Alchemical Portrait Begun in 1975," *Art Contemporary*, Fall, 1976, p. 24.

23. *Ibid.*, p. 26.

24. Moira Roth, "An Interview with Lynn Hershman," LAICA Journal, January-February, 1978, p. 19.

25. Ant Farm, *Automerica*, E.P. Dutton, 1976, p. 123.

26. Peggy Gale, *Video by Artists*, Art Metropole, 1976, p. 22.

27. A full transcription to the "Artist-President's" address delivered at Ant Farm's *Media Burn* is published in Gale, *op. cit.*, p. 21-22.

28. Howard Smith, "Doing It Again in Dallas," *The Village Voice*, November 3, 1975, p. 24.

29. Ant Farm and T.R. Uthco, "The Eternal Frame," *Art Contemporary*, Fall, 1976, p. 31.

PERFORMANCE ART
IN SOUTHERN CALIFORNIA:
AN OVERVIEW

Linda Frye Burnham

There are no performance artists in Southern California. There are some 30 individuals consistently using live action in artworks, but in interviews with them, I found that none of them wished to be categorized as a "performance artist." Almost unanimously, they wish to be seen as "artists," that is creators of visual images arising out of the context of art history.

Their use of the human body, sound, light, color, action, time, autobiographical detail and photography and other technology is seen by them as closely related to the choice of materials by painters and sculptors. But they are also unanimous in their opinion that the artist's assignment in the seventies/eighties call for more than paint, canvas, paper, stone and clay. If they see themselves simply as "artists," that nomenclature carries with it a mandate to break through the restrictions imposed by the sanctions of art history and to move beyond two-dimensional imagination.

If there is a discernible trend in Southern California performance, it may be away from the gallery and back out into the street. Bolting in reaction to the restrictions of space and sponsorship involved in gallery performance, many artists are concentrating religiously on outdoor environmental performance. They are making use of downtown streets, baseball stadiums, beaches, shopping centers, civic malls, alleys and dirt lots in their live works, incorporating the ingredients of their daily lives into artmaking.

There is no question that two of the most celebrated artists in the history of performance are Chris Burden and Allan Kaprow, both residents of Los Angeles. Their divergent work and attitudes toward art have influenced virtually every artist working anywhere in live performance. While both continue to contribute to the art scene, Kaprow tends to participate mostly as a teacher. Burden still works in live action and environments, though his work since 1975 differs from the tortuous body art that made him famous in the early seventies.

Three other artists may be said to be outstanding in their importance within the Southern California environment as artists and role models: Barbara Smith, Eleanor Antin and Suzanne Lacy.

Certain artists can be distinguished categorically by their involvement with a kind of performance that dovetails with music and theater. These artists work in the gallery or on stage in traditional performer-audience relationships. Tending toward theater with the use of cast, script, props, scenery, makeup, lighting and other properties of theatrical drama are Rachel Rosenthal and Guy de Cointet.[1] Eleanor Antin and Norma Jean Deak are related to these artists in that they use narrative forms, story lines and slide projections to define their works.

Music is an important part of the influential work done by Pauline Oliveros (who, in fact, is the director of the Center for Music Experiment in San Diego).[2] The Kipper Kids work within a British Music Hall tradition, and Bob & Bob owe something to the Las Vegas lounge show. Bob Wilhite, though his work is linked to the sensibilities of the conceptual artist, has worked with "sound from shapes" in the last few years, creating and performing on musical instruments.

A coterie of women artists must be viewed together as feminists because the overriding character of their work is political. These include Suzanne Lacy, Nancy Buchanan, Leslie Labowitz, The Feminist Art Workers (Cheri Gaulke, Nancy Angelo, Laurel Klick and Vanalyne Green), Mother Art (Helen Million-Ruby, Laura Silagi, Suzanne Siegel and Gloria Hadjuk), as well as a number of very active women current in the Feminist Studio Workshop at the Woman's Building.

These categories set aside, there are a number of energetic and important artists whose work can be put into no conceivable pigeonhole. They are performers who work alone and most often outside the gallery/museum framework. These artists are most challenging, difficult and private performers, mavericks all. Grouped together, if only because they are utterly unique, their works swing from the examination of the dark side of human nature (John Duncan, Paul McCarthy, Stephen Seemayer, Paul Best and Kim Jones) through eroticism (Richard Newton) and humor (Newton, John White, Lowell Darling) to a silent and subtle spirituality (Bradley Smith, Dorit Cypis and Doni Silver). Several of these artists have created performances for an audience of a single person.

The contemporary Southern California art scene can easily be separated into two geographical areas: Los Angeles and San Diego.[3]

Performance activity in the San Diego area is all but limited to the University of California, San Diego campus in La Jolla (UCSD). The art and music faculty there includes important figures from the early days of Happenings as well as the Fluxus Movement. Teaching at UCSD are: Allan Kaprow, Eleanor and David Antin, Helen and Newton Harrison, Pauline Oliveros, Linda Montano, Jerome Rothenberg and historian Moira Roth (who has written much about performance). Closely allied with the campus are Aviva Rahmani, Paul Best and Norma Jean Deak. The vigorous and innovative atmosphere of the campus and the MFA program have drawn such visiting faculty as Barbara Smith, Alexis Smith, Martha Rosler and Suzanne Lacy.

The employment of performance artists as faculty is probably the most important factor in the validation and spread of performance art as a contemporary medium. UCSD is the only campus in Southern California where students are regularly exposed to performance-oriented artists who

use innovative techniques, interdisciplinary experimentation and advanced technology.[4] The result of such programs is that a significant number of young MFA graduates do much of their work as live performance.

The San Diego faculty, though it includes many of the strongest and, historically, most important artists in performance history, is, in a sense, removed from the Southern California art scene. The view from Los Angeles is that these artists tend to relate strongly to the milieu from whence they came—New York—and tend to avoid Los Angeles as a place to market their wares and enhance their reputations.[5]

In looking at Southern California geographically, San Diego must also be viewed separately. Briefly, San Diego is the country, Los Angeles is the city. And geography, climate and physical environment may be of paramount importance when talking about California art.

Much has been made of the general lassitude of the whole scene, replete with bedroom communities, swaying palms, swimming pools and hot tubs. The weather is so consistently balmy that softball can be played 350 days a year and it is possible to live quite comfortably on the streets or the beaches as a transient. Any action at all requires significant motivation in such a climate. It could be argued that to be a native of Southern California is to be born with a propensity to inertia.[6]

Los Angeles lifestyle heavily affects most performance art works. Environmental factors related to the Southern California area often figure in the work of one or more L.A. performance artists: the problems of isolation and communication (Burden, Barbara Smith), the auto culture (Burden, Newton), threat of violence (Lacy, Jones, McCarthy), the urban environment (Seemayer), billboard art (Labowitz), show business (Bob & Bob) and the pop music scene (Kipper Kids).

In L.A., perhaps more than in any other art milieu, artists are giving themselves permission—even assignments—to make art incorporate life, as we will see from an examination of the kinds of work being done.

An important factor for performance (of any kind) is audience and performance space.

Performance art is supported by only a few established "art spaces" in Los Angeles. Foremost in sponsorship of gallery performance is the Los Angeles Institute of Contemporary Art (LAICA). An artist-run space supported by its members and by grants, LAICA has a performance committee of elected members who review proposals for performances and facilitate shows within the space and elsewhere.

Since 1974 LAICA has presented local artists as well as important visiting artists such as Hermann Nitsch of Vienna. Chris Burden has curated two very important programs at LAICA. The works of Richard Newton, Bradley Smith and Bob Wilhite were shown in live performance as well as a month-long exhibition of documentation, records, films, videotapes and performance relics. More recently (1978), Burden curated an exhibition of performances and photographic documentation by three European performance artists: Gina Pane of France, Petr Stembera of Czechoslovakia and Richard Kriesche of Austria.

These exhibitions were important for two reasons: they dealt very well with the issue of performance documentation, providing the gallery visitors with a sampling of the performers' whole body of work for a frame of reference, and the European show exposed Los Angeles audiences to a heavy dose of a kind of work they might never have another chance to see live.

Two other active performance spaces in Los Angeles are the Vanguard Gallery, a small space run by four artists, and the Woman's Building, a feminist community. Others that present performance from time to time are LACE, Otis Art Institute, Jan Baum-Iris Silverman Gallery, Space Gallery, Mount Saint Mary's College, L.A. Louver, and I.D.E.A.

Two organizations that have provided service to performance art in other ways are Some Serious Business (SSB) and Close Radio. SSB serves as a support organization without a space, helping to facilitate performance all over the city, indoors and out, and aiding artists in obtaining funding, materials and publicity.

Close Radio presented performance art on a weekly radio program over a local non-commercial station.[7] More than 100 programs were presented to an estimated nightly audience of 10,000 over a two-year period, featuring artists live and on tape from all over the world. The program tried the format and the patience of the station many times and finally pushed past the boundaries of what was acceptable on March 21, 1979, when Chris Burden presented an hour-long special in which he asked the audience to "conceive of the idea" of sending him money, giving his address over the air. Exasperated with the unruly nature of performance and fearing for its license in this case, the station cancelled the program.

Performances on videotape are regularly available for viewing at the Long Beach Museum of Art and at LAICA.

The print media are becoming interested in performance art in Los Angeles, although it is rare that a performance is reviewed in the *Los Angeles Times*. *Artweek* (published in Oakland) reviews performance from all over the West in each of its weekly issues and the LAICA *Journal* (bimonthly) prints interviews and criticism of performance artists. In February 1978 *High Performance* was born, the first magazine completely devoted to performance art documentation and interviews.

There is interest and a growing audience for performance art in Los Angeles. The continuing problem is economics, but it has been demonstrated that a well-publicized piece can draw as many as 3-400 people. If a $3 admission is charged, the money taken in can pay for materials and publicity with enough left over to provide a fee for the artist. The form will probably never become highly commercial because of its unpredictable nature. It is doubtful that performance artists wish to become comfortably established in show business. Witness the vigorous activity going on outside the gallery scene, in which artists like Richard Newton and Kim Jones perform on the streets with little publicity and no remuneration whatsoever.

Allan Kaprow is often credited with "inventing" the Happening when he presented *18 Happenings in Six Parts* at the Reuben Gallery in New York in 1958. He knew he was in the midst of an art scene that would make history and in 1959 he began to collect photographs and to write the books that chronicled those days: *Assemblages, Environments, Happenings* (1966). Hundreds of photographs documented the live works of Red Grooms, Jim Dine, Claes Oldenburg, the Gutai Group, Jean-Jacques Lebel, Wolf Vostell, George Brecht, Kenneth Dewey and Milan Knizak, grouping it and linking it historically with the environments and assemblage of Robert Rauschenberg, Jean Follet, Jackson Pollock, Clarence Schmidt and Robert Whitman.

Kaprow went on to become an important and established academician,

with full tenure at the University of California, San Diego. As an influence on art history, he knew what he was about from the beginning. In that book's preface, he stated:

> The book . . . has been written in the midst of a young activity with an interest that was both observant and highly biased. Being part of the activity, I was inclined to look at and judge an art-in-the-making as well as influence its course. Artists, like critics and historians, make the history they reflect, even with best of intentions to remain objective. I thought, when I began writing, that I should try both to observe and to influence as much as possible.[8]

Kaprow has, without question achieved his goal. What he has said about the form, aesthetics, and ethics of performance has gone down as history and fact. No individual has done more to shape what we know about the art form.

Kaprow began early to prescribe the properties of performance (happenings). In his book he laid down certain rules of thumb derived from what had emerged over the years as "issues."

> A) The line between art and life should be kept as fluid and perhaps indistinct as possible. B) Therefore, the source of themes, materials, actions, and the relationships between them are to be derived from any place EXCEPT from the arts, their derivatives and their milieu. C) The performance of a Happening should take place over several widely spaced, sometimes moving and changing locales. D) Time, which follows closely on space considerations, should be variable and discontinuous. E) Happenings should be performed only once. F) It follows that audiences should be eliminated entirely. G) The composition of a Happening proceeds exactly as in Assemblage and Environments, that is, it is evolved as a collage of events in certain spans of time and in certain spaces.[9]

While Kaprow's early pieces tended toward the spectacular, many of them were scripted for the participants only, with no spectators, becoming a kind of situational research. By the time Kaprow moved to California in 1969, he was ready for his final spectacular, *Fluids,* in which giant ice sculptures were constructed by a group of participants, cemented together with rock salt and melted in the sun.[10]

Joining the faculty at the California Institute of the Arts in Valencia (about 30 miles north of Los Angeles), Kaprow began teaching with Fluxus Movement figures like Alison Knowles, Dick Higgins and Nam June Paik. Kaprow's attentions started to focus on the normal actions and interactions of everyday life as subjects for art, rather than large, contrived events. He wrote at this time:

> To escape from the traps of art, it is not enough to be against museums or to stop producing marketable objects; the artist of the future must learn how to evade his profession. . . . The most important short-range prediction that can be made (is) that the actual, probably global, environment will engage us in an increasingly participational way. The environment will not be the 'Environments' we are familiar with already: the constructed fun house, spook show, window display, store front and obstacle course. These have already been sponsored by art

galleries and discotheques. Instead, we'll act in response to the given natural and urban environments such as the sky, ocean floor, winter resorts, motels, the movement of cars, the public services and the communications mediums . . .[11]

Kaprow moved to UC San Diego in 1974 and continues to teach on performance and to perform now and then in small, highly controlled pieces. If the performances are presented to audiences of non-participants, the presentation will serve only to prescribe a performance that may or will be done later, or to release the performance in video or film.

A typical presentation took place at the San Francisco Art Institute in December 1977, where Kaprow showed films and tapes and lectured:

Two aspects of the evening that seemed at odds with typical performance etiquette were Kaprow's last-minute shortening of his presentation (so that he might attend a 'real'performance afterward) and his explication of his film and video which dispelled the air of discovery and confusion that normally surrounds art performance. Instead of the elaborately scripted mass spectacles he once did, Kaprow's work in recent years has taken the form of simple exercises involving elements from everyday life.[12]

The three tapes Kaprow showed were: *Comfort Zones,* in which a man and a woman perform simple actions such as pressing their bodies together or thinking of each other in separate rooms until one or the other says "now"; *Seven Kinds of Sympathy* and *Common Senses,* brief exercises in which two participants are instructed to perform actions, then to copy these and help each other perform them.

Allan Kaprow. *Fluids.* **Los Angeles, 1967.**

Chris Burden. *Shoot.* F Space, Santa Ana, Ca., November 19, 1971.
"At 7:45 p.m. I was shot in the left arm by a friend. The bullet was a

copper jacket 22 long rifle. My friend was standing about fifteen feet from me.''

Kaprow explained that these were intended as "reference systems" rather than works of art or documents, deliberately dry in style to enable those who used them to create their own version of the actions and find their own "feelings" within them.

An informal survey of Kaprow's students reveals that they see him as open and supportive to all students and all kinds of performance but, at the same time, reductive about performance activity to the point of alienating students who wish to work live. Some received his message as related to "interior performance," that is, that performance can be used to "take care of yourself."[13]

Kaprow has voiced concern over performances that "manipulate" the audience and has questioned the morality of pieces that do not take the audience into careful consideration.

His influence with his colleagues is revealed in a discussion between two performance artists, Barbara Smith and European Gina Pane. Smith related Kaprow's concerns as she sees them:

> How do you feel about the idea that the people who come to your performances will feel the pain that you are supposedly feeling? The question that Allan would raise is: Why do you do that to us? Is it fair? He thinks all performances release a strong emotion that becomes part of the piece.[14]

If Kaprow's attitudes as historian, teacher and friend have had a strong effect on Southern California artists, Chris Burden's performances have certainly shaped and altered the way artists and audiences view the art form.

In 1971, Chris Burden endured the shot heard round the art world. His piece *Shoot*, in which he was wounded in the arm with a rifle in the name of art, received attention in the national media. By 1973, his work had been written up in the *Los Angeles Times, New York Times, Time, Avalanche, Esquire* and *Newsweek*.[15]

Between 1971 and 1975, the art world watched with fascination as he imprisoned himself in a locker, crawled nearly naked across broken glass in a city street, had a steel stud nailed into his sternum, had pins pushed into his stomach, shocked himself, hanged himself upside down, remained in one spot for weeks at a time, disappeared, set fire to himself, tried to breathe water and had himself kicked downstairs at an art fair. He became "identified with those themes: melodrama, violence, risk, control and threat within the performer-spectator situation."[16]

The media treated his work as a spectacle, sensation, he was called the "Evel Knieval of the Art World." Exhibitions of his documentation became the focus of controversy, with newspapers calling him a fraud instead of an artist. He ran afoul of the law, facing trial for "causing a false emergency to be reported" when he lay under a tarp on a busy Los Angeles street.[17]

After 1975 Burden's work turned to pieces that appeared less sensationalistic and risky. He spent two months in 1975 designing and constructing a bicycle-powered automobile, the B-Car, and assembled it in four days as a performance in Amsterdam; he constructed a working model of the first mechanical television set and demonstrated it at the Documenta art fair in Germany in 1977. He bought time on television for a "full financial disclosure" of his personal affairs (1977); he glued $100 in one dollar bills to the short palm trees in front of his studio where they stayed untouched for

two days (*In Venice Money Grows on Trees,* 1978); he performed inside of his installation of five hundred detailed model space ships (*The Citadel,* 1978); he attached two American-grown marijuana cigarettes to the wings of a model airplane and flew them into Mexico (*Coals to Newcastle,* 1979).[18]

In a 1978 interview, Burden discussed his view of his events as sculpture:[19]

Before it happened, it didn't exist. All of a sudden, a guy pulls a trigger, and in a fraction of a second, I'd made a sculpture.

as control states:

I wanted to see if I could force my body to do something that logically it couldn't do, by setting up a mind state.

as violence:

The violence part wasn't really that important, it was just a crux to make all the mental stuff happen . . . the anticipation, how you dealt with the anticipation. Physically it was no big deal.

as risk:

There was one part of me that kept saying, 'You don't have to do this! What are you doing?'

The implications for artists and the state of the art in general:

I wanted them (these events) to really be there, instead of making an illusion about them. It's nice that they're really there because it gives society a broader range—it makes the world fuller . . . at least somewhere in the world there's a B-Car and there's somebody who got shot on purpose to see what it would feel like.

It is apparent that Burden has narrowed his work down to a literal examination of the real, practical concerns of his life as an artist. While others are minutely examining the relationships of form and color, Burden is on the radio asking people to send him money because he needs it. While other artists are working over a series of images in painting after painting, Burden concerns himself with being able to conquer his feeling of helplessness regarding physical transportation and actual communication, creating the B-Car and the CBTV. While others endure as victims of the gallery-museum power structure, Burden makes plans to escape the art world in a 16,000 pound tractor-trailer truck (and calls it an art performance).[20]

This channeling of images directly from personal life into art harkens back to Allan Kaprow's definition of the new art, or "non-art" in 1969:

Non-art is obviously whatever has not yet been accepted as art, but has caught an artist's attention with that possibility in mind. (Dry-cleaning processes) double as Kinetic Environments, simply because I had the thought and have written it here.[21]

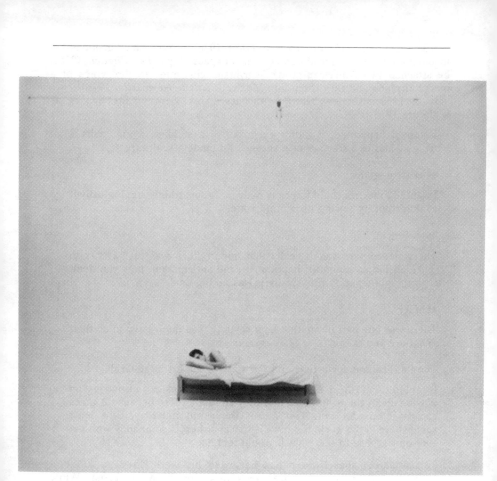

Chris Burden. *Bed Piece*. Market Street, Venice, Ca., February 18-March 10, 1972. "Josh Young asked me to do a piece for the Market Street Program, from February 18-March 10. I told him I would need a single bed in the gallery. At noon on February 18, I took off my clothes and got into bed. I had given no other instructions and did not speak to anyone during the piece. On his own initiative, Josh Young had to provide food, water, and toilet facilities. I remained in bed for twenty-two days."

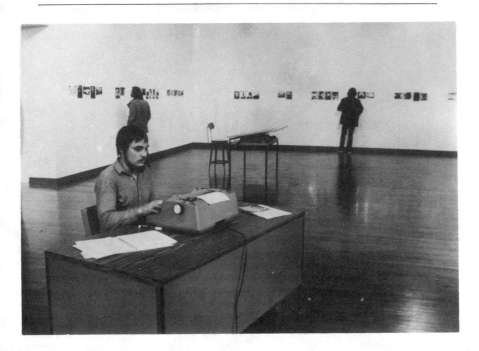

Chris Burden. *Working Artist.* University of Maryland, Baltimore, Maryland, November 22-24, 1975. "Upon arrival at the University of Maryland, I had a poster printed which described 'Working Artist' as a three day performance and exhibition of past works. In the University Gallery, which was quite large (measuring 64 feet square), I hung photographs and written explanations of all my past performances in a continuous chronological line around the gallery walls. In the center of the room was an island of expensive furniture, I requested that a desk, a telephone, an electric typewriter, a television set, a photo copystand, and a drafting table be installed in the space. During the three day period, from Nov. 22-24, I lived in the gallery, slept on the leather couches and attempted to conduct my affairs as if I were in my studio. Visitors to the gallery were treated as my guest, and I talked freely with them and answered their questions. My accessibility, and the routineness of my daily existence contrasted sharply with the extraordinary activities depicted on the walls."

401

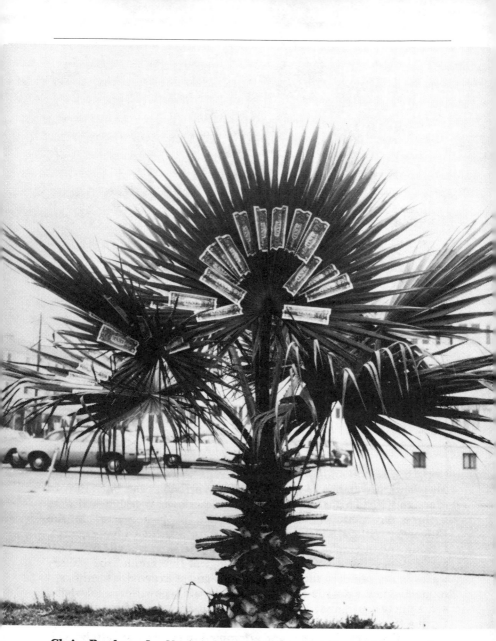

Chris Burden. *In Venice Money Grows on Trees.* Venice, Ca., October 6, 1978. "Just before sunrise two friends and myself glued one hundred brand new one dollar bills to the leaves of two very low palm trees on the Venice boardwalk. The bills were folded lengthwise several times so that they fit into the creases on each palm leaf. Although in plain sight and within arm's reach, some of the money remained untouched for two days."

Chris Burden. *Big Job*. **Venice, Ca. 1978.**

After years of circling the issues of her image and utility as an artist Barbara Smith made graphic use of her own life as art material in a two-part performance in Los Angeles and San Francisco titled *Ordinary Life* (1978).[22] Using a counterpoint of lyrical visual imagery and bits of conversation from her life, she examined the agonizing effect of performance on her daily existence. She reflected her longstanding hopes that art would "repair my life, find me a lover, a home and give me personally what I need." Her frustration in the failure of art to do these things was mitigated at the end of the piece by an army of female friends who helped her to recover from her trauma and begin to celebrate life.

Smith has been active in performance since it first surfaced in Los Angeles, in a 1968 workshop with Alex Hay. Her recurrent theme has been nurturance and communion and she has repeatedly used food imagery as a metaphor for the enrichment exchanged by artist and audience. Her first major work was *Ritual Meal* (1969) at the home of art collectors Stanley and Elyse Grinstein. A group of sixteen guests were dressed in surgical caps and gowns and served odd assortments of foods which they ate with surgical instruments. The mood was further enhanced by a film of an open heart operation playing on the walls and the sound of a human heartbeat reverberating throughout the house.

Smith followed this performance with *Mass Meal* (1969), *White Meal* (1970), *The Longest Day of Night,* an all-night banquet (1973), *The Celebration of the Holy Squash* (1971), *Feed Me* (1973) and *Pure Food* (1972). In the late seventies her work moved into a complex examination of her role as a woman and an artist, combining mysticism with sensuality, vulnerability and humor.

A major piece in 1979 revealed her personal experience with death, specifically her observations, drawings and feelings about witnessing the death of her mother. The piece combined a somber and dramatic use of funereal ritual with a wild session of dancing with the audience to rock and roll music.

One of the most frankly autobiographical of performers is Rachel Rosenthal. Employing her extensive background in theatre, Rosenthal uses costumes, masks, projections and other devices in her highly structured pieces.

Rosenthal's subjects are her own childhood in Paris, her obsession with food and her personal fears. Her imagery ranges from the lyrical to the disgusting and gut-wrenching. She is willing to turn over any stone in a search for the truths buried in her own life story:

> My specific work is about me, and it's really in lieu of writing an autobiography. If you put all my performances together, then you will have my life, done in the form of an art work.[23]

A major piece about her childhood, *Charm,* (1977), was structured like the Paris house in which she lived, a sonata in three parts. Each movement described life on a different floor of the house and life on a different level of existence.

Rosenthal's discreet, graceful presence was offset by a cast of characters dressed in frightening costumes and masks. While she daintily ate French pastries, these characters portrayed ugliness, eroticism, cruelty, and sadism. The contrast represented the blindness of her family to the cruel and ugly realities of life. Her manner became more bestial until she had buried her face in a chocolate cake.

Linda Montano. *Three Day Blindfold*. Womanspace, Los Angeles, Ca., 1975. Performed with Pauline Oliveros as a silent guide.

The Head of O.K. (1977), about her half-sister Olga, was "done as a dance inferno, broken into about ten cantos." A series of narrative scenes, played out by beautiful women in 20's costumes and men dressed as African natives, revealed Olga's life as strange and violent and her nature as "a blind type of stupid person who had a good, but unused, mind."[24]

The Death Show (1978) examined the theme of "the apprenticeship of death, of rehearsing the hundreds of little deaths that occur in all our lives, in order to be able to handle the big one when it comes."[25] Having recently lost a good deal of weight, Rosenthal portrayed her former self as *The Fat Vampire,* "surrounded by a funeral wreath of cakes, doughnuts and Danish pastries, all sprayed with black enamel paint resembling tar. The Fat Vampire is fat from accumulations of countless botched up deaths not allowed to die."[26] The *Stations of the Fat Vampire* confronted a series of crucial life events in which Rosenthal had ignored a turning point in her life, hiding from change and its attendant pain. At each station was a compulsively eaten sweet food.

Linda Montano, a San Francisco artist now living in Southern California, used autobiography in *Mitchell's Death* (1978) in a devastating performance about the violent death of her former husband. Attended by two musicians making drumming and gong-like sounds, Montano appeared before the audience wearing white makeup and acupuncture needles in her face. A nearby monitor played a tape showing her inserting the needles. In a droning monotone, she described her feelings of guilt about her separation from her husband:

"Did I do it? My fault? Was he despondent? Lonely? Miss me too much?"

She describes her journey to the funeral and her invasion of the crematorium chamber where Mitchell's body is being prepared for burning:

I pull the sheet down, shocked by black stitches, autopsy. . . . Ask him how he is. How did it happen? Why?. . . . I remember the Tibetan Book of the Dead and whisper in his ear. Don't be afraid, Mitchell. It's ok pups, go on. Don't be scared. . . . I can't get my eyes off him . . .[27]

This was the third performance in which Montano attempted to exorcise the death and she considered it successful.

Eleanor Antin uses the details of her personal life in a different way from any of these artists. She has created a mythology around four personae—the Ballerina, the King, the Black Movie Star and the Nurse—presenting narrative art works about each of them.

Antin describes herself:

I am a post-conceptual artist concerned with the nature of human reality, specifically with the transformational nature of the self. I began with biographical explorations before moving into autobiography. I am interested in defining the limits of myself, meaning moving out to, in to, up to and down to the frontiers of myself. The usual aids to self-definition—sex, age, talent, time and space—are merely tyrannical limitations upon my freedom of choice. . . . I needed core images . . . the four selves soon began to lead their own lives, moving out of their names through their careers into the fullness of lives that I am hardly in a position to control.[28]

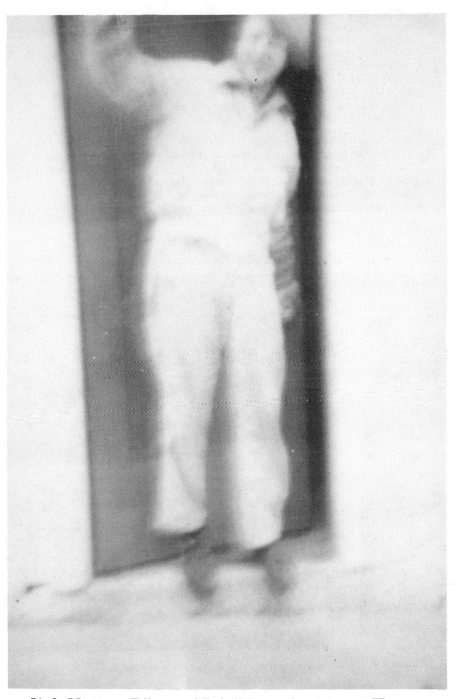

Linda Montano. *Tribute to Mitchell Payne.* **San Diego, 1977.**

Trained as a creative writer and actress, Antin employs sets, costumes, videotapes, cut-out dolls (sometimes life-size) and her own voice and body in variety of characterizations.

When Antin moved from New York to California in the late sixties, she took up residence in the small seaside town of Solana Beach (near UCSD where she now teaches). It was here that the King inherited his kingdom. A performance about the King reveals Antin, both live and in slides, dressed in a beard, hat and flowing cape, conversing royally with the citizens and tourists of Solana Beach.

Writer John R. Clarke describes the character:

She left the Conceptual Art camp . . . by putting the King into the world, not a symbol but herself as himself, swilling beer with surfers in Solana Beach, another displaced person plagued with conscientious objections to being in the wrong century with wrong feelings about most everything. His Meditations are writ in a strange diction, accompanied by ink and chalk drawings that form a wistful scenario far from the the surfboards and Have-a-nice-days of Southern California.[29]

Eleanor Antin. *The Adventures of a Nurse.* **Videotape, 1976.**

Eleanor Antin. Various characterizations.

Yet the King becomes involved with the problems of "my people," as he calls them, translating the pathos of uprooted senior citizens into an imaginary war between his soldiers and the real estate developers.

In *The Angel of Mercy* (1977), Antin presented an elaborate exhibition, catalog and performance about the mother of nursing, Florence Nightingale, using the UCSD art faculty in period costumes for the photographs and modeling thirty-nine 4½' tall painted masonite figures after the characters in the photographs.

In her preface to the catalog, Antin reiterates some of the questions that led her to the piece:

> Just what did Miss Nightingale intend to invent and what had she actually invented? Could it really have been that small subservient space that nursing seems to occupy today?..... What was the nature of the world that could initially provoke and then reduce so grand a claim. Merely to imagine this would be trivial. To understand a human situation, which plays itself out in a world, one must let the people play out their lives in that world and join them there.[30]

The importance of both Antin and Smith as teachers and guides for other artists cannot be overemphasized. Both take a personal interest in their students, encouraging and reinforcing vigorous risk-taking.

But no performance artist-as-teacher can be said to have had the deliberately powerful influence upon artists (especially women artists) that Suzanne Lacy has exercised. A student of Judy Chicago in the Feminist Art Program at Fresno State College in the late sixties, Lacy became one of the prime movers behind the Woman's Building and its Feminist Studio Workshop in Los Angeles, the only such space and program of any scope in the world. Performance is *de rigueur* in the training of the women who pass through the program. Lacy, no longer as active with the building as she was in the critical early years, was a tough and demanding teacher and administrator. She and her students have become watchdogs of a new morality in the art world, demanding that all artists, male and female, take responsibility for their own imagery and that they go over it with a fine tooth comb for lapses into sexism or the advocation of violence.

Lacy and her collaborator, Leslie Labowitz, have created a number of media events crying out against violence against women. They have produced performances great and small designed to raise the consciousness of the community about rape, about commercial imagery destructive to women and about demeaning sexist images in general. Their subjects are universal but their materials are drawn from actual experience of life in L.A..

Labowitz's *Record Companies Drag Their Feet* (1977) attracted the attention of the media to images of violence against women on record jackets and Sunset Strip billboards. The performance took place beneath a billboard advertising an album called *Love Gun* by the rock group Kiss. Red paint represented the " 'blood money' made by the commercialization of sexually violent images of women." Four women were painted with red Xs, then tore them off "and threw them at the audience as a symbol of refusing victimization." The women attempted to communicate with record company executives, who were portrayed by performers costumed as roosters.

410

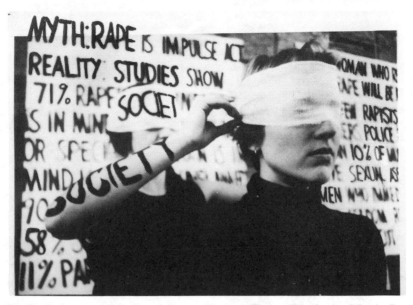

Leslie Labowitz. *Myths of Rape* (during Three Weeks in May). Los Angeles, Ca., 1977.

Labowitz describes the lengths she went to to attract and use the news media:

> Graphic images were specifically set up for a particular number of shots and staged in such a way as to make it easy for the camera crews to shoot. Shot Sheets and explanatory information about the performance were given out to the media at the site so that misinterpretation would be avoided. . . . It was covered by Channels 2, 4, 5, 7, 9, 11 and 13 locally, and nationally received about four to five minutes of news time on each station . . . Those newscasters who are visually represented in the final newscast as shown on TV become actual performers in the event.

Lacy's *Three Weeks in May* (1977) which involved many women artists featured public events about rape as well as a large map installed in the L.A. City Mall where Lacy stamped "RAPE" each day over the location where a rape had occurred the night before. *In Mourning and in Rage* (1977) was an event in front of L.A. City Hall that was covered by six television stations and examined the effects of and issues involved in the case of the so-called Hillside Strangler, a murderer-rapist. In all of these works, the artists' objectives were to picture women as strong and not victims, as "women fighting back."[32]

Nancy Buchanan, a close associate of both Lacy and Barbara Smith, treats women's issues with perhaps a more intellectual style than either of those artists. Buchanan became known for her early seventies pieces in which she

411

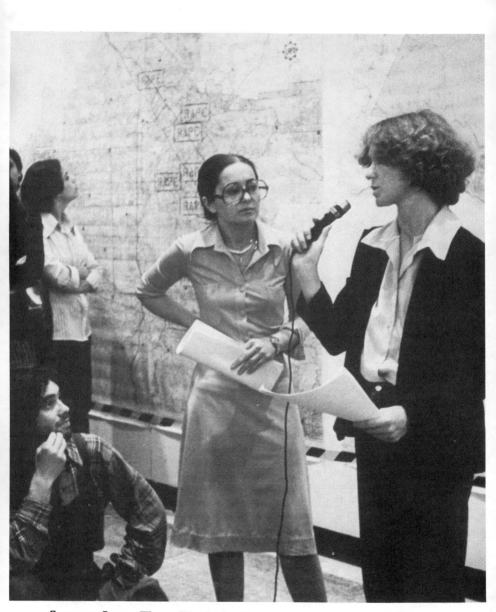

Suzanne Lacy. *Three Weeks in May.* **Los Angeles, Ca., 1977.**

used human hair, equating work with aspects of her own past, relating them to similar themes in the lives of all women. Her work often involves a prepared script which addresses such questions as the expectations of women(*Meager Expectations* 1977); the physical interaction of men and women (*Tar Baby,* 1976); male-female roles (*Hair Transplant,* 1972); and versions of beauty and purity.

Recently, Buchanan has made use of historical material from the writings of the early Gnostics, examining Dionysian abandon and the confusing, conflicting dualism of attitudes toward the body and soul. (*Around and About Purity,* 1979).[34]

Additionally, Buchanan has presented highly political pieces, critical of the abuses of multinational corporations, specifically the oil monopolies. (*Bedtime Stories,* 1977). She is a member of XX (Double X), a Los Angeles feminist art cooperative group without an exhibition space. The group consists of women artists working in all media who regularly challenge not only the notions of acceptable contemporary art, but frequently attack the art establishment as biased, sexist and insensitive to the needs of women artists.

Another group of women artists caught in political crossfire is Mother Art. The group formed in 1972 "to create art relevant to issues facing women in today's society and to place this art in public places accessible to everyone, not just to those who frequent museums, galleries and other places where art is traditionally seen."[35]

In 1976, Mother Art presented a series of performances titled *Laundryworks* in five laundromats in the Los Angeles area, a project supported by a $700 grant from the California Arts Council. When the council came under fire from the media during the vote on Proposition 13 (a tax-cutting measure), the *Los Angeles Times* pointed to this project as an example of wasteful and frivolous spending by the state government. In response the four artists issued a manifesto calling for public support of contemporary art,

> . . . especially as it diverges from tradition. Artists working in traditional forms may count on the wealthy for patronage, but from the hermetic system of artist, gallery and buyer, a large part of the public, both as artist and audience, is excluded. We wish to speak to and hear that audience and urge those who want contemporary art to thrive to join in the effort to attain this goal.[36]

Sexual politics has also surfaced in the work of male artists in Southern California. Richard Newton's series of performances about *The Former Miss Barstow* centered on a woman artist who had a sex change operation in a bid for success in the art world. He appeared in these pieces garbed in jewelry and clothing suggesting himself as a woman. In an examination of "the intimate relationship between imagery and the self,"[37] he has juxtaposed his own image with those of beauty queens, brides, whores, movie stars and mannequins. A close parallel is drawn between the power of sex and the power of art as a personal identification. This work was highly colorful and used such technology as slide projections, movies, audio- and videotape and color xerox, sometimes with all media operating at once.

More recently, Newton's attention has turned to the urban environment in which he lives. Casting about with Kaprow's "non-artist's" eye, Newton fastens on imagery lifted from his own neighborhood. Walking daily through

Richard Newton. *The Great and Glorious Reverend Ric.* **Performed on Close Radio, Los Angeles, Ca., 1979.**

downtown L.A., he encounters sidewalk preachers shouting their messages to the passersby with religious fervor. The idea that a person could stand on a public streetcorner and scream "Oh Jesus" as loudly and as often as he wanted appealed to Newton's sense of conceptual art as much as it appealed to his sense of adventure. So, dressed in a blue satin jumpsuit and assuming the persona of "The Great and Glorious Reverend Ric," he appeared several times in the area, leaping into the air and shouting "Oh Jesus" until he was hoarse. This piece was also created on Close Radio and exists on film.[38] He caught the attention of pedestrians as well as other preachers, who tried to help him define and expand his message.

Newton is committed to searching his environment for art materials and his artist's resume includes his organization of an artist's softball team, Mr. Twister. The team comprises painters, sculptors and art administrators as well as performance artists.[39]

Dodger Stadium is within walking distance of Newton's studio and in 1978 he performed *Capacity Crowd* there by dropping 56,000 baseball players (on baseball cards) into the stadium during a game. The cards, amounting to Art (portraits), were greedily received by the fans in the stands below him.[40]

He has used the streets of Los Angeles for an automobile performance, *A Glancing Blow* (1979). Driving a white car, he sideswiped a blue car driven by another artist. It happened eleven times in two locations. The piece coincided with the beginning of the "gasoline crisis" of 1979, a period in which automobile transport was foremost in the minds of Californians.

Paul Best. *Octavia.* **San Diego, Ca., 1978.**

Newton's work has moved from an examination of sex roles into various portrayals of the young male's fascination with "male things": baseball, cars and pranking. But he has not been the only male artist caught up in gender identification.

Paul Best takes on sexually-mixed persona in his created character Octavia. Dressed either as a man or a woman in outlandish outfits that suggest a preference for activity sado-masochistic, Best walks the streets of San Diego, shops, stops in bars and is recorded by his photographer interacting with onlookers.

Best describes himself as,

. . . a radical feminist. One of the issues in contemporary with which I have been dealing quite heavily is that of segregation by various dress codes with respect to gender. I have been studying the social and political implications of male vs. female clothing and how people are oppressed, confined, stereotyped and sometimes granted social approval according to what they wear.[41]

Octavia appeared at various shopping centers (1978) wearing red-purple hair, black boots, clear plastic pants and a black slave collar with studs.[42]

Also in dual sex roles, John Duncan directly confronted the issue of violence against women in *Every Woman* (1978). The piece was part of *Connecting Myths* which Duncan organized with Cheri Gaulke and other female artists from the Woman's Building. On two successive nights, Duncan hitchhiked on Santa Monica Boulevard, an area of Los Angeles notorious for its population of prostitutes of both sexes. The first night he appeared dressed as himself, the second night, as a woman. The event was filmed by Paul McCarthy and the two artists appeared before a *Connecting Myths* audience to discuss what had happened and why. Duncan, dressed again as a woman, explained he was aware that women live with a constant paranoia about sexual aggression from men. He said he wanted to know what that felt like. While hitchhiking as a man he narrowly escaped such an attack.[43]

In another challenging piece, *Sanctuary* (1978), he asked each man in his audience how sexual development had affected his character. Then he asked the women to respond to what was said.

Two other events by John Duncan caused a stir in the Los Angeles art community because of their remarkably violent nature.

One was *Scare* (1976), performed "against" two people on two separate nights. Wearing a rubber mask, he knocked on the doors of two people he knew well. When each man answered, he shot him with a gun loaded with blanks, then ran away. Duncan has explained this piece in his documentation as a reaction to a mugging he suffered in Venice (California), when he felt he was near death. His experience and its attendant survival brought a euphoria that he wished to recreate for others.

No (1977) was performed live over Close Radio. It was a Reichian exercise designed to cause convulsions and sounded like increasingly heavy breathing, then gasping. It was performed over a tape of Duncan's voice saying incomplete phrases about cultural oppression. The impression of some who heard the show was that Duncan was masturbating on the air, a rumor that still persists at the radio station.

One of Duncan's earliest works is a striking mono-print photo-narrative of his own suicide (*Again,* 1974). In his works, Duncan reveals his most intimate

416

John Duncan. *Scare.* **Los Angeles, Ca., 1976. Performed spontaneously for 2 successive nights, Duncan rang the doorbell of his friends and upon answering shot them with a blank pistol. This work was in response to Duncan being held up himself.**

fears and terrifying fantasies. Asked about the connections of these works with art, he states that his early paintings were really personal expressions, but they weren't direct enough. Events became, for him, a more direct expression:

> To make sense for other people, this work should keep giving them some kind of feeling, similar to what I was feeling. Either the same feeling or a slightly different one, but similar. Actually, it's both, that they should get something from it to give some kind of value, and I should get something from doing it. And having done, hopefully I've kind of purged myself of it.[44]

Duncan ruminates a great deal on the meaning of his performance work, and finds that meaning changed for him over the years. In reaction to this shift of meaning, he has planted a succulent garden in the Mojave Desert (*Desert Landmark, Succulent Maze,* 1978). The 90,000 square foot labyrinth is a finished work in that it has been planted, but the whole maze will not be mature and visible for 20 years. In a sense, Duncan's impulse in this work cannot be examined at all until long, long after the act of its creation.

Duncan has been called on the carpet by his feminist colleagues for "irresponsibility" in pieces like *Scare.* The charge is that the meaning of the piece is not clear to the observer and that it was in fact dangerous and threatening, even though the gun was loaded with blanks. They question Duncan's right to assault an unprepared audience with unexplained violence.

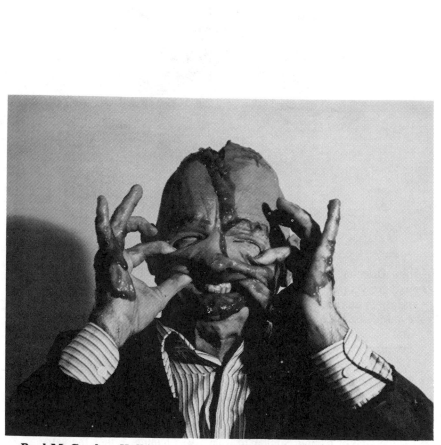

Paul McCarthy. *Halloween.* **Pasadena, Ca., 1978.**

This is the same kind of charge levelled at Duncan's close friend Paul McCarthy. McCarthy's work, the mildest of which has been called disgusting, is impossible for many performance audiences to watch. His artistic space is one in which he persuades himself to indulge in the most primitive and infantile fantasies of violence and monstrosity. Barbara Smith, in a seminal article in the LAICA *Journal* (January, 1979), described her friends performances:

> Since 1972 all of his performances have involved the ingestion of either raw meat, mayonnaise or cold cream and the binding or adding to his penis of dolls and other material and smearing his body, particularly his face, hair and genital area with ketchup, mayonnaise and/or actual makeup. It is not clear whether my descriptions adequately convey the repellent quality of the work nor indeed the exact nature of these feelings. Perhaps it may seem that a certain objectivity could be maintained but this never seems to be the case.[45]

In one representative piece, *Sailor's Meat*, (1974), McCarthy appeared on a sleazy bed wearing a woman's blond wig and bikini underpants with his penis hanging out one side. The visual effect was masculine and feminine simultaneously. The bed was covered with chunks of ground meat. He slithered on the bed in ketchup and mayonnaise, at once lazily sexual and abusive, appearing to pantomime rape and masturbation.

> With a sort of slow deliberateness McCarthy is able to subordinate the details of his movements and manner in the piece into an astonishing and incredible display. It is as if he has set out to become all, and certainly the most deceptively reviled, aspects of our androgynous humanity. It is a display of inner power, as well as a prayer coming from great need—by putting himself in such a position, he may effect the harmony and energy of wholeness. There is a sort of rapture to his display.[46]

In response to the charges of ambiguity and irresponsibility McCarthy has said: "If you understood the work, then it would be ok? Intentions are only fantasies which. prove not entirely true."

Smith absolves him of guilt by referring to cultural sanctions:

> In some countries persons such as he who BEHAVE rather than MAKE are considered holy! Rather than say he is merely being self-expressive or throwing a tantrum, it would be better to honor the mutual journey that performer and audience take together which can be realized in perhaps no other way so concretely.[47]

In defense of his motives, McCarthy states:

> It is my belief that our culture has lost a true perception of existence. It is veiled. We are only fumbling in what we perceive to be reality. For the most part we do not know we are alive.[48]

McCarthy has performed only three times for the general public. Each time he was stopped by the authorities, the audience or the sponsors. (*Political Disturbance* at the Los Angeles Biltmore Hotel, 1976; *Class Fool*, UCSD, 1976; and a public video display, the Southland Video Anthology, Long Beach Museum of Art, 1976).[49] He now tends to choose his audience carefully and to specify that his videotapes not be on public display, but available for viewing by request.

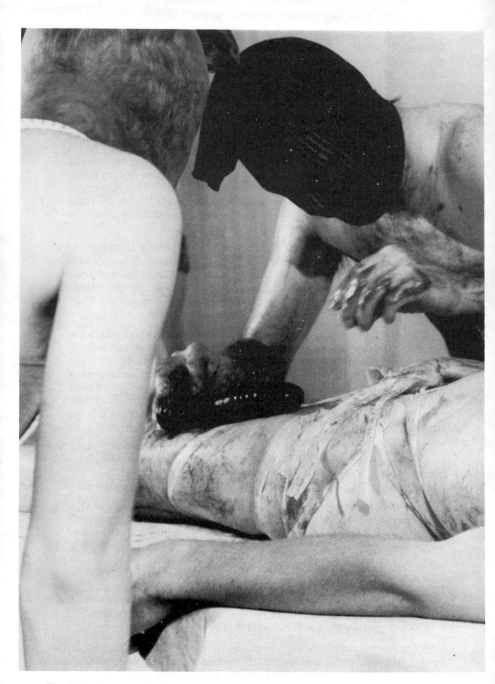

Paul McCarthy. *Contemporary Cure-all*. 1979.

A 1979 taped work *Contemporary Cure-all,* is shown in tandem with *Deadening,* a second tape intended to "deaden Contemporary Cure-all."

In the first tape McCarthy, dressed in jockey shorts and wearing a black stocking over his head, portrays a beastly "surgeon." Using dildos, ketchup and Barbie Dolls, he performs a sex-change operation on a masked, prostrate, live nude male (John Duncan). To the distorted sound of screams, McCarthy tapes a dildo to Duncan's groin and forces others into the mouth of the mask. When he "amputates" the rubber penis, the remaining stump becomes a rubber vagina. Finally, he chops the "head" and the dildos with an ax.

In the second tape, an audience watching the first tape is obstructed from viewing the more violent portions by McCarthy and an interfering band of musicians dressed in thriftstore dresses and head stockings and "playing" radiator hoses. McCarthy is clearly addressing the issue of audience here.

An observance of Barbara Smith's should be noted:

> The art context provides areas and ways for the artist to be and do things which could never be believed or permitted in ordinary life. It is precisely this dilemma which often makes for the viewer's discomfort with some performance art, and created a persistent desire to continue doing performance on the part of the artist.[50]

It is exactly this opportunity taken by Stephen Seemayer in bold and graphic pieces, always performed for only one person, with the images recreated in giant photographic blowups, sometimes eight feet tall. The image is a frightening, nightmarish one, an almost-human figure crouching in the darkness with a head of flames.

Working since 1964 with such materials as fire, meat, explosives and human foetuses, Seemayer is after a single powerful image that seems to represent human birth. Beginning with sculptural environments, the work always featured a "nucleus" or "unit" trapped inside a structure, most often triangular. Early films show roasts of beef or parts of human cadavers hanging over a square or circle drawn on the floor. Seemayer's hand is seen spinning the meat on its cable over the enclosed space, "unable to escape the shape" beneath it, "perpetually trapped."

He made elaborate charts and drawings, looking for "a logical, orderly way that the structure could decompose itself, come apart, open up. It fascinated me that in biology when a cell breaks up the wrong way, the nucleus within it will die. If it breaks up the right way, it will survive and carry on."[51]

The performances began when the artist acquired his studio in an old hotel in downtown Los Angeles, and observed the level of degradation in the lives of transients who frequented his neighborhood (the produce district).

> People outside my studio were getting shot and killed, dying right in front of my place. Seeing that human beings in this area are not like human beings, they're like animals, that bothered me, sent me through this incredible culture shock. It was a whole different world from what I'd come from (the San Fernando Valley). I decided I wanted to WEAR the idea of the trapped unit. All these people down here are trapped. It was a depressing thing to see a man crawling on the ground and his face was just totally smashed, his legs were damaged, he couldn't see, couldn't think. Rolls Royces driving by and cops are driving by and nobody gives a shit. So I wanted to be real up front about my ideas, like saying, "Here's the idea, I'm wearing it."[52]

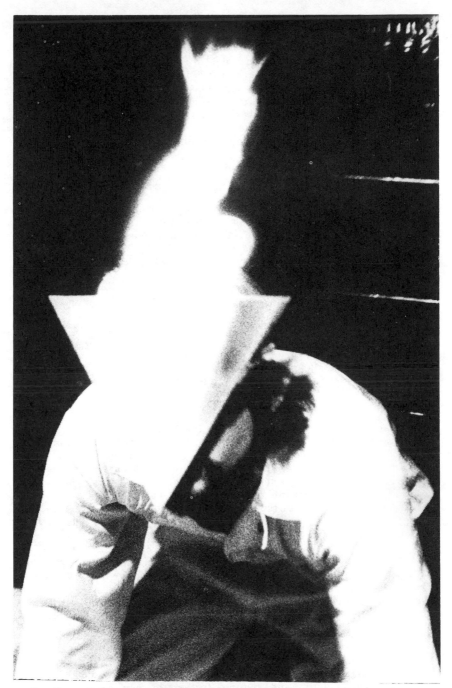

Stephen Seemayer. *559-80-2364.* **Close Radio, KPFK-FM, Los Angeles, Ca., 1979.**

Seemayer started with triangular masks with meat attached to them standing in front of buildings in the area for as long as 45 minutes. He then began to perform at night in back alleys with flaming masks on which variously disintegrating triangles were inscribed.[53]

Within this same series, he began in 1979 to celebrate his Social Security number, with which he has always signed his work, 559802364. The number represents the trapping of the individual by a mechanized society: each of us is depersonalized by such a number and yet each number underscores our individuality, making its owner totally unique.[54]

He performed many times wearing a flaming mask of each numeral and taking low leaps over the numerals arranged in a V shape on the ground before him. In a live work on Close Radio, Seemayer could be heard shouting his numbers while he jumped, and fire singed his hair in a kind of baptism, the assumption of adult identity.[55]

Seemayer further depersonalizes and unifies his image by wearing a white worker's jumpsuit at all times, both in performance and in any kind of public appearance. The more blurred and "inhuman" the photographic image of his wan body, the more perfect it is to him.

Discussion of violence in works of art in Los Angeles always includes mention of the "rat piece" by Kim Jones, performed at Cal State Los Angeles in 1976. Jones burned four rats to death in the performance. The resulting hue and cry cost gallery director Frank Brown his job and found Jones charged with cruelty to animals.

The police report detailed the entire performance, summarizing the actions under "unique or unusual actions that may tend to identify this suspect's m.o. (modus operandi, or method of operating): disrobed before audience/packed mud onto body/wore panty hose over face/set fire to live rats." These actions are, in fact, Jones' m.o. and he continues to use them in various combinations in his work.)

The report describes the audience reaction:

> Victim I stated that several persons left the gallery during part of the performance, one girl screaming at suspect 'you are sick . . . you are sick . . .' as she ran from the room. Vict I also stated that when rats made a screeching sound the suspect in turn bent toward them and gave forth a screeching sound the suspect in turn bent toward them and gave forth a bloodcurdling scream . . . Vict I did state that he was appalled and sickened by the act and surprised even when it became apparent what the suspect's intentions were, that he would actually commit the act.[56]

In a book about the piece, Jones lists his own experiences with death in an attempt to create a framework for what he did. Included are his experiences in the Vietnam war, sadistic experiments with childhood friends, shooting for sport and assorted destructive images found in everyday life:

> vietnam dong ha marine corps our camp covered with rats they crawled over us at night they got in our food we catch them in cages and burn they to death i remember the smell. . . . some enjoyed watching the terrified ball of flame run. . . . vietnam dong ha marine corps feel sorry for one end let it go my comrades attack me verbally. . . . running with friends killing birds and putting feather in our hair. . .[57]

In a recent series of performances Jones again covered himself with mud and shouldered a stick structure in which he walked the streets and climbed the telephone poles of Los Angeles.[58]

In one particularly aggressive and crude performance, Jones related the murder of his grandfather, then smeared human feces on his body and asked members of the audience to hold him. In another, he took three rats to a hotel in Mexico and killed them in several ways, documenting it as artwork.[59]

In severe contrast to these hostilities, several artists in Los Angeles are working with very sensitive, minimal and meditative material in works which might be called spiritual.

Dorit Cypis creates subtle environments in her own home for selected observers, as well as gallery installations in which she allows the "situation to perform." One series was called *The Paradise of Shared Solitudes* (1977-78) in which she created in her living space an environment of black felt, bamboo poles, gold paint and a light beam. The sound was the singing of a single mockingbird. Cypis sat at the back of the room and altered the light with a dimmer switch. Within this environment she would sometimes perform the *Leaf-Blue-Dance* whirling under a blanket of leaves: "I thought of being caught at the tip of wind coming up from the cyclone cellar. I became a whirlwind through the trees eyes."[60]

For *Fly by Night* (1979) Cypis sat in the gallery space for three days watching the light and listening to the ambient sound, "integrating them with my personal symbology. It is my intent to affect a certain mood, to alter the environment to induce a hypnotic state.[61] The resulting environment consisted of, among other things, a shelf to hold the window's shadow when it fell at a certain time of the day, as well as "hole shoes" (circles of black velvet) to be worn by the audience as they passed quietly through the space.

Doni Silver is a sculptor who has performed privately in several pieces memorable for their descriptions. In *Zero Plus* Silver performed for nine individuals who had marked her life in some way.

Meeting individually with them for exchange of food, drink and conversation, she had each person mark the white walls of her studio by walking around the room holding a writing instrument against the wall. In a final performance, all met and marked the room again.

In *Whisper Pitch,* she arranged a performance for an art historian who was interested in her work. The historian was instructed to walk through Silver's studio to the back room where personal objects were arranged on a table. The visitor was told to sit still for 25 minutes contemplating the table and listening to the sounds from the street as they blended with music by flutist Paul Horn.

Out of curiosity about the power of her work done for private audiences, Silver turned to public performance with a four-part series called *Caesura* (1978-79). Each cycle occurred in a different city so as to completely vary the audience. In the piece figures dressed in leotards were manipulated by Silver according to a score she had written. They performed actions the duration of which was limited by body fatigue—the performer changed position when it became uncomfortable to hold the same position any longer. Silver describes this as separate from the form of dance:

> The piece is different from dance in that it has no dance vocabulary or technique. It owes no allegiance to dance history. I am not concerned with any individual element. Sound is light is movement. It is about

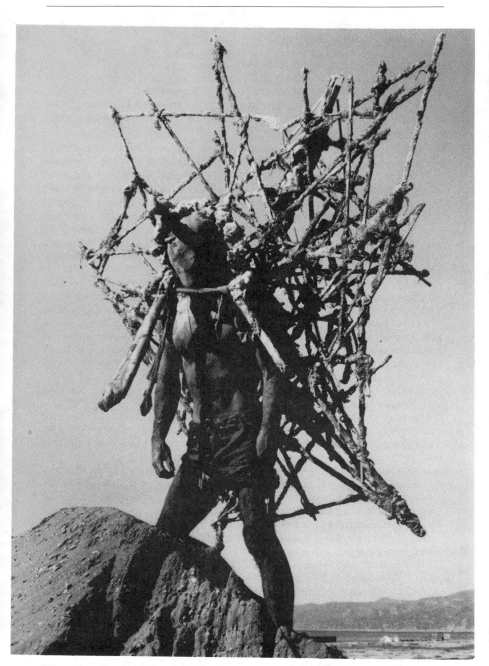

Kim Jones. *Wilshire Walk.* **Los Angeles, Ca., 1976.**

isolated purified form, about perfection. I see art as a massive audience that looks at purified form and pulses against it. Periodically a person rises to change the art.[62]

In discussing the isolated atmosphere of Los Angeles, Silver remarked, "I found that if I stayed in New York I pursued my career. When I am here I pursue my work."

Bradley Smith is an intensely private artist who lives as far away from the city as he can and still take part in the art scene. He does much of his work alone in the woods, bringing back relics and remains, sometimes only a feeling that he will set down in watercolors as a document of the action.

His public gallery pieces are slow and involve a minimum of activity, no language. His art persona is so handicapped and isolated as to appear half-human. He dresses in rags, covers his visage, vomits, crawls, scrabbles and cries out in frustration. His work seems to represent the painful performance of the creative act, an obsession that must be acted upon no matter how unsatisfactory or incomplete it might seem to others.

In one piece he appeared under a tarp across the room from the audience on a plank held up by two ladders. In the space of perhaps five minutes, he moved across the plank, but so slowly that the motion was nearly invisible. In

Bob Wilhite. *Sculpture.* **Los Angeles Institute of Contemporary Art, Los Angeles, Ca., 1977. Wilhite attempted to conjure up an imaginary sculpture by hypnotizing the audience.**

John White. *Santa Studies: Arrivals and Departures, "Sky Piece."*
Los Angeles, Ca., 1972.

others he appeared as a man with no legs and only one functioning hand
attempting to draw or make some mark on papers on the floor. He cried out
and fell backward in a helpless fit.

For *Roll* (1977) he appeared in darkness on a downtown rooftop, doing
backward somersaults around a skylight and emitting small flashes of light.
He gradually increased the light until it became clear he was using a
flashlight. He beamed the light around the roof with a dental mirror and
eventually beamed it into his mouth. He exited with more backward
somersaults.[63]

Smith brings meaning out of the meaningless, making the most
insignificant of motions into a ritual. He illustrates the artist's fear and
courage relating to the exhibition of his work. In a live performance, it
becomes an endearingly open declaration of the artist's faith in himself.

428

Bob Wilhite, a conceptual artist whose work is sometimes pure idea, has recently become recognized for his work with "sound from shapes."

As a conceptualist, Wilhite makes proposals for pieces or describes them as though they have actually occurred. He has cut a long-playing record, *Buckaroo,* in which he describes with quiet humor several works which may be only figments of his imagination.

Another record, *Bob Wilhite in Concert,* features a performance on his handmade instrument, the One-string. His other musical instruments are designed from basic shapes such as the Cube, the Cone, and the Sphere, and involve such unmusical components as a vacuum cleaner and human body heat. One instrument, the Silent Harp, makes no sound at all and was used to accompany conceptual artist Alexis Smith during a performance in which she read from a book.

Past works by Wilhite include a bicycle ride down the Los Angeles "River," (actually a huge man-made drainage ditch), the flight of a radio-controlled airplane from the top of the Empire State Building, and the "performance" of paintings made with gunpowder and set on fire at an appointed time in the gallery.

Such whimsy plays an important part in the work of John White. White, who has produced more than 40 performances since 1971, is concerned with control of his performances and a clearly-defined role of the performer in relation to the audience, thus he prefers to work in galleries,museums and homes. His pieces are elaborately choreographed with detailed instructions and charts of elements and movements. As structured as the works are, they appear to be awash with random activity and imagery and come closer to maps of the unconscious than the conscious. Despite the plan for control, White becomes easily distracted and led off down a tangent road, telling stories and jokes like a stand-up comic. The piece is usually tied together at its end, sometimes by a comi-logical charted analysis of key words used.

Writer James Welling describes *In the Following Sequence* (1975) as a good example of the zany-obsessive work done by White. He was guided through the piece by a tape recorder and a set of instructions taped to his chest, yet he

> . . . barely manages to remember his purpose. He forgets what he's doing, he falls asleep for a second. He follows instructions. He meanders, programmed, slowly, aimlessly . . . And you might be left with this feeling as a lasting one if it were not for the backwards-reaching concluded tape section where ineptitude and clumsiness are incorporated as part of the plot.[64]

White's early participation in performances by Yvonne Rainer and Steve Paxton led him to recognize similarities between live performance and his paintings and he began titling them *Performance Plans, Floor Plans, Guides* and *Environmental Notations.* In 1974 he began notating in drawings several golf course activities. After playing 28 holes of golf in the morning, he would return to his studio and mentally replay the game while drawing

> Wind trajectories, ball trajectories, divot marks, distance speculations and interactions between players were all notated in diagrammatic form. Once in a performance situation I hit a golf ball out of a fourth story window with concealed audiotape describing how it was traveling through space as a small object.[65]

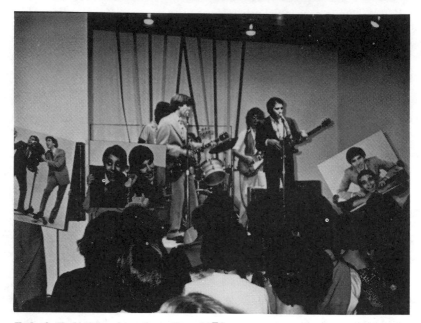

Bob & Bob. Los Angeles, Ca., 1978.

Bob & Bob. Memorandums distributed every Thursday night at midnight to Beverly Hills merchants.

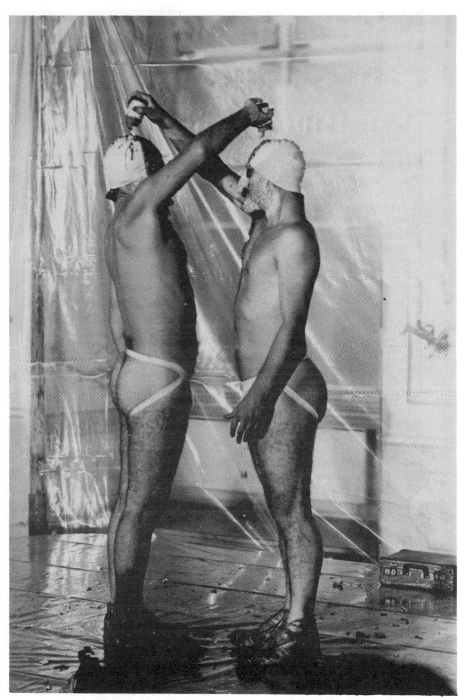

Kipper Kids (Harry and Harry Kipper). In performance.

The golf notations, with others, were incorporated into live pieces. White noticed that his golf partner could actually affect the outcome of a game by performing small personal rituals, such as unbuckling and unzipping his pants on the course to tuck in his loose shirt. White now uses this gesture in performance "as an element of surprise and humor or as a transitional element towards another vignette."

Humor is an essential element in the works of Bob & Bob and the Kipper Kids.

A product of the environment of Beverly Hills, the aesthetic of Bob & Bob seems to arise from the techniques of public relations: "Here we are with our product and our product is Bob & Bob. Bob & Bob is to us what the soup can was to Andy Warhol. They're our iconography."[66]

This iconography is available on slick announcements and brochures ("Making Art That Makes Sense!") and on their record albums. The two wear short-cut hair and business suits and state that they "approach art differently and reach alot of people with something they can understand, to give them one element associated with art where they won't have to scratch their heads."

In live gallery performance, their work most often takes the form of song and dance, performing songs that "you invent while you're driving on the freeway or sing on the toilet." In one piece, the two had ten women dressed in surgical gowns greeting the audience members at the door and tying them into their seats. A *History of Bob & Bob* filmstrip was shown, "following each of us from infancy to the present moment."

A series of *Deals* were performed in which every Thursday night at midnight, the two would slip things under the doors of the merchants of Beverly Hills. When the merchants arrived at work the next morning, they would have notes from Bob & Bob such as: "While you were out we were robbing the place," signed "Love, Bob & Bob." Another "deal"—for women—contained the phrase, "Women only play tennis, right? Love, Bob & Bob."

A piece called *Oh great, now what?* consisted of eating lavish meals at expensive restaurants in Beverly Hills, then "discovering" they were broke, saying "Oh great, now what?" and being thrown out.

At a 1979 event, structured around an exhibition of their paintings, *Sex Is Stupid,* they required that the audience be drunk, reasoning that they would buy more of the work if under the influence. If not intoxicated, audience members were escorted to a waiting room where they had the opportunity to drink until the desired state was reached.

A performance by the Kipper Kids may be classified "at one end of the aesthetics scale as revolting mayhem or at the other end as grotesque good fun."[67] Their special talent has been seen to be "their ability to push banality to its hopelessly illogical conclusions."[68]

Lacing each piece with songs from the British Music Hall—and embellishing those with burps, farts and raspberries—the two Kids invariably drop their trousers, hit each other, make a hilarious cup of tea and assault the audience with flour and other equally messy commodities.

Each piece is complicated by elaborate Rube Goldberg devices: pots, jars and tea kettles hanging over the stage; propulsion systems that cause eggs or balloons (filled with yogurt or confetti, etc.) to fly out of or into the audience. Undressed, or dressed in men's and women's underwear, their faces in

432

Lowell Darling campaigning for Governor of California. 1978. (Pictured with Richard Newton, on left).

heavy makeup, they pay much attention to painting and showering each other with the likes of soup, gravy, feathers, paint, chocolate milk, bean sprouts, syrup, glitter and creamed corn.

In a grandiose finale to a 1979 work, they sprinkled cleaning powder over their bodies and into their jockey shorts, squirted piles of shave cream on each other's heads and blew up the cream with firecrackers.

These actions are accompanied by grunts, squeaks and comments about the art world, giggles, children's voices with British or German accents and their traditional cry "Ei-Oh, Ei-Oh!" The two perform anywhere they can, not limiting themselves to art galleries. They have appeared on stage at the Whiskey-a-Go-Go in Hollywood. In Europe they enjoy a large reputation and have been flown to several performance festivals at the sponsor's expense.

Among the "zanier" artists is Lowell Darling, the only performance artist ever to be an official candidate for governor of California (1976). Darling, an artist who once performed acupuncture on Los Angeles to relieve the pressure and who sewed up the San Andreas Fault, received much publicity for his campaign promises: to designate certain areas of the state as "No Smoking" areas, to get rid of 1984 so as to reduce the mounting paranoia resulting from George Orwell's book, to implant a video camera in the President's forehead so American will see what the president sees on their television sets at home, to force murderers to eat who they kill, to give everybody Wednesdays off and to put Reverend Ike in charge of the state budget. Darling received 60,000 votes.[69]

About an art community that will support such professionals, what more can be said?

Notes:

1. Rachel Rosenthal co-founded the improvisatory Instant Theater Group in Los Angeles in 1956. Using experimental techniques, the group performed for ten years to an audience largely from the art community rather than the usual theater-going public. Rosenthal sees this work as different and separate from performance art. Likewise Guy de Cointet, whose early performance productions were "explanations" by actors of his books written in invented codes, has moved to theatrical "operas," as he calls them, such as *Ethiopia, Iglu* and *Ramona*. De Cointet, who does not appear in these productions, has moved out of the realm of performance art and wholly into theater, making his work accessible to an audience other than the art community, though artists continue to enjoy and find value in his plays.

2. Pauline Oliveros is a trained musician who is peripherally involved with the performance art community. Her relationship to the "new music" movement is special; her interest in sound centers on meditation and spiritual exercise: "My own way of meditation is personal and secular. It has evolved out of my relationship to sound. I started and continued as a musician, but I am no longer interested in the same ways of making music that I learned. As my work changed I found myself listening to long sounds. I became more interested in what the sounds might do than in what I might do to the sounds." (Pauline Oliveros, "Rose Mountain Slow Runner," LAICA *Journal*, October/November 1978). She was awarded the prestigious Beethoven Prize in 1977 by the city of Bonn, Germany, and presided there over eight days of performance and sound activities.

434

3. Other areas of Southern California have been important to performance historically, specifically California Institute of the Arts in Valencia and the University of California, Irvine, but these two areas no longer figure importantly in activities.
4. UCLA is beginning to move in that direction, recently employing Chris Burden and Barbara Smith, and the experimental arm of the University of Redlands, Johnston College, has offered its students such opportunities. Otis Art Institute, the municipal art school of Los Angeles, encourages its students in performance activities.
5. This is obviously the correct step toward art world distinction. For instance, the only performance artists profiled in the biographical directory *Contemporary Artists* are San Diego faculty members.
6. Add to this the isolation-separation syndrome afflicting this flung-out community where—even from the center of the city—it takes 20 minutes of driving to get to a gallery opening and if one wishes to see a friend, it is necessary to call and make an appointment. There is no regular organ of communication among the artists of Southern California (most performance artists are ignored by the ubiquitous *L.A. Times*). Because performance artworks are events, advance publicity is of vital importance. In New York, publicity for an art event means the *Village Voice* and the *Soho Weekly News* and a sprinkling of posters or flyers throughout the tiny area that is SoHo. Stand on the corner of Broome and Broadway long enough and you may see every artist in New York.

In Los Angeles, there is no central area to be blanketed with posters announcing an event. There is a concentration of artists in the beachside Venice area, but there are just as many living downtown, as well as Pasadena, and an equal number flung out from Tujunga to Northridge, from Hollywood to Eagle Rock.

Communication is accomplished on a one-to-one basis through the mail and on the telephone. Whenever the Kipper Kids perform, they spend days on the telephone alerting interested art fans.

Just as it would have been pointless being horseless in the Wild West, it is a disaster to live without an automobile in Los Angeles. The bus system is inadequate, to say the least. A trip from one side of L.A. to the other on the city bus will take as long as three hours.

The freeway system is a vital tool to an artist who wishes to get building materials in Glendale, pick up film in Hollywood, stop in at the Institute of Contemporary Art and get to an opening in Santa Monica. This list of tasks can be taken care of in a day unless one ventures out during the rush hours: 7-9 a.m. and 3-6 p.m. At 5 p.m. on a weekday, it can take one hour to travel 10 blocks across downtown Los Angeles.

The decision to live in Los Angeles County is hard on the lungs as well. The air quality of the inner city and the eastern side of the Basin is very bad and does not improve unless there is a great deal of rain and wind. Artists who live in cleaner air to the south and north often find themselves making apologies for their apparent retirement from the "scene," but invariably point to the unmistakable drawbacks of living in the smog.

Real estate values also figure in the balance. Artists who have lived near the beach in Venice, a slum where the sea air diminishes the smog quotient, find that when their leases are up, their rent is raised sky-high, sometimes tenfold. As a result, hundreds of artists have moved into the downtown area since 1976, into abandoned lofts and warehouses and commercial spaces emptied by the exodus of business into surrounding communities. It is still possible to obtain a loft of 5,000 square feet at 8 cents a foot or less (raw space). The city's official estimate is that there are one million empty square feet downtown. Some buildings are condemned because they are made of brick and subject to earthquake damage, another environmental factor peculiar to California.

Downtown Los Angeles is described by freeways. A circle of concrete ribbon runs around "the delta," a triangular area approximately one mile square. It is, like most urban neighborhoods, culturally mixed, comprising one of the busiest Mexican shopping streets in the world (Broadway), Chinatown, and a rapidly expanding Little Tokyo. The South Central area tips into a Black community.

Though not considered as dangerous as New York City, the area has in the past four years suffered the rampages of some spectacular murderers: The Skid Row Slasher, the Skid Row Stabber and the Hillside Strangler. Undaunted, artists move into the most notorious of neighborhoods, revamping buildings and creating art environments where only transients, winos and ambulatory schizophrenics walked before.

To live downtown is an enormous decision for most Californians, having been raised in the velvet quietude of suburbia or the beach. The noise level of Broadway or the produce district makes it nearly impossible to sleep. The dirt and inconvenience of warehouse living is unfamiliar and rare in a county that looks, from the air, like a blue and green checkerboard of lawns and pools.

Los Angeles supports about the same level of political activism, religious cultism, commercialism and violence as any other large city. What makes L.A. relatively unique for the creative artist is the level of hype around show business.

Only New York can challenge Los Angeles as a center for activity in the film, television and recording industries. When a new film opens at the Chinese Theatre in Hollywood (where the stars have left imprints of their feet in cement), the temptation to be among the first to see it is almost irresistible. The hoopla surrounding new movies is a Los Angeles tradition (in a tradition-poor state). To be caught up in it is natural, almost a pleasure, and has little to do with the quality of the art product.

A drive on the Sunset Strip becomes a visit to an art gallery of billboards touting the latest record releases. Enormous handpainted outdoor boards costing the advertiser as much as $5,000 are changed nearly every month. Becoming more and more elaborate, they are truly a Los Angeles art form.

The music and art scenes are closely intertwined in Los Angeles. Many of the local punk bands, springing up nightly by the dozen, are made up of visual artists. In a recent article in the LAICA *Journal* (January/February 1979), writer Savannah Roller asserts, "Being an artist is just being a rock-and-roll star for a smaller and less exciting bunch of people." The article, titled "Show Me a Boy Who Never Wanted to Be a Rock Star and I'll Show You a Liar," lists nearly 100 rock stars trained as visual artists in England and America. The less formal L.A. artspaces will often feature new wave bands between exhibitions.

It is true, then that Los Angeles artists are assaulted by pleasure and razzle-dazzle on every side and, in order to made their art, must either push these things aside or make use of them.

One difference between New York artists and Los Angeles artists may be that Californians more often work full time regular jobs than do New Yorkers. While L.A. artist John Duncan drives a city bus and Paul McCarthy works in a special effects movie lab, New York performance artist Donna Henes reports that she makes a living putting up illegal posters in SoHo and occasionally sells cheap used clothing to expensive boutiques, adding that none of the New York artists she knows have regular jobs. And it is more reasonable to raise a family in Los Angeles than in Manhattan and many L.A. artists do so.

7. The program was conceived in 1976 by John Duncan and Neal Goldstein. Later they were joined by Paul McCarthy, Nancy Buchanan and Linda Burnham as producers and facilitators. The show received a grant from the National Endowment for the Arts.

8. Allan Kaprow, *Assemblages, Environments, Happenings,* New York, Abrams, 1966.

9. Ibid.

10. "In retrospect, Kaprow has reflected that *Fluids* as 'pretty much the end of my spectaculars,' shortly afterward began the shift toward more private and low-keyed sociological and psychological exchanges between groups or pairs of people." Moira Roth, "Toward a History of California Performance Part 2," *Arts,* New York, June 1978.

11. Allan Kaprow, "The Education of the Un-Artist, Part 1," *ARTnews,* New york, February 1971.

12. Janice Ross, "Excursions into Behavior," *Artweek,* Oakland, January 14, 1978.

13. From informal interviews among Kaprow's UC San Diego students, conducted by Janet McCambridge in February 1979.

14. Barbara Smith, "Gina Pane Talks with Barbara T. Smith," *High Performance*, Los Angeles, March 1979.
15. Roth, op. cit. (footnotes).
16. Roth, op. cit.
17. Chris Burden, *Chris Burden 74-77*, Los Angeles, 1978.
18. The 1978 and 1979 pieces are documented in an article by Jim Moisan, "Border Crossing," *High Performance*, Los Angeles, March 1979.
19. Robin White, interview with Chris Burden, *View*, Crown Point Press, Oakland, January 1979.
20. Chris Burden, "The Curse of Big Job," *High Performance*, Los Angeles, March 1979.
21. Kaprow, "The Education of the Un-Artist," op. cit.
22. Barbara Smith, "Ordinary Life," *High Performance*, Los Angeles, February 1978.
23. Jim Moisan, "Rachel Rosenthal," LAICA *Journal*, Los Angeles, January 1979.
24. Moisan, *Ibid.*
25. Ruth Askey, "Rachel Rosenthal Exorcises Death," *Artweek*, Oakland, November 11, 1978.
26. Askey, *Ibid.*
27. Linda Montano, "Mitchell's Death," *High Performance* Los Angeles, December 1978.
28. Eleanor Antin, *Contemporary Artists*, 1977.
29. John R. Clarke, "Life/Art/Life, Quentin Crisp and Eleanor Antin: Notes on Performance in the Seventies," *Arts Magazine*, New York, February 1979.
30. Eleanor Antin, catalog, "The Angel of Mercy," La Jolla Museum of Contemporary Art, September 10-October 23, 1977.
31. Leslie Labowitz, "Record Companies Drag Their Feet," *High Performance*, Los Angeles, June 1978.
32. Suzanne Lacy, "Three Weeks in May" and "In Mourning and in Rage," *High Performance*, Los Angeles, February 1978.
33. Nancy Buchanan, "Meager Expectations," *High Performance*, Los Angeles, February 1978.
34. Nancy Buchanan, "Around and About Purity," *High Performance*, Los Angeles, June 1979.
35. Mother Art, statement of intent, August 27, 1978, unpublished
36. Mother Art, *Ibid.*
37. Shelley Rice, "Image Making", *SoHo Weekly News*, New York, November 30, 1978.
38. Close Radio, KPFK-FM, Los Angeles, February 28, 1979.
39. The team is pictured in two paid advertisements in *High Performance*, December, 1978, and March 1979.
40. Richard Newton, "Capacity Crowd," *High Performance*, Los Angeles, September, 1978.
41. Paul Best, letter to Linda Burnham, February 1979.
42. Paul Best, "Octavia Goes Shopping in Her New Hair Color," *High Performance*, Los Angeles, March 1979.
43. John Duncan and Cheri Gaulke, "Connecting Myths," *High Performance*, Los Angeles, June, 1978.
44. John Duncan, interview with Linda Burnham, March, 1979.
45. Barbara T. Smith, "Paul McCarthy," LAICA *Journal*, Los Angeles, January-February, 1979.
46. Smith, *Ibid.*
47. Smith, *Ibid.*
48. Smith, *Ibid.*
49. Richard Newton and Linda Burnham, "Performance Interruptus: Interview with Paul McCarthy," *High Performance*, Los Angeles, June, 1978.
50. Smith, op. cit.
51. Stephen Seemayer, interview with Linda Burnham, March 1979.

52. Seemayer, *ibid.*
53. Stephen Seemayer, "Wound/Facade," *High Performance,* Los Angeles, September, 1978.
54. Stephen Seemayer, paid advertisement in *High Performance,* Los Angeles, December 1978.
55. Stephen Seemayer, paid advertisement, *High Performance,* Los Angeles, March 1979.
56. Los Angeles Police Department, "Preliminary Investigation of 597 PC Cruelty to Animals," filed against Kim Jones on February 18, 1976, by Shirley Blackman, Cal State University, Los Angeles, Police.
57. Kim Jones, *Rat Piece,* Los Angeles, 1976.
58. Kim Jones, "Telephone Pole," *High Performance,* Los Angeles, June 1978.
59. In support of his exposure of violent impulse, Jones presents behavioral research materials: *A Promise to the Oriole* is based upon the author's observations of the behavior of a group of 11-year-old boys in a small, semi-rural western Pennsylvania town. It documents the very considerable extraspecies aggression practiced by young male humans. Since the targets of the boys' aggressive acts are infrahuman—insect, birds, fish and small animals—the essentially violent nature of these acts has gone unnoticed. However only a small shift in perception is necessary for the behavior to be reconstructed. (A Promise to the Oriole," John Wallace, PhD, *Human Behavior,* August 1978.)
60. Dorit Cypis, "The Leaf-Blue-Dance," *High Performance,* Los Angeles, June 1979.
61. Dorit Cypis, interview with Linda Burnham, April 1979.
62. Doni Silver, interview with Linda Burnham, April 1979.
63. Bradley Smith, "Roll," *High Performance,* Los Angeles, February 1978.
64. James Welling, "Linking Dream Structures and Images," *Artweek,* June 28, 1975.
65. John White, a paper accompanying documentation of his work.
66. Michael Kurchfeld, "Bob & Bob get Serious," *High Performance,* Los Angeles, June 1979. All other statements by Bob & Bob in this chapter are from this interview.
67. Ruth Askey, "The Kipper Kids-Food is the Medium" *Artweek,* Oakland, January 7, 1978.
68. Peter Clothier, "The Kipper Kids: Illogical Conclusions" *Artweek,* Oakland, February 3, 1979.
69. Lowell Darling, "One Thousand Dollar a Plate Dinner," *High Performance,* Los Angeles, June 1978.

WOMEN, REPRESENTATION, AND PERFORMANCE ART: NORTHERN CALIFORNIA

Judith Barry

". . . the codes of representation have been shattered to make room for a multiple viewing space no longer based on painting, but rather on the theatre." [1]

The way in which women represent themselves through performance art at this historical moment is directly related to the following questions: How are women represented through social practices which support the psychoanalytical definition of women as "other," meaning sexually different from men? How are the mechanisms describing production, and hence women's representation, inscribed within these social/psychoanalytical practices? This essay examines how women are represented in their performance art foregrounding both the psychological and social representation of women. This examination of the works of several women performance artists attempts to illustrate the need to go beyond description of art into an explanation of how meaning is produced. An application of semiotics, psychoanalysis, and film theory to a discussion of performance art by women may make it possible to begin elaborating some of the processes surrounding the production of meaning in this art practice, and give some insights into the question of representation specifically as it applies to women.

Women's representation in the culture is crucially at stake in questioning how women represent themselves. The issues involved have expanded to include more than descriptively identifying whether there is a similarity among types of women's art. Women's performance is often described as autobiographical or psychological while women's painting and sculpture are often described in terms of concave, circular, and vaginal. Laura Mulvey states in her article, "Visual Pleasure and Narrative Cinema," that women's place within the symbolic order, hence the system of representation in our culture, is as the "other," sexually differentiated from man. [2] Specifically, as the one without the phallus, the woman's lack becomes the signifier for the male "other," setting into motion male desire. [3]

It is the position of women as "other" that allows for the display and consumption of women in the process of representation. In advertising, women are used to sell products. Not only is the desire for the totality of the woman, the product, and various connotated life styles a primary mechanism here, but "desire" itself is also the product of this process of representation.

The history of the female nude in painting has been well-documented in art historical texts. [4] We know how she is passively displayed and contorted for the imagined male spectator, how she looks away from the picture plane, at him, how if she is shown clothed, the clothes are arranged seductively, for him. Does this basic situation alter when women view these works? No. Yet, in many works constructed or performed by women artists these same conventions for self-presentation are employed. While in one sense this can be seen to valorize women's autoeroticism, little thought seems to have been given to questioning, subverting, or destroying the inherent and culturally constructed visual pleasure.

A feminist art practice might ask what the implications are for the "category of women" when it is defined to facilitate the consumption of women as part of its practice? If an art work is intended for an all female audience is it removed from this type of interrogation? Can the intention of the artist to create a new viewing context subsume the normal viewing context? Is women's representation as sexually different and as the product of social processes ignored when women define themselves by their feelings or consider their femininity as residing somewhere in their bodies?

No one has yet been able to fully develop a semiotics of performance art. Semiotics is used here to describe the complex association in which sign systems interact to produce meaning. One reason is due to the difficulties in defining and categorizing performance art. Performance has attempted to be all things—a catchall container for a heterogeneous variety of disciplines which do not easily fit into other more traditional groupings. Because of the visual art tradition from which performance art derived, there has been an aversion until recently to apply a discourse of theatre to performance art. The intention of the performance artist has been seen as differing from the intention of the theatre artist in that early performance pieces often used an "art as life / life as art, one-time only, real-time" demarcation. This demarcation had the dual function of differentiating performance art from theatre and tied performance art to the tautological tradition of the conceptual art movement: art for art's sake, art by definition, and art as a non-commodity.

These latter two constraints prevented theoretical examinations of performance art—if one could define any action as a performance, audience considerations became unimportant, as in Chris Burden's duration pieces (in which seeing the actual work take place was unimportant), and Adrian Piper's subway pieces (in which the work might be taking place with the audience unaware of it.) In addition, the one-time-only aspect of the pieces precluded the possibility of systematically analyzing them. Neither is film semiotics in itself directly applicable, since performance art is a dynamic process changing each time it is performed, whereas film at least physically stays the same. Also, the spectator is usually in a different relationship to the performance than the movie-goer, since her/his participation is often complicitous and not voyeuristic. In performance the mechanisms of the viewing process differ, since the spectator does not identify with the camera.

440

In analyzing traditional narrative films, Laura Mulvey described how women are positioned within the story as erotic objects—icons—connoting passivity, which make or inspire the hero to act. Using psychoanalytic theory as applied by Jacques Lacan, Mulvey outlines how the mechanisms of narcissism and scopophilia force the viewer to identify with the protagonist. [5] This identification allows the viewer to experience the pleasure of the female form displayed for his enjoyment connoting male fantasy, forcing the spectator, fascinated with the image of his like, to gain control and possession of the women within the narrative.

Mulvey further states that because of the threat of "unpleasure" signified by what the woman ultimately represents—sexual difference/lack of phallus—the male unconscious in filmmaking has found two avenues for escape. One is to sadistically demystify the woman by investigating, saving, or punishing her. The other is to disavow castration entirely by turning her into a fetishized object so that she is overvalued (the cult of the female star) and reassuring in her self-enclosed totality of meaning. Her beauty is a thing in itself which renders her harmless.

Even though film theory is not directly applicable to performance art, women's position within much narrative performance is often similar to her position within film. Terry Allen's *The Embrace Advanced to Fury* performed at the University Art Museum, Berkeley, in October, 1978, verbally and visually scrutinizes a woman's behavior—thus demystifying her for us—as two surrogate egos, a man and a woman, box it out in a specially constructed ring. In the performance of Constance de Jong at the San Francisco Art Institute in January, 1978, as a reader of *Modern Love,* she strikes the stationary poses of her female character who has adventures mainly about men or who in the style of some new novelists, silently records the movement of other phenomena. These two examples are mentioned not to imply that the mechanisms of narcissism and scopophilia are "bad," but to illustrate how there are some correlations between the codes of these two mediums, film theory and performance art.

Since Mallarmé and Joyce, works of art have been allowed more than one interpretation. Julia Kristeva critiques "the unitary text based on the construction of a single entity with its own consistent identity." She advocates a "multi-valent plural vocal text whose various discourses confront each other in opposition [and which is] an apparatus for exposing and exhausting ideologies in their confrontation." [6] Roland Barthes characterizes this plurality of texts as the position which makes the reader not only the consumer, but the producer of the text. [7] This is particularly apparent in performance art which is already composed of amalgams from other disciplines, often with few clear references. Audiences over the last several years have had to construct many meanings from the purely formal (as in advancing an art-world dialogue) to the more psychological or social (as in the implications of much feminist art which is often credited with introducing the psychological, the intuitive, and the social into art practices.)

Carrying this theory further, it is easy to imagine a diversified high art tradition that might be more directly related to people's experiences on a par with mainstream cinema or Ancient Greek theatre. For example, with the influx of the "art world" into the punk or new wave music scene, bands originating from an art context perform in both cultural spheres, that of the

mainstream culture of rock clubs as well as the art world, in addition to marketing products sold in the commercial sector. This analogy illustrates how both the spectator and the artist as consumer/maker(s) are implicated in a more plural, less passive way, and that in fact a radical change in the type of art in the art world is not necessarily implied.

Narrative has been a part of the women's performance art tradition since women invented rituals to expiate their feelings. Formalist precursors of performance art such as Simone Forti and Yvonne Rainer often drew from their experiences as women which were then abstracted to fit into the rigorous minimal mode. Later breaking with that tradition, both artists claimed their experiences as women had always informed their work, as a silent underpinning. [8] Recently this narrative tradition has become more explicit, perhaps because performance art is experiencing a natural maturation from its early narcissism to its current more overtly social, less personal concerns. In addition, women are using narrative structure dialectically both to explore their placement within the social structure and to foster an identification with the audience. Women are beginning to speak as women in a language that represents their entry into the symbolic order and that is by definition necessarily related to the lived-experiences in which they find themselves. The demands of careerism may also be a factor since the older style performance as a one-time only, usually real-time event is difficult to market and control in an art world that is commodity oriented. No doubt there are other factors that contribute to this interest, all of which underscore this tradition of plurality.

By examining recent performances by women in Northern California we can begin to question how women represent themselves. While the work discussed here is by committed and intelligent women artists, these criteria, with a different emphasis, could be applied to the work of male artists as well.

In Nina Wise's *Glacier* (written in collaboration with the performers Grace Ferguson, Suzanne Landucci, Margaret Lutz, and Deborah Buchar) the performance opens with an indistinguishable mass of singing black-cloaked figures, scarcely illuminated by lanterns. The piece contrasts three women's personal solutions to the larger questions of ecology and urban living. Over the duration of the performance, the figures become the characters Adelle, Elaine, Bertie and Tree. Because of the fragmentary and non-linear "anecdotal" style of the performance and possibly the collaborative style, with each performer having equal importance, the characters never become independent of one another, but reside in their diverse environments as parts of a whole, reflecting one another's and Nina Wise's persona. [9]

None of the three women characters occupy traditional male roles. Instead, they speak from their shared experiences more as part of one whole, present a multi-valent experience, reflecting one woman and one consciousness. Structurally, this is reinforced by the fact that little descriptive background information is provided, interfering with the way a narrative normally ties characters to individual identities. Their fears connote all the cultural definitions of women. They fear the dark, to be alone, and often appear helpless and disoriented. They present themselves as "victims" of the culture. The destruction of the character, Tree, which takes place in a dream sequence (that becomes real) may inspire them to take action. However, this action still remains on the level of imagination. A song about clean air and the rehabilitation of the forest environment is offered, but this is not backed up

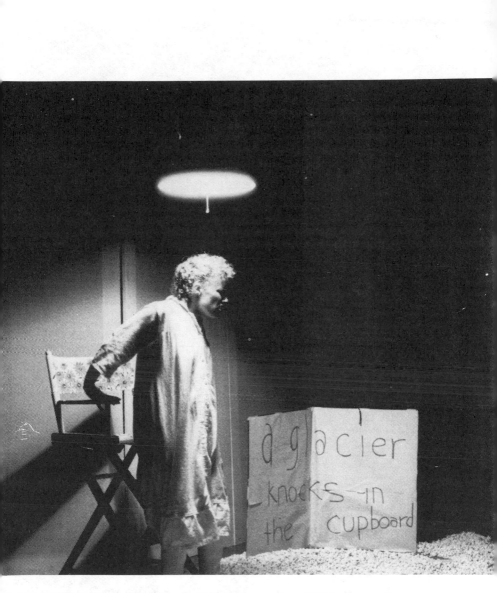

Nina Wise. *Glacier*. **San Francisco, Ca., 1978. Grace Ferguson as Adelle.**

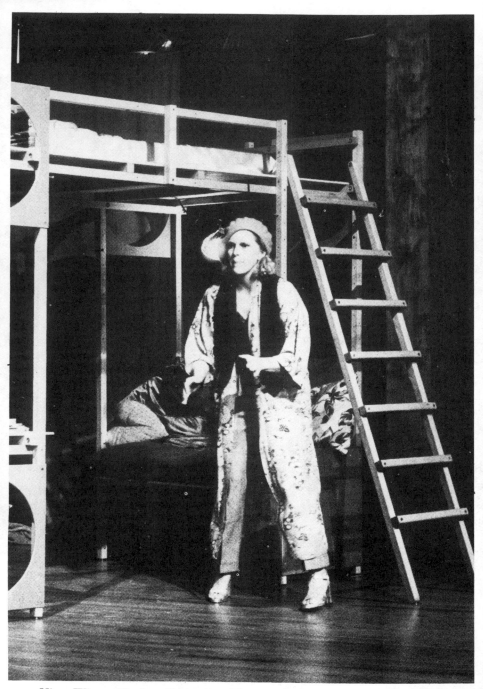

Nina Wise. *Glacier*. **Gumption Theatre, San Francisco, Ca., 1978.**
Featured in photo: Suzanne Landucci.

by any concrete plan or even by a metaphor. What is of interest here is the breakdown of normal ways of presenting information resulting in insights into narrative as a reflection of the culture in which we live.

Using narrative form calls into question the notion of realism which is inscribed within culture, or more specifically, which implies a relationship between the myriad of beliefs/assumptions/structures that characterize a society and its forms of representation. Painting conventions prescribed that painting was a "window onto the world." Narrative as a vehicle for storytelling represents the real world. It uses a number of illusionistic devices to establish a one-to-one correspondence with the world as perceived. However, closer scrutiny as provided by semioticians, particularly Barthes (*Elements of Semiology* and *S/Z*), reveals that the "meaning" we derive from any interaction depends on our knowledge of a set of conventions ensnaring every aspect of our lives from the food we eat to the art we like.

Realism can be seen as the complex interaction of a variety of codes operating through secondary mimesis. As Stuart Hall has said, "In any given society there is a lexicon of expressive features which impose the multiplicity of meanings inherent in any given situation as not an invariable, but as a preferred meaning." In other words, realism is not homogeneous, but heterogeneous, composed of multiple interdependent codes that can be broken down, structurally isolated to reveal how they form a particular meaning. Realism depends specifically on the illusion of naturalism and references to other models. Narrative performance art highlights many of these cultural conventions.

It is definitionally impossible to place any performance outside an ideological framework. Ideology can be seen as a "momentary complex of social practices and systems of representation which have political consequences."[10] This is particularly important for a feminist art practice which is trying to wrest itself from the imposition of the dominant order, the Western metaphysical traditions. Feminists are asking, "how can women stand outside this tradition and risk not existing, while simultaneously remaining within it, which is in fact where we are, as part of our lived experience?" Being cognizant of the ideological assumptions which informs an art work is a step toward demystifying this process and beginning a dialogue with the culture at large about the representation of women.

What converts objects, people and action into signs in an audience/performer situation is the relevance to "life" and the simultaneous separation from the real world of the performance. This separation has the effect of placing quotation marks around the performance. For example, a performer signifies a fictive character who does not necessarily coincide with the person/actor. Sometimes the performer can represent a non-human entity such as Tree in Nina Wise's performance. Over the duration of the performance, the performer subsumes other self-definitions, other realities, in favor of her/his function as sign. An audience is aware of this functioning in public speaking as well, contrasting the politician's public persona with her/his private life, or in distinguishing movie stars and soap-opera actresses from their roles.

Performance art is often composed of dense layers of multiple sign systems (references to art, politics, literature, theatre, science, etc.). It is impossible to isolate particular events to extract a linear meaning sense. Instead a densely plural, multi-textual reading is available when a variety of systems or codes converge. The spectator must determine the validity of several

interpretations. As Keir Elam suggests, "no possible classification of the codes in performance will be exhaustive . . . potential density of these simultaneous signifying practices on the stage is limitless, though in practice restricted in order to keep mayhem at bay."[11]

In Nancy Blanchard's *Still Life,* a three code classification system was adopted. The iconic, indexical, and symbolic codes were chosen although other systems could easily be devised.[12] The *iconic* refers to what the image represents or connotes as in the analogical or pictorial representation of a concept. Included in this particular performance are the set, props, performers, and pre-recorded narrative. The *indexical* describes effects of the interaction of various parts of the performance such as changes in lighting which signal changes in time or mood. Finally, the *symbolic* pertains to the suggestions of ideas or emotions by means of symbols as in the use of church architecture to a signify a sacred, holy or inviolable place.

Glamour and the objectification of women are two themes that run continuously throughout Nancy Blanchard's *Still Life.* Narration and action are separated; the performers move only in response to or as illustrations of the pre-recorded audiotape that advances the story. This device allows the characters to function clearly as iconic signs, foregrounding their actions through descriptions by the narrative. The "she" of the narrative is a beautiful and elegantly dressed woman whose elusive qualities in this role are further enhanced by the fact that "she" is not given a functional identity as are the other supportive characters. This includes Henrik as the "boyfriend,"

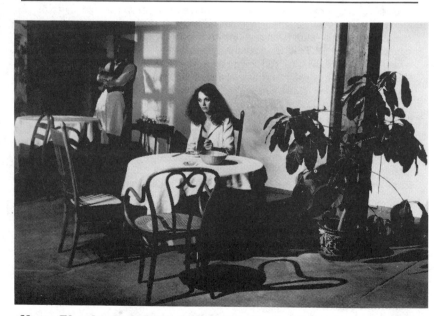

Nancy Blanchard. *Still Life.* **80 Langton St., San Francisco, Ca., 1979.**

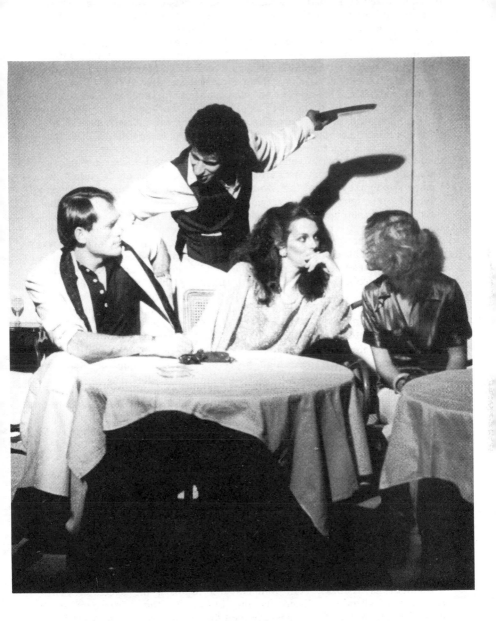

the Dutchman as the "bad guy," and two French women who are significantly less beautiful than "she" is. In fact, only at the beginning of the narrative is a hint given about her identity. She is in a church describing in her diary the trompe-l'oeil renovations of the nave. She notices the workman looking at her and wonders if they think that she is an architect. This is a substantive clue to her identity. It reveals she is aware of the look of others on her. This fragment has the function of inscribing her in the narrative as the recipient of the male look. It sets her up to be encoded iconically, to function as an object. Why does she imagine that they think of her at all? Perhaps as a woman, she has been taught to present herself to others, to objectify herself, even in her own thoughts. Many of the other elements within the text reinforce this function. The story is a description of her stay on the European Riviera and her dissatisfaction with her life and the life-style of the people she encounters. Throughout the story references are made to the restoration of the church, its trompe-l'oeil imagery, and the two-dimensionality of the landscapes. These references function symbolically, tying and contrasting the relationship of the description of the objects (objectification) to the descriptions of the people who appear to be objectified. Furthermore, these objects function as antinomies: as both mundane and secular, yet sacred and holy; and also as both what they seem and what they are not. In addition, the use of description instead of a spoken dialogue to advance the drama flattens the audience's perception of the characters, enhancing their two-dimensionality and relating them to the other elements. Similarly the props for the piece, the furniture and plants of the restaurant, convey the same mood, evoking an artificiality that mingles with their other connotative references, the glamour and luxury of cafe-living.

"She" cuts the bottoms of her feet on new high-heeled sandals when walking with Henrik. These high heels are fetished items of glamour indicative of her paralysis. She must wear them or risk appearing "strange." She says she must "keep moving" or "nothing will happen to her." The shoes and the cuts they make symbolize both mobility and the pain of the dictum that she must keep moving. They also allow her to fetishize herself as she does on her walk in the park, where Henrik accuses her of walking that way in those high heels, as though she were looking for someone. Instead, she has made herself a lure, a moving target, so that someone will discover her. She considers that she is waiting. The two bleeding cuts refer also to the church and sacrificial offerings, even to stigmatization (the bleeding by saints on holy days replicating Christ's wounds.)

The indexical codes, for instance, lights dimming to demarcate the passage of time, effectively place the audience in a new relation to the depicted "scene." However, ironically, except for the rearrangement of the furniture, very little has changed. In one sequence at the restaurant, a conversation is portrayed entirely in poses as the lights dissolve in between, once again directing attention to the title, *Still Life*.

Glamour as a device both compels and repulses the spectator. The audience is visually seduced by the beauty of the performers, the attractiveness of the effects, even the mellifluous voice of the narrator. Yet, the emptiness of the heroine's life, her lack of self-awareness, her complicity in her own objectification, effectively undermine the promise of glamour, rendering it impotent, useless, void—exposing it.

How is the audience implicated in the process of viewing performance art? As some early performance pieces sought to involve the spectator as thoroughly as possible, questions about the responsibility of the artist as a producer became important. Was it right to kill animals (as in Ralph Ortiz's pieces)? How responsible was the artist or gallery for the safety of the audience or the artists? This form of question was discarded as being antagonistic and antiformalistic, consequently, what was implied in the questions (the relationship of artist to the production process) was never voiced. Walter Benjamin describes how the modern photographic process "succeeded in turning abject poverty itself into an object of enjoyment" as in the photographs of the slum workers of Renger-Patzsch which were avidly digested by the museum-going public.[13] In much the same way, other forms of art including performance often place the spectator in an uncritical situation. Similarly, the artist is often unaware of the message(s) her/his work conveys.

Theresa Hak Kyung Cha's *Reveille Dans la Brume* (Awakened in the Mist) places the spectator in a viewing situation equivalent to the cinema, where "the spectator identifies with her/himself, with herself as a pure act of perception: as a condition of the perceived and hence as a kind of transcendental subject anterior to every there is."[14] The legacy of photomontage "as that form of allegory with the ability to connote dissimilars in such a way as to shock into new recognitions"[15] facilitates the spectator's participation in that "other scene on which the drama of the construction of the subject is played out."[16]

Standing in the center of a pitch black space, Theresa Cha lights a match. As she circles her arm and the match goes out, an audiotape repeats these words: . . . firefly . . . glowworms. She lights another match, walks to the microphone and recites, "Everything is light. Everything is dark." Meanwhile the lights fade in and out. Gradually Cha weaves in other elements, juxtaposing several levels of content with one another "in a hunt for language before it is born on the tip of the tongue." Her sense of timing adumbrates the visual and audio dialogue. Slides, punctuated with written information and by her movement in front of the screen, mingle with phases and questions dangled in midair, making an interstice through which we slip, creating a nexus for perception. "Now?" a distant figure asks. "No, not yet," she says. We are floating, coming close to something, suspended, yet in a vortex of ineffable thoughts and sensations, alone.

In the cinema viewing process, the spectator is the producer of the discourse in much the same way as the dreamer is the enunciator of the dream. The relationship is reminiscent of the relationship of the child to the "imaginary," defined as the "mirror" phase in the Lacanian system.[17] This place also marks the earliest beginnings of language for it is after the child learns to recognize itself as "other" that it will be possible to symbolize. In order to recognize itself as other, the child must develop a sense of her/himself as a unified "I." This totality is homologous to the transcendental ego of Western philosophy. Recent theoretical elaborations of the cinematic viewing situation have discussed the identification the spectator has with the images on the screen in terms of this unified ego. The transcendental subject, constructed by the ego's sense of itself as a strong, unified "I," is considered problematic since its assumed unity does not readily allow for contradiction and diversity. Thus it continues the division of Western metaphysical thought into binary oppositions which are reflected in various dichotomies: I/You, Good/Evil, Male/Female, etc.

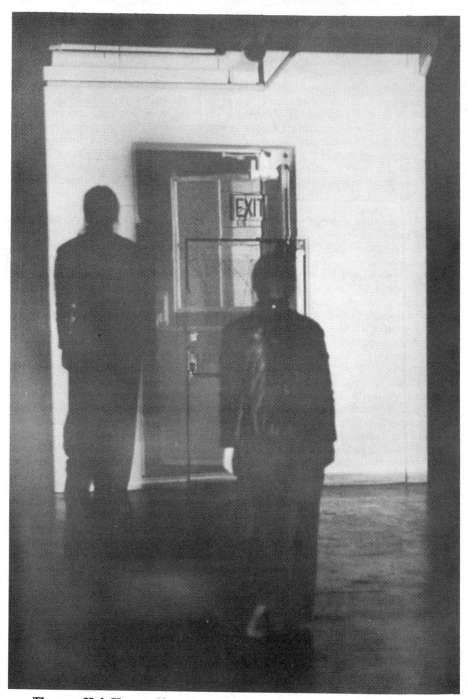

Theresa Hak Kyung Cha. *Reveille Dans la Brume.* **La Mamelle Arts Center, 1977.**

The trace-like state precipitated during *Reveille Dans la Brume* returns the spectator to a "mirror phase" where this identificatory process is subverted because the artist prefers to remain outside traditional narrative forms. This happens when our inscription in this viewing process is questioned through the persistence of the audiotape phrases which force us to consciousness, or when the equally fragmented questions appear on the screen, or when Cha interrupts the viewing process by standing suddenly before the audience.

However, since the cinematic apparatus may be by definition impossible to subvert, and because as spectators it is difficult for us to remain consciously unconscious, we lapse into a void, sometimes empty of tangible associations. This undifferentiation is not necessarily a negative evaluation, for it positions us temporarily outside the symbolic in what Julia Kristeva has called the "semiotic chora," a pre-language domain equivalent to the babbling of a child or the rhythm of music. Perhaps this will be the reservoir from which women will learn to speak their own language.

Barbara Howard's *Wanting a Picture of the Salmon Appearing on the Trained Musical Muscle Situated Between the Skirts of the Two Spanish Sisters* shares with Theresa Cha's *Reveille Dans la Brume* similar performance and cinematic conventions. A dissolve unit elides the images of a bend in a road rather than showing the jarring break of light between images during normal carousel projection. A text is sometimes spoken by two figures seated with their backs to the audience, played on an audiotape or tied visually onto slides that resemble an outline of the head of Louis XIV. Changes in scale of the various types of visual information prevent the hypnotic effects of a more unified perceptual field.[18]

In the first half of the piece, a man and a woman drive to sea (symbolized by the use of the dissolving bend in the road, and the fact that the two characters ape the posture of people driving), and talk about a woman who is not present. Although she is adequately described throughout this dialogue, the woman never becomes present for the spectator, but remains "absent," lost. Her name is Ida-Maia. The man and woman begin to describe her, exchanging reminiscences of her; they have seen photos of her pitching a tent, masquerading as a sailor. They compare her to objects, a ship, the sea. The man relates a story from Ida-Maia's point of view as though he has become her—disjointed, non-sensical, whimsical, immobilized. When he recovers himself, he succumbs to his desire for her, forgetting his lecture appointment, or symbolically, his place in the speaking world. He is feminized by the chain action of recalling her photograph, and speaking her words. He decides to change his life.

In the second part of the performance Ida-Maia attempts to represent herself in photographs, paintings, and text presented in slide form, forcing the audience to construct her identity. She tries to establish her identity outside the culture, wishing to be outside the subjecthood imposed by the first part of the work, undefined by male desire, recognizing her own desire.

She wishes to be speaking "to be talking, she is not talking to be there." Ida-Maia *is*. She takes her place as the "difference," signified by her definition as "woman" in both sections. Several elements in the piece foreground this primary reading. She is absent in the performance; in the first section, the audience unsuccessfully attempts to construct her identity when given descriptions of her. She remains unknown, defined within the reading as the object of male desire. She is unknowable by definition since desire in psychoanalytical terms is the desire for the "ultimate object that

can never be realized." Her position as an object of desire inscribes her in culture as that which is exchangeable, which can be substituted and displaced, in other words as "woman." According to Levi-Strauss, the exchange value of women provides the basis for culture, since the universal incest prohibition forces marrying outside of kin. It is women and not men who are traded between men, putting into place a complex relationship among groups of people. Ida-Maia attempts to capitalize on her difference in the second part, again using her absent presence, substituting her lack for the verisimilitude. She displaces her image onto others, talking as she eats, changing her position in relation to them, trying to reify herself as this difference. She returns to her mother, accepting her difference, while the spectator wonders if women can be more than signs.[19]

Current feminist and tangentially women's art making practices are eager to spawn a new category of female identity. This identity would be independent of the definitions of "women" described under patriarchy, psychoanalytically defined as sexually different and socially defined as subject to oppression, and would position "women" as the subject of their own discourses within a cultural milieu, hence, a system of representation of their own construction. While feminist artists agree this is the answer to Freud's question, "What do women want?," they disagree as to how this can be accomplished.

At this moment in history feminist artists hold one of two positions. "One type of women's art can be seen as the glorification of an essential female power. This power is viewed as an inherent feminine essence which could find expression if allowed to be explored freely. The essentialist position is based on the belief in a female essence residing somewhere in the body of women. This orientation finds expression in a reading that emphasizes 'vaginal' forms in painting and sculpture and can also be associated with mysticism, ritual and the postulation of a female mythology."[20] By glorifying the bodies of women in art work the women for whom the work is intended identify with the work and validate their own femaleness as a source of positive feeling and creativity. Through the glorification of the female body and subsequent bonding with other women a new social order of women emerges. While it is important for women to explore their feelings and attitudes and to develop self-esteem through love and trust for one another there are serious shortcomings with this position as a strategy for implementing social change. Specifically, it positions women's culture as separate and different from mainstream culture. It is not subversive because it continues to maintain women as different, as outsiders. By failing to theorize how women are produced within the social complex this position has little insight into the social problems indigenous to any social grouping, setting up a fallacious equivalency between the personal and the social, and forcing the group to rely on personal decision as the solutions to social problems. Further, women as a category is pre-supposed, still defined as sexually different, and femininity is considered unproblematic.

The other position, while sharing with the feminist essentialist position a respect for the personal, situates "women" squarely within the patriarchy. This position attempts to deconstruct and recreate the category of "women" by exploiting the contradictions that inform the patriarchy. "This position sees artistic activity as a textual practice which exposes the existing social contradictions toward productive ends. Culture is taken as a discourse in which art as a discursive structure and other social practices intersect. This

452

Barbara Howard. *Wanting a Picture of the Salmon Appearing on the Trained Musical Muscle Situated Between the Skirts of the Two Spanish Sisters.*

dialectic foregrounds many of the issues involved in the representation of women. In these works the image of women is not accepted as an already produced given, but is constructed through the work itself. This emphasizes that meanings are socially constructed and shows the importance and functioning of discourse in the shaping of social reality."[21] Through a theoretical reflection on how women are produced, perceived, and socially situated a critical understanding of women's oppression can occur. This group places the re-presentation of women, and the situation of women as subjects of their own discourse at this nodal point.

This summary is not meant to factionalize or polarize women into either group. In fact, the issues are much less clearly delineated in practice than this discussion indicates. Many artists working in the area espouse elements of both positions.

Other elements borrowed from psychoanalysis are useful for explaining how meanings are created. Jean-Louis Baudry has stated that is is especially through art practices that the unconscious proposes to represent itself.[22]

Performance, particularly women's performances, are often arrived at "intuitively." The artist works with the material allowing unconscious associations to reveal its final shape and meaning. This theatre and dance technique known as "improvisation" informs *What House?*, a collaborative work by Fern Friedman, Terri Hanlon, and Deborah Slater.

Throughout most of their performance all three women are active, effectively layering the viewer's attention as different information is presented simultaneously in different quadrants. Meaning is constructed by the interplay of disparate elements, often random, illogical, like that impossible of possibles, a daydream. If the cinema is analogous to the "dream-state," then certain performances may be analogous to a daydream, particularly those constructed intuitively by association and thus dependent on the audience's ability to simultaneously make those associations.

What House?, a series of eleven sections lasting one to three minutes, is about waitressing, work that many artists do to support themselves. The eleven sections overlap, making it impossible to tell where one begins and another ends. The audience shifts its attention as new information is introduced and other information is displaced. An example of the overlapping action in this work is described: Three women are talking together, folding napkins . . . two women leave . . . one woman places a napkin blindfold over her eyes . . . she tells waitress stories as she folds more napkins . . . the other two women reenter . . . one woman takes off her blindfold . . . one woman pretends to hang check stubs on a spindle . . . another woman leaves the room . . . the real check stubs are falling from the imaginary spindle to the floor . . . another woman pretends to hang check stubs . . . a backward bell rings six times . . . the woman hanging the first check stubs leaves the room . . . the space is vacant . . . another woman enters . . . the bell ringing stops . . . two women enter . . . one woman is at the microphone saying, "oh,oh,oh,oh, a-oh,a-oh,a-oh,a-oh," and gradually becoming hysterical . . . another woman sets the table, clears and resets the table . . . another woman balances plates in her arms, spinning and whirling with them, a kind of live tea cart . . . a machine sound cuts in . . . the plates drop . . . one woman picks up a blank guest checkbook and begins to write . . . another woman mirrors her . . . one waitress begins talking . . . the other woman mirrors the other two . . . the tape ends . . . the two standing figures read columns of active and passive verbal constructions beginning with "I am walking, I am walked on" . . . the

Eva Sisters (Fern Friedman, Terri Hanlon, Deborah Slater). *What House?* **La Mamelle Arts Center, San Francisco, Ca., 1977.**

other waitress is balancing plates . . . a wirewhip tape loop begins . . . fifteen plates fall to the floor . . . a plate rolls across the space . . . two waitresses leave . . . one woman does a dance with two teapots responding to the rhythm on the tape loop . . . one waitress says, "oh, no," going from a mundane exclamation to a sensual inflection . . . the figure on the left becomes more sexually involved with her guest check pads . . . the figure on the right transforms the blue-veiled contents of a discarded vacuform container into an altar where several creamers adorned by folded napkins are placed. The action of the performance continues in this overlapping fashion.

Several psychoanalytical terms are useful to understand how an audience is able to construct meanings through associations. *Displacement* is the mechanism that allows the spectator to plug into the chain of associations and make sense of disjointed information. Displacement "refers to the fact that an idea's interest or intensity is liable to be detached from and pass on to other ideas which were originally of little intensity, but which are related to the first idea by a chain of association."[23] For instance, the act of taking off a blindfold which formerly was a napkin, is supplanted by the pretense of hanging check stubs, which may refer back to the stories the waitress told about waitressing. The sense that these activities are metnoymic, in some logical relation to one another as equivalencies, is further reinforced by the ironic connotations of folding napkins blindfolded and placing checks on an imaginary spindle. As each activity is displaced by another, further reverberations are created, carrying with them the earlier, other meanings. As the intensity of associations builds, *condensation* makes it so that meanings collect around a nodal point.

Condensation is a "sole idea that represents several associative chains at whose point of intersection it is located."[24] It may operate in various ways. Sometimes, one element (themes, person, etc.) alone is preserved because it occurs several times in different dream-thoughts (nodal points), alternately, various elements may be combined into a discontinuous unity or again, the condensation of several images may result in the blurring of those traits which do not coincide so as to maintain and reinforce only those that are common. A field of metaphor develops. The backward bell ringing, the hysterical woman repeating "oh,oh . . . a-oh," the resetting of the table, the phantasmagorial balancing of the plates, form a metaphor for a work process. Furthermore, this work process could be read as being "mechanistic and inhuman."

This particular meaning is *overdetermined* in the sense that much other information through the piece supports a "mechanistic and inhuman" interpretation. Overdetermination is "the fact that formation of the unconscious (symptoms, dreams, etc.) can be attributed to a plurality of determining factors. This can be understood in two ways. 1)The formation in question is the result of several causes, since one alone is not sufficient to account for it. 2)The formation is related to a multiplicity of unconscious elements which may be organized in different meaningful sequences, each having its own specific coherence at a particular level of interpretation."[25] For instance, the machine sounds from the tape loop, the repetitious nature of the actions, the contained hysteria of the "oh,a-oh" sequence, the disjointed entrances and exits of the performers, all lend credence to this interpretation. However, a number of equally well-determined meanings could also be construed. For instance, since all three women were performing

simultaneously a number of "circus" connotations come to mind. Notice that the readings of "circus" and "mechanistic and inhuman" are in some ways similar and in other ways dissimilar.

Since *What House?* functions solely along its associative path, nothing is explained, so other senses of meaning than the two described are equally plausible. In addition, elements of the potential meaning fall away in the sense that they do not directly signify anything, or are not readily subsumable into a code.[26] Consequently, the intricacy of meaning is also unaccountable; one cannot really determine how one meaning attains precedence.

Narcissism as a developmental stage between the love-object and autoeroticism, and narcissism as a structuring device channeling desire, can be applied to a discussion of much recent performance art. It is especially relevant to performance art utilizing video since parallels between the video process and the "mirror phase" can be so well drawn.[27]

Certainly narcissism must be considered in an analysis of women's entry into performance, since the art world is one way women can participate in the cultural world viewed as the *symbolic.* The symbolic is conceived of as being the site of the entry of the sexed subject into language. Women's entry into the symbolic is marked by her passage through the "oedipus complex." For women it is acknowledged that she will never enjoy direct possession of the phallus (as the signifier, and the power position in the symbolic, since all is defined *vis-a-vis* this power relation); she must give up her claim to her mother and, by implication, to all women and assume a role that is not symbolic, but pre-symbolic, that of the mother who is the ultimate object of desire, consequently unattainable. As the mother, the female is the object of the desire of the child. As the wife/mother, she is the object of desire, she includes phallic power in as much as she has power over the men for whom she is desirable and over her children to whom she represents the phallus.

It is precisely here that the characteristic features of feminine narcissism become important, in the need to be loved and the fear of losing her loved objects. One of the relevant fissures of narcissism for women is in the choice of the love object. Freud has said that narcissistic object choice can be of several kinds: love for what s/he is, once was, or would like to be. For women this includes an identity with the dependent, since that is who she once was, but also points toward identities with a more aberrant self, as what she would become. This ruptures older categories of women, and allows replacement with new categorizations.

Narcissism as a mechanism in performance art both forges an identity for the artist and forces identification on the part of the spectator with the events/artist as portrayed. In Joanne Kelly's *Tahmar* a large advent screen and a lone dancer present an elliptical narrative in a dimly lit room. Pans of the Marin countryside and the Lake Tahoe basin coupled with written fragments from a taped monologue fill the screen as the dancer augments the sense of movement, performing disassociated, often Tai Chi-like gestures throughout the space. From the tape it is possible to surmise that Tahmar came to the seaside to "figure things out," perhaps after a traumatic accident or a shattering love affair. Tahmar, the heroine, is seldom directly shown on the screen. Instead, as the dancer moves the viewer begins to create her image from within the landscape. The rotating head of the dancer recalls the whirling surf; a leg in develope, the shoreline of a deserted beach; an arched back, the form of the mountain top. Similarly, her voice, emanating

Jill Scott. *Inside Out*. San Francisco, Ca., 1977.

from speakers around the room is echoed by the dancer's repetition of key phrases.

The spectator begins to identify kinesthetically with the landscape as her body, and with the tape-recorded words as her voice. Through repetitious movements and her placement between the screen and spectator, the dancer's function is to force the closure of this identity and to put it into place for the spectator. In film theory, this is referred to as *suturing,* a psychoanalytical term implying "taking the place." It functions in cinema when a lack is recognized by the spectator.[28] In Kelly's work, the real Tahmar, though absent from the screen, forces her presence through the suturing device which the dancer implemented. Both the fluidity of the dancer and the video process underscore this activity.

Tahmar functions on another level for Joanne Kelly who wrote, scored, and danced the piece. She identifies with the video apparatus as a mirror for herself. It is not only her image that is mirrored, but her reflection in the footage she shot of the Tahoe-Marin basin (hence the name Tahmar). It is her story recollected in the memories she reconstructs, and will further remember as she performs the piece.

Inside Out, Jill Scott's video performance installation, contains many features that make narcissism an appropriate model for decoding how the artist represents herself. She and the audience are positioned differently from Joanne Kelly's *Tahmar*. An environment was constructed in a basement studio where one window fronts the street, offering the audience a view of pedestrians from the knees down. The long rectangular space is painted black and sand covers the floor. A monitor to camera hook-up gives the

audience another view of the street. Under the window a lighted mouse house can be seen. Along the right wall a 4' x 10' light-box contains two transparent drawings. For one-half hour on six consecutive days the artist occupies this space, marking her presence by recording her movement as well as that of the spectators, mice, cars and pedestrians onto the 4' x 10' transparency. This transparency divides the space horizontally, effectively separating the audience's quadrant from her area.

She has built an environment installing herself both as the decoder of the information framed in the environment (it is she who orchestrates the audience's attention, pointing out the movement of pedestrians, mice, etc.) and as a recording device, systematically encapsulating the movement in the area onto the transparency.

The use of video is greatly diminished. It is just another element in the environment. It functions similarly to the family TV set, often left on as accompaniment to other activities simultaneously taking place, i.e., the interactions of family members. Recent theories about the role of television emphasize that the livingroom of the family is analogous to family situations portrayed on TV. For instance, even during the news where close intimate

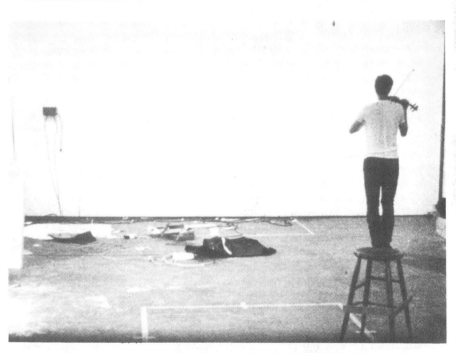

Bruce Nauman. *Playing a Note on the Violin While I Walk Around the Studio.* **1968. Black and white 16 mm film with sound, 8-10 min. Film produced for "straight forward recording of an activity" and to fill time in the studio.**

459

shots predominate, the anchorman can be identified as daddy, the weathergirl as the daughter, the sports person as the son, and the co-anchor, who is often a woman, as guess who . . . mommy. In this performance, the audience is in a livingroom of Ms. Scott's. It is a room that she has created and where she is in control of what is experienced. The video monitor as a live feedback system mirrors this function.

Whereas Joanne Kelly's performance created the presence of an absent "other," Jill Scott's environment installs her as real presence, utilizing the marks to affirm her functionality, to confirm her importance. Her position is analogous to that of the male in mainstream film since she is the one who acts, whose presence advances the action. Her performance environment demands her presence in order to function, but since she is also a woman, she also functions as the object of desire, as what we look at while we watch her decode the information. Her real presence and the environment contribute to this reading. For example, the fact that she is involved in her activities, and hence never looks directly at the audience, invites our uninterrupted stares. Here in the darkened space we can behave nearly as voyeuristically as in a movie house because the viewing conventions are so similar. Since we are removed from the information as she decodes it, we are more passive than in other performance situations, hence we are more likely to perceive her in this way.

There are significant differences between this representation and male activity-oriented performance. In Bruce Nauman's early performances and video work, such as in *Violin Tuned D.E.A.D.*, he used his body as a single signifying unit (the phallus). Nothing within the confines of the performance was done either to disturb the imposing presence of the signifier or to question the homogeneous order which prevailed. Nauman stayed stationary in the space, repeating the activity. Ms. Scott's function as an object is significantly different. In her presentation of herself she employs a multi-valent body sense characterized by her division of the area into various quadrants where different activities occur. This demonstrates the improvisatory method she uses for recording the stimuli. Consequently, a heterogeneous, less rigidly formulated order is maintained.

One outgrowth of considering performance as an interaction of complex sign systems is that often more questions are generated than are sufficiently addressed within one analysis. Current theories of representation revolve around an axis with the personal/psychological at one pole and the social/cultural at the other. Consequently, the positions taken in this essay reflect that dichotomy, attempting to exploit the relationship between the social and psychological by exploring how they converge in the activity of performance art. To do this it has been necessary to simplify a theory of the productions of meaning in performance art into this dichotomy not only to foreground the issues involved in the representation of women, but to underscore the interdependency of these two poles. In the future, a more complex theory of the production of meaning for performance art would hopefully be able to separate these mechanisms and more specifically apply their functions.

NOTE: I wish to acknowledge my debt and gratitude to my friends Sandy Flitterman, and Dan Graham for their careful readings, critiques, suggestions, and discussion of the manuscript in its several stages.

Notes:

1. Roland Barthes, *S/Z*, New York: Hill and Wang, 1974, p.56.

2. Laura Mulvey, "Visual Pleasure and Narrative Cinema," *Screen*, 16, 1975, p.3.

3. In psychoanalysis the use of the term "phallus" underlines the symbolic function taken on by the penis, while the term "penis" tends to be reserved for the organ thought of in its anatomical reality. It would be mistaken to assign a specific allegorical meaning to the phallus symbol no matter how broad (fecundity, potency, authority, etc.). Rather, the phallus turns out to be the meaning behind, that is, what is symbolized by the most diverse ideas just as often as it appears as a symbol in its own right. What really characterizes the phallus as it reappears in all its figurative embodiments is its status as a detachable, transformable object. For example, "the term 'penis envy' crystallizes an ambiguity which may be a fruitful one, and which can not be disposed of by making a schematic distinction between, say, the wish to derive pleasure from the real man's penis in coitus and the desire to possess the phallus qua virility symbol." (J. La Planche and J.-B. Pontalis, *The Language of Psychoanalysis*, NY: Norton, 1973, p.134). In Jacques Lacan's reorientation of psychoanalytic theory from which I am drawing here, the phallus is the "signifier of desire." Consequently, the oedipus complex consists of a dialectic whose major alternatives are to be or not to be the phallus, and to have or not to have the phallus.

4. John Berger, *Ways of Seeing*, London: British Broadcasting Co. and Penguin, 1972. Thomas Hess and Elizabeth Baker, *Art and Sexual Politics*, New York: Collier, 1971.

5. In this instance, Narcissism refers to how the subject learns to recognize her/himself and identify with others through the 'mirror phase' by idealizing her/his reflection, hence others. Scopophilia refers to the pleasure derived from looking at another, specifically voyeuristically.

6. Julia Kristeva, "The Ruins of Poetics," *20th Century Studies*, 7, 1972, p.8.

7. Roland Barthes, *Image-Music-Text*, New York: Hill & Wang, 1977. And Roland Barthes, *S/Z*, New York: Hill & Wang, 1974.

8. See Simone Forti, *Handbook in Motion*, Halifax, Canada: Press of the Nova Scotia College of Art and Design, 1974; and the interview with Yvonne Rainer by Lucy Lippard in *From the Center: Essays on Women's Art*, New York: E.P. Dutton, 1976.

9. In an early scene the mass of women install Deborah Buchar as Tree, a statue-like object which gently sways throughout the duration of the piece. Then, the women waltz through the forest, imitating one another, finally taking charge of their respective domiciles. Adelle (Gay Ferguson) and Elaine (Suzanne Landucci) reside in apartments on opposite sides of the performance arena. Often their activities directly mirror one another's. In consecutive monologues Elaine declares she loves walls and staying inside alone with windows locked and doors bolted, while Adelle envisions her own suicide. Both women share dissatisfaction and alienation with their job situations; Adelle as a candy-counter person in the movie theatre, Elaine as a school teacher. Both suffer from insomnia, nightmares and the dreariness of a clock-punching, time-conscious society where activities are somehow out of whack with what is 'good' or 'natural.' Bertie (Margaret Lutz) as the other woman has the good life, living by herself on the river, fishing (but never eating her catch), looking for UFO's, etc. It is clear from her attitude that she is a recent refugee from city life. In fact, she is the alter ego of her two city sisters, positioned at back center stage, she is always in view of the audience, acting as a foil, a pivot point, as the dialogue shifts from side to side.

Elaine and Adelle, mirroring one another, do little to advance the action of the plot. Instead, the denouement in the traditional sense occurs in a dream they share. In the dream Bertie changes into a bear and is witness to the destruction of Tree who has been swaying in front center stage throughout the entire piece. When the women awaken, they discover their dream has happened and resolve to remedy the situation. Here the style of characterization subverts the normal plot development. The Tree occupies the usual position of woman in narrative. She is beautiful, mysterious, always present, swaying and undulating. The audience is made to feel by identifying with the three women that she is the 'object of desire,' simultaneously inaccessible,

unpossessible both as a symbol of the forest (which the city folk cannot have) and as what she is, a tree. Her death and destruction augment her fetishization, forcing the three characters to resolve to take action, to change the existing order in an attempt to possess her, or at least have her, or her double, as an object of contemplation.

10. Paul Hirst, "Althusser's Theory of Ideology," *Society and Economy*, 5, 1976, p.4.
11. Keir Elam, "Language in the Theatre," *Sub-stance*, 18/19, 1977, p.141.
12. An example of another system is the five codes Roland Barthes applies in his reading of Balzac's *Sarrazine* in *S/Z*.
13. Walter Benjamin, "The Author as Producer," *Understanding Brecht*, London: NLB, 1973, pp.85-103.
14. Christian Metz, "The Imaginary Signifier," *Screen*, 16, 1975, p.51.
15. Walter Benjamin, *Illuminations*, New York: Harcourt, Brace, & World, 1968, p.xviii.
16. Metz, *op. cit.*, p.8.
17. Mirror Phase (or stage): "According to Jacques Lacan, a phase in the constitution of the human individual located between the ages of six and eighteen months. Though still in a state of powerlessness and motor incoordination, the infant anticipates on an imaginary plane the apprehension and mastery of its bodily unity. This imaginary unification comes about by means of identification with the image of the counterpart as the total Gestalt; it is exemplified concretely by the experience in which the child perceives its own reflection in a mirror. The mirror phase is said to constitute the matrix and first outline of what is to become the ego." J. LaPlanche and J.B. Pontalis, *The Language of Psychoanalysis*, New York: W.W. Norton, 1973, pp.250-51.
18. For example, the slides in the dissolve unit are of differing sizes and colors, and a large wall painting covers the viewing area at points throughout the performance. Textual information, both that which is written on the slides and what is heard in a more traditional narrative form, forces the audience to concentrate.
19. The notion of women as signs, which revolves around the exchange value of women as explained by Levi-Strauss, is problematic. Women are defined into position within this structure—seen as produced by this structure—and simultaneously, posited as occurring prior to this structure. In addition to the fallacious logic of these assumptions, clearly, women are more than solutions to sexual difference.
20. Judith Barry and Sandy Flitterman, "Textual Strategies: the Politics of Art-making," unpublished paper, 1979.
21. *Ibid.*
22. Jean-Louis Baudry, "The Apparatus," *Camera Obscura*, no.1, 1976, p.122.
23. La Planche and Pontalis, *op. cit.*, p.121.
24. *Ibid.*, p.83.
25. *Ibid.*, p.383.
26. Roland Barthes, "The Third Meaning," *Image-Music-Text*, New York: Hill and Wang, 1977.
27. For a detailed analysis, see Stuart Marshall, "Video Art, the Imaginary, and the Parole Vide," *Studio International*, v.191, 1976, p.981.
28. "As Stephen Heath has said, 'the suture functions in the cinematic text to bind the spectator as subject in the realization of the film's space. The spectator is bound to the image-frame and to the narrative in such a way that his/her fictional coherence as a subject is maintained.'" Mark Nash, *Dreyer*, London: British Film Institute, 1977. See also: *Screen*, v.18, Winter 1977/78, pp.23-76. Articles include: Jacques-Alain Miller, "Suture (elements of the logic of the signifier)"; Jean-Pierre Oudart, "Cinema and Suture"; and Stephen Heath, "Notes on Suture."

AUTOBIOGRAPHY, THEATER, MYSTICISM AND POLITICS: WOMEN'S PERFORMANCE ART IN SOUTHERN CALIFORNIA

Moira Roth

A woman dressed in black, whitened face pierced by acupuncture needles, chants the story of her ex-husband's death from the time she first learns of it to when she sees his body in the mortuary. *Mitchell's Death* by Linda Montano is a factual account of the death of Mitchell Payne.

<center>* * *</center>

An old woman shuffles around, arranging medication, dried roses and knick-knacks on her bedside table. Across from her a very young girl sprawls on a crumpled bed. Throughout the night in *Vigil* the old woman (Suzanne Lacy) and the girl (Barbara Smith) lead their audience through physical and psychological experiences of extreme age and youth, blending imagination and autobiography.

<center>* * *</center>

Nine tall women in black and red stand on the steps of the Los Angeles City Hall. The banners behind them and their own statements protest both the rape and murder of Los Angeles women by the Hillside Strangler and the sensational coverage of these events by the media. Television and newspaper reporters and photographers attend *In Mourning and In Rage* by Leslie Labowitz-Starus and Suzanne Lacy: a media event to protest the media coverage of a real event.

<center>* * *</center>

A woman and her company of 40 actors and actresses (almost - lifesize masonite figures on wheels) act out Victorian England's drama of Eleanor Nightingale and her nursing exploits in the Crimean War. In *The Angel of Mercy*, Eleanor Antin plays the lead role and speaks in behalf of her masonite companions. The play intertwines real history with invented episodes and fictitious autobiography.

<center>* * *</center>

A group of women sit in mandala formation and meditate in silence. Three male dancers enter and abrasively attempt to disrupt the mood with gestures

<center>463</center>

and sounds. Finally they are forced off the stage by the power of the meditation, and Pauline Oliveros's *Crow Two: A Ceremonial Opera* ends as the women continue to sit in silence.

<p style="text-align:center">* * *</p>

Women and their experiences are the substance of these five recent works. Autobiography, mysticism, theater and politics are the main ingredients and the setting is Southern California. This area possesses a long history of mystical concerns and cults. It houses Hollywood with its tradition of theater and glamour. And it is Hollywood film and television studios which are the main breeding ground for the myths and images of the American Woman.

A remarkable group of women performance artists have lived and worked in this Hollywood ambiance. To my way of thinking, they are the strongest such group in the United States and are among the finest American performance artists, male or female. Finally, the art of these women provides an excellent springboard for discussing distinctions between art by women per se and art by feminists and for examining the pros and cons of performance art.

Among the women performance artists currently working in Southern California are Jerri Allyn, Nancy Angelo, Eleanor Antin, Nancy Buchanan, Candace Compton, Norma Jean Deak, Cheri Gaulke, Vanalyne Green, Tyaga Kaur, Laurel Klick, Leslie Labowitz-Starus, Suzanne Lacy, Linda Montano, Pauline Oliveros, Rachel Rosenthal, and Barbara Smith. Others (Martha Rosler) have moved away from the area or have left performance art (Judy Chicago, Vicki Hall, Jan Lester, Sandra Orgel, Aviva Rahmani, Faith Wilding, Margaret Wilson, Nancy Youdelman). Some work separately, some collaboratively, and some do both (the Feminist Art Workers, Mother Art and Ariadne). Some are feminists, some are not. But all resort to autobiography, theater, mysticism or politics—and usually to a blend of more than one of these—as means for exploring the central subject of their art: the character and role of women in isolation and in the world.

<p style="text-align:center">* * *</p>

A woman rocks back and forth monotonously, her face dulled, expressionless. She recites the litany of waiting: the waiting which women experience from birth to death. Faith Wilding begins hers with:

> "Waiting . . . waiting . . . waiting
> Waiting for someone to come in
> Waiting for someone to pick me up
> Waiting for someone to hold me
> Waiting for someone to feed me
> Waiting for some to change my diaper. Waiting . . ."

She recites the waiting throughout childhood, adolescence, marriage, childbirth, menopause and eventually:

> "Waiting for the mirror to tell me I'm old,
> Waiting for release
> Waiting for morning
> Waiting for the end of the day
> Waiting for sleep. Waiting . . ."

<p style="text-align:center">* * *</p>

<p style="text-align:center">464</p>

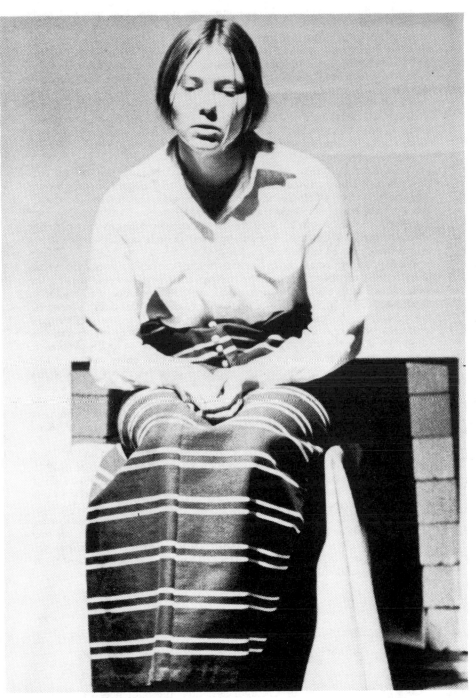

Faith Wilding. *Waiting.* Womanhouse, Los Angeles, Ca., 1972.

Faith Wilding's *Waiting* (1971) epitomizes the thrust of much of early feminist performance art in Southern California. Wilding and others had studied in the Feminist Art Program, started by Judy Chicago, at Fresno State (a school some hundred miles north of Los Angeles) in 1970. Chicago and several of her students, including Wilding and Suzanne Lacy, subsequently moved down to Los Angeles in 1971, where Chicago and Miriam Schapiro jointly organized the Feminist Art Program at the California Institute of the Arts (Cal Arts). Both programs utilized performance; as Chicago later explained it: "Performance can be fueled by rage in a way painting and sculpture can't. The women at Fresno did performances with almost no skills, but they were powerful performances because they came out of authentic feelings."

The feminist performances at Fresno and Cal Arts came fast and furious. In Fresno, Wilding created a memorable scene of a beserk butcher-farmer pouring blood over a helpless white-clad victim while slaughterhouse images were projected over her. Vicki Hall's *Ominous Operation* transformed women into hermaphrodites with latex phalluses. On an overnight desert trip, under the directorship of Chicago, women appeared as nude goddesses painted to match amid colored smoke.

Feminist energy continued at Cal Arts in the general lively atmosphere, as Lacy recalls, of "huge Happenings that Alison Knowles would do and the inflatables that we would all get drunk in." Performance was taught in feminist classes. Highway 126, a route that runs from Cal Arts to Ventura, was the scene for one particularly inventive series of events. Chicago's performance class created a sequence of events throughout the course of a single day along the highway. The day began with Lacy's *Car Renovation,* in which the group decorated an abandoned car with pink paint, red velvet and tinfoil, and ended with the women standing on a beach watching Nancy Youdelman, wrapped in yards of gossamer silk, slowly wade out to sea until, seemingly, she drowned. Chicago was reminded of an Isadora Duncan image and the death of Virginia Woolf; for Wilding it recalled the suicide ending of the heroine in the turn-of-the-century novel, *The Awakening,* by Kate Chopin.

It was in this context and with this audience in mind that Faith Wilding wrote *Waiting* in 1971 and performed it for a Womanhouse audience in 1972. Womanhouse was a summary of much that had been learnt and made in these two early Feminist Art Programs. The Cal Arts Feminist Art Program group transformed an old run-down mansion in Los Angeles into Womanhouse. In the kitchen a progression of sculptured breasts turned gradually into fried eggs; one bathroom contained a mass of Tampax, another an excessive collection of makeup; and if you opened the linen closet you found a trapped mannequin. Performances formed an integral part of these Womanhouse dramatic environments.

* * *

Sanda Orgel ironed a tablecloth quietly, devotedly, obsessively. *Ironing.*

* * *

Chris Rush scrubbed the floor, kneeling, head bowed. *Scrubbing.*

* * *

Cock and Cunt, a play by Chicago, assaulted the audience with a story which began, as Wilding once described it, "with a dispute over dishwashing

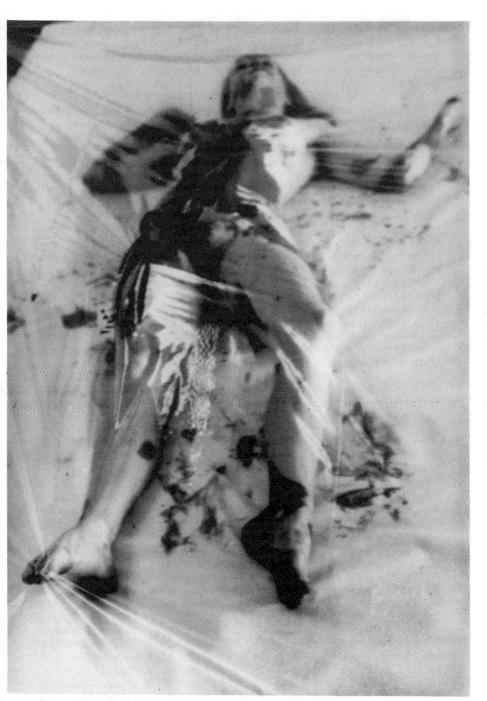

Laurel Klick. *Suicide*. Fresno, Ca., 1972.

and ended with castration." Womanhouse audiences also watched extravagantly costumed figures enact the lives of *Three Women*. They watched a group of women struggle and writhe through *Birth Trilogy*. And they watched the daily scene of a woman making up her face in a room modeled after that of Colette's Leah.

The angers and despairs of these Womanhouse events are echoed by other work of early feminist performance artists in Southern California. A woman lies dying, having written an explanatory note and slashed her wrists with paint; men—played by women—finish off her death and comment callously on her suicide (*Suicide* by Laurel Klick, 1972). Women bathe themselves in broken eggs, blood and clay and then are wrapped in sheets and bound to one another; throughout the piece the audience hears taped accounts of rape (*Ablutions* by Chicago, Lacy, Orgel and Rahmani, 1972).

Trust, intimacy and shared convictions between performers and audiences were of paramount importance to the success of these early feminist performances. The performer(s) needed to trust the audience if she were to risk exposing such highly loaded and often autobiographical, or at least self-revealing, material. Conversely, the audience had to trust in the emotional goodwill and psychological astuteness of the performer in order to be willing to undergo the painful intensity of many of the events. Because of the intimacy that developed within a group who often shared work and living spaces as well as experiences and within an audience who returned time and again to performances, the psychological and political impact of these performances was cumulative, and the barriers between audience and performers indistinct. The performer in one event was a member of the audience for the next. References were made to earlier performances, and psychological shorthand was the order of the day.

Feminist ideology was given on both sides, so the performer could safely assume that the audience knew and supported the underlying convictions of her performance and vice versa. Finally, and very key, the combination of trust, intimacy and shared convictions ensured that anyone disturbed by a performance—whether a performer or a member of the audience—would be given attention and support. It was an emotional and political atmosphere in which great risks could be taken and cathartic pain experienced in a safe situation.

These performances came out of the Feminist Art Programs at Fresno and Cal Arts. In 1973, while the program continued at Cal Arts, a group of women, including Chicago, decided to form the separatist Feminist Studio Workshop. At the same time Womanspace (a women's gallery) was founded, and by the end of the year the Woman's Building opened. The Woman's Building, housing the Feminist Studio Workshop, Womanspace and two other women's galleries, Grandview and 707, immediately became the center for the feminist art movement in Los Angeles. Among its many functions,, the Building provided hospitable space to women performance artists who had developed outside the context of the performance art of the Feminist Art Programs and the Feminist Studio Workshop.

Some people use the term "feminist" to denote women (and men) generally supportive of the cause of women—who are sympathetic to women's issues and possess insight into the nature and needs of women. I would prefer a narrower definition of feminist: one who is concerned with the political and economic as well as the psychological rights of women and who often operates from within a group context, with some commitment to

468

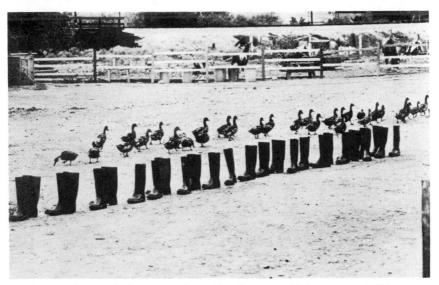

Eleanor Antin. *100 Boots Move On.* **Sorrento Valley, Ca., 1972.**

collective action. And feminist artists? Suzanne Lacy phrases it well when she states: "At first we defined feminist art as all art which reflects a woman's consciousness but as our politics evolved some of us chose stronger definitions. For me now, feminist art must show a consciousness of women's social and economic position in the world. I also believe it demonstrates forms and perceptions that are drawn from a sense of spiritual kinship between women." Some of the women discussed in the remainder of the essay are, in my eyes, clearly feminist artists—some murkily so—and some are not. But none are anti-Feminist.

Shortly after the opening of the Woman's Building in 1974, Eleanor Antin, Nancy Buchanan, Pauline Oliveros and Barbara Smith were invited to participate in workshops and to create performances. These four had already developed careers in performance art, were connected with the feminist movement to varying degrees, and came from highly divergent backgrounds. That they should all appear in the Woman's Building in 1974-1975 was a symbol of the general emergence and coming together of women performance artists in Southern California. Buchanan and Smith, Los Angeles-based artists, had met in the late 1960's while in graduate school at the Irvine campus of the University of California (south of Los Angeles), which was a flourishing center of early performance art for its graduates but not for its faculty. Oliveros and Antin live in the San Diego area and currently teach at the University of California there; Oliveros derives from the ambiance of Bay Area experimental music and Antin from New York theater and poetry.

In 1974 the Woman's Building audience watched the encounter between a young actress (represented by 1954 cheesecake stills on video of the aspiring actress Antin) and a King, a Black Movie Star, a Ballerina and a Nurse (personae whom Antin created in the 1970s) in *Eleanor 1954,* a performance

in which Antin shifts back and forth between her past and present selves, between mockery and compassion. This was Antin's first year of live performances before an audience, and she presented both of her 1974 works, *The Ballerina Goes to the Big Apple* and *Eleanor 1954,* at the Woman's Building, whose audience she remembers as being highly supportive—"a perfect audience."

Antin had immersed herself in narrative and performance art for several years. Her hundred boots marched around Southern California—living, loving and working—in the postcard series *100 Boots* (1971-1973), and then Antin herself, variously garbed as King, Ballerina, Nurse and Black Movie Star, lived, loved and worked in performances presented through the media of photography, video and live events. Her work deals with being a woman in the world, the world of fact and of her own fantasies. The characters change within themselves: the Ballerina appears in a moment of triumph and in poverty and obscurity; the Nurse appears in a doctor's office, a hijacking and in the Florence Nightingale saga; but always they deal with the surprisingly live issues of women. This is equally true of the male character, the King, for it is obvious he is played by a woman; Antin never

Eleanor Antin as "King discoursing on the state of the economy with one of his subjects." Solana Beach, Ca., 1973.

Eleanor Antin in *The Angel of Mercy*. New York, N.Y., 1977.

Pauline Oliveros. *El Relicario de los Animales.* **La Jolla, Ca., 1979.**

attempts the visual deception of Rrose Selavy. Her women aim high—whether for kingdom, fame, glamour or romance. For the most part they are realistic about the barriers between them and their ambitions, and they aim to win. Antin does not create losers. They may be down and out on occasion, but they always regain their energy. The aspirations of Eleanor of 1954—to become a fine actress—and of the 1960's to become a well-known artist—have been realized. In the 1970's she has set up feminist questions for herself, and her work is beginning to answer them.

When Pauline Oliveros came to the Woman's Building in 1975 to give a workshop, she encountered Linda Montano, who was performing blindfolded. As a result, Oliveros remained silent throughout the conference and became Montano's seeing guide. For a later conference at her own UCSD Center for Music Experiment, of which she is currently the Director, Oliveros spent the whole three-day conference blindfolded and silent. Such acts are rare but characteristic of her interests: meditation, myth, trance states and attempts to acheive what is often termed a state of higher consciousness, drawing strongly on Eastern ideas and modes.

* * *

A woman stands on a stool covered with sand, her feet trace patterns as she moves in a trancelike state; players with instruments from flutes to palm branches surround the singer. She and they respond to one another, their sounds representing a jungle of animal cries in Oliveros's *El Relicario de los Animales.*

* * *

Nancy Buchanan. *Hair Transplant*. Santa Ana, Ca., 1972.

Oliveros presented this piece in the spring of 1979. I attended one performance of it in which the audience watched the event in a courtyard from above, absorbed, moved and caught up in the singer's trance and the animal cries. It was surprising when the ordinary world—a courtyard of singer and players—re-emerged. The myth and the jungle had disappeared. In another work by Oliveros, *Crow Two: A Ceremonial Opera* (1973-1974), meditation forces disrupting dancers off the stage while the meditators—a group of women, young and old, in mandala formation—remain powerfully at rest. These women performers had worked with Oliveros in private in her Sonic Meditations group, in which they had practiced physical and spiritual exercises, kept dream journals and diaries and meditated together.

Oliveros creates astonishing mythic and meditative worlds which haunt the mind long after the performances; and it is women who preside over these worlds.

Nancy Buchanan has performed at the Woman's Building several times. In 1974 her *Please Sing Along* begins with two nude men languidly dancing to soft flute and guitar music. It ends with two women, dressed in white karate suits, fighting until exhausted. Indeed, when Buchanan and Smith performed the struggle, Smith actually strained her hand and Buchanan's ankle bothers her to this day.

Buchanan created her first performance in 1972 at Irvine, where the graduate students had organized an alternative space, F Space, the site of many performances, including the early ones of Chris Burden. It was in this intimate and somewhat private space with a mixed audience, mainly her fellow graduates and friends, that Buchanan presented *Hair Transplant* (1972), her first performance.

* * *

A woman in a doctor's lab coat enters with a patient similarly dressed into a hospital-like white environment. She removes her patient's clothes and shaves off his mustache and body hair. She then cuts her own waist-length red hair, glues patches of it onto the patient's body and distributes the rest of the hair among the audience.

* * *

Beginning with *Hair Transplant,* in which she twists and turns the Samson and Delilah story, Buchanan has tackled male and female roles in the context of autobiography and myth. She explores her early childhood experiences as an obese child (*True Confessions*) and through mementoes of her father, mother and grandmother (*Throw-Away*) and the relationship of blacks and women to society (*Tar Baby*).

Deer/Dear (1978) begins with a woman in a sleeping bag recounting horrifying dreams of violence. Buchanan devotes the rest of this performance to the waking nightmare of violence toward women; she uses slides and stories drawn from her own history and that of others, ending with the fear and anger triggered by the Hillside Strangler murderers (one of which took place near her house) and an image of deer in snow.

Barbara Smith had participated in Buchanan's *Please Sing Along* as one of the two female karate fighters, but in her own performance, *Scan 1,* for the Woman's Building in 1974, she did not make feminist references. In *Scan 1,* Smith's 45 performers, staring out of white masks cut to reveal eyes and

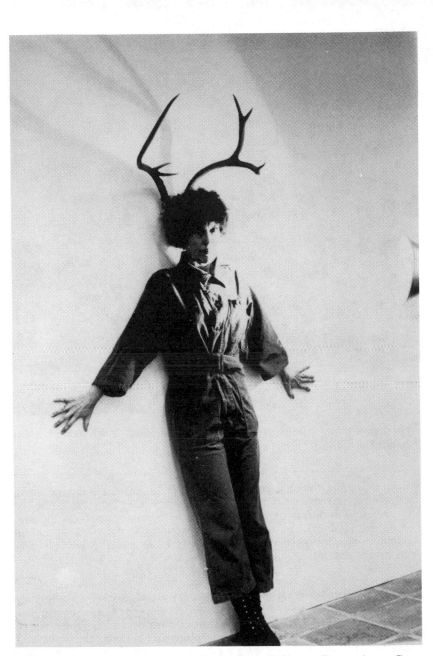

Nancy Buchanan. *Deer/Dear*. Santa Ana College, Santa Ana, Ca., 1978. (Kitty Hodge as "deer.")

Barbara Smith. *Ritual Meal.* **Los Angeles, Ca., 1969. (Liver being cooked at table.)**

mouth, attempt through gestures and props to create an abstract image simulating television scanning patterns. Since the late 1960's Smith has been a powerfully influential figure for other performance artists in the area, including feminists. However, her concerns have not been specifically feminist ones, though women, usually herself, are central characters in her myths and dreams.

<div align="center">*　　　*　　　*</div>

An amplified heartbeat throbs through the house. Sixteen elegantly clad men and women are given white surgical coats and caps before they sit down for a six-course dinner served by silent costumed and surgically masked figures. The food is served in plasma bottles and beakers, the utensils are forceps and scalpels and the guests eat with their bare hands or don surgical gloves.

<div align="center">*　　　*　　　*</div>

Food as a metaphor for giving and taking spiritual and sensuous nourishment and for the idea of communal participation is central to Smith's concerns and was announced in the *Ritual Meal* of 1969. She recouched these themes in more personal and extreme terms in *Feed Me* and *Pure Food* in 1973. In *Feed Me* Smith sat nude among incense, food, oils, pillows, rugs, flowers and books. Participants entered one at a time. The context was an all-night series of events in an alternative space (San Francisco's MOCA) in which most of the participants were fellow artists and friends, male and female. Smith performed the companion piece, *Pure Food*, in which she sat meditating for eight hours in a small clearing in a field.

In 1978, Smith and Suzanne Lacy collaborated in *Vigil*, the performance described at the beginning of this essay in which Lacy is the old woman and Smith the girl. This collaboration represented a fruitful encounter between two gifted artists and a significant converging point in the history of women's performance art in Los Angeles.

<p style="text-align:center">* * *</p>

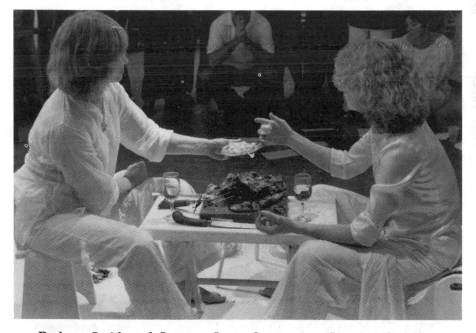

Barbara Smith and Suzanne Lacy. *Incorporate.* **Los Angeles, Ca., 1978. (The sequel of** *Vigil.***)**

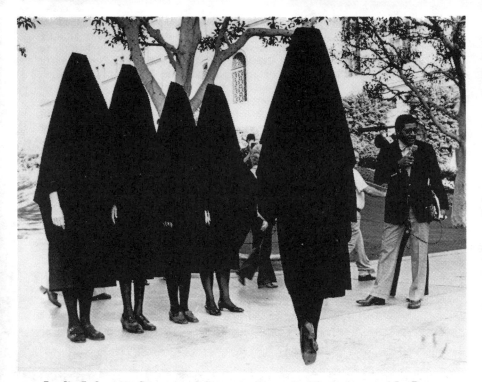

Leslie Labowitz-Starus and Suzanne Lacy. *In Mourning and In Rage.*
Los Angeles, Ca., 1977.

A woman marks off the rape and attempted rape locations in Los Angeles
on a large map placed in the Los Angeles City Hall; each day she records the
previous day's rapes reported to the police. Women conduct rape discussions
and selfdefense demonstrations; city officials give speeches; and women
artists organize performances ranging from militant street theater to private
cathartic situations for women who have experienced sexual violence.

<p style="text-align:center">* * *</p>

Suzanne Lacy coordinated these highly successful activities for three weeks
in May of 1977. She arranged for a second map, with the location and phone
numbers of rape intervention agencies, to be installed in the same space as
the first. She was intent from the beginning to stress in *Three Weeks in May*
means for political and social change as well as to portray the continuing
victimization of women. This message was clearly spelled out in the title of
the public performances which Leslie Labowitz-Starus contributed to the
action: *The Myths of Rape, The Rape, All Men Are Potential Rapists* and
Women Fight Back.

Since meeting Judy Chicago in 1970 while in the Fresno graduate
program in psychology, Suzanne Lacy has worked from a strongly feminist
point of view. A staunch believer in collaboration and an excellent organizer,

Lacy is highly influential as a theorist of feminist performance and as a teacher (she teaches in the Feminist Studio Workshop) as well as being a superb artist. As I quoted earlier in this essay, Lacy believes (and I think quite correctly) that over the last 10 years the needs and directions of feminist art have changed: At the beginning it was sufficient for art to reflect a woman's consciousness, but recently the emphasis has shifted (and should shift) to women's position in the world.

Leslie Labowitz-Starus, Laurel Klick and Cheri Gaulke participated, among others, in *Three Weeks in May;* all three are clearly committed to feminist causes and to action.

A poster announced that Labowitz-Starus would be waiting in her studio for her menstruation cycle and that anyone interested was welcome to join her; she performed *Menstruation Wait* twice, once in Los Angeles in 1971

Leslie Labowitz-Starus. Poster for *Menstruation Wait*. Dusseldorf, Germany, 1972.

and again in 1972 in Germany, where she had gone to study with Joseph Beuys. In Europe she created two performances, *To Please A Man* (in which she laboriously curls her straight hair before a mirror) in 1973 and in 1975 an event addressed to the need to change German abortion laws (a scene of Ku-Klux-hatted black figures and screaming women covered with red paint), which together with *Menstruation Wait* established her powerful style of dramatic costumes and gestures and boldly scripted statements and slogans. She returned to Los Angeles from Europe in 1977, participated in Lacy's *Three Weeks in May* and a few months later directed *Record Companies Drag Their Feet,* a street theater event protesting the depiction of women on record cover albums.

Labowitz-Starus and Lacy decided to collaborate on *In Mourning and in Rage* (the media event protesting the event and coverage of the Hillside Strangler murders) at the end of 1977 and have continued joint projects, including the organization of Ariadne, a feminist discussion and action group.

The Feminist Art Workers, created in 1976 by Nancy Angelo, Cheri Gaulke, Laurel Klick and Candace Compton (Vanalyne Green has now replaced Compton), tour together and produce joint performances,

The Waitresses (Jamie Wild, Denise Yarfitz, Anne Gauldin, Leslie Belt, Jerri Allyn, Patti Nicklaus). *Ready to Order?* **Los Angeles, Ca., April-May 1978.**

480

Cheri Gaulke. *Talk Story*. **San Francisco, Ca., 1977.**

Ten years ago in Fresno, California, Judy Chicago introduced me to artmaking through the Feminist Art Program. Since then her personal encouragement and the inspiration of her professional accomplishments has nurtured, in my own art as well as that of other women, the creation of aesthetic forms which reflect women's community.

As I watched The Dinner Party grow and draw near completion, I wanted to acknowledge Judy and the people who worked on it, to pay tribute to their work with my own. Thus The International Dinner Party Event came into being, a performance structure for the expression of the contemporary lives and loving connections of women around the world. This piece is dedicated to Judy, who mothered me that which I give back to her through...

Suzanne Lacy

Suzanne Lacy. *The International Dinner Party*. San Francisco, Ca., 1979. (Map to show location of dinners.)

workshops and lectures. In addition each has established her own domain of interests and symbols in separate work. Nancy Angelo invented the image of herself as the Nun. Laurel Klick followed her *Suicide* (1972) by *Secrets* (1974), performed in the Woman's Building, in which she placed two chairs in a small space and sat there trading secrets with one individual at a time. Cheri Gaulke works with the metaphor of shoes (as objects of attire and their meaning in folklore) in order to comment on oppression and confinement among women. Her performances range from *Talk Story* in a San Francisco gallery setting—a performance which began with Cinderella trying on the fateful shoe and then launched into three fairy stories involving shoes—to the events she created in Malta. There she danced the Red Shoes story until she collapsed in an ancient Maltese temple dedicated to a female goddess; healing rituals followed.

Six women, possessing considerable experience in waitressing, founded the Waitresses collective; they perform, sometimes announced and sometimes guerilla-action, in restaurants, galleries and for women's groups. To them the "waitress" is a metaphor for the position of most women vis-a-vis money, work, stereotypes and sexual harrassment.

Finally, another collective is Mother Art (1974-), a support group for women artists with children, whose performances in laundromats were funded by a small California State grant only to be publicly singled out after the passing of Proposition 13 as examples of wasteful state funding.

*　　　*　　　*

In Iowa a group of women dine together and honor women of their choice. From New Zealand comes news of another such dinner at the same time. Cables and telegrams, often of a highly personal nature, describing dinner parties all over the world by and for women, pour into the San Francisco Museum of Modern Art.

<center>*　　　　*　　　　*</center>

Suzanne Lacy planned this global dinner party as a contribution to the opening festivities for Judy Chicago's *The Dinner Party* exhibition. This *International Dinner Party* attracted women participants outside the art realm, as Lacy's mailing list had contained a wide range of women's organizations. It was a feat of organization on a large scale which still allowed private personal experiences—not an easy combination to achieve.

The International Dinner Party stands for a new genre of public and positive feminist performance art remote from the pains, angers, lamentations and private audiences of the early 1970s.

Three other women performance artists—Linda Montano, Norma Jean Deak and Rachel Rosenthal—whose work demonstrates a private bent rather than a public feminist focus should be mentioned in this essay.

Linda Montano. *Mitchell's Death*. La Jolla, Ca., 1978.

Norma Jean Deak. *Travel Log.* **La Jolla, Ca., 1977.**

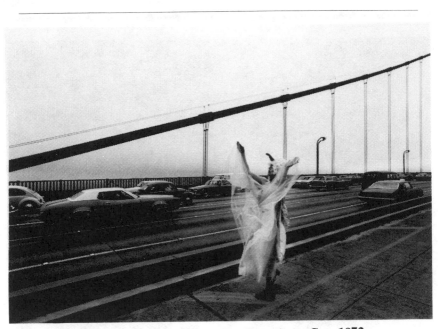

Linda Montano. *Chicken Dance.* **San Francisco, Ca., 1972.**

Linda Montano blended autobiography, mysticism and theater in *Mitchell's Death,* a performance to celebrate the life and mourn the death of her friend and ex-husband, Mitchell Payne. Montano worked over the material of Payne's death and her memories of him intensely for over a year, and I found the third version of the ritual, conducted almost a year after the death, one of the most brilliant and moving art events I have experienced. She left the audience stunned, and many wept.

Montano began performance work while still on the East Coast before moving to the Bay Area in 1971, where as a motionless nunlike figure garbed in white she sat and lay in public places and, at other times as the Chicken Woman, danced wildly through San Francisco streets. From the beginning she has established two domains as both the source and content of her work: trance, meditation and hypnosis on the one and wild humor on the other. Montano, now living in Southern California, is currently moving in the direction of video rather than live performance. She continues to use herself and her women personae as vehicles for ideas which relate to the experience of being a woman but also reach strongly into mystical and spiritual realms where, in her eyes, one's sex is not the issue.

* * *

A woman, alone in a foreign country, talks brightly to the audience of what she sees and whom she meets. Her diary tells another story: she is on the verge of madness.

* * *

485

Cast of *An Oral Herstory of Lesbianism*. Seen in photo: Louise Moore, Sue Maberry, Nancy Angelo, Brook Hallek, Chutney Lu Genderson, Cheri Gaulke, Arlene Raven, Jerri Allyn, Cheryl Swanneck, Christine Wong, and Catherine Stifter. (Not shown, Terry Wolverton).

Rachel Rosenthal. *The Death Show*. Los Angeles, Ca., 1978.

In *Travel Log* Norma Jean Deak alternates the monologues of her private and public fictitious self with slides of real people she knows and real places she has visited. Drawing on her years in theater, an unusual background for a performance artist, Deak stages vignettes in the lives of her women characters with fine psychological and theatrical precision.

Rachel Rosenthal, another storyteller trained in theater and dance as well as art, mines performance material—usually for one-time presentations—from episodes in her own life. She based *Charm* (1976) on the mixed emotional blessings of her glamorous childhood in Paris and *The Story of O* on the character and life of a close relative. In *The Death Show* (1978) Rosenthal displays an earlier photograph of herself while fat to symbolize "the fat vampire" against whom she struggles to free herself; dressed in black, amid candles and elborate props, she ends the performance by slashing the photograph with a knife.

The current fabric of women's performance art in Southern California is rich when viewed from the first half of the year 1979. In March, Lacy organized *The International Dinner Party,* and she and Labowitz-Starus are continuing action-directed public projects in the vein of *Three Weeks in May* and *In Mourning and in Rage.* In April, Oliveros created the jungle cries of her *El Relicario de los Animales*; and Smith the ritual ambiance of candles, readings and performance to respond to the death of her mother in the week before the event. In May at the Woman's Building a Lesbian theater collective, who had been working closely together for months, put on *An Oral Herstory of Lesbianism:* music and dance skit formats to explore the performers' experiences of the pleasures and difficulties of their Lesbian commitment and lifestyle.

The audiences of the above performances range from the unknown public of Lacy and Labowitz-Starus, Smith's circle of personal friends and fellow artists to the close-knit women-only audience of the Lesbian theater event. The intent of these pieces is equally varied: Lacy and Labowitz-Starus want political and social action; Oliveros wishes to establish a meditative state in her listeners; and Smith and the Lesbian theater group want to work through their experiences of, respectively, death and lesbianism in order to understand more fully themselves and to offer insights to their audiences.

<p style="text-align:center">*　　*　　*　　*　　*</p>

There is a powerful informal collective at work in Southern California among women performance artists; although there have never been specific assignments for one woman to deal with autobiography, the second with theater, the third with mysticism and the fourth with politics, yet these issues have naturally distributed themselves among this informal "collective." As a result, the portrait of women in the world today painted by these performance artists presents a synthesis of concerns about women never achieved before in the fine arts, and it was performance not painting or sculpture, that was the necessary medium for this synthesis in Southern California - the last outpost.

The writing of this essay began with a conversation with Jan McCambridge on a train to Los Angeles and ended one Sunday morning with Pauline Oliveros and Linda Montano in Leucadia. It draws from a long-term interest in and study of California performance art in general (see my "Toward a History of California Performance," Parts One and Two, *Arts,* February and

June 1978) and from my admiration for the Performance art produced by women in Southern California. The statements by artists are from taped interviews I have made over the last few years; I have published edited versions of these with Barbara Smith (*Barbara Smith,* Mandeville Art Gallery, University of California, San Diego, 1974), with Norma Jean Deak and Linda Montano (*High Performance,* February and December 1978) and with Pauline Oliveros (*New Performance,* Vol. 1, No. 2; Vol. 1, No. 3 contains an interview/essay about *Mitchell's Death* by Linda Montano).

* * *

PHOTO CREDITS

All photographs courtesy of the artist except where otherwise noted.

Richard Alpert, pp. 128/9, 132, 135, 136, 137, 139, 221; Sue Amon, p. 321; Anna Banana, p. 183; Judith Barry, p. 281; Michael Beaucage, p. 294; Grace Bell, p. 472; Ronald Benom, p. 421; Gary Beydler, p. 400; Rob Blalack, pp. 314, 482; Ron Blanchette, p. 233; George Bolling, p. 42; Lennart Bourin, pp. 58, 59; Kathan Brown, p. 366; Will Brown, p. 55; Chris Burden, pp. 286, 403; Elizabeth Canelake, p. 477; Leo Castelli Gallery, pp. 25, 26, 27, 112, 459; Alvin Comiter, pp. 160-4; Michelle Conway, p. 312; R. Cram, p. 418; Jonathan Dent, p. 330; Eternal Network, pp. 96, 97; Gary Fong, p. 141, bottom; Larry Fox, pp. 40, 44, 52, 252; Nancy Frank, pp. 111, 173, 277, 279, 280, 319, 341, 346, 360; Philip Galgiani, pp. 230, 231, 293, 327; T. Gerlach, p. 61; Lilla Gilbrech, p. 223, bottom; Kathy Goodell, p. 18; Jo Goodwin, p. 486; Marion Gray, pp. 295, 296, 446; Robert Gross, p. 483; Diane Hall, pp. 140, 141, top, 143, 239; Lloyd Hamrol, p. 463; Mayde Herberg, p. 474; Charles Hill, pp. 333, 414, 433; Joel Huckins, p.148; Babs Jackson, p. 473; Neil Jacobs, p. 84, bottom; Maria Karras, pp. 478, 480; Tom Keller, p. 332; Barry Klinger, pp. 16, 33, 38, 121; Ute Klophaus, p. 35; Chris Knowlton, p. 423; Art Kunkin, p. 48; Patrick LaBanca, p. 309; Suzanne Lacy, p. 411; La Jolla Museum of Contemporary Art, p.22; Alec Lambie, pp. 77, 78; Levitan-Feinstein, p. 116; Carl Loeffler, pp. 150, 196, 334; L.A. Louvre Gallery, p. 270; Alfred Lutjeans, pp. 397, 398; Dottie Madeasin, p. 86; Wyatt McSpadden, p. 99; James Melchert, p. 134; Minette, p. 85; Susan Mogul, p. 220; David Moreno, pp. 405, 487; Polly Ester Nation, p. 224; Otis Niles, p. 4; Larry Nimmer, p. 234; Bee Ottinger, pp. 2-6-8; Ferdinand Neumuller, p. 431; Floris Neussus, p. 53; Allen Payne, p. 170; Mitchell Payne, pp. 226, 485; Eric Pollitzer, p. 9; photo from a film by William Ransom, p. 476; Christine Reinhold, pp. 131, 133; Terry Schutte, p. 316; Harry Shunk, pp. 408, 471; Denise Simon, p. 339; Gary Sinick, p. 227; Ned Sloane, p. 426; Alexis Smith, p. 252; Barbara Smith, pp. 56, 72, 191, 192; Lyn Smith, p. 363; Liz Sowers, p. 269; Philip Steinmetz, pp. 145, 249, 352-7, 469, 470; State of California, Dept. of Public Works, p. 29; Sarah Tamor, p. 250; Blaise Tobia, p. 484; Raul Vega, p. 261; Jerry Wainwright, p. 15; Megan Walker, pp. 110, 138, 262, 318; E. K. Waller, p. 481; Jan Wolf, p. 104.

INDEX

493

CONTEMPORARY ARTS PRESS

CONTEMPORARY DOCUMENTS is published by Contemporary Arts Press, La Mamelle Inc., publisher of **ART CONTEMPORARY, VIDEOZINE, AUDIOZINE, IMAGEZINE, and MICRO-PUBLISHED DOCUMENTS.**

ART CONTEMPORARY, ISSN 000188

A periodical produced by artists reporting on contemporary new art activity. The most widely read contemporary art magazine published in California. Beginning publication date 1975. Current issue, Nos. 15/16. Back issues $5.00 each. Subscription: 8 issues, US$ 12.00, additional US$ 4.00 foreign.

VIDEOZINE

New electronic magazine produced by artists. Published on standard ¾ video cassette format. Presenting selections of art video, and art documentation on video from international sources. Beginning publication date 1977. Six issues available. Approximately 30 minutes, ¾ cassette, B/W, some color, with titles. Price: purchase, US$ 200.; rental, US$ 100., plus $50. transfer.

AUDIOZINE

New electronic magazine produced by artists published on standard audio cassette format. Presenting selections of audio art and art documentation on audio from international sources. Beginning publication date 1977. Six issues available. Approximately 60 minutes, stereo, dolby, with case and program notes. Price: US$ 10.00 each.

IMAGEZINE

A periodical published on a rubber stamp format. "If publishing is the making public of information, then Imagezine imprints upon surfaces is an act of art publishing. Be an art publisher!" Beginning publication date 1977. Four issues available. A rubber stamp approximately 2 × 4 inches. Price: US$ 20.00 each.

MICRO-PUBLISHED DOCUMENTS

High quality microfiche reproductions of important art publications from international sources. Presently available on library quality positive fiche, standard size: Selected issues from Art Contemporary; Intermedia; Vile; Dadazine; Impulse; and La Mamelle Inc. exhibition catalogues. Additional in preparation. Write for price list.

La Mamelle Inc., educational art organization beginning 1975, has undertaken a vital developmental role in the field of contemporary art through the founding and maintenance of new art presentation spaces, publications, and archives.